0060815

J++VASP 99

VINCENNES *and* SÈVRES PORCELAIN

CATALOGUE OF THE COLLECTIONS

VINCENNES *and* SÈVRES PORCELAIN

CATALOGUE OF THE COLLECTIONS

ADRIAN SASSOON

THE J. PAUL GETTY MUSEUM

MALIBU, CALIFORNIA 1991

© 1991 The J. Paul Getty Museum
17985 Pacific Coast Highway
Malibu, California 90265

Mailing address:
P.O. Box 2112
Santa Monica, California 90407–2112

Christopher Hudson, Head of Publications
Andrea P. A. Belloli, Consulting Editor
Cynthia Newman Helms, Managing Editor
Deenie Yudell, Design Manager
Karen Schmidt, Production Manager
Leslee Holderness, Sales and Distribution Manager

LIBRARY OF CONGRESS CATALOGING-IN-PUBLICATION DATA

J. Paul Getty Museum.
 Vincennes and Sèvres porcelain : catalogue of the collections /
 Adrian Sassoon.
 p. cm.
 Includes bibliographical references and index.
 ISBN 0-89236-173-5
 1. Vincennes porcelain—Catalogs. 2. Sèvres porcelain—Catalogs.
3. Porcelain—California—Malibu—Catalogs. 4. J. Paul Getty
Museum—Catalogs. I. Sassoon, Adrian, 1961– II. Title.
NK4399.V55J2 1991
738.2'0944'363—dc20 90-26063
 CIP

ISBN: 0-89236-173-5

Project staff:

Editor, Karen Jacobson
Designer, Sean Adams with production assistance from Thea Piegdon
Production Coordinator, Amy Armstrong
Photographer, Jack Ross

Typography by Wilsted & Taylor, Oakland, California
Printed by Dai Nippon Printing Co., Ltd.

Cover: *Lidded Vase* (detail). Sèvres manufactory, circa 1769.
Soft-paste porcelain set on a gilt-bronze base. Height (including
base) 45.1 cm (1 ft. 5¾ in.). Malibu, J. Paul Getty
Museum 86.DE.520 (see no. 19)

Contents

Foreword

WE ARE PLEASED to present another volume in the Getty Museum's series of catalogues devoted to the permanent collection. The Department of Decorative Arts under Gillian Wilson has previously produced *Mounted Oriental Porcelain* (by F. J. B. Watson, Gillian Wilson, and Anthony Derham; 1982) and will soon see the publication of *Clocks* (by Gillian Wilson et al.) and subsequent volumes devoted to French furniture and decorative arts. *Italian Maiolica* (by Catherine Hess, 1988) and the forthcoming *Glass* (by Timothy Husband) treat the collections of the Department of Sculpture and Works of Art under Peter Fusco.

Our collection of Vincennes and Sèvres porcelain is marked indelibly by the taste of its curator, Gillian Wilson, who for twenty years has combed the market for the most remarkable pieces. The collection has been formed not for a house, not for a great repository, but instead for a small museum that attempts to show eighteenth-century French design and craftsmanship at its most successful. Its size is modest, and it consists primarily of display pieces. These are installed in the galleries, with individual objects displayed on various pieces of furniture, while larger groupings are shown in vitrines.

This catalogue is the work of a Getty alumnus. Adrian Sassoon was invited by Gillian Wilson to the museum as a volunteer in 1980 and stayed as a curatorial assistant and assistant curator until 1984; he later returned to England to enter the art trade and pursue private scholarship. We are grateful that his expertise and thorough knowledge of the Sèvres documents could be trained on a collection that he knows well, and that he also had a hand in forming.

John Walsh
Director

Acknowledgments

WITHOUT GILLIAN WILSON this catalogue would not exist as it does. She assembled the bulk of the collection described herein and has encouraged many scholars to contribute their knowledge. I must thank her for her invaluable help at every stage of my involvement with the collection and the catalogue. The Introduction owes a great deal to Wilson's unpublished manuscript "J. Paul Getty as a Collector of Decorative Arts."

I would particularly like to thank Sir Geoffrey de Bellaigue, Tamara Préaud, and Rosalind Savill for generously sharing information. Their numerous published works and patient guidance have been of immense importance to this catalogue. The author is also well aware of his debt to Marcelle Brunet, Svend Eriksen, and Pierre Verlet for their ground-breaking publications.

Others who have helped me prepare this catalogue include Susan Newell, who carried out much documentary research; Frances Buckland, whose research into Sèvres porcelain sold at auction in London in the nineteenth century has proved most interesting; and James Folsom of the Huntington Library, Art Collections, and Botanical Gardens, who identified the flowers painted on the porcelain. I am grateful to Frank Berendt for his patience.

At the J. Paul Getty Museum, David Cohen, Charissa Bremer-David, Gay Nieda Gassmann, Barbara Roberts, and Teresa Morales have each contributed much to this catalogue. Laurel Oden and Libby Spatz, formerly of the Photographic Archives at the J. Paul Getty Center for the History of Art and the Humanities, have also been of great help. Attention must be drawn to the outstanding restoration that has been carried out on various pieces in this collection by Lynn Wickes and his staff in Santa Barbara.

Many others have contributed information to this catalogue and have kindly allowed the author to inspect objects in their collections or under their guardianship. They include Antoine d'Albis, Jean-Dominique Augarde, Rainier Baarsen, Michele Beiny, Rotraut Beiny, Dr. Shelley Bennet, Richard Beresford, Dr. van den Blawen, Michael Booker, Clare Le Corbeiller, Didier Cramoisan, Aileen Dawson, Bernard Dragesco, Pierre Ennès, Elisabeth Fontan, Alexandra and Rupert Galliers-Pratt, Angela Galliers-Pratt, the late David Garlick, Michael Hall, Antoinette Hallé, Peter Hughes, Bonita LaMarche, Mme Leleu, John McKee, Sarah Medlam, Jeffrey Munger, Robert Pirie, Sir John Plumb, Maxime Préaud, Lynn Roberts, the Countess of Rosebery, Linda Roth, Col. Slessor, Edith A. Standen, Dr. Stubenvoll, Dr. Robert Wark, Sir Francis Watson, John Whitehead, Robert Williams, Marc Wilson, and several private collectors in the United States and England.

Adrian Sassoon

Note to the Reader

THIS CATALOGUE DESCRIBES a variety of Vincennes and Sèvres porcelain objects, which have been divided into two categories: useful wares and vases, and plaques for furniture. Within these categories the objects are presented in chronological order. More background information is given on some models than on others. Those models covered less fully in this catalogue have been published elsewhere in greater detail.

Each entry provides general information concerning the design, introduction, manufacture, and development of the model at the Vincennes and Sèvres factory. Biographical information on the decorators is given in the Appendix. The factory's sales records and other eighteenth-century documents provide varying amounts of relevant information concerning each model, and this is presented and related to the example under discussion. Other known or surviving examples of the model are then described, as are other closely related objects produced by the factory. When possible, the subsequent provenance of an object is then given, and in some cases background information on the subsequent owners is presented as well. The exhibitions cited are those in which the actual objects were displayed; exhibition catalogues that simply refer to an object are cited under Bibliography. In the latter section only those references that relate to the object described are included, and less scholarly periodical and newspaper articles have been omitted. Measurements in centimeters are given as accurately as possible; when a measurement is expressed as "25 cm," it is approximate, whereas "25.0 cm" can be regarded as a precise reading.

ABBREVIATIONS
In bibliographies and notes, frequently cited works are identified by the following abbreviations:

Abbreviations for documents in the archives of the Manufacture Nationale de Sèvres and the library of the Institut de France

A.L.
Artists' ledgers, Vj series, entitled "Travaux des ateliers de peinture et dorure," covering 1777 to 1800.

B.K.R.
Biscuit kiln records, entitled "Registre de défournements de biscuit," covering October 18, 1752, to September 24, 1759 (very incomplete). Institut de France MS. 5673.

1814 INVENTORY
U.3; this inventory lists the eighteenth-century plaster models in the archives of the Sèvres factory at that date. The names given to various models often do not agree with those found in eighteenth-century documents.

E.K.R.
Enamel kiln records, entitled "Registre de défournements de couleurs," November 28, 1752, to December 31, 1755 (very incomplete). Institut de France MS. 5676.

G.K.R.
Glaze kiln records, entitled "Registre de défournements de couverte," covering October 19, 1752, to October 29, 1755, and December 30, 1755, to September 24, 1759, and October 18, 1759, to July 1771 (very incomplete).

K.R.
Kiln records, Vl series, entitled "Registres fournées de peinture," covering from April 12, 1777, on.

P.O.R.
Painters' overtime records, F series, entitled "Recettes et dépenses," covering 1741 on (very incomplete), including "Travaux extraordinaires" and "Travaux à la pièce."

R.E.
Register of employees, Y7, entitled "Registre contenant les employés aux ateliers des mouleurs en plâtre, mouleurs en pâte, de la couverte, du blutoir, des fours, des tourneurs et répareurs," and Y8, entitled "Registre contenant les noms des employés aux ateliers de la dorure, des couleurs, de la peinture et de la sculpture," partly covering 1755 to 1758.

R.R.
Répareurs' records, Va series, entitled "Travaux des tourneurs, mouleurs et répareurs," covering 1773 to 1800.

S.L.
Stock lists, I.7 and I.8, entitled "Inventaires annuels," covering from October 1, 1752, on (incomplete from 1774). From 1753 the inventory was generally taken on January 1 of each year and recorded the new work of the previous year. In several years the inventory was taken on a later date, including 1759, 1760, 1773, 1778, 1780, 1785, 1786, and 1788 on.

S.R.
Sales records, Vy series, entitled "Registres des ventes," covering from October 1, 1752, on. From the early 1760s objects are described very generally, with few details regarding their decoration. For example, vases from this period are usually described as "pièces d'ornemens" rather than by the model's proper name.

Other Abbreviations

BRUNET 1974
M. Brunet. *The Frick Collection*. Vol. 7, *Porcelain*. New York, 1974.

BRUNET AND PRÉAUD 1978
M. Brunet and T. Préaud. *Sèvres des origines à nos jours*. Fribourg, 1978.

CORDEY 1939
J. Cordey. *Inventaire des biens de Madame de Pompadour, rédigié après son décès*. Paris, 1939.

DAUTERMAN 1964
C. C. Dauterman. In *Decorative Art from the Samuel H. Kress Collection at the Metropolitan Museum of Art*. London, 1964.

DAUTERMAN 1970
C. C. Dauterman. *The Wrightsman Collection*. Vol. 4, *Porcelain*. New York, 1970.

DAUTERMAN 1986
C. C. Dauterman. *Sèvres Porcelain: Makers and Marks of the Eighteenth Century*. New York, 1986.

DE BELLAIGUE 1979
G. de Bellaigue. *Sèvres Porcelain from the Royal Collection*. London, 1979.

DUVAUX 1873
Livre-Journal de Lazare Duvaux, marchand-bijoutier ordinaire du roy, 1748–1758. . . . Edited by L. Courajod. 2 vols. Paris, 1873.

ERIKSEN 1968
S. Eriksen. *The James A. de Rothschild Collection at Waddesdon Manor: Sèvres Porcelain*. Fribourg, 1968.

ERIKSEN 1980
S. Eriksen. *The David Collection: French Porcelain*. Copenhagen, 1980.

ERIKSEN AND DE BELLAIGUE 1987
S. Eriksen and G. de Bellaigue. *Sèvres Porcelain: Vincennes and Sèvres, 1740–1800*. London, 1987.

GARNIER [1889]
E. Garnier. *La Porcelaine tendre de Sèvres*. Paris, [1889]. (Also published as *The Soft Porcelain of Sèvres*. London, 1892.)

GETTYMUSJ
J. Paul Getty Museum Journal.

JPGC
J. Paul Getty Center for the History of Art and the Humanities.

JPGM
J. Paul Getty Museum.

MNC
Musée National de Céramique, Sèvres.

MNS
Manufacture Nationale de Sèvres.

PARKER 1964
J. Parker. In *Decorative Art from the Samuel H. Kress Collection at the Metropolitan Museum of Art*. London, 1964.

PRÉAUD AND FAŸ-HALLÉ 1977
T. Préaud and A. Faÿ-Hallé. *Porcelaines de Vincennes: Les Origines de Sèvres*. Exhibition catalogue. Grand Palais, Paris, 1977.

SASSOON 1982
A. Sassoon. "Two Acquisitions of Sèvres Porcelain in the Getty Museum." *GettyMusJ* 10 (1982), pp. 87–94.

SASSOON 1985
A. Sassoon. "Vincennes and Sèvres Porcelain Acquired by the J. Paul Getty Museum in 1984." *GettyMusJ* 13 (1985), pp. 89–104.

SASSOON AND WILSON 1986
A. Sassoon and G. Wilson. *Decorative Arts: A Handbook of the Collection of the J. Paul Getty Museum*. Malibu, 1986.

SAVILL 1985
R. Savill. In *The Treasure Houses of Britain: Five Hundred Years of Private Patronage and Art Collecting*. Exhibition catalogue. National Gallery of Art, Washington, D.C., 1985.

SAVILL 1988
R. Savill. *The Wallace Collection: Catalogue of the Sèvres Porcelain*. 3 vols. London, 1988.

STANDEN 1964
E. A. Standen. In *Decorative Art from the Samuel H. Kress Collection at the Metropolitan Museum of Art*. London, 1964.

TROUDE [1897]
A. Troude. *Choix de modèles de la Manufacture Nationale de Sèvres appartenant au Musée Céramique*. Paris, [1897].

VERLET 1953
P. Verlet. *Sèvres: Le XVIIIᵉ Siècle* Paris, 1953.

WARK 1961
R. R. Wark. *French Decorative Art in the Huntington Collection.* San
Marino, Calif., 1961.

WILSON 1977
G. Wilson. "Sèvres Porcelain at the J. Paul Getty Museum."
GettyMusJ 4 (1977), pp. 5–24.

WILSON 1978–1979
G. Wilson. "Acquisitions Made by the Department of Decorative
Arts, 1977 to Mid 1979." *GettyMusJ* 6–7 (1978–1979), pp. 37–52.

WILSON 1980
G. Wilson. "Acquisitions Made by the Department of Decorative
Arts, 1979 to Mid 1980." *GettyMusJ* 8 (1980), pp. 1–22.

WILSON 1982
G. Wilson. "Acquisitions Made by the Department of Decorative
Arts, 1981." *GettyMusJ* 10 (1982), pp. 63–86.

WILSON 1983
G. Wilson. *Selections from the Decorative Arts in the J. Paul Getty
Museum.* Malibu, 1983.

WILSON, SASSOON, AND BREMER-DAVID 1983
G. Wilson, A. Sassoon, and C. Bremer-David. "Acquisitions
Made by the Department of Decorative Arts in 1982." *GettyMusJ*
11 (1983), pp. 13–66.

WILSON, SASSOON, AND BREMER-DAVID 1984
G. Wilson, A. Sassoon, and C. Bremer-David. "Acquisitions
Made by the Department of Decorative Arts in 1983." *GettyMusJ*
12 (1984), pp. 173–224

Introduction

DESPITE ITS MODEST SIZE, the J. Paul Getty Museum's collection of Vincennes and Sèvres porcelain contains several items of key importance to any student of the eighteenth-century French royal porcelain manufactory. Its strengths lie in the variety of display pieces and in the large number of plaques mounted on furniture. The collection was assembled in three distinct phases, each subject to different pressures. The earliest acquisitions were made by the founder of the Museum, J. Paul Getty (1892–1976). In 1970 the J. Paul Getty Museum appointed its first curator of decorative arts, Gillian Wilson, whose acquisitions can be divided into two phases: the first from 1970 to 1976, when acquisitions were proposed to Mr. Getty, and the second from 1976 to the present, when acquisitions have been proposed to the Museum's Board of Trustees.

Mr. Getty preferred furniture with Sèvres porcelain plaques to individual pieces of porcelain, and he began acquiring Sèvres as an extension of his collection of French furniture. His purchases reflect his affinity for large, impressive objects rather than smaller useful wares, especially when they had the added cachet of coming from well-known collections. Initially he may have been dissuaded from collecting Sèvres porcelain by the notion, especially prevalent in England earlier in this century, that it was a tricky area for collectors, with many plausible fakes and reproductions on the market. This belief may have prevented him from acquiring pieces that did not come from prominent collections.

Mr. Getty's first acquisitions of Sèvres porcelain were made at Christie's in London on June 22, 1938, at the auction of the collection of French furniture and objects formed by the New York banker Mortimer Schiff. His purchases included an *écuelle* (no. 16), a pair of hard-paste vases (no. 23), a pair of biscuit porcelain figure groups (no. 6), and two circular tables fitted with porcelain tops (nos. 33, 34). The *écuelle,* with its unusual decoration and almost too obvious monogram and coat of arms, was later pronounced a fake by various experts and consigned to a cupboard. After Mr. Getty's death it was found by Gillian Wilson, who proved that it was made for one of Louis XV's daughters, Madame Louise. The unusually decorated vases were set on later marble bases and were thought to have been redecorated in the nineteenth century. In 1983, however, it was discovered that they are mentioned in the Sèvres factory's documents and that the comtesse d'Artois owned a similar pair. The biscuit figure groups were until the early 1980s mounted on pseudo-rococo gilt-silver bases that distorted their appearance.

As a result of these early purchases, Mr. Getty was unjustly criticized by his advisers. This criticism may have undermined his confidence, making him hesitant to acquire Sèvres subsequently. No doubts were cast upon the two tables acquired at the Schiff sale, however. Indeed in the years following, Mr. Getty no doubt discovered that there were tables of this model in the Musée du Louvre and the Musée Nissim de Camondo in Paris, and in the collections of Stavros Niarchos and Mr. and Mrs. Charles Wrightsman (whom he knew personally). This "comparative" approach to collecting appealed to Mr. Getty, who consistently sought the approval of collectors and dealers he respected. He was also very eager to know who had owned an object in his collection, or a similar example, regarding this as a form of endorsement.

Probably no collection of quality has ever been formed without the collector (whether private or institutional) regretting missed opportunities. About two weeks before the Schiff sale Mr. Getty had his first such experience as a collector of Vincennes and Sèvres porcelain. On June 5, 1938, he visited Duveen's gallery and was shown a large group of very fine objects, chiefly Sèvres porcelain vases and furniture with Sèvres porcelain plaques, all from the Hillingdon collection. He noted that it was the most wonderful French furniture that he had ever seen, and he made a second visit three days later. One week later he went back to Duveen's, which was asking $1.5 million for the entire collection, or $1 million for the furniture alone. He noted that it would have been "expensive at half of that price." The objects were later purchased by the Samuel H. Kress Foundation, which donated them to the Metropolitan Museum of Art, New York. Possibly this superb collection seemed too important for the nascent collector, or perhaps it was just too expensive. When confronted with similar objects in the Schiff sale a week later, however, Mr. Getty purchased all of the Sèvres porcelain wares and the furniture with Sèvres porcelain plaques.

In 1941 Mr. Getty purchased a *secrétaire* with Sèvres plaques (no. 37) at a sale from the extensive collections of Mr. and Mrs. Henry Walters of Baltimore, but he showed no interest in the other Sèvres objects in the auction. The *secrétaire,* by Claude-Charles Saunier, has very fine plaques, but its stand is modern. Following the end of World War II, in 1949, Mr. Getty returned to London and Paris and resumed his visits to museums and dealers. In October he visited Partridge's and noted an "odd looking Sèvres plaque cabinet. . . . It had several plaques with Chinese scenes including people. Woodwork painted blue." This was probably one of two cabinets painted with blue *vernis Martin* and decorated with eight Vincennes porcelain plaques imitating

Cantonese enamels. Made in 1755, possibly for the minister in charge of the factory, Jean-Baptiste de Machault, they were surely among the earliest examples of French furniture with specially produced plaques from the Vincennes and Sèvres factory. It was unfortunate that Mr. Getty found the cabinet "odd looking."

In November 1949 Mr. Getty visited the dealer Rosenberg and Stiebel in New York and was shown a table fitted with a very fine Sèvres porcelain top (no. 32). He knew that there was a similar table from the collection of François Guerault, now in the Musée du Louvre, and he bought it instantly. The carcass has since been shown to be a modern reproduction, produced to display a top that had been removed, badly broken, from another table. At the same time Mr. Getty was shown two *secrétaires* with Sèvres plaques, one by Martin Carlin and one attributed to Adam Weisweiler (nos. 35, 40), from the Viennese Rothschilds' collections. He acquired both pieces a few months later. The Carlin *secrétaire* is very similar to one in the Wallace Collection, London, which Mr. Getty visited on September 23, 1950. He made his habitual appraisal of the collection as he toured the museum, valuing all the furniture with Sèvres plaques very highly—both in dollar terms and in his own esteem—compared with the other French furniture. During the same visit to London he bought a *secrétaire* from Partridge's (no. 36). Though it is of nineteenth-century date and has seven plaques imitating Sèvres porcelain, the piece displays one very fine Sèvres *plaque ronde,* which presumably came from another piece of furniture.

During the 1960s Mr. Getty bought very few important pieces of French furniture and absolutely no Sèvres porcelain. The J. Paul Getty Museum was by then open to the public on a regular basis in an extension of his Malibu home. The collection of French decorative arts was displayed in two rather oddly arranged rooms that were notably devoid of smaller objects. By the end of the decade Mr. Getty had decided to commission a new museum on the same site and to add considerably to his collections in order to furnish the building. It was to this end that Gillian Wilson, with the help of Theodore Dell, was from 1971 charged with proposing objects to be acquired for the Museum's collection. Mr. Getty had by this time developed an active interest in acquiring Vincennes and Sèvres porcelain wares, wishing to emulate such great nineteenth-century collectors as Henry Clay Frick and J. Pierpont Morgan. He favored vases, large objects, and pieces with a pink ground.

The first Sèvres wares that Wilson acquired for the collection, in 1972, were a pair of black-ground hard-paste *seaux à demi-bouteille* with gold and platinum decoration (no. 30). In the following year Mr. Getty was persuaded to buy a very fine and rare *cuvette Mahon* of 1761 (no. 14) from French and Company, New York. In December 1972 he bid on four lots of Sèvres porcelain from the collection of Mr. and Mrs. Deane Johnson (which Mrs. Johnson and her former husband, Henry Ford II, had assembled with the help of Rosenberg and Stiebel). Only two bids were successful, those for a pink-ground tray and a pair of pink-and-green-ground cups and saucers (nos. 7, 8).

Mr. Getty's purchase in 1973 of a very splendid Vincennes porcelain *cuvette à tombeau* of 1754–1755 (no. 2) came about by chance. Theodore Dell had obtained photographs of four pieces of Sèvres porcelain from Rosenberg and Stiebel: a garniture of three turquoise-blue-ground *cuvettes à tombeau* dated 1760 from the Harewood collection and a single example. Since the garniture was slightly grander than the single vase (the vases were painted with figure scenes after David Teniers the Younger), he decided not to show Mr. Getty the photograph of the single one. After Mr. Getty had agreed to purchase the garniture, he caught sight of the photograph of the single vase and asked its price and size. Finding that the vase was both larger than the largest in the set of three, and cheaper, he decided to buy the single example rather than the set.

On a visit to Paris in 1975 Wilson was offered one of the ten known examples of the celebrated *pot pourri vaisseau.* The example offered had pink, blue, and green grounds and came from the collection of the late Baronne Edouard de Rothschild. It was originally sold to Madame de Pompadour in May 1760 as the central vase in a garniture of five vases and two Sèvres porcelain wall lights (see below). Because it was the only example of the model remaining in France, an export license was thought to be unobtainable, and its purchase was never pursued (the vase was later bought by René Grog and has since been donated to the Musée du Louvre by his widow).

On her return journey from Paris, where she had been offered the *pot pourri vaisseau* from the Rothschild collection, Wilson visited New York, where by coincidence Rosenberg and Stiebel offered her what was probably the only other available example of this model (no. 10). It was an ideal acquisition, not only because of its rarity and pink and green grounds but also because of its illustrious provenance, coming from the collections of the earls of Coventry and Dudley and later that of J. Pierpont Morgan. A few months later Rosenberg and Stiebel sold Mr. Getty a rare pair of *pots pourris à bobèches* with pink and green grounds, dated 1759, also from the Morgan collection (no. 9). By the time of his death on June 6, 1976, Mr. Getty had acquired some very fine Sèvres porcelain, much of it since 1971. His last two purchases, the *pot pourri vaisseau* and the *pots pourris à bo-*

bèches, alone would constitute an important collection of the factory's grandest products.

One of the Museum's most important purchases since Mr. Getty's death is the pair of *pots pourris fontaine* (no. 11) from the garniture sold to Mme de Pompadour in 1760. They enjoyed great fame in the 1870s, when the Earl of Dudley paid an exorbitant price for them at Christie's, and are exceptionally fine examples of exotic rococo taste.

In 1979 the Museum acquired some high-quality domestic Sèvres porcelain from the Christner collection, including a *gobelet et soucoupe enfoncé,* commonly known as a *trembleuse* cup and saucer (no. 15), and an intriguing *théière litron* (no. 31). Mr. Getty would no doubt have been pleased with the 1981 purchase of a *secrétaire* stamped by Carlin with five Sèvres porcelain plaques (no. 38). It has since been discovered that this *secrétaire* was among the last acquisitions made by the great collector and cofounder of the Wallace Collection, the fourth Marquess of Hertford, before his death in 1870. The only other piece of furniture with Sèvres porcelain plaques purchased since Mr. Getty's death is the *bureau plat* stamped by Carlin (no. 39). It was originally bought by the future tsarina of Russia when she visited Paris in 1782, and it remained at Pavlovsk until 1931, when Duveen bought it from the Soviet government. He sold it to Anna Thomson Dodge, and when it was sold at auction after her death, in 1971, Mr. Getty was outbid. The table is the only known *bureau plat* of its type with Sèvres plaques, and its provenance is outstanding.

The Museum's collection has grown steadily to include early vases and grand domestic wares with ground-color decoration, as well as extravagantly decorated neoclassical objects. A green-ground basket of 1756 (no. 4) and a *seau à bouteille* of 1790 from the service made for Louis XVI (no. 29) were acquired in 1982. At a sale at Sotheby's in London on June 12, 1984 (perhaps the most important auction of Vincennes and Sèvres porcelain of the decade), the Museum secured two of the three objects on which it was bidding: the watering can of 1754 (no. 1) and the pink-ground ewer and basin of 1757 (no. 5). The Museum also tried to buy a very fine Vincennes *gobelet litron couvert* of circa 1752–1753, decorated with a dark blue ground and gilding, but was outbid by the Nelson-Atkins Museum of Art, Kansas City. In December 1985, at the auction of the collection of the late Charles Clore, the Museum purchased the so-called egg vases of circa 1769 (no. 19). They are of outstanding technical and artistic quality, yet they cannot be traced in the factory's documents. It is ironic that the finest products of the Sèvres factory—an enterprise from which so much documentation survives—are often difficult to identify in the records, while insignificant objects are sometimes thoroughly documented. Indeed the records often provide so much information about a mediocre piece that it becomes interesting for reasons unrelated to its quality. Only relatively recently have the value and complexity of these documents come to be recognized, yet it seems that objects are often judged solely on the basis of their documentation. The three *vases des âges* (no. 25) purchased by the Museum in 1984 are an example of remarkable pieces of Sèvres that can be traced in the documents from their decoration, through their firing, to their purchase by Louis XVI for his library at Versailles.

During the 1970s and 1980s there has been a resurgence of interest in Vincennes and Sèvres. This is partly due to the increased use of the factory's documents, allowing scholars to make more confident attributions. As a result, competition among collectors has increased, with a corresponding increase in auction prices. This has hindered expansion of the Museum's collection, as has the enactment of tighter export restrictions. Nevertheless the collection ranks among the most important holdings of Vincennes and Sèvres porcelain formed in the twentieth century.

1 *Watering Can*
(arrosoir, deuxième grandeur)

1754
Vincennes manufactory; soft-paste porcelain; painted by Bardet

HEIGHT 19.7 cm (7¾ in.); WIDTH 24.5 cm (9⁹⁄₁₆ in.); DEPTH 13.0 cm (5⅛ in.)

MARKS: Painted in blue under the base with the factory mark of crossed L's (with a dot at the apex) enclosing the date letter B for 1754, over the painter's mark of two short parallel lines; incised 4 under the base.

84.DE.89

DESCRIPTION: The watering can is composed of two conical shapes that slope outward from the relatively narrow top and bottom to their maximum diameter at the vessel's center. The plain foot is recessed under the base. The top and bottom halves of the watering can each bear two bands of raised molded lines. The flat top has a slightly raised edge and a lobed opening. Applied to one side of the body is a straight tapering spout, which is oval in section. It is topped by a flared circular rose, the face of which is molded with a dense field of pierced flower heads.

The raised molding is painted with lines of royal blue (*filets bleus*), and the same blue color (*beau bleu*) is used on the molded forget-me-nots that form the rose. The white panels are painted with scattered sprays of colored flowers, including primulas, ranunculuses, yellow roses, and anemones or poppies.

Burnished bands of gilding highlight the centers of each of the raised lines of molding, the base, and the rim. There are short diagonal pairs of slashes in burnished gilding at regular intervals along the blue lines.

CONDITION: The watering can is in excellent condition. There is a line of firing weakness on one side of the join between the spout and the body. This has been partly concealed by painted flowers. Some of the openings in the rose are clogged with glaze.

COMMENTARY: This shape of watering can, known as an *arrosoir,* was made at Vincennes and Sèvres in two sizes beginning in 1753. The Museum's example is of the smaller, second size.[1] The molds for both sizes appear in the factory's stock list of 1754, indicating that they were produced in 1753.[2] Gillian Wilson has suggested that the body of the *arrosoir* was developed from that of a two-handled wineglass cooler, a *seau à verre,* examples of which are in the Musée des Arts Décoratifs, Paris (GR 197; height 11.9 cm),[3] and in a private collection, Los Angeles (height 11.8 cm). Inverting one such *seau à verre* on top of another would produce the body of the watering can, though closer in scale to the larger, first size.

Marcelle Brunet and Tamara Préaud have noted that the first *arrosoir* listed in the biscuit kiln records appears after a firing completed on July 10, 1754.[4] It is not listed in the usual way, but a note at the end reads, "It is necessary to add to the above list one *arrosoir* of the first size, which had been diverted before anyone counted the pieces, as it came out of the kiln, by the Directors of the Company."[5] Four *arrosoirs* (two of the first and two of the second size) are listed in biscuit kiln firings in November 1754,[6] and six more of the second size are listed in 1755.[7] The glaze kiln records list one example of the first size in November 1754, though it had to be returned for refiring.[8] In 1755 three examples of the second size are listed in the glaze kiln records,[9] and four of the first size are listed in 1756.[10] A glazed example of the second size, awaiting painting and gilding, was valued at 18 *livres* in the stock list of 1755,[11] and a year later the stock list shows three examples of the second size, in biscuit state awaiting glazing, also valued at 18 *livres* each.[12] In 1758 the Magasin de Vente had two *arrosoirs* of the second size valued at 108 *livres* each and three of the first valued at 120 *livres* each.[13] These were thus the sale prices for the two versions of the *arrosoir* in finished state. Examples are also listed in the Magasin de Vente in 1759.[14]

All known examples of the watering can are decorated with sprays of flowers; the majority of these flowers are in colors, but some are in blue monochrome (*camaïeu bleu*). Where the decoration is specified in the sales records, it is always referred to as "fleurs," except for one instance (a sale to M. Bouderey), where it is described as "fleurs filets bleu" (both the flowers and the outlines may have been blue monochrome).[15] At least thirteen *arrosoirs* are listed in the Sèvres sales records between November 1755 and June 1757. Three were of the first size (two of these were sold to the Parisian *marchand-mercier* Lazare Duvaux,[16] and one was sold for cash),[17] and ten were of the second size (one was sold to M. Bouderey,[18] and one to Mme Berryer,[19] one was sold

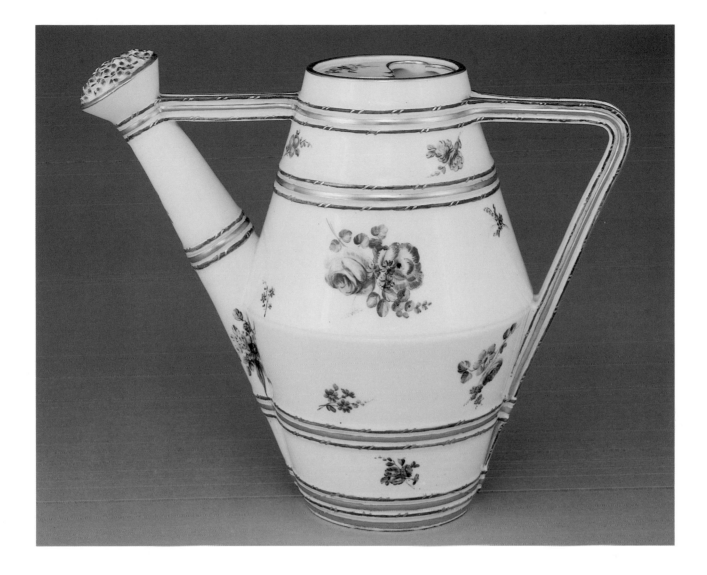

for cash,[20] two were sold to the dealer Machard,[21] and five to Duvaux).[22] In Duvaux's *Livre-Journal* four Vincennes porcelain *arrosoirs* are listed; examples of the first size were sold to Mme Berryer in December 1755[23] and to the duc de Bouillon in December 1756.[24] Duvaux sold examples of the second size to the marquis de Gontaut in December 1755[25] and to the dauphine, Marie-Josèphe de Saxe, in January 1757.[26]

Only seven *arrosoirs* are known today (three of the first size and four of the second). Those of the larger size are in the Musée National de Céramique, Sèvres (MNC 21593),[27] and in private collections.[28] In addition to the Museum's *arrosoir,* examples of the smaller size are in the George R. Gardiner Museum of Ceramic Art, Toronto;[29] the C. L. David Collection, Copenhagen (FK 86);[30] and an English private collection (marks unknown). It seems very likely that others have survived, since several were included in various auctions in the late nineteenth and early twentieth centuries. Three, of unknown size, were sold in London in the 1880s. One was sold twice, from the collections of W. Angerstein and the late W. King,[31] and two were sold from the collection of the late Earl of Lonsdale (one had a metal replacement handle and flowers "in colors," while the other was described as having "bouquets of flowers with blue").[32] Examples of the first size were sold in Paris from the collection of Anatoly Demidov, prince of San Donato, in 1870;[33] from the Watelin collection in 1885;[34] from the collection of the comtesse de Béarn in 1920;[35] and anonymously in 1929.[36] Others of the second size were sold from the collection of Anatoly Demidov, in Paris in 1870[37] and in Florence in 1880;[38] from the collection of the late baron L. d'Ivry in 1884;[39] and from the collection of the comtesse de Béarn in 1920.[40] The latter example had a metal replacement handle and therefore is possibly one of the two from the 1887 Lonsdale sale. The example in the David Collection, which is the only known *arrosoir* of the second size with monochrome blue flowers, may also be connected with that sold in December 1755 to M. Bouderey and with one from the Lonsdale sale. It is certainly possible that some of the above references refer to subsequent sales of the same watering can.

The artists at Sèvres sometimes depicted a metal version of this watering can in pastoral scenes on other tableware. This representation is found, for example, on two *gobelets litron* (one, dated 1756, was sold at auction in 1984;[41] the other, dated 1774, is in the Victoria and Albert Museum, London [D. M. Currie Bequest, c.408A-1921]).

PROVENANCE: Florence, Countess of Northbrook (married the 2nd earl 1899, died 1946) (sold, Christie's, London, November 28, 1940, part of lot 78); Hugh Burton-Jones, England, 1940; Kathleen Burton-Jones (Mrs. Gifford-Scott)

(sold, Sotheby's, London, June 12, 1984, lot 172); [Winifred Williams Ltd., London, 1984]; the J. Paul Getty Museum, 1984.

BIBLIOGRAPHY: Sassoon 1985, pp. 89–91; Sassoon and Wilson 1986, p. 72, no. 160; David Battie, ed., *Sotheby's Concise Encyclopedia of Porcelain* (London, 1990), ill. p. 107.

1. Examples of the first size range in height from approximately 23 to 23.5 cm; those of the second size, from approximately 19.5 to 20 cm.
2. S.L., I.7, 1754 (for 1753), fol. 6. Each size had two molds, those of the first size valued at 3 *livres,* and those of the second size at 2 *livres.*
3. See Préaud and Faÿ-Hallé 1977, no. 276.
4. Préaud and Faÿ-Hallé 1977, no. 1; Brunet and Préaud 1978, p. 148, no. 73.
5. B.K.R., July 10, 1754, fol. 29 ("Il faut ajouter au présant Etat 1 arozoir 1ᵉ gᵈ qui avait été distrait avant qu'on se Comptat les pieces, et en Sortant du four, par Mˢ de la Compagnie").
6. B.K.R., November 4, 1754, fol. 30/28; November 26, 1754, fol. 31.
7. B.K.R., March 12, 1755, fol. 36/34 (one); March 26, 1755, fol. 38/36 (two); December 19, 1755, fol. 53/50 (three).
8. G.K.R., November 14, 1754, fol. 32.
9. G.K.R., April 9, 1755, fol. 38 (one); October 1, 1755, fol. 47/55 (two).
10. G.K.R., May 4, 1756, fols. 55/63 (one), 57/65 (three).
11. S.L., I.7, 1755 (for 1754), fol. 22.
12. Ibid., 1756 (for 1755), fol. 11.
13. Ibid., 1758 (for 1757), fol. 22.
14. Ibid., 1759 (for 1758), fol. 20; October 1, 1759 (for January–September, 1759), fol. 26.
15. See below (note 18).
16. S.R., Vy2, October 1–December 1, 1755, fol. 116r; Vy3, August 20, 1756–January 1, 1757, fol. 17r.
17. S.R., Vy3, June 4, 1757, fol. 24v.
18. S.R., Vy2, December 14, 1755, fol. 107r.
19. Ibid., December 24, 1755, fol. 108v.
20. Ibid., November 3, 1755, fol. 98r.
21. S.R., Vy2, December 29, 1755, fol. 109r; Vy3, December 21, 1756, fol. 6v.
22. S.R., Vy2, October 1–December 1, 1755, fols. 115r, 116r (three); January 1–August 20, 1756, fol. 134v.
23. Duvaux 1873, December 10, 1755, no. 2305.
24. Ibid., December 27, 1756, no. 2682.
25. Ibid., December 22, 1755, no. 2340.
26. Ibid., January 3, 1756, no. 2370.
27. Painted by Antoine Caton, incised Z and 3 (see Verlet 1953, pl. 17; Préaud and Faÿ-Hallé 1977, no. 1).
28. One ex-coll. Wilfred J. Sainsbury; the other sold, Christie's, Monaco, December 3, 1989, lot 33.

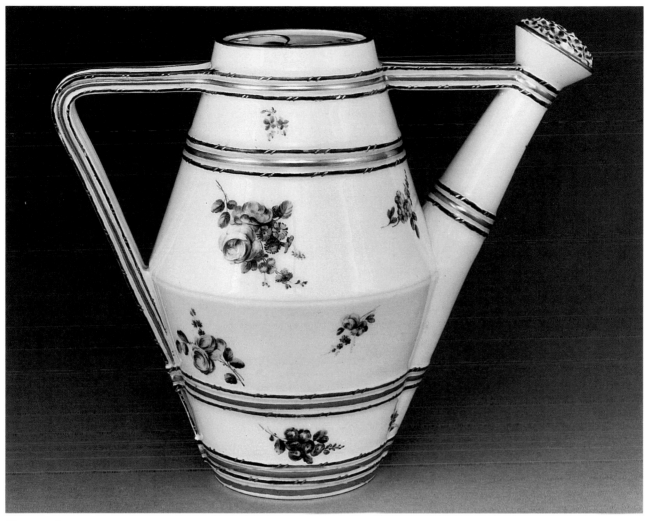

Alternate view

29. Sold from the collections of Hugh Burton-Jones and Kathleen Gifford-Scott, Sotheby's, London, June 12, 1984, lot 173 (dated 1753, painter's mark *B*, incised *4*).

30. See Eriksen 1980, no. 39 (painted with flowers in blue monochrome, dated 1754, painter's mark of a crown).

31. Christie's, London, February 23, 1884, lot 53, to King for £58 16/-; Christie's, London, July 18, 1884, lot 99, to Wertheimer for £26.

32. Christie's, London, June 13 et seq., 1887, lot 199, to Wilson for £11 11/-, lot 200, to Cooper for £4 14/6.

33. Messrs. Pillet and Mannheim, Paris, March 22–April 28, 1870, lot 157.

34. Hôtel Drouot, Paris, February 9–11, 1885, lot 131 (dated 1755). I thank Aileen Dawson for this information.

35. Hôtel Drouot, Paris, November 29, 1920, lot 95 (dated 1755).

36. Galerie Georges Petit, Paris, June 12, 1929, lot 33 (painted by Binet).

37. See above (note 33), lot 158.

38. Messrs. Pillet, Le Roy and Mannheim, San Donato, Florence, March 1880, lot 31.

39. Galerie Georges Petit, Paris, May 7–9, 1884, lot 147 (dated 1754).

40. See above (note 35), lot 96.

41. See above (note 29), lot 188.

2 Vase

(cuvette à tombeau, première grandeur)

1754–1755
Vincennes manufactory; soft-paste porcelain; painted by the crescent mark painter

HEIGHT 23.4 cm (9¼ in.); WIDTH 30.0 cm (11⅞ in.); DEPTH 21.6 cm (8½ in.)

MARKS: Painted in blue underneath with the factory marks of crossed L's enclosing the date letter A for 1753, and with the painter's mark of a crescent. No incised marks.

73.DE.64

DESCRIPTION: This open vase is rectangular, with slightly flared *bombé* sides. Each side is framed by four moldings, and each of the curved corners has five tapered flutes rising from a rounded foot. The raised base is modeled with scrollwork at the center of each side. The undulating rim is also modeled with scrollwork and with a shaped fanwork motif atop each corner.

The vase is decorated with a mottled turquoise-blue (*bleu céleste*) ground. The large oval reserves on each of the four sides are painted in colors with birds set among trees and flowers. The molded fan motifs at the corners and the scrollwork at the base on the front and back are left white.

Tooled, burnished gilding frames each reserve. On the front and back this takes the form of an open trellis wound with flowers, which fall to form a loose garland below. On the side panels the frame is formed by palm fronds, tied with a bow and wound with trails of gilded flowers. Thick bands of burnished gilding highlight the modeling, the frames of the panels, the fluting, the rim, and the base.

CONDITION: The vase is in excellent condition. There is some pitting in the glaze over the white reserve on the rear panel. These spots have been filled with a white substance, and four of them have been overpainted with a bird in dark red; these fills may be contemporary.

COMMENTARY: This vase is the earliest known example of the first, and largest, size of the *cuvette à tombeau,* which was also made in two smaller sizes. It bears the date letter for 1753, yet the documents clearly indicate that it was made in 1754–1755. Two variants of this shape were made at Vincennes and Sèvres; the Museum's vase has fluted corners (*contreforts cannelés*), while the other version has plain, curved corners. A drawing recorded in the factory's stock list of October 1, 1752—"1 Dessein long en forme de Caisse avec architecture" (one wide drawing for the shape of a vase with moldings)[1]—may relate to this shape, but the plaster model and mold are not listed until the end of 1755.[2] A plaster model survives in the archives of the factory, listed as a "Caisse à Fleurs A à contreforts cannelés."[3] There is also a drawing depicting the profile and plan of the plain, curved corner for the second and third sizes of the shape; it is inscribed *Cuvette à fleurs . . . fait en juillet 1759 2eme et 3eme grandeur* (Vase . . . made in July 1759, second and third sizes; MNS R.1, l.III, d.1, fol. 7). The shape is first listed in the biscuit kiln records during 1755 as a "cuvette à tombeau" and a "cuvette à fleur à tombeau."[4] It first appears in the glaze kiln records in October 1755; the single example noted had black blemishes ("taches noires") and was scheduled to be sent through the glaze kiln again.[5] A "caisse en tombeau" recorded in the enamel kiln records between February 1754 and February 1755 may well be the Museum's vase. It is described as having a *bleu céleste* ground and "oise[aux] à terrases" (birds in landscapes).[6]

The decoration of the Museum's vase is exceptionally grand for the year 1753; it is not surprising therefore that the documents indicate that it was actually made a year or two later. The *bleu céleste* ground was introduced during 1753 by the chemist Hellot, who used an aquamarine pigment imported from Venice to develop it. The painting in the reserves on the Museum's *cuvette* is executed on a large scale, in keeping with the size of the vase, and the birds depicted are set among very finely painted trees and flowering plants. In 1861 the painter's mark of a crescent was attributed by D.-D. Riocreux to Jean-Pierre Ledoux, but Ledoux is recorded as being active at the factory only between 1758 and 1761.[7] Dated examples bearing this crescent mark include a pair of *caisses à fleurs carrés* of 1754 in the Carnegie Museum of Art, Pittsburgh.[8] There are many pieces of Vincennes and Sèvres porcelain dating from 1752, which, like the present example, bear the painter's mark of a crescent yet cannot have been painted by Ledoux.[9] All of these vases are notable for the elaborate gilded frames surrounding their painted reserves. Gilding had to be applied at least twice over a *bleu céleste* ground. Because of its high copper content, the turquoise-blue ground tended to absorb the gilding during firing.

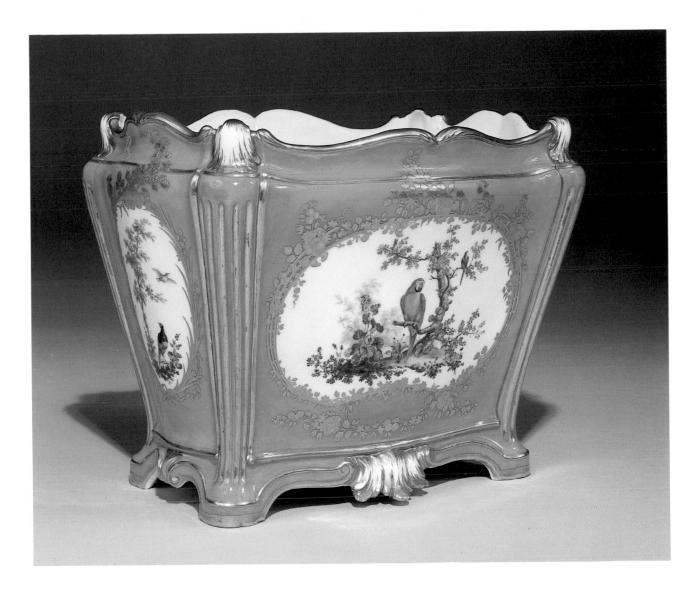

Rosalind Savill has proposed the identification of the Museum's vase in the factory's sales records. She believes that it was not sold until the first half of 1756, when Lazare Duvaux purchased "1 caisse en tombeaux oiseaux" for the high price of 840 *livres* (less the discount granted to dealers).[10] In March 1756 he sold the *cuvette* to Count Joachim Godske Moltke of Denmark as the central part of a garniture of five vases; it was described in Duvaux's *Livre-Journal* as "Une garniture de cheminée de cinq morceaux de Vincennes, bleu céleste, dont une grande caisse à quatre pieds, peinte à oiseaux, 840 l[ivres]" (A Vincennes porcelain mantlepiece garniture of five pieces, turquoise blue ground, of which one is a large vase on four feet, painted with birds, 840 *livres*).[11]

That the price for this vase was relatively high, owing to its decoration, can be seen from the fact that in 1762 Madame de Pompadour purchased a *cuvette à tombeau* of the first size with a blue ground and painted with flowers for 360 *livres*.[12] At the end of 1762 the king's *commissaire* at the factory, the marquis de Courteille, was presented with a *cuvette à tombeau* of the first size with a *bleu céleste* ground decorated with a scene after David Teniers the Younger, which cost 408 *livres*; this was accompanied by a pair of the second size, similarly decorated, costing 330 *livres* each.[13] In the second half of 1756 Duvaux bought another *cuvette à tombeau* for 840 *livres*, presumably also of the first size, with *bleu céleste* ground and painted in colors with depictions of children.[14]

An example of a *cuvette à tombeau* with *contreforts cannelés* of the first size, dated 1757, is in the Wallace Collection, London (C204).[15] The model was later produced in hard-paste porcelain at Sèvres. One appears in the factory's stock list of March 1786 among the hard-paste wares in the Magasin du Blanc; it was valued at 48 *livres*.[16]

PROVENANCE: Possibly sold by the Vincennes factory to the *marchand-mercier* Lazare Duvaux, Paris, between January 1 and March 1, 1756, for 840 *livres;* possibly sold by Lazare Duvaux to Count Joachim Godske Moltke, Copenhagen, as part of a garniture of five vases, March 1, 1756; by descent (sold, Paris, nineteenth century); [(?)Gilbert Lévy, Paris, early twentieth century]; private collection, Paris; [Rosenberg and Stiebel, New York, early 1970s]; J. Paul Getty, 1973.

BIBLIOGRAPHY: Sassoon and Wilson 1986, no. 159; Savill 1988, pp. 33, 40, n. 2a.

1. S.L., I.7, 1752 (to October 1), fol. 12 (valued at 2 *livres*).
2. Ibid., 1756 (for 1755), fols. 6, 8 (valued at 2 *livres* each).
3. MNS Archives, 1814 Inventory, 1740–1780, no. 122 (height 28 cm, width 35 cm, depth 21.5 cm).
4. B.K.R., June 2, 1755, fol. 46/44; September 10, 1755, fols. 49/46, 51/48.
5. G.K.R., October 29, 1755, fol. 50.
6. E.K.R., February 4, 1754–February 3, 1755, fol. 34; I thank Rosalind Savill for this information.
7. Eriksen 1968, p. 58; Brunet and Préaud 1978, pp. 371, 383, n. 8; Dauterman 1986, p. 98; Eriksen and de Bellaigue 1987, pp. 149–150, 168, no. 145, p. 261, no. 76.
8. Formerly in the Alfred de Rothschild collection; London art market, 1987 (*bleu céleste* ground, with birds set in landscapes that include ships and châteaux).
9. These examples, all painted with colored birds in landscapes, include a series of *assiettes à berceaux* circa 1752–1753, in the Musée des Arts Décoratifs, Paris (4577), and in the Victoria and Albert Museum, London (C.99&A-1974) (one of these *assiettes* is painted with parrots similar to those on the Getty Museum's vase); a pair of *vases à oreilles* of 1755 at Waddesdon Manor (*bleu lapis caillouté* ground, with landscapes based on prints by Anthonie Waterloo; Eriksen 1968, no. 13); and a pair of *vases à dauphins* of 1756 in the Wallace Collection (C215–216; *bleu céleste* ground).
10. S.R., Vy2, fol. 133v.
11. Duvaux 1873, March 1, 1756, no. 2420. Count Moltke was a Danish minister of state who made many purchases in Paris in the 1750s and 1760s. A descendant of his brought some of his Sèvres porcelain wares back to Paris for sale in the mid-nineteenth century (Eriksen 1968, pp. 160–162).
12. S.R., Vy3, August 15, 1762, fol. 117v.
13. Ibid., December 1762, fol. 199r.
14. Ibid., August 20, 1756–January 1, 1757, fol. 16r.
15. Pink ground, painted with cherubs by Jean-Louis Morin (height 23.5 cm, width 30.5 cm).
16. S.L., I.8, March 30, 1786 (for February 20, 1785–March 30, 1786), fol. 44.

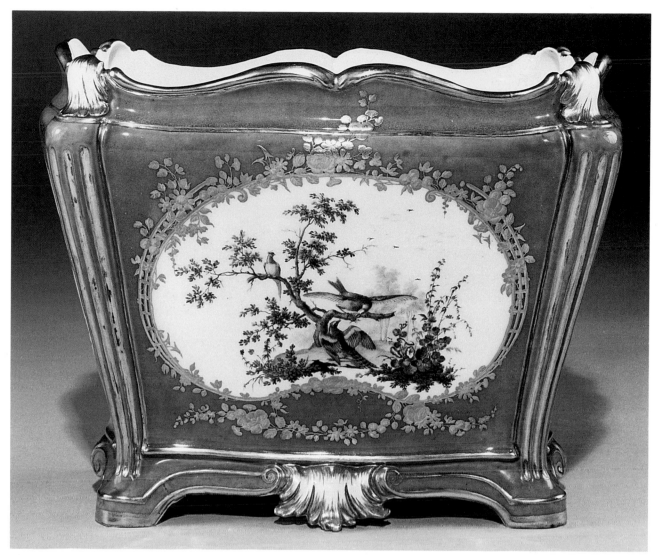

Alternate view

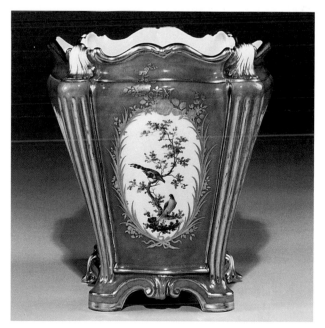

Side view

3 Pair of Potpourri Vases
(pots pourris Pompadour, troisième grandeur)

1755
Vincennes manufactory; soft-paste porcelain; model designed by Jean-Claude Duplessis, painted by Jean-Louis Morin after engraved designs by François Boucher

HEIGHT 25.5 cm (10 in.); DIAM. 15.2 cm (6 in.)

MARKS: Each vase is painted in blue underneath with the factory mark of crossed L's enclosing the date letter C for 1755, and with the painter's mark M and two dots; each vase is incised 2.

84.DE.3.1–2

DESCRIPTION: Each circular vase rests on a stepped, incurved base, which is recessed underneath. At the shoulder there are six oval pierced holes, framed by scrolls in low relief. The lid is also pierced with six oval holes, framed in a manner similar to those on the body. The knop is modeled as an open carnation on a stem with leaves and a bud, painted in natural colors.

Each vase is decorated with a mottled underglaze dark blue (*bleu lapis*) ground. On the front and back panels there is a white reserve. Each reserve shows a winged putto, painted in tones of pink (*camaïeu rose*), seated on clouds.

Bands of burnished gilding are applied to the base and stem, and gilding in dentil patterns is applied to the rims of the vase and lid. The reserves are framed with tooled gilding over the blue ground. These frames are composed of combinations of C- and S-scrolls, sprays of flowers, feathering, scrollwork, and panels of trelliswork. Around the foot is a tooled garland of flowers and leaves. Gilding also highlights the relief work of the frames surrounding the pierced holes on both the vase and the lid.

CONDITION: The flowers forming the knops have chipped petals, and on lid .1 the flower became detached and has been reglued. The surfaces have sustained some scratching, and the tooling of the gilding is a little worn, particularly on the feet.

COMMENTARY: This shape of vase was designed with holes pierced near the top and in the lid to allow the scent of potpourri to escape and permeate the room. It was named the *pot pourri Pompadour* in honor of the marquise de Pompadour, who became Louis XV's mistress in 1745. The model was produced at Vincennes and Sèvres by 1752. Because a drawing for this model in the Sèvres factory's archives inscribed *Vase Pot Pourri* is signed *Duplessis,* the shape is attributed to Jean-Claude Duplessis (illus.). The drawing includes a scheme of painted floral decoration, although such designs generally show only the outline of an object. There is also a drawing dated 1788 showing a vase of similar shape (MNS R.1, l.III, d.10, fol. 2). It is entitled *Pot pourri Pompadour* and inscribed *pot pourri fait Daprès une porcelaine De France Ancienne forme cela a Été Commande par M.Basin Le 8 avril 1788* (potpourri vase made after an earlier Sèvres porcelain model, which was ordered by M. Basin on April 8, 1788). This drawing indicates that a variant was designed with a ring of small circular holes placed just below the rim of the vase; no such examples are known to have survived. There is no plaster model for the *pot pourri Pompadour* in the factory's archives. The shape was produced in four sizes; the Museum's vases are of the third size.[1] It is worth noting that the modeling around the pierced holes of the *pot pourri Pompadour* is very similar to that found on the *soucoupe à pied* produced at Sèvres from 1756.[2] The same shape was also produced by 1753 without the pierced holes in the vase and lid; this version was called the *urne Pompadour,* an example of which is in the British Museum, London.[3]

The factory's documents show that numerous *pots pourris Pompadour* were produced, including many with an underglaze dark blue ground. The stock lists of October 1, 1752, and January 1, 1753, show that on both those dates there were three examples of the third size "en Couvertes Cuitte" (glazed but undecorated).[4] They were valued at 18 *livres* each. At the same time undecorated examples of the fourth size were valued at 12 *livres* each, examples of unspecified size "en bleu" (with an underglaze blue ground) were valued at 12 *livres* each, and defective undecorated examples of the first size were valued at 24 *livres* each.[5] In the factory's Magasin de Vente at the same time there were three examples of the third size painted with "camayeux bleu" (blue monochrome) decoration and no ground color.[6] They were valued at 48 *livres* each.

References to *pots pourris Pompadour* and *urnes Pompadour* appear in the biscuit kiln records in March 1753.[7] Four *pots pourris Pompadour* of the fourth size with an underglaze blue ground were fired, though one was broken in the kiln. One of six *urnes Pompadour* of the third size, all decorated with a blue ground, broke during the same firing. The glaze

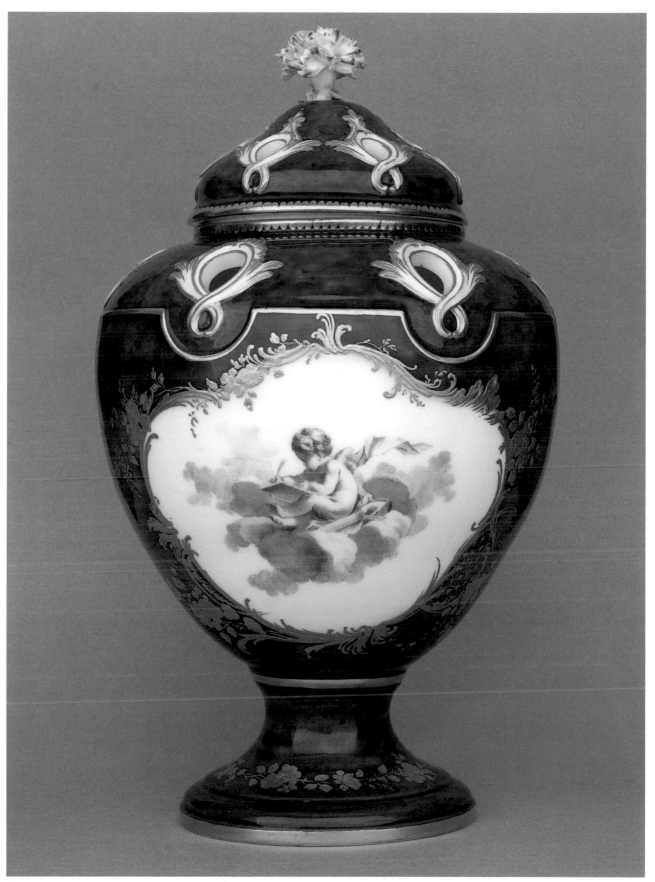

Vase . 1

kiln records show that later that year, in October, three *pots pourris Pompadour* of the third size and three of the fourth all passed through the kiln without mishap.[8] The stock list taken after the end of 1753 records two *pots pourris Pompadour* of the third size awaiting painting and one "Entre Les mains des Peintres" (in the hands of the painters).[9] They were valued at 18 *livres* each. Five *pots pourris Pompadour* of the third size are listed in the biscuit kiln records during 1754. Three were fired in March, along with one example of the second size.[10] A *pot pourri Pompadour* of the third size emerged broken from the biscuit kiln in November 1754, and another was successfully fired in December.[11] The stock list compiled after the end of 1754 shows two undecorated *pots pourris Pompadour* of the third size, again valued at 18 *livres* each.[12] During 1755 four *pots pourris Pompadour* of the third size were recorded in the biscuit kilns, while seven examples of the third size were recorded in the glaze kilns.[13]

The underglaze dark blue ground on the Museum's vases was widely used at Vincennes and Sèvres from 1752 to 1763.[14] It is characteristically uneven and has a textured appearance. The pink-mauve color used *en camaïeu* to decorate the reserves on these vases was one of many supplied to the Vincennes factory by Pierre-Antoine-Henry Taunay beginning in the early 1740s.[15] In 1754 the factory purchased the secret recipes for the purple, carmine, and violet pigments from Taunay.[16]

The putti shown on the Museum's *pots pourris* are copied from engravings by Louis-Félix de La Rue, after designs by François Boucher, published by Huquier in Boucher's *Troisième Livre de groupes d'enfans* and in his *Livre des arts* (illus.).[17] These engravings may have been among the twenty-three after Boucher's *Jeux d'enfants* recorded in the factory's stock list for 1752.[18] The painter's mark of Jean-Louis Morin appears on other examples of Vincennes porcelain of similar date that are painted with putti *en camaïeu*. These include a pair of *vases à oreilles* of 1754 in the Musée du Louvre, Paris (OA.10302–10303);[19] and a *caisse à fleurs ovale* of 1755 sold at auction in 1980.[20] Other painters also executed similar work at this date.[21]

Only one application of gilding was needed to produce a strong color over a *bleu lapis* ground. The gilding on the Museum's vases is very elaborate and typifies the highest quality produced in the mid-1750s. The gilded frames of the reserves are more elaborate on one side of each vase, indicating that there is a definite front and back. The gilding around the front reserve of one vase has a cartouche of trelliswork at the left side, whereas the trellis is at the right on the other vase. This demonstrates that the gilding, which is intricately tooled and burnished, was also very carefully planned.

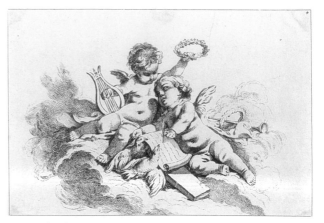

Louis-Félix de La Rue (French, 1731–1765?) after François Boucher (French, 1703–1770). *La Poesie*. Engraving. New York, The Metropolitan Museum of Art, Harris Brisbane Dick Fund, 53.600.1079(4).

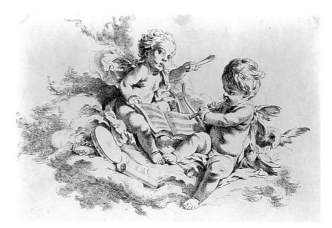

Louis-Félix de La Rue (French, 1731–1765?) after François Boucher (French, 1703–1770). *La Musique*. Engraving. New York, The Metropolitan Museum of Art, Harris Brisbane Dick Fund, 53.600.1079(5).

Vase .1, gilding

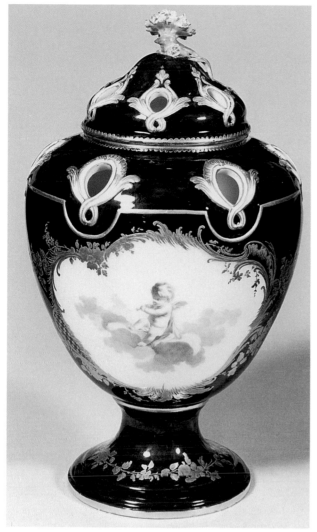

Vase .2

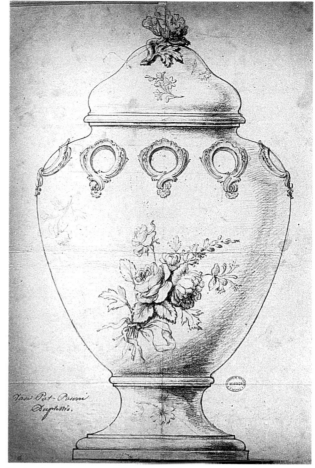

Design for the *pot pourri Pompadour*, circa 1752. Manufacture Nationale de Sèvres, Archives R. I, l.III, d.10, fol. 1.

The sales records of the Vincennes factory show the prices of many *pots pourris Pompadour* and *urnes Pompadour*. Three *pots pourris Pompadour* of the first size are recorded as costing 216 *livres* each;[22] those of the second size cost 120 and 144 *livres* each; examples of the third size ranged from 72 to 360 *livres* each (see below); and those of the fourth size ranged from 72 to 216 *livres* each. *Urnes Pompadour* cost less than similarly decorated *pots pourris* of the same size since the modeling of the latter shape was more elaborate. Two *pots pourris Pompadour* of the third size decorated with a *bleu céleste* ground (one of the most costly ground colors to produce) and flowers were sold to Lazare Duvaux for 360 *livres* each in 1754; an *urne* of the same size and decoration was sold to him at the same time for 288 *livres*.[23] By comparison, two *pots pourris Pompadour* of the fourth size decorated with a *bleu céleste* ground and painted with birds were sold in 1754 to Sr. Bazin for 216 *livres* each.[24] Five *pots pourris* of the third size decorated with a *bleu lapis* ground and "enfants camayeux," like the Museum's vase, were sold to Duvaux in 1755 (one) and 1756 (four) for 180 *livres* each.[25] Two similarly decorated examples of the fourth size—possibly forming a garniture with the single example of the third size that he purchased in 1755—cost Duvaux 144 *livres* each.[26] In the first half of 1755 he purchased two *pots pourris Pompadour* of the third size decorated with flowers (possibly colored rather than monochrome); they cost 108 *livres* each.[27] At the same time he purchased two examples of the second size for 144 *livres* each and one of the fourth for 72 *livres,* all with similarly described decoration. M. Roussel, a shareholder in the factory, purchased two examples of the third size, also decorated with flowers, for 108 *livres* each in May 1755; it seems likely that the price was reduced from 120 *livres*.[28] In December 1754 Duvaux purchased two *pots pourris Pompadour* of the third size decorated with flowers for 72 *livres* each.[29]

On the above evidence the Museum's vases can be judged to have cost 180 *livres* each at the time of their manufacture. We know of only one other pair of vases that closely resemble the Museum's (illus.). They are of the same size, have the same scheme of painted and gilded decoration, and bear the same painted and incised marks.[30] These four similar vases are surely those purchased in a group by Duvaux in the second half of 1756: "Pots pouris Pompadour 3e gd. Lapis Enf. Cama." (*pots pourris Pompadour* of the third size, with a *bleu lapis* ground and monochrome children).[31] They are also identifiable in Duvaux's *Livre-Journal* as "Quatre pot pourris, forme d'urne, en Gros bleu, peints à enfants-camayeux" (four *pots pourris* of an urn shape, with a deep blue ground, painted with monochrome children), sold for 720 *livres* (the Vincennes factory's retail price) in September 1756.[32] They were purchased from Duvaux by Frederick, third Viscount St. John, second Viscount Bolingbroke (1734–1787), whose principal residence was Lydiard Park, Wiltshire.[33] Some of the contents of Lydiard Park were sold after the death, in 1824, of the third Viscount Bolingbroke.

Examples of *pots pourris Pompadour* in various sizes and with a wide range of decoration are in the Musée National de Céramique, Sèvres; the Musée du Louvre; the Petit Palais, Paris; the C. L. David Collection, Copenhagen; the Victoria and Albert Museum, London; the Philadelphia Museum of Art; Upton House, Warwickshire; Belton House, Lincolnshire; and in various private collections. The Chantilly factory made a small, similarly shaped potpourri vase, possibly copying the Vincennes shape.[34] The model was also copied by the Meissen factory; a pair of these Meissen *pots pourris* was sold at auction in 1935.[35]

PROVENANCE: Possibly sold by the Sèvres factory to the *marchand-mercier* Lazare Duvaux, Paris, between August 20 and September 1756, for 180 *livres* each; possibly sold by Lazare Duvaux to Frederick, 3rd Viscount St. John, 2nd Viscount Bolingbroke, Lydiard Park, Wiltshire, September 1756; anonymous collection (sold, Sotheby's, London, March 5, 1957, lot 96); [The Antique Porcelain Company, London, 1957]; private collection; [The Antique Porcelain Company, London, 1983]; the J. Paul Getty Museum, 1984.

BIBLIOGRAPHY: Sassoon 1985, pp. 91–94; Sassoon and Wilson 1986, no. 161; Savill 1988, pp. 129, 132, n. 3k, 134, nn. 15e, 26, 32, pp. 851, 857, n. 59.

1. Examples of the first size range in height from about 42 to 43 cm; those of the second size, from about 28 to 29 cm; the third size, from about 22.8 to 25.5 cm; and the fourth size, from 19 to 20 cm.
2. Two examples dated 1757 are in the Musée des Arts Décoratifs, Paris; Préaud and Faÿ-Hallé 1977, nos. 285–286; one dated 1758 is in the C. L. David Collection, Copenhagen (FK 28a); see Eriksen 1980, no. 49; one dated 1757 is in the Fitzwilliam Museum, Cambridge (C.2-1957).
3. Decorated with a *bleu lapis* ground and gilded birds; marked with blue crossed L's and a dot; A. W. Franks, *Catalogue of a Collection of Continental Porcelain* (London, 1896), no. 377.
4. S.L., I.7, 1752 (to October 1), fol. 23; 1753 (for October–December 1752), fol. 22.
5. Ibid., 1752 (to October 1), fol. 28; 1753 (for October–December 1752), fol. 27.
6. Ibid., 1752 (to October 1), fol. 40; 1753 (for October–December 1752), fol. 39.
7. B.K.R., March 28, 1753, fol. 7.

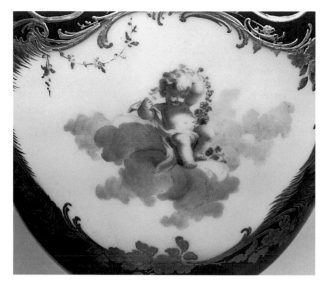

Vase .2, detail showing painted decoration

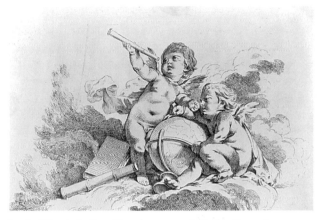

Louis-Félix de La Rue (French, 1731–1765?) after François Boucher (French, 1703–1770). *Trois Amours avec des trophées militaires*. Engraving. New York, The Metropolitan Museum of Art, Harris Brisbane Dick Fund, 53.600.1079(8).

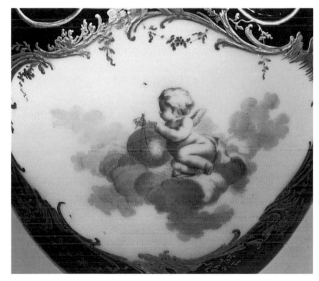

Vase .1, detail showing painted decoration

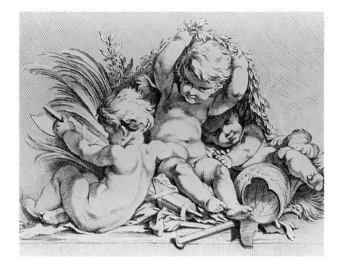

Louis-Félix de La Rue (French, 1731–1765?) after François Boucher (French, 1703–1770). *L'Astronomie*. Engraving. New York, The Metropolitan Museum of Art, Harris Brisbane Dick Fund, 53.600.1079(6).

8. G.K.R., October 22, 1753, fol. 12.

9. S.L., I.7, 1754 (for 1753), fols. 18, 22.

10. B.K.R., March 18, 1754, fol. 18; Jacques-René Boileau de Picardie, the director of the Vincennes factory at the time, noted that this firing produced many faulty pieces because the wood, which had been stored in the snow, had not burned evenly.

11. B.K.R., November 4, 1754, fol. 30/28; December 19, 1754, fol. 33.

12. S.L., I.7, 1755 (for 1754), fols. 18, 23.

13. B.K.R., March 12, 1755, fol. 36/34 (three); December 19, 1755, fol. 53/50 (one); G.K.R., February 26, 1755, fol. 43/55 (two); April 9, 1755, fol. 38 (three); October 1, 1755, fol. 47/55 (two).

14. Eriksen and de Bellaigue 1987, p. 50.

15. A. d'Albis and T. Préaud, "Eléments de datation des porcelaines de Vincennes avant 1753," *The French Porcelain Society, London* 2 (1986), p. 3.

16. A cup dated 1748 that is signed by Taunay and painted with thirty-two sample colors (Sèvres, Musée National de Céramique MNC 24574) has long been thought to be a demonstration of his "couleurs fines" (Eriksen and de Bellaigue 1987, p. 49, pl. A). The recent discovery of a cup painted with fifty-two color samples, dated 1749 and signed by Louis-Denis Armand *l'aîné,* suggests that such objects may have been merely working tools intended to aid the painter (Sotheby's, London, February 23, 1988, lot 301).

17. P. Jean-Richard, *L'Œuvre gravé de François Boucher dans la collection Edmond de Rothschild,* exh. cat. (Musée du Louvre, Paris, 1978), nos. 1289, 1303, 1306, 1309.

18. R. Savill, "François Boucher and the Porcelains of Vincennes and Sèvres," *Apollo,* no. 115 (March 1982), p. 162; S.L., I.7, October 1, 1752, fol. 15.

19. Decorated with a *bleu lapis* ground and painted *en camaïeu bleu* with the same four scenes on the Museum's vases (although in *L'Astronomie* the putto has no globe).

20. Sold from the collection of Sir Henry and Lady Tate, Sotheby's, London, July 1, 1980, lot 33.

21. For example, Charles-Nicolas Dodin's mark is found on a two-handled *gobelet à lait* (see no. 17 below) dated 1754 (private collection, Massachusetts; formerly in a private collection, Cambridge, England [JPGC Photo Archives, no. 201967]). It is decorated with a *bleu lapis* ground and painted *en camaïeu rose;* the scene from *La Musique* shown on the Museum's vase is painted on the saucer.

22. S.R., Vy2, January 1–August 20, 1756, fol. 135v; Vy3, October 2, 1756, fol. 1v.

23. S.R., Vy2, December 5–31, 1754, fol. 71v.

24. Ibid., December 9, 1755, fol. 103r.

25. S.R., Vy2, June 1–October 1, 1755, fol. 94r (one); Vy3, August 20, 1756–January 1, 1757, fol. 14r (four).

26. See above (note 24).

27. S.R., Vy2, January 1–June 1, 1755, fol. 88r.

28. Ibid., May 5, 1755, fol. 83r.

29. Ibid., December 5, 1754, fol. 57v.

30. Collection of H. M. W. Oppenheim, Esq. (sold, Christie's, London, June 10 et seq., 1913, lot 230, to the dealer Asher Wertheimer); property of a lady (sold, Christie's, London, December 2, 1974, lot 16, to Garabana); anonymous collection (sold, Sotheby's, London, March 5, 1985, lot 116); present location unknown.

31. See above (note 25).

32. Duvaux 1873, no. 2590.

33. Bolingbroke bought other pieces of Vincennes porcelain from Duvaux including, in August 1756, a *cuvette à masques* mounted with Vincennes porcelain flowers on metal stems. It formed the central part of a *surtout de table* that also included eight smaller vases set on a mirror (ibid.; S. Eriksen, "Rare Pieces of Vincennes and Sèvres Porcelain," *Apollo,* no. 87 [January 1968], pp. 36–38, pl. II). Bolingbroke was described by Horace Walpole as "a very trying gentleman," and indeed his wife divorced him in 1768. He and his younger brother the Hon. Henry St. John were friends of George Selwyn, a great francophile and frequent visitor to the French court. In December 1766 Bolingbroke wrote to Selwyn asking him to buy him some fashionable clothes in Paris so that he might "exceed any Macaronis [dandies] now about Town [London], and become the object of their envy" (J. Heneage Jesse, *George Selwyn and His Contemporaries,* vol. 2 [London, 1843–1844], p. 113). In a letter from Henry St. John to Selwyn of October 1768 he mentioned that his brother was then in Paris (ibid., p. 338). Henry St. John was in Paris himself in 1770, and he wrote to Selwyn on December 22 that he had just visited the *marchands-merciers* Mme Poirier and Tenières, and also the silversmith Auguste (ibid., vol. 3, p. 4). I am grateful to Susan Newell of the Wallace Collection for background information on Viscount Bolingbroke.

34. Y. Dallot-Naudin, *Porcelaines tendres françaises* (Paris, 1983), p. 47; I am grateful to Clare Le Corbeiller for this information.

35. Paul Graupe Galleries, Berlin, January 25–26, 1935, lot 349.

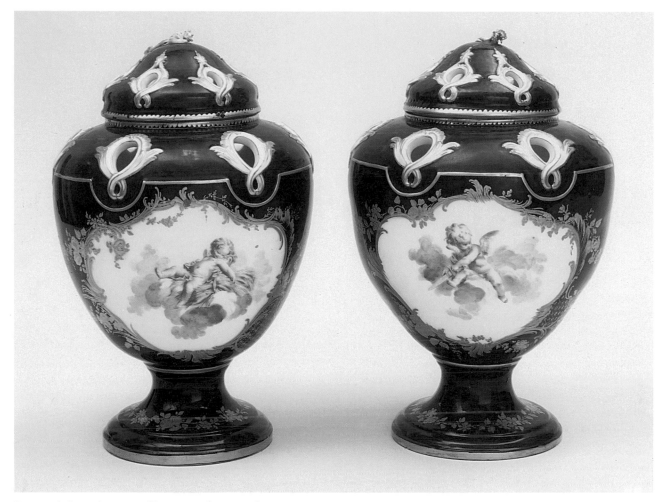

Pots pourris Pompadour, 1755. Sèvres manufactory, soft paste
porcelain, painted by Jean-Louis Morin. Photo courtesy
Sotheby's, London.

4 Basket
(panier, deuxième grandeur)

1756
Sèvres manufactory; soft-paste porcelain

HEIGHT 22.0 cm (8⅝ in.); WIDTH 20.1 cm (7⅞ in.); DEPTH 18.0 cm (7⅛ in.)

MARKS: Painted in blue underneath with the factory mark of crossed L's enclosing the date letter D for 1756, and with three dots; incised PZ.

82.DE.92

DESCRIPTION: This circular open basket has straight, flared sides that are pierced and modeled in imitation of cane-work. The basket stands on a stepped foot that is recessed under the base. The arched handle, bound with canework, is wound with a modeled ribbon where it joins the rim.

A mottled green (vert) ground covers the bands of molding at the base, waist, and rim, and also the broad chevrons. The handle and some of the canework attaching it to the rim are also covered with green pigment, thinly applied in some areas.

Thick, burnished gilding is used in broad lines to highlight the canework, base, waist, rim, chevrons, ribbons, and handle. On the inside of the rim there is a broad pattern in gilding over the white glaze.

CONDITION: The basket is in excellent condition. The gilding on the base is worn in a few small areas. The gilding over the green ground has contracted during firing in some areas.[1]

COMMENTARY: No designs, models, or molds for this shape of panier survive in the archives of the Sèvres factory. Baskets were made in at least two sizes, but those of the larger size had a different pattern of piercing and a different model of handle from those of the second size. The earliest mention of a basket in the documents is a panier à jour (pierced basket) in the biscuit kiln records for November 1753, and indeed an example of that date is known (see below).[2] The stock list of 1756 includes among the new work of 1755 a plaster model and a plaster mold for a panier rond of the second size, though none is listed for a larger size.[3] In Septem-

ber 1755 one "pagnier" emerged broken from the biscuit kiln.[4] In the stock list of 1757 two paniers of the second size were ready to be glazed (valued at 24 livres each),[5] and one of the first size was glazed but undecorated (valued at 72 livres).[6] In January 1757 one example of the first size and two of the second are noted in a biscuit kiln firing,[7] and one of unspecified size emerged from the glaze kiln in October of that year.[8] The stock list of 1758 shows that during 1757 six-teen molds were made for various "corbeilles pompadour, serés à Jours" (baskets with pierced walls), but it is not known whether these would have been related to the shape of the Museum's panier.[9] The first mention of a panier in the stock of the factory's Magasin de Vente occurs after the end of 1757, and it is valued at 192 livres.[10] In the stock list after the end of 1758 two undecorated baskets are shown in the Magasin du Blanc,[11] and four in the Magasin de Vente (one valued at 192 livres, and three at 240 livres each).[12] The same examples are also listed in subsequent years, and in the stock list of 1763 there are two baskets with green ground—possibly similar to the Museum's panier—marked down to 132 and 168 livres since they were old stock.[13]

Rosalind Savill has pointed out that the factory's sales records show only one panier of the second size with green ground. It was given in December 1757 to the painter François Boucher; its value was 240 livres.[14] At the end of each year the Vincennes and Sèvres factory presented examples of its products to its senior employees, directors, and share-holders, as well as to those who contributed to its artistic development. One other panier of the second size, with bleu céleste ground and filet d'or, is noted in the sales records. It was sold to Lazare Duvaux in the last quarter of 1755 for 240 livres.[15] Two paniers of the first size with bleu céleste ground are also listed in the sales records; they sold for 360 livres each. One, described as having filet d'or decoration, was bought by Duvaux in the last quarter of 1755,[16] and the other was bought by Mme de Courteille in December 1756.[17]

Five paniers are known, two of the first size and three of the second. The piercing differs in design on each ex-ample of each size, suggesting that the répareur created the design as he worked. A basket sold at auction in 1983 from the Hillingdon collection (illus.) is very similar to the Mu-seum's panier.[18] It was purchased by Sir Charles Mills (father of the first Lord Hillingdon) in the 1840s or 1850s and was exhibited at the South Kensington Museum, London, in 1862.[19] The piercing of the Hillingdon basket differs from that of the Museum's example, as does the arrangement of the broad vertical chevrons. The Hillingdon basket is more heavily gilded with geometric patterns over the green ground. Like those inside the rim of the Museum's basket,

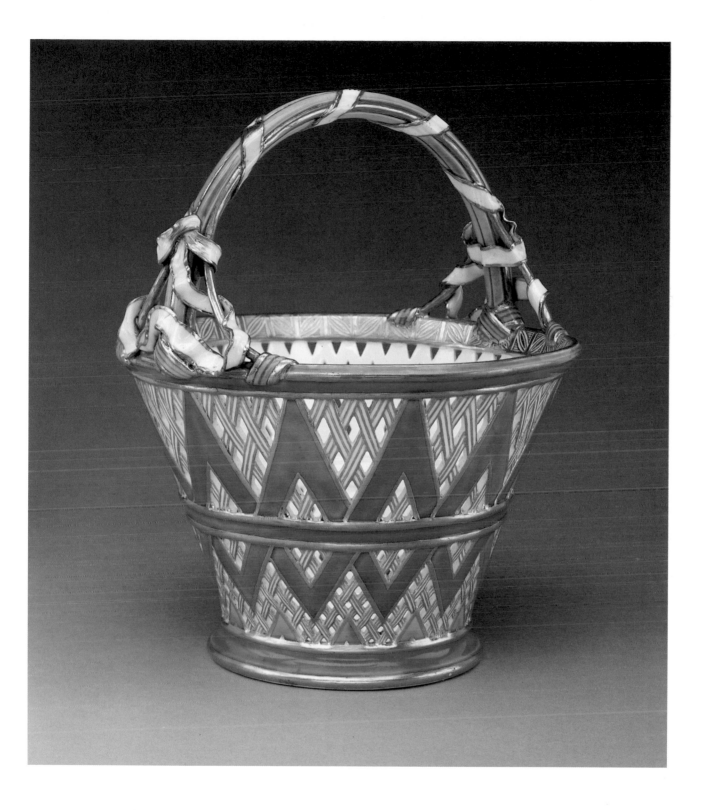

these patterns would appear to be based on motifs found on Japanese lacquer boxes and panels imported to France by this date.[20] The green color used on the Museum's example and the Hillingdon basket was introduced at Sèvres in 1756.

Another basket of the second size, also dated 1756, is in the Musée National de Céramique, Sèvres (MNC 25342; height 21 cm, width 19.2 cm, depth 17.5 cm). It does not have the bands of chevrons seen on the Museum's and on the Hillingdon basket, and it is decorated with a greenish ground of a turquoise-blue hue and with simpler patterns of gilding. Any one of these three baskets may be identified with the one given to Boucher in 1757. Neither the Hillingdon basket nor the basket now at Sèvres have the incised mark *PZ* found on the Museum's *panier*.

The two known *paniers* of the first size are the example in the Wallace Collection, London, dated 1753, with *bleu céleste* ground (C472), and one formerly in the Rosebery and Fribourg collections with no handle and a green ground.[21] The Wallace basket does not have the intricate porcelain ribbons at the junction of the handle and rim found on smaller baskets such as the Museum's. The basket of the first size from the Rosebery and Fribourg collections is filled with Vincennes flowers on gilt metal stalks. A Sèvres basket with turquoise-blue ground and a handle, like that in the Wallace Collection, was sold at auction in 1886.[22]

PROVENANCE: Private collection, France (sold, Christie's, London, June 28, 1982, lot 19); [Armin B. Allen, New York, 1982]; the J. Paul Getty Museum, 1982.

BIBLIOGRAPHY: Wilson, Sassoon, and Bremer-David 1983, pp. 45–47; Sassoon and Wilson 1986, p. 73, no. 162; Savill 1988, pp. 753, 756, n. 3d, 757, n. 16.

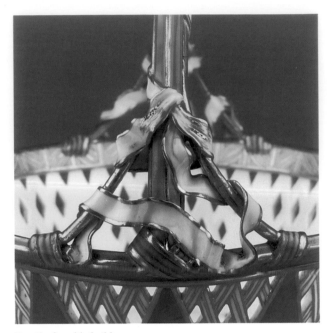

Detail of molded ribbons

1. Antoine d'Albis has pointed out that gilding applied over this green ground often contracts due to the difficulty encountered in adhering the gold to this particular color.
2. B.K.R., November 22, 1753, fol. 16; Préaud and Faÿ-Hallé 1977, p. 61.
3. S.L., I.7, 1756 (for 1755), fols. 6, 8 (the model valued at 6 *livres* and the mold at 5 *livres;* generally models and molds had the same value).
4. B.K.R., September 10, 1755, fol. 48/55.
5. S.L., I.7, 1757 (for 1756), fol. 11.
6. Ibid., fol. 17.
7. B.K.R., January 12, 1757, fol. 72/74.
8. G.K.R., October 24, 1757, fol. 80.
9. S.L., I.7, 1758 (for 1757), fol. 16.
10. Ibid., fol. 28.
11. S.L., I.7, 1759 (for 1758), fol. 14 (valued at 60 *livres* each).
12. Ibid., fol. 27.
13. S.L., I.7, 1763 (for 1762), fol. 34.
14. S.R., Vy3, December 31, 1757, fol. 47v.
15. S.R., Vy2, October 1–December 31, 1755, fol. 115r.
16. Ibid., fol. 119r.
17. S.R., Vy3, December 17, 1756, fol. 3v.
18. Property of Phoebe, Lady Hillingdon (sold, Christie's, London, March 28, 1983, lot 25); present location unknown.
19. *Special Exhibition of Works of Art,* South Kensington Museum, London, June 1862, no. 1463; see also Parker and Dauterman 1964, pp. 116–119.
20. See F. Watson, "A Note on French Marquetry and Oriental Lacquer," *GettyMusJ* 9 (1981), pp. 157–166.
21. *Three French Reigns,* exh. cat. (25 Park Lane, London, 1933), no. 292 (lent by the Earl of Rosebery, Mentmore Towers, Buckinghamshire); sold, Christie's, London, May 4, 1939, lot 65; collection of René Fribourg, New York (sold, Sotheby's, London, June 25, 1963, lot 68); present location unknown; see also Préaud and Faÿ-Hallé 1977, p. 45, n. 15.
22. Sold, Christie's, London, March 26, 1886, lot 88, to Currie for £1 1/2-.

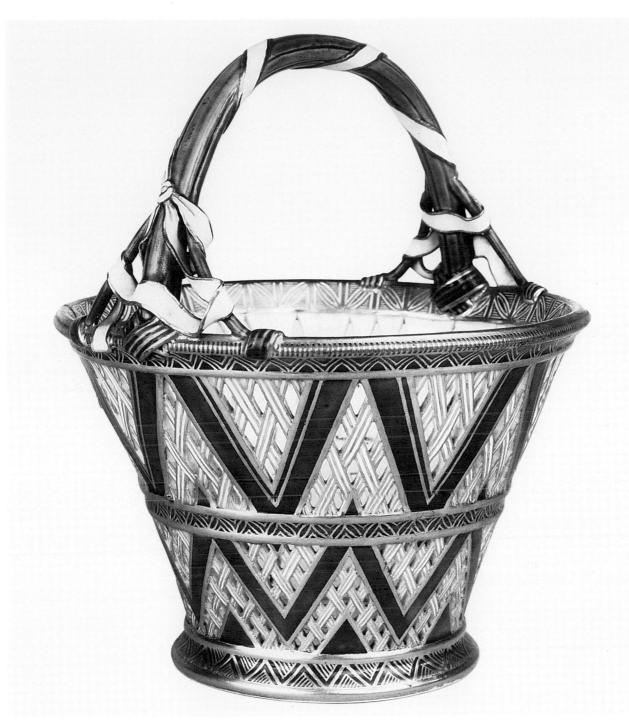

Panier, 1756. Sèvres manufactory, soft-paste porcelain. Formerly
in the Hillingdon collection. Photo courtesy Christie, Manson,
and Woods Ltd., London.

5 Ewer and Basin
(broc et jatte feuille d'eau, première grandeur)

1757
Sèvres manufactory; soft-paste porcelain; possibly designed by Jean-Claude Duplessis

Ewer: HEIGHT 19.2 cm (7%₆ in.); WIDTH 14.4 cm (5⅝ in.); DEPTH 8.1 cm (3³⁄₁₆ in.). *Basin:* HEIGHT 7.1 cm (2¾ in.); WIDTH 29.1 cm (11½ in.); DEPTH 22.1 cm (8¹¹⁄₁₆ in.)

MARKS: The basin is painted in blue underneath with the factory mark of crossed L's enclosing the date letter E for 1757, and with the painter's mark of a branch with leaves; it is incised *.T.m* and *C.N.*

84.DE.88

DESCRIPTION: Both the ewer and the basin are oval in plan and are modeled with water lilies in relief. The ewer stands on an oval foot ring, recessed under the base. Vertical moldings run up the front of the ewer, culminating in a large water lily leaf that forms a high, pointed spout with an undulating rim.

The basin, recessed under the base, has a multilobed rim, and the wall is molded on the interior with broad water lily leaves. There is a kiln suspension hole underneath.

The ewer and basin are both decorated with panels of pink (*rose*) ground color. The pink is somewhat paler on the ewer, and slightly purple on the basin. In the center of each water lily leaf is a white reserve, which is painted with a bouquet of flowers in colors. The white panels on each wall of the ewer and on the exterior of the bowl are also painted with flowers and fruit.

Burnished gilding highlights the modeling and the rims and frames the panels of ground color. Near the base of the ewer a three-lobed line of feathered gilding is placed within the edge of the shaped panel of pink ground. Pendant husks and dots in gilding decorate the white outer edge of the handle. In the center of the basin a thick area of gilding covers the point from which the modeled ribs radiate.

CONDITION: There is a small chip on the lip of the ewer on one side and another small chip in the foot ring directly beneath. The flat base section of the ewer cracked slightly during firing. A firing crack about 3 cm in length extends from above the foot ring, below the handle. It is partly concealed by a painted trail of flowers and leaves. The decorated surfaces are unscratched, although the gilding on both pieces shows some wear.

COMMENTARY: This model of ewer and basin was probably designed by Jean-Claude Duplessis. It was first produced at Sèvres in 1756 and was called the "pot à eau et jatte feuille d'eau."[1] The Museum's example is of the first, and largest, size. A second size was introduced in 1757, and apparently a third size of ewer only was introduced in 1758. Six models and sixteen molds for these three sizes were recorded in the factory's stock list of October 1, 1759.[2] They included a model and four molds for a basin of the second size called a "jatte à feuilles d'Eau unie," which may have had no molded relief decoration. Three plaster models of this shape of ewer survive in the factory's archives, one of each size (see illus.).[3] The shape is first mentioned in the biscuit kiln records in July 1757, when eight basins of unspecified size and three ewers, two of the first size and one of the second, are recorded.[4] The biscuit kiln records also show that in July 1758 two "Pots à l'eau feuilles d'eau" of the first size were fired.[5] No examples of this shape are identifiable in the glaze kiln records until a firing of October 1, 1759, when ten ewers (three of the first size, five of the second, and two of the third) and eight basins (five of the first size and three of the second) are listed.[6] All of these were then recorded in the stock list of the same date as being in the Magasin du Blanc.[7] The glazed ewers of the first size were valued at 24 *livres* each, those of the second at 18 *livres* each, and those of the third at 12 *livres* each. The basins of the first size were valued at 18 *livres* each, and those of the second, at 12 *livres* each. Two "Pots à l'Eau feuille d'Eau et Jatte" were recorded in the Magasin du Blanc in 1774; they were valued at 30 *livres* each, though they were considered old-fashioned by then.[8]

The pink ground used on the Museum's ewer and basin was described in the factory's documents as *rose*. Ranging in tone from an orange-pink to a purple-pink, the pigment is the same as that used for *camaïeu rose* (monochrome pink) decoration (see no. 3 above).[9] It was initially supplied to the factory by Pierre-Antoine-Henry Taunay, and it is possible that the formula was among those he sold to the factory in 1754. Its high cost prevented the factory from producing this ground color until 1757, however. The application of gilded decoration adjacent to this color sometimes causes the pink ground to yellow, so a red barrier was often placed between the ground color and the areas to be gilded.

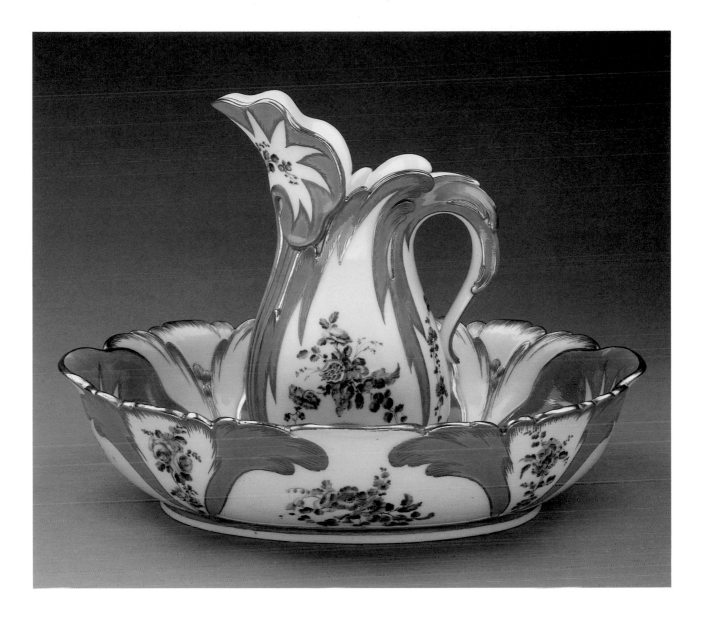

The unidentified painter's mark on the Museum's basin has been attributed to Jean-René Dubois, who left the factory in 1757. It is found, however, on pieces dated as late as 1764.[10] The painter who used this mark painted flowers on pieces of the dinner services given by Louis XV to Empress Maria Theresa of Austria in 1758 and to the Duchess of Bedford in 1763. A large *jatte à punch* dated 1761 in the Musée Ile-de-France, Collection Ephrussi-Rothschild, Saint-Jean-Cap-Ferrat, bears a similar mark. The mark is also found on a *vase hollandois* dated 1764 in the British Royal Collection[11] and on a pair of *vases hollandois* dated 1764 in the Metropolitan Museum of Art, New York (50.211.156–157).

Only three *pots à eau feuille d'eau et jatte* are identifiable in the Sèvres factory's sales records up to 1760. In the second half of 1757 Lazare Duvaux purchased two "Brocs Roussel Et feuille d'eau" and two accompanying basins, all decorated with green ground and flowers, for 600 *livres* each.[12] One ewer and basin was of the model named after Jacques Roussel, a shareholder in the factory, and the other was of the same model as the Museum's example.[13] In December 1758 two "[brocs] feuilles deaux" were listed among the porcelain wares given by Louis XV to Maria Theresa.[14] Their ground colors were recorded as "Verds Et B.C. [bleu céleste]," and they were painted with flowers. The description also indicates that one had a green ground and the other a turquoise-blue ground; they cost 480 *livres* each. No example with a turquoise-blue ground is in a known collection.

Four eighteenth-century ewers and basins of this model are known, as well as one further ewer and two basins now separated from their partners. The ewers of the first size are 19.1 and 19.2 cm high, while those of the second size are 17.1 to 17.6 cm high. No examples of the third size seem to have survived. All the known basins measure between 29.1 and 30.1 cm in width, and they are probably all of the first size. Apart from the present example, the only other known ewer and basin of the first size of this model is in the Musée des Arts Décoratifs, Paris (GR 228).[15] It is dated 1756 and is decorated with a green ground and flowers. A basin dated 1757, missing its ewer, similarly decorated with a green ground and flowers, is in the Musée National de Céramique, Sèvres (MNC 1868).[16] Two ewers of the second size survive with their basins. One, dated 1757, has a pink ground and flowers similar to those on the Museum's ewer (Toronto, George R. Gardiner Museum of Ceramic Art).[17] Its ground color is much purpler, and the exterior of its basin is decorated with a solid ground color. The exteriors of all the other examples, like that of the Museum's basin, display panels of ground color and reserves painted with flowers. Another *pot à eau feuille d'eau* of the second size with a

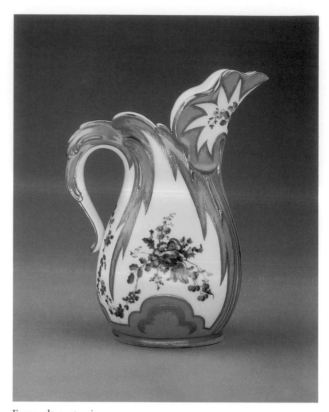

Ewer, alternate view

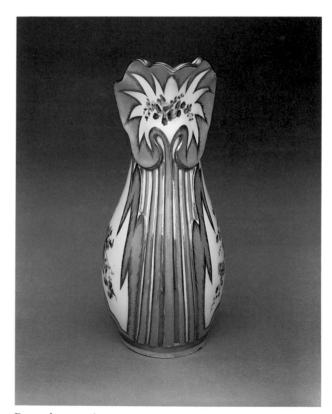

Ewer, alternate view

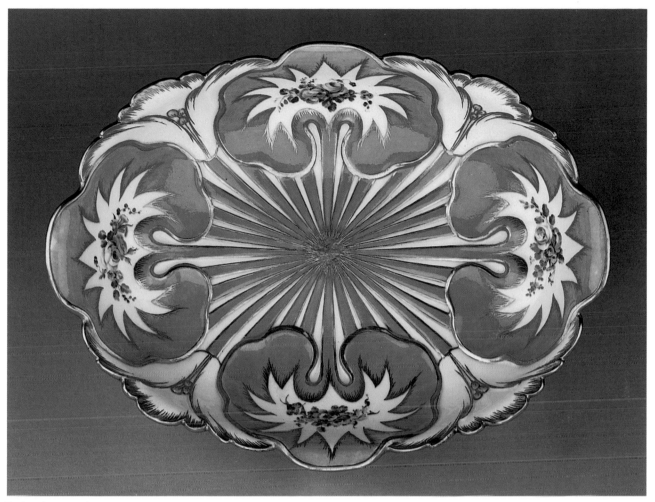

Basin, alternate view

jatte of the first size is in the Art Institute of Chicago.[18] It is decorated with a green ground and flowers, and it is undated. A ewer of the second size is in an English private collection.[19] It is dated 1757 and is the only known example without a ground color; it is painted with long trails of flowers and with highlighting in *beau bleu*. It probably matched a basin of this model dated 1760, also painted by Thévenet (Paris, private collection).[20] Although a pea green ground was added to the basin in the nineteenth century, the *beau bleu* highlighting is still visible. It is possible that these were decorated as a pair at the factory, despite the different date letters.[21]

Examples of a plainer shape of ewer and basin, the *pot à eau ordinaire et jatte ovale unie,* with decoration similar to that of the Museum's ewer and basin, are in the Petit Palais, Paris (Tuck collection, no. 100), and in the Rosebery collection at Dalmeny House, Midlothian. Both date from around 1757–1760 and are decorated with panels of pink ground color in patterns similar to those on the Museum's ewer and basin, as if their bodies were similarly modeled in relief. Close examination reveals that the ground color on the example at Dalmeny was, however, added in the nineteenth century. The Sèvres factory has continued to produce

copies of the *pot à eau feuille d'eau et jatte* in the nineteenth and twentieth centuries. An example dated 1865 is in the Musée des Arts Décoratifs, Paris (given by the Sèvres factory in 1870, no. Sèvres II).

The Museum's ewer and basin were listed in a privately printed catalogue of the contents of Welbeck Abbey, Nottinghamshire, in 1897.[22] This was published for the sixth Duke of Portland (1857–1943), who had succeeded his unmarried cousin in 1879. He first visited Welbeck after his succession with his stepmother, Ottoline Morrell, and they found most of the rooms empty.[23] The contents had been removed to avoid damage during the almost constant construction commissioned by the fifth duke. In 1937 the sixth duke described cabinets displaying Sèvres porcelain in the Gobelins Drawing Room and in a long corridor off the hall at Welbeck.[24] This collection was probably formed by the fifth duke, William John Cavendish-Bentinck-Scott (1800–1879), who succeeded in 1857. He was known as a collector of French paintings and Sèvres porcelain.[25] The second Duchess of Portland, who collected oriental porcelain and natural curiosities, also owned a Sèvres porcelain tea service, which was sold after her death in 1786.[26]

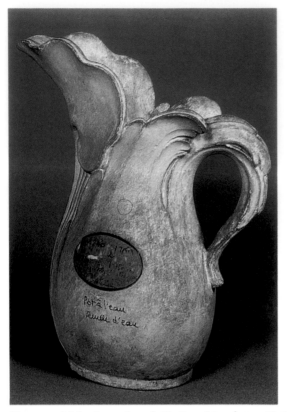

Plaster model for the *pot à eau feuille d'eau*. Manufacture Nationale de Sèvres, Archives.

PROVENANCE: (?)William John Cavendish-Bentinck-Scott, 5th Duke of Portland, died 1879; by descent to the Dukes of Portland, Welbeck Abbey, Nottinghamshire (sold, Henry Spencer and Sons, Retford, Nottinghamshire, July 23, 1970, lot 288); [Winifred Williams Ltd., London, 1970]; Eric Robinson, Mereworth Castle, Kent (sold, Sotheby's, London, June 12, 1984, lot 213); [Winifred Williams Ltd., London, 1984]; the J. Paul Getty Museum, 1984.

BIBLIOGRAPHY: Best, Son, and Carpenter, *Catalogue of the Ornamental Furniture, Works of Art, and Porcelain at Welbeck Abbey* (London, 1897), p. 52, no. 296; Sassoon 1985, pp. 95–98; Sassoon and Wilson 1986, no. 163; David Battie, ed., *Sotheby's Concise Encyclopedia of Porcelain* (London, 1990), ill. p. 109.

1. Brunet and Préaud 1978, p. 150, no. 81; Préaud and Faÿ-Hallé 1977, p. 72, nos. 143–144.
2. S.L., I.7, October 1, 1759 (for January–September 1759), fols. 66–68.
3. MNS Archives, 1814 Inventory, "Pot à l'eau feuille d'eau," 1740–1760, no. 2 (height 21.5 cm). This refers to the model of the first size; those of the second and third sizes are possibly not of eighteenth-century date.
4. B.K.R., July 27, 1757, fols. 86/84, 88/86.
5. B.K.R., July 24, 1758, fol. 112/110.
6. G.K.R., October 1, 1759, fol. 3.
7. S.L., I.7, October 1, 1759 (for January–September 1759), fol. 17.
8. S.L., I.8, 1774 (for 1773), fol. 65.
9. I thank Antoine d'Albis, Manufacture Nationale de Sèvres, for this information.
10. Eriksen and de Bellaigue 1987, pp. 154, 173, no. 189.
11. De Bellaigue 1979, no. 101.
12. S.R., Vy2, July 1, 1757–January 1, 1758, fol. 49v.
13. This reference has previously been published as indicating a pair of ewers and basins of the same model as the Museum's example; see Brunet and Préaud 1978, p. 150, no. 81; Sassoon 1985, p. 95.
14. S.R., Vy2, December 1758, fol. 85v.
15. Formerly in the Grandjean collection; see Brunet and Préaud 1978, p. 150, no. 81 (height of ewer 19.1 cm; width of basin 29.4 cm; no painter's marks).
16. See Préaud and Faÿ-Hallé 1977, p. 72, no. 144 (width of basin 29.1 cm; no painter's mark).
17. Ex-coll. the Hon. Jack Michelham (sold, Sotheby's, London, July 5, 1966, lot 136); Eric Robinson, Mereworth Castle, Kent (sold, Sotheby's, London, June 12, 1984, lot 214); [Winifred Williams Ltd., London, 1984] (height of ewer 17.1 cm, width of basin 30.2 cm; painted by Antoine-Toussaint Cornaille).
18. Ex-coll. Lord Hillingdon (sold, Christie's, London, March 25, 1968, lot 67); Eric Robinson, Mereworth Castle, Kent (sold, Sotheby's, London, June 12, 1984, lot 215); [Armin B. Allen, New York, 1984] (height of ewer 17.6 cm, width of basin 30.1 cm; no painter's marks).
19. Sold, William Doyle Galleries, New York; Dalva Brothers, New York, 1982 (height of ewer 17.4 cm; painted by Louis-Jean Thévenet *père*). See Sassoon 1985, ill. p. 97.
20. Width 30.2 cm; I am grateful to Brian Considine of the J. Paul Getty Museum for bringing this example to my attention.
21. Another example of this model has erroneously been published as being at Hillwood House, Washington, D.C. (Préaud and Faÿ-Hallé 1977, p. 72). I am grateful to Katrina Taylor, curator, Hillwood House, for her help.
22. I thank Susan Newell, Wallace Collection, for providing this information on the Portland collections.
23. O. Morrell, in *Men, Women, and Things: Memoirs of Sixth Duke of Portland, William John Arthur Charles James Cavendish-Bentinck, K.G., G.C.V.O.* (London, 1937), pp. 33–34.
24. Ibid., pp. 95–96, 100.
25. A. S. Turbervill, *A History of Welbeck Abbey and Its Owners, 1755–1879*, vol. 2 (London, 1938), p. 426.
26. *A Catalogue of the Portland Museum, Property of Dowager Duchess of Portland, Deceased,* sale cat., Skinner & Co., Privy Gardens, Whitehall, London, April 24, 1786, and thirty-seven following days, lot 432.

6 Pair of Figure Groups
(Les Mangeurs de raisins *and* Les Flûteurs)

Circa 1757–1766
Sèvres manufactory; soft-paste porcelain

Les Mangeurs de raisins: HEIGHT 22.9 cm (9 in.); WIDTH 24.8 cm (9¾ in.); DEPTH 17.8 cm (7 in.). *Les Flûteurs:* HEIGHT 22.3 cm (8¾ in.); WIDTH 25.4 cm (10 in.); DEPTH 15.2 cm (6 in.)

F

MARKS: *Les Flûteurs* is incised F on the back. No painted marks.

70.DE.98.1–2

DESCRIPTION: *Les Mangeurs de raisins* (The grape eaters) depicts a young man and a young woman sitting on rocky ground with a dog in front of them. The man is offering to feed his companion a bunch of grapes.

Les Flûteurs (The flute lesson) depicts a young man giving a flute lesson to a young woman. A lamb lies on the ground near a flowering bush by the woman's feet, and a barking dog is seated by the man's feet.

Both groups are unglazed, and traces of a red pigment can be seen in some crevices in the modeling.

CONDITION: There are firing cracks in the base at the front and back of *Les Mangeurs de raisins;* they are partially filled with a white substance that is possibly contemporary. The handle of the basket and some grape leaves were missing and have been restored. There are firing cracks in the base at the front and back of *Les Flûteurs.* The right ear of the lamb, the flute, the fingers of the man's hands and the woman's big toe, the dog's left paw, the handle of the basket, and various leaves were all broken or missing and have been replaced, using the original plaster models and molds in the archives at Sèvres.

The Museum's groups were mounted on pseudo-rococo gilt-silver bases by A. Aucoq, Paris, in the late nineteenth century. These bases have been removed.

COMMENTARY: This pendant pair of figure groups, *Les Flûteurs* and *Les Mangeurs de raisins,* was based on designs by François Boucher. In the Vincennes and Sèvres factory documents these groups are referred to as "Groupes de Boucher." Four examples so described are listed as being in the factory's Magasin de Vente in the stock list of October 1, 1752, though they are not necessarily of the same model as the Museum's.[1] An example of *Les Flûteurs* clearly recorded in Lazare Duvaux's *Livre-Journal* in July 1752 provides evidence for the dating of this model. Plaster models for both of the Museum's groups survive in the archives of the Sèvres factory,[2] but no molds or models are recorded in the early stock lists. A terracotta model of *Les Flûteurs* is in the Musée National de Céramique, Sèvres (MNC 7723). These groups were produced in one size; glazed examples and examples modeled with a tall porcelain basket mounted on the back are known.

The interesting development of these groups from paintings by François Boucher has been discussed by several authors.[3] Both compositions illustrate scenes from *La Vallée de Montmorency* (The vale of Montmorency), a comic operetta by Charles-Simon Favart and F. Parfaict. Favart ran the Opéra-Comique, and his wife was a leading dancer and actress. Her appearance in this 1752 production represented an important return to the stage.[4] The costumes and stage sets were designed by Boucher, who was a friend of Favart. The operetta was adapted from Favart's 1745 pantomime *Les Vendanges de Tempé* (The grape harvests of Tempe). The latter inspired Boucher to execute a series of oil paintings including *Les Mangeurs de raisins* (now called *Autumn Pastoral,* London, Wallace Collection)[5] and *L'Agréable Leçon* (The pleasant lesson), also known as *Le Flûteur* (The flutist; Melbourne, National Gallery of Victoria).[6] The popularity of the 1752 production of *La Vallée de Montmorency* inspired the Vincennes factory to produce figure groups based on its scenes.[7] Rosalind Savill has suggested that the factory may have based these groups on drawings that are not known to have survived. Guy Stair Sainty has pointed out, however, that Boucher's paintings themselves could have been sent to Vincennes; this practice was observed in 1783 with the artist's painting of Rinaldo and Armida.[8] René Gaillard's engraving of *L'Agréable Leçon* was not published until 1758, six years after the group was first produced at Vincennes (illus.).[9] There is no known engraving of *Les Mangeurs de raisins,* although a very similar composition by Boucher entitled *Le Goûter de l'automne* (The taste of autumn) is known from an engraving by Gaillard (illus.). Copies of both these engravings survive in the archives of the Sèvres factory.

There are no surviving documents that identify the sculptor who translated these two compositions into three-dimensional groups. Several sculptors working at Vincennes carried out this type of work during the early 1750s, among them Pierre Blondeau, Louis-Félix de La Rue, Jean-Baptiste Fernex, and Claude-Louis Suzanne. The Museum's example of *Les Flûteurs* is incised F on the back; *Les Mangeurs de raisins* is not marked. The incised marks found on figures produced at Vincennes and Sèvres have been interpreted by Wilfred Sainsbury and Nina Birioukova.[10] Sainsbury has suggested that the mark F was not for the sculptor Fernex, as several authors had previously proposed, but that it related to work carried out at the factory while Etienne-Maurice Falconet was director of the sculpture workshop, from 1757 to 1766. That the incised letter F on porcelain sculptures was Falconet's control mark was proved by Birioukova and has been confirmed by other authors.[11] Thus the Museum's groups may be dated to 1757–1766.

A large variety of porcelain sculptures were produced at Vincennes from the mid-1740s. Until about 1751–1752 they were all glazed, and some were decorated with enamel colors. From 1752 on, the majority of sculptures were sold in the biscuit state, which allowed the careful modeling to retain its sharpness, rather than being dulled by a thick glaze. Several *groupes de Boucher* are listed in the incomplete biscuit kiln records for 1753–1756,[12] and one can be identified in the glaze kiln records for 1754.[13] A firing crack in the center of the base is found on most known examples of *Les Mangeurs de raisins*. The factory would fill the crack and refire the group if possible.[14] Modern versions of this model, produced in soft-paste porcelain from the original molds, have also cracked in the same location.

Antoine d'Albis has pointed out that both of the Museum's groups bear traces of a red color. Figures that were to be glazed were painted with a red pigment,[15] which, when covered by the slightly green glaze, produced a desirable warmer white hue. It seems likely therefore that the Museum's groups were intended to be glazed, which, as has been noted, would have been unusual in the late 1750s and early 1760s. It is worth noting that Duvaux occasionally sent biscuit figures back to the factory on behalf of his customers for glazing. The sales records show that in the first half of 1755 two "Enfans de Bouché" (single figures) were glazed for him at a cost of 9 *livres* each.[16]

Dominique Menager has noted that the factory's stock lists record different values for *groupes de Boucher*.[17] She states that from 1752 to 1756 they were valued at 60 *livres* each; from 1758 to 1774, at 144 *livres* each; and from 1774 to 1777, at 96 *livres* each. As Savill has shown, however, more than seventy different models of single figures and groups based

on Boucher's work were produced at the factory by 1769.[18] It would therefore be questionable to assume that the term *Groupe de Boucher* necessarily applies only to *Les Flûteurs* and *Les Mangeurs de raisins*. It seems unlikely that either of these two models was sold for less than 144 *livres* in biscuit in the 1750s, though their price was probably reduced by the 1770s. A price of 144 *livres* is clearly noted in Duvaux's *Livre-Journal;* on July 23, 1752, he sold "un groupe de Vincennes, sujet de Boucher, le joueur de flute" for that price to the duchesse de Lauraguais.[19] On the basis of the stock list of October 1, 1752, Svend Eriksen has suggested that the factory's "cost price" for these groups was 60 *livres* each.[20] He has also suggested that although the regular price was 144 *livres*, examples were sold to shareholders at cost. As an example, he cites an entry in the sales records on June 30, 1753, noting that J.-F. de Verdun bought three "Groupes de Boucher" for 60 *livres* each.[21] We have seen that shareholders possibly received a discount of approximately 10 percent off the factory's regular price (see entry for no. 3 above), yet we have also seen that the values given in the stock lists for objects in the Magasin de Vente were the regular sales prices, and not "cost prices" (see entry for no. 1 above). It seems clear that smaller figures or groups after Boucher of models different from the Museum's were sold in 1753 to Verdun. Menager states that the records of payments to *répareurs* for the year 1777 show that for work on groups similar to the Museum's a sculptor of the first class received 37 *livres,* and a sculptor of the second class received 30 *livres*.[22]

The sales records show that several "Groupes de Boucher, Biscuit" sold for 144 *livres* each. In 1753 one was sold at this price for cash,[23] and another was sold to Duvaux.[24] In 1754 one was sold to a M. Gaudin,[25] and another was sold to a M. de Cromos in 1756.[26] In 1757 (the earliest possible date for the Museum's groups) one example was sold to Duvaux,[27] and two others for cash.[28] Two *groupes de Boucher* were included among the Sèvres porcelain sculptures given by Louis XV to Christian VII of Denmark in 1769; again, they cost 144 *livres* each.[29] It is a measure of their popularity and success that these models were included in such an important royal gift seventeen years after they were designed for the factory. Madame de Pompadour owned examples of these models, and they are clearly identifiable in the inventory of her possessions taken after her death in 1764. At Versailles she had "Deux groupes d'après Mr Boucher: la Bergère jouant du flageolet, et la Corbeille de raisins" (Two groups after M. Boucher: the shepherdess playing the flute and [with] the basket of grapes).[30] Another example of *Les Flûteurs* was in the Hôtel Pompadour in Paris.[31] Among her porcelains at the Château de Ménars were "Quatre figures de porcelaine de Sève, representant

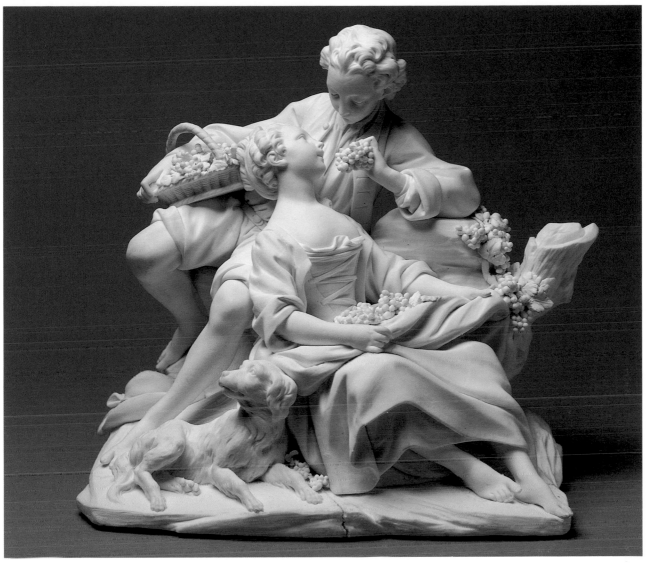

Les Mangeurs de raisins

differends sujets, dans leur boetes de verre" (Four Sèvres porcelain figures, representing different subjects, in their glass covers).[32] This entry shows that consideration was given in the eighteenth century to protecting such figures from dust.

Biscuit porcelain examples of *Les Mangeurs de raisins* are in the C. L. David Collection, Copenhagen (42/1973);[33] the Musée National de Céramique, Sèvres (MNC 7755); the State Hermitage, Leningrad; and Woburn Abbey, Bedfordshire.[34] Examples have also appeared at auction.[35] A biscuit example modeled with a porcelain basket at the back is in the Musée des Arts Décoratifs, Paris (Gould Bequest, 28601 B),[36] and a glazed example is in a private collection, Massachusetts.[37] Biscuit porcelain examples of *Les Flûteurs* are in the Musée du Louvre, Paris (incised with Falconet's control mark); and the Detroit Institute of Arts (55.85; incised with Jean-Jacques Bachelier's control mark); others have appeared at auction.[38] A biscuit example with a porcelain basket is in the Musée des Arts Décoratifs (Gould Bequest, 28601 A),[39] and an unmarked glazed example is in the Wadsworth Atheneum, Hartford (1917.956).[40]

The engraving *L'Agréable Leçon* was also used at the Sèvres factory as a source for scenes painted on porcelain. Examples painted with this scene include one of a pair of *vases bouteilles* of 1767, painted by Charles-Nicolas Dodin (San Marino, Huntington Art Collections).[41] The same scene appears on two cups of 1768 painted by Etienne-Jean Chabry *fils:* a *gobelet Calabre* (Boston, Museum of Fine Arts 53.1011) and a *gobelet litron* (London, Victoria and Albert Museum C.457&A-1921). Other porcelain factories used this engraving as a design source for figure groups.[42] The Chelsea factory made a large group of this design, with a tall *bocage* attached to the back; an example of about 1758–1765 is in the Victoria and Albert Museum (Schreiber Collection, 1.197). The Frankenthal and Vienna factories also produced groups of this subject, examples of which have appeared at auction.[43] The Chelsea factory produced a slightly less elaborate group of a shepherd and shepherdess eating grapes, modeled after Boucher's design; an example of about 1775 is in the Victoria and Albert Museum (Schreiber Collection, 1.355). The scene of *Les Flûteurs* is painted on a *vase antique ferré* of about 1779 in the Wallace Collection (C266). The figures are arranged in the same way as the biscuit groups, rather than being based on the engraving *Le Goûter de l'automne*.[44]

PROVENANCE: Provenance: Goury de Rosland, Paris (sold, Galerie Georges Petit, Paris, May 29–30, 1905, lot 108); Mortimer L. Schiff, New York; by descent to John L. Schiff (sold, Christie's, London, June 22, 1938, lot 27); J. Paul Getty, 1938.

Les Mangeurs de raisins, back view

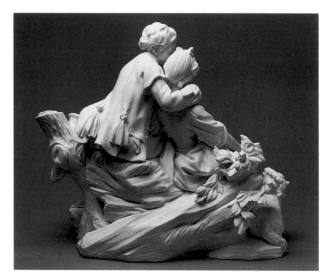

Les Flûteurs, back view

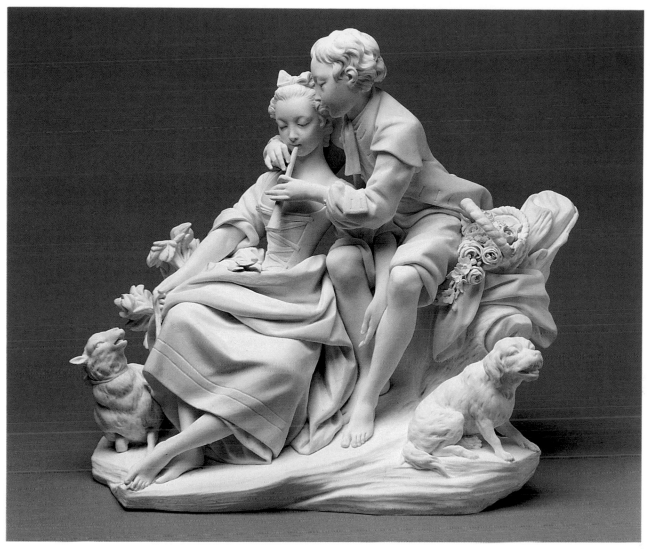

Les Flûteurs

BIBLIOGRAPHY: Sassoon and Wilson 1986, p. 71, no. 158 (erroneously dated circa 1752).

1. S.L., I.7, October 1, 1752, fol. 46 (costing 60 *livres* each).

2. The model for *Les Mangeurs de raisins* is 26 cm high and 29 cm wide; that for *Les Flûteurs* is 24 cm high.

3. See E. Bourgeois, *Manufacture Nationale de Sèvres: Biscuits du XVIIIe siècle* (Paris, 1913), nos. 313, 398, pl. 1; A. Faÿ-Hallé, in Préaud and Faÿ-Hallé 1977, nos. 484, 496–497; idem, in *François Boucher*, exh. cat. (Metropolitan Museum of Art, New York, 1986), nos. 98, 100; R. Savill, "François Boucher and the Porcelains of Vincennes and Sèvres," *Apollo*, no. 115 (March 1982), pp. 162–170; D. Menager, "Catalogue raisonné des biscuits de porcelaine de Vincennes et de Sèvres du XVIIIe siècle dans les collections du Musée National de Céramique a Sèvres," 1985, MNS Archives n.133, pp. 78–91; A. Laing, in *François Boucher* (see above), pp. 70–71; G. Stair Sainty, in *François Boucher: His Circle and Influence*, exh. cat. (Stair Sainty Matthiessen, New York, 1987), pp. 117–123.

4. B. Scott, "Rococo Flirtations: French Porcelain Figures Inspired by Favart's Plays," *The Antique Dealer and Collectors Guide* 39 (July 1986), pp. 32–35.

5. *Summary Illustrated Catalogue of Pictures in the Wallace Collection* (London, 1979), no. P482.

6. A. Ananoff and D. Wildenstein, *François Boucher* (Lausanne and Paris, 1976), no. 311.

7. *Le Jaloux* (The jealous lover), another figure group based on this operetta, was referred to in the Vincennes factory documents as the "Groupe de Vandevrole," presumably after the sculptor (Eriksen and de Bellaigue 1987, pp. 248–249).

8. Gillian Wilson, "New Information on French Furniture at the Henry E. Huntington Library and Art Gallery," *GettyMusJ* 4 (1977), p. 29.

9. P. Jean-Richard, *L'Œuvre gravé de François Boucher dans la collection Edmond de Rothschild*, exh. cat. (Musée du Louvre, Paris, 1978), pp. 258–259.

10. W. J. Sainsbury, "Les Marques sur les biscuits en pâte tendre de Vincennes et de Sèvres," *Cahiers de la céramique, du verre, et les arts du feu* 37 (1966), pp. 14–29; N. Birioukova, "A propos des marques sur les biscuits de Vincennes et de Sèvres," *Cahiers de la céramique, du verre, et les arts du feu* 40 (1968), pp. 257–260.

11. Eriksen and de Bellaigue 1987, p. 144.

12. B.K.R., November 22, 1753, fol. 16 (four, of which two needed refiring); February 22, 1754, fol. 17 (two); November 8, 1756, fol. 66/69 (eight, of which two needed refiring, one was cracked, and two were overfired).

13. G.K.R., December 23, 1754, fol. 41/33.

14. I thank Antoine d'Albis, Manufacture de Sèvres, for this information.

15. See MNS Archives, Y.72, fol. 34, for a copy of Jean Hellot's report on this red pigment, dated June 14, 1752; and Y.71 for another, dated October 7, 1757.

16. S.R., Vy1, January 1–June 1, 1755, fol. 88r. In the second half of 1760 the factory glazed twenty "Enf[ants] de Boucher et Falconet" for the dealer Mme Lair at a charge of 6 *livres* per figure. At the same time she paid 15 *livres* for the glazing of a "Groupe de Boucher" (S.R., Vy3, July 1, 1760–January 1, 1761, fol. 34v).

17. Menager (note 3), p. 78.

18. Savill (note 3), p. 163.

19. Duvaux 1873, no. 1181.

20. See above (notes 1, 7).

21. S.R., Vy1, June 30, 1753, fol. 13r.

22. Menager (note 3), p. 79.

23. S.R., Vy1, December 17, 1753, fol. 21r.

24. Ibid., December 31, 1753, fol. 28v.

25. Ibid., November 27, 1754, fol. 54v.

26. Ibid., May 7, 1756, fol. 125r.

27. S.R., Vy2, January 1–July 1, 1757, fol. 27v.

28. Ibid., October 7, 1757, fol. 36v.

29. S.R., Vy4, July 1, 1769, fol. 180r.

30. Cordey 1939, no. 667.

31. Ibid., no. 383.

32. Ibid., no. 1911.

33. Eriksen 1980, no. 64.

34. Supplied in 1763 as part of the sculpture decorations for a dinner service; S. Eriksen, "Ducal Acquisitions of Vincennes and Sèvres," *Apollo*, no. 82 (December 1965), pp. 484–489.

35. Menager (note 3), p. 82.

36. Brunet and Préaud 1978, no. 307.

37. Eriksen and de Bellaigue 1987, fig. 66.

38. Collection of Wilfred J. Sainsbury (sold, Sotheby's, London, March 14, 1967, lot 46).

39. Préaud and Faÿ-Hallé 1977, no. 484.

40. X. de Chavagnac, *Catalogue des porcelaines françaises de M. J. Pierpont Morgan* (Paris, 1910), no. 56.

41. Wark 1961, fig. 115; Brunet and Préaud 1978, no. 152.

42. G. Zick, "D'Après Boucher: Die 'Vallée de Montmorency' und die europäische Porzellanplastik," *Keramos* 29 (July 1965), pp. 3–47.

43. Sotheby's, New York, April 22, 1982, lots 50 (Vienna), 130 (Frankenthal).

44. Savill (note 3), pp. 165–167.

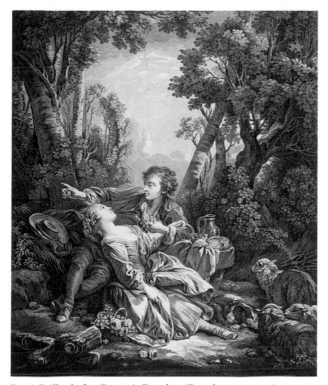

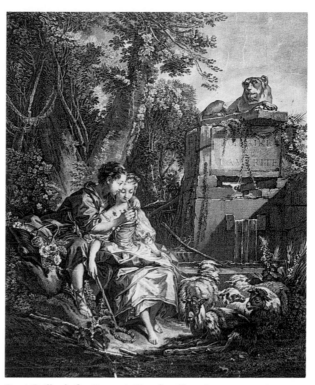

René Gaillard after François Boucher (French, 1703–1770).
Le Gôuter de l'automne. Engraving. Manufacture Nationale de
Sèvres, Archives D VII, Boucher.

René Gaillard after François Boucher (French, 1703–1770).
L'Agréable Leçon, 1758. Engraving. Manufacture Nationale de
Sèvres, Archives D VII, Boucher.

7 Tray
(plateau carré, deuxième grandeur)

1758
Sèvres manufactory; soft-paste porcelain

HEIGHT 2.3 cm ('⁵/₁₆ in.); WIDTH 12.7 cm (5 in.); DEPTH 12.8 cm (5¹/₁₆ in.)

MARKS: Painted in blue underneath with the factory mark of crossed L's enclosing the date letter F for 1758, above an unidentified painter's mark E; incised 60 underneath.

72.DE.75

DESCRIPTION: The square tray has a flat base and an angled, straight wall. The base is flat underneath, unglazed, and has a kiln suspension hole.

The interior of the tray is decorated with a pink (rose) ground. In the center of the tray's interior is a circular white reserve; the exterior is white. The reserve is painted in colors with a winged putto seated on clouds.

Burnished gilding is laid onto a maroon base and frames the reserve with flowing C- and S-scrolls and trails of tooled flowers. The rim is decorated with a band of burnished gilding with dentil borders.

CONDITION: The tray has been broken into many pieces and restored.

COMMENTARY: Square trays, called plateaux carrés, were produced at Vincennes and Sèvres in large quantities and in many sizes. This model was made in three principal sizes; the Museum's example is of the second size.[1] The description plateau à tiroir was given to similar, but rectangular, trays.[2] From 1757 a variant was also produced—described in documents as a plateau carré à jours—its raised wall pierced with Vitruvian scrolls and bellflowers.[3] The first mention of a square tray in the factory's stock lists appears in 1752, a variant molded with gadroons (plateau carré à gauderons). An example of this type of tray is at Blair Castle, Perthshire; another was formerly at Mentmore Towers, Buckinghamshire.[4] In the stock list compiled at the end of 1753 three plateaux carrés are listed in the Magasin du Blanc, valued at 15 livres each.[5] The biscuit kiln records list plain plateaux carrés regularly from December 1754.[6] In the glaze kiln records examples of this shape appear regularly from May 1756.[7] The sales records show that these trays were generally sold with a cup and saucer, forming a déjeuner carré; it is now fairly rare to find three such pieces surviving together.[8]

In the factory's sales records for the year 1757 plateaux carrés of unspecified sizes are listed both individually and as parts of déjeuners carrés. The trays cost 9 and 12 livres each when painted with sprays of flowers and 15 livres each when painted with flowers in garlands.[9] Déjeuners (in various sizes) were priced at 36 livres when painted with birds[10] or with children en camaïeu,[11] 60 livres with gilded friezes[12] or when painted with sprays of flowers,[13] 240 livres with a green mosaïque ground,[14] and 288 livres when decorated with bleu céleste ground and children painted in colors.[15]

No plateaux carrés or déjeuners carrés decorated with a pink ground are listed in the sales records until December 1758, when several appear, chiefly at the year-end sale at Versailles. It is not until that sale that porcelain decorated with this pink ground appears in the records. The pink ground is, however, found on pieces bearing the date letter E, supposedly for 1757. The existence of pink-ground wares dated with an E, linked with the documentary evidence, strongly suggests that E represented a part of both 1757 and 1758.

Pink-ground déjeuners carrés of the third size cost 108 livres each when painted with sprays of flowers[16] and 144 livres each when painted with unspecified decoration.[17] Two "déjeuners quaré 2ᵉ" are listed in the sales records for December 1758; one, with a mosaïque ground, was sold to Madame de Pompadour,[18] the other, with unspecified painted decoration, was sold to the dauphine.[19]

Déjeuners carrés are listed in the inventory of Mme de Pompadour's possessions made after her death in 1764. At Versailles she had "Six desjeuners quarrés, première grandeur dont chacun est composé d'une tasse, une soucoupe, un plateau de porcelaine, dont trois à mignature; prisés deux cents cinquante livres" (Six déjeuners carrés of the first size, each consisting of a cup, a saucer, and a tray of porcelain, three of which are in miniature, valued at 250 livres) and "Un dit moyen, même forme, prisé trent livres" (one of the middle size, same shape, valued at 30 livres).[20]

Several pink-ground plateaux carrés painted with flowers in the central reserve are known, including examples dated with an E for 1757–1758 in the Victoria and Albert Museum, London (D. M. Currie Bequest, c.400–1921), and in a private collection, Massachusetts.[21] A plateau carré à jours of the first size with a pink mosaïque ground was sold at auction in 1987.[22]

The painter's mark, which can be read as a C or an E, is very similar to that associated with Claude Couturier.[23]

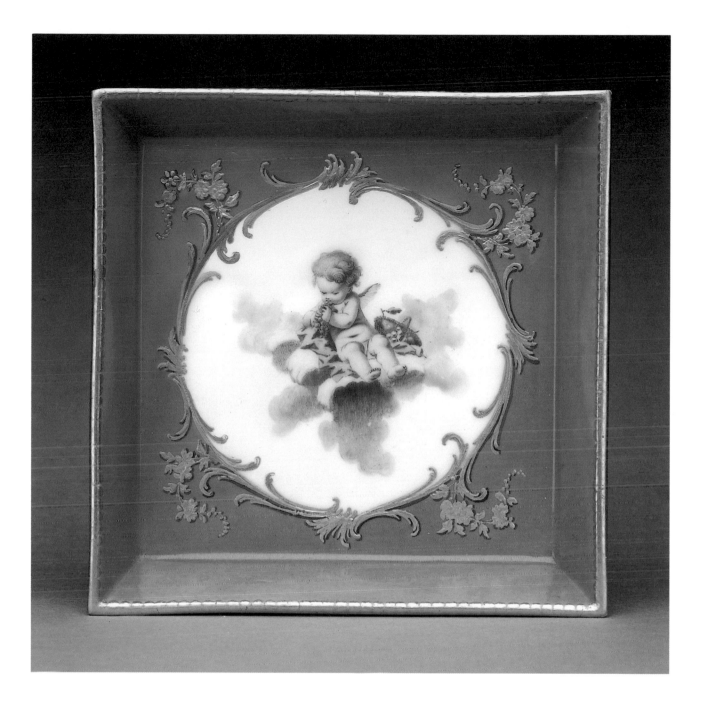

PROVENANCE: Deane and Anne Johnson, Los Angeles (sold, Sotheby's, New York, December 9, 1972, lot 27); J. Paul Getty, 1972.

BIBLIOGRAPHY: Sassoon and Wilson 1986, p. 74, no. 164; Savill 1988, p. 589, n. 3m.

1. Examples of the first size measure approximately 15.3 to 14.4 cm in width, and those of the third size, approximately 11.2 to 10.2 cm in width.

2. Eriksen and de Bellaigue 1987, p. 304, no. 116; Préaud and Faÿ-Hallé 1977, nos. 126–128.

3. Eriksen 1968, no. 35.

4. S.L., I. 7, 1752 (to October 1, 1752), fols. 7, 12. The example at Blair Castle, circa 1752–1753, has a *bleu lapis* ground; see JPGC Photo Archives, no. 129178; see also Sotheby's, Mentmore Towers, May 24, 1977, lot 2152, for an example with similar decoration (described, probably incorrectly, as having been decorated later).

5. S.L., I.7, 1754 (for 1753), fol. 13.

6. B.K.R., December 19, 1754, fol. 34/32; April 12, 1756, fol. 60/57; July 20, 1756, fol. 65/62; March 26, 1757, fols. 78/76, 79/77.

7. G.K.R., May 4, 1756, fol. 67/59; August 27, 1756, fol. 62; April 6, 1757, fol. 79/71.

8. Examples include two with *gobelets Bouillard et soucoupes,* one dated 1755 (Eriksen 1968, no. 38) and another, dated 1755, in a private collection, London (ex-coll. Florence Gould, sold, Sotheby's, Monaco, June 27, 1984, lot 1533); one with a *gobelet couvert et soucoupe* but no lid, dated 1764, in the Musée National de Céramique, Sèvres (see Verlet 1953, pl. 52); and one with a *gobelet litron* missing its saucer, dated 1766 (Dauterman 1970, no. 103).

9. S.R., Vy3, July 1, 1757–January 1, 1758, fol. 48v (six examples to Lazare Duvaux).

10. Ibid., September 17, 1757, fol. 34r (for cash).

11. Ibid., December 31, 1757, fol. 46v (to M. Machard).

12. Ibid., July 1, 1757–January 1, 1758, fols. 48v–49r (to Lazare Duvaux).

13. Ibid.

14. Ibid.

15. Ibid.

16. S.R., Vy3, December 29, 1758, fol. 76r (to M. Roussel); December 1, 1758–January 1, 1758, fol. 7v (two to Mme Duvaux [Lazare Duvaux's widow]). For surviving examples, see below (note 21).

17. S.R., Vy3, December 30, 1758, fol. 76v (to Mesdames de France and Madame Victoire).

18. Ibid., fol. 78r. For a surviving example, see below (note 22).

19. Ibid., fol. 76v.

20. Cordey 1939, p. 61, nos. 678–679.

21. Two examples: one, ex-coll. Mr. and Mrs. Deane Johnson (sold, Sotheby's, New York, December 9, 1972, lot 25); the other, ex-coll. the Hon. Jack Michelham (sold, Sotheby's, London, July 5, 1966, lot 119). Both were subsequently in a private collection, Cambridge, England.

22. Christie's, London, March 30, 1987, lot 22; previously offered for sale as "Property of a Lady," Christie's, London, July 1, 1985, lot 37, unsold.

23. Eriksen and de Bellaigue 1987, pp. 153, 158.

8 Pair of Cups and Saucers
(gobelets Calabre et soucoupes)

1759
Sèvres manufactory; soft-paste porcelain; painted by
Charles Buteux *père*

Cups: HEIGHT 8.3 cm (3¼ in.); WIDTH 10.2 cm (4 in.);
DEPTH 7.0 cm (3⅛ in.). *Saucers:* HEIGHT 4.1 cm (1⅝ in.);
DIAM. 15.7 cm (6 3/16 in.)

MARKS: Each saucer is painted in blue underneath with the
factory mark of crossed L's enclosing the date letter *g* for
1759, and with the painter's mark of an anchor; one cup is
incised *h* underneath; the other is incised with an indeci-
pherable mark.

72.DE.74.1–2

DESCRIPTION: The cups have a small, straight-sided foot,
which is recessed underneath. The curved handle is formed
by a simple tapering beam. The deep saucer rests on a short
foot, also recessed.

Both cups and saucers are decorated with a pink (*rose*)
ground overlaid with panels of green (*vert*) ground. There is
a white oval reserve on the front of each cup, while each
saucer has a white trefoil reserve. Cup .1 is painted with a
trophy of a woven straw basket filled with grapes and a
knife hanging from a blue ribbon bow. Saucer .1 is painted
with a trophy of a water-filled conch shell, a quiver of ar-
rows, and a flaming torch. Cup .2 is painted with a trophy
of a feathered yellow straw hat bound with a white and
mauve ribbon. Saucer .2 is painted with a trophy of a hel-
met and shield, a quiver of arrows, a sheathed sword, and
three arrows.

Burnished lines of gilding outline the green panels.
The rims of the cups and saucers have a gilded dentil design.
The reserves are framed by gilded bands tooled with alter-
nately burnished and matt rectangles.

CONDITION: Cup and saucer .1 are in good condition,
though the gilding in the well of the saucer is somewhat
worn. Cup .2 has a very small firing crack under the arch of
the handle; the gilding is not worn. The saucer has been
broken into six pieces and restored.

COMMENTARY: The *gobelet Calabre et soucoupe* was produced
at Vincennes from 1752 in several sizes, initially with a va-
riety of handle shapes.[1] The shape was named after one of
the factory's shareholders, Pierre Calabre.[2] A drawing for
this shape in the archives at Sèvres, dated 1753, bears an an-
notation indicating that it represents an improved version
(MNS R.1, l.II, d.2, fol. 6). In the stock list covering the last
three months of 1752, cups and saucers of this shape are
listed in the Magasin de Vente, but the models and molds
are not identifiable.[3] *Gobelets Calabre* are listed in the biscuit
kiln records from August 1753 in two sizes and in the glaze
kiln records from July 1753 in three sizes.[4]

Decoration employing panels of pink and green
grounds is found on other examples of Sèvres porcelain
dated from about 1759 to 1761 (see nos. 9–11 below). Nu-
merous porcelain wares decorated with "rose et verd"
grounds appear in the factory's records of the December
1760 sale at Versailles, which list many *gobelets et soucoupes*
of unspecified shape and painted decoration. In December
1760 Louis XV purchased a pair for 39 *livres* each, along with
a *pot à sucre*.[5] The dealers Bachelier, Mme Lair, Machart,
Poirier, and Tesnieres also purchased a variety of cups and
saucers with pink and green grounds between late 1760 and
mid-1761. The prices for each cup and saucer were 60, 66,
84, and 96 *livres*.[6] In the second quarter of 1761 the dealer
Dulac purchased a *déjeuner* (tea service) with pink and green
grounds for 528 *livres*.[7] This pink and green decoration was
often imitated in the nineteenth century, with the intention
to deceive.[8]

The bold decoration of green panels over a principal
ground of pink on the Museum's examples is found on
other cups and saucers of similar date, for example, a *gobelet
couvert* (now missing its lid) dated 1759 and painted with
similar trophies by Charles Buteux *père* (London, Victoria
and Albert Museum, D. M. Currie Bequest, C.409&A-
1921) and a *gobelet Bouillard et soucoupe* of 1760 (Art Institute
of Chicago 1965-1209a–b). The trophies painted in the re-
serves of the Museum's cups and saucers must have been
based on drawings since they appear on other pieces of
Sèvres porcelain, for example, on elements of a *déjeuner Du-
vaux* dated 1760 (Victoria and Albert Museum, Jones Col-
lection, C.768&F-1882) and on one of a pair of cut-down
straight-sided *gobelets*, circa 1760, sold at auction in 1983.[9] A
cup and saucer very similar to the Museum's was sold at
auction in 1913 from the collection of John Cockshut, Esq.[10]

PROVENANCE: Otto and Magdalena Blohm, Hamburg
(sold, Sotheby's, London, July 5, 1960, lots 126, 127);
Deane and Anne Johnson, Los Angeles (sold, Sotheby's,
New York, December 9, 1972, lot 21); J. Paul Getty, 1972.

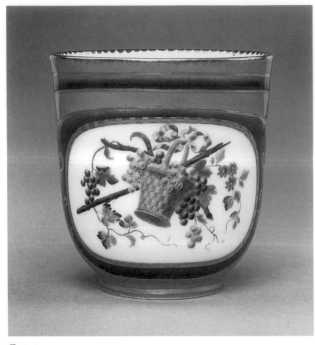

Cup . 1

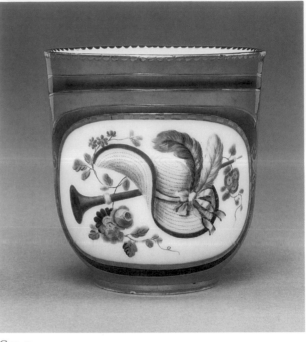

Cup . 2

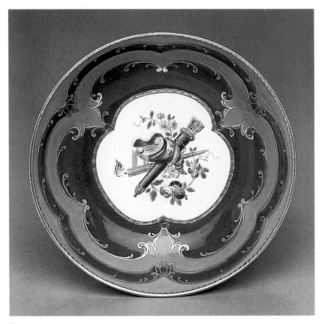

Saucer . 1

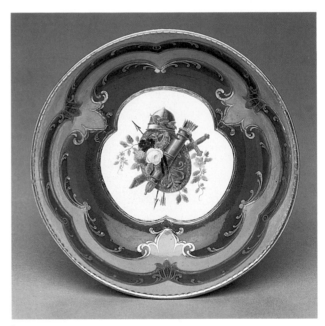

Saucer . 2

BIBLIOGRAPHY: R. Schmidt, *Early European Porcelain as Collected by Otto Blohm* (London, 1953), p. 101; Sassoon and Wilson 1986, p. 75, no. 165; Savill 1988, pp. 629, 637, n. 2, 652, 666, n. 134.

1. Préaud and Faÿ-Hallé 1977, nos. 334–343.
2. Eriksen and de Bellaigue 1987, p. 278.
3. S.L., I.7, 1753 (for October–December 1752), fol. 38.
4. B.K.R., August 6, 1753, fols. 10, 11; G.K.R., July 7, 1753, fol. 8.
5. S.R., Vy3, fol. 43v.
6. Ibid., fols. 41v, 42r, 49v, 51v, 53v, 54v.
7. Ibid., fol. 50v.
8. For example, a redecorated *gobelet couvert* (London, Wallace Collection c367).
9. Collection of the late Mrs. Robert Tritton (sold, Christie's, Godmersham Park, Kent, June 6, 1983, lot 85, in later gilt-bronze mounts).
10. Sold, Christie's, London, March 11, 1913, lot 36, to the dealer Harding.

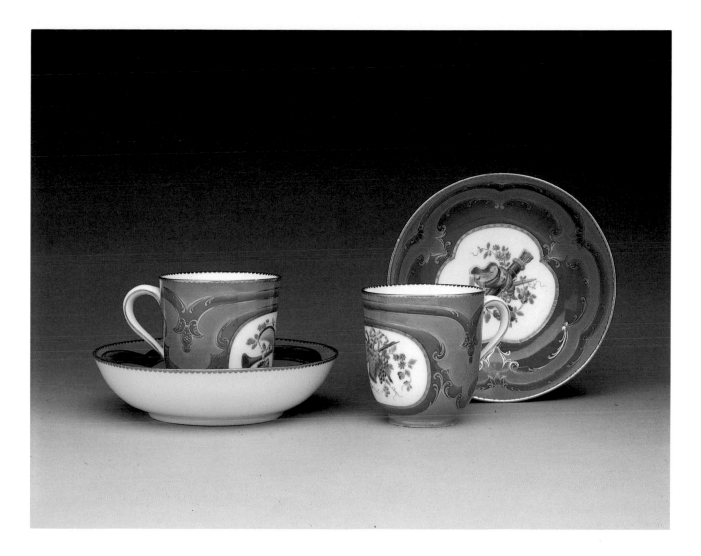

9 Pair of Vases
(pots pourris à bobèches)

1759
Sèvres manufactory; soft paste-porcelain; painted by Charles-Nicolas Dodin after engraved designs by David Teniers the Younger

HEIGHT 24.9 cm (9¹³⁄₁₆ in.); WIDTH 14.4 cm (5¹¹⁄₁₆ in.); DEPTH 9.4 cm (3¹¹⁄₁₆ in.)

MARKS: One vase painted in blue underneath with the factory mark of crossed L's enclosing the date letter G for 1759, above the painter's mark k. No incised marks.

PAPER LABELS: Various collector's labels pasted under each vase.

75.DE.65.1–2

DESCRIPTION: Each vase is oval in section. The scrolled foot is pierced at the front and back, and the six-lobed base is molded with a concave rim. Ribbon-bound moldings support a fluted and pierced candleholder (bobèche) at each side. Each candleholder sits on an added collar of lambrequin ornament. At either side of the central reserve is a narrow panel of piercing. The top section has four pierced panels cut in a trellis pattern. At the top of the vase is a group of modeled flowers, buds, and leaves. There is a hole in the base.

Each vase is decorated with a pink (rose) ground, with panels of green (vert) ground. The pierced areas at the sides and top and the flat areas of the base are left white. The front of each vase has a colored reserve painted with rustic figures in country settings. The colored reserve on the back of each vase is painted with a building in a landscape.

The modeling of each vase is highlighted with lines of burnished gilding. Gilding is also used to outline the pierced trellis at the top.

CONDITION: Vase .1 is in good condition; its decorated surfaces are unabraded. The candleholders have been broken more than once. They were originally fired in one piece with the vase but are now separate and have been given collars to conceal the breaks. The side moldings originally flowed into the gadroons of the candleholders. The candleholders, which may be replacements, are now attached to the vase by a metal pin headed with a plug of modern white porcelain. Some of the gilding has been touched up on the candleholders and on one small chip at the base.

Vase .2 has been broken across its lower section and restored more than once. Its candleholders have suffered a fate similar to that of those on vase .1. The decorated surfaces are in good condition.

COMMENTARY: This shape of vase was designed to contain potpourri, which was inserted through a hole in the base, and to hold candles in the bobèches at each side. In the Sèvres factory's documents this model of vase was referred to as both a pot pourri à bobèches and a pot pourri girandole. It was made in one size and is thought to have been designed by Jean-Claude Duplessis. The model and mold for the "pot poury girandole" were recorded in the factory's stock list of new work carried out during the first nine months of 1759.[1] Two plaster models still survive in the factory's archives (see illus.).[2] One "pot poury à Bobèches" is listed in the biscuit kiln records during July 1759, in the same firing as one vase vaisseau.[3] Another example, recorded as a "pot poury Girandole," is listed in a biscuit kiln firing of September 1759.[4] Similarly described vases are listed in the glaze kiln records in December 1759, May 1760, and August 1761.[5] Six "pots

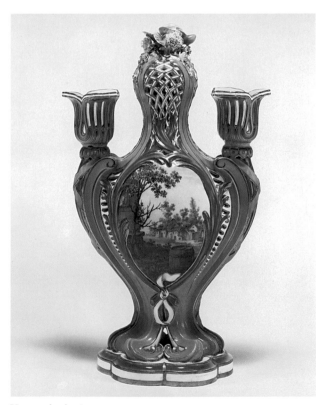

Vase .1, back view

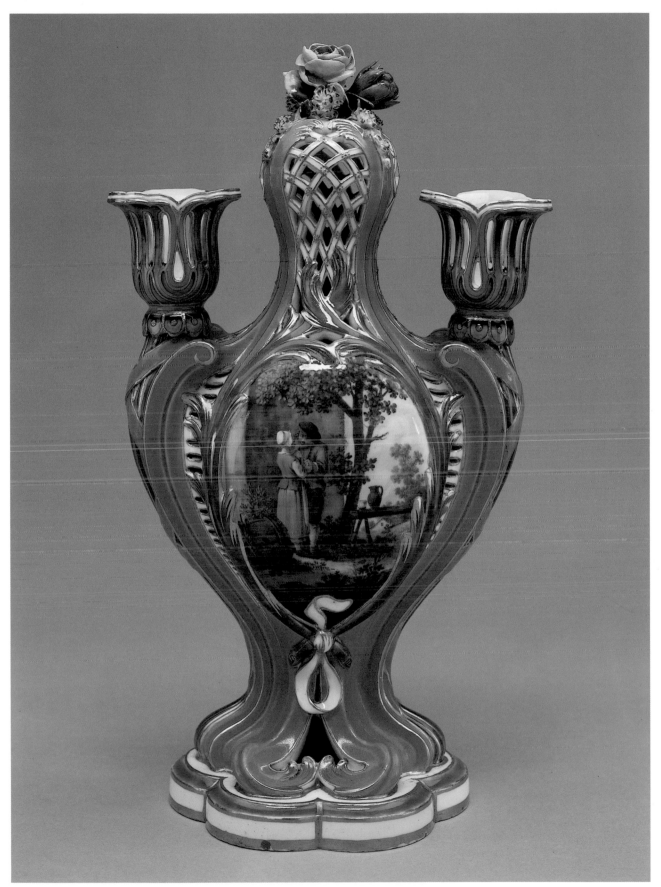

Vase . 1

pourri Girandoles ou à Bobèches" were recorded in the Magasin du Blanc after the end of 1760, valued at 30 *livres* each.[6] Two of these remained in the Magasin du Blanc after the end of 1762 and in subsequent years.[7]

The porcelain *bobèches* are of the same model as those mounted in pairs on the elephants' trunks on the *vase à éléphants,* produced at Sèvres from 1756.[8] On both types of vase the *bobèches* develop from a fluted cylindrical molding. Those on the Museum's vases have been broken and remounted on collars of more modern porcelain (they can be seen in a photograph of the vases dating from 1903; see Bibliography). It is possible that the *bobèches* are also more modern replacements, which, like the collars, have been painted to match the vases. Pierre Ennès has noted that the *bobèches* on this model are fragile.[9] A pair of *pots pourris à bobèches* sold to Madame de Pompadour in 1762 as part of a garniture were in a cupboard at the Château de Menars by the time of her death (within two years of their purchase).[10] They were described as "Quatre vases de porcelaine verte, dont deux, avec bobèches de cuivre doré d'or moulu" (four vases of green porcelain, of which two have candleholders of gilt bronze). Evidently their candleholders had been broken and replaced with gilt-bronze versions. The *bobèches* on another pair of *pots pourris à bobèches,* sold at auction in 1895

and 1910 (see below), also appear to have been broken. In both auction catalogues they appear with later (probably nineteenth-century) gilt-bronze putti in place of the candleholders.

Though the Museum's vases bear the date letter G for 1759, it seems very likely that they were not sold before 1760. Items with pink and green grounds are not identifiable in any quantity in the Sèvres sales records until the Versailles sale of December 1760 (see entry for no. 8 above). The decoration of the Museum's vases—with two ground colors and painted scenes after David Teniers the Younger, as well as modeled and colored flowers—is a good example of the taste at Sèvres in the late 1750s and early 1760s. Charles-Nicolas Dodin was one of the factory's most accomplished figure painters, specializing in colored reserves.

The couple painted on the front of vase .1 are based on figures standing by a tree in an engraving after Teniers that survives in the archives at Sèvres (MNS D III, Teniers). The engraving, a reduced version of *La Quatrième Fête flamande,* bears an eighteenth-century inventory number on its reverse, as well as a sketch of a drunken man seated on the ground, which relates to the scene painted on the Museum's lidded potpourri vase (no. 10 below). The couple shown seated on a bench on the front of vase .2 are taken from an

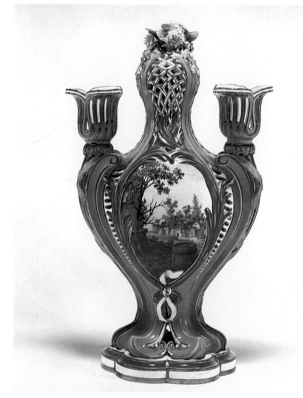

Vase .2, back view

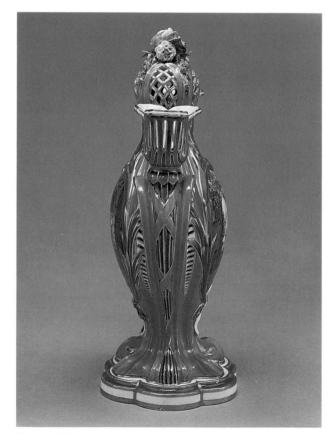

Vase .2, side view

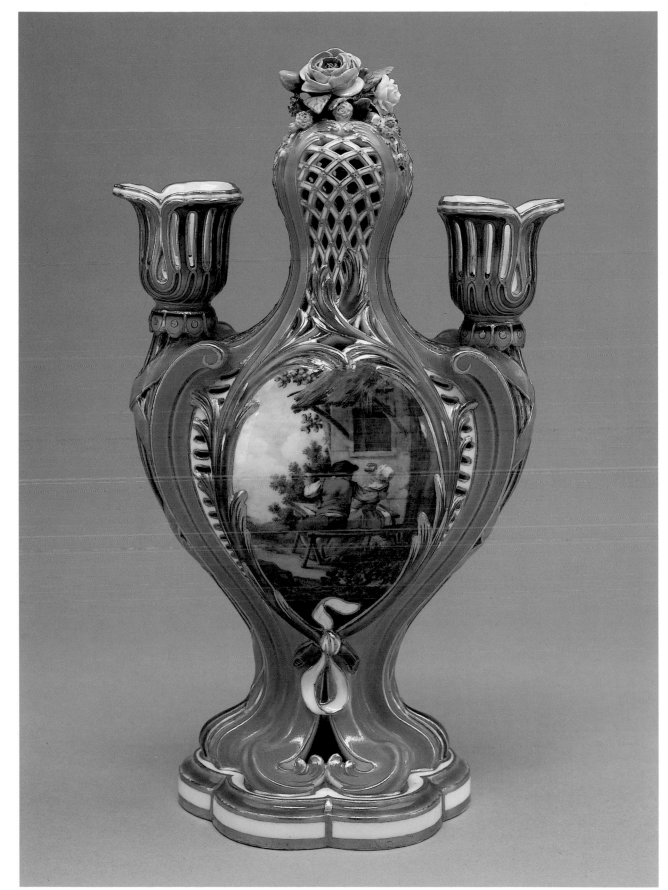

Vase .2

engraving entitled *IV^me Fête de village,* after a Teniers painting then in the collection of the duc de Praslin. A later version of this composition in the Sèvres archives bears an eighteenth-century inventory number; it was published by Jacques-Philippe Le Bas in 1751 (MNS D III, Teniers).

The scene of the standing couple painted on vase .1 was not commonly repeated at Sèvres. A similar couple is, however, painted on the front of one of a pair of *pots pourris à bobèches,* dated 1759 (New York, Metropolitan Museum of Art; see below); the painter is unknown. Similar standing figures were painted by André-Vincent Vielliard on one of a pair of *vases hollandois nouveaux* dated 1759 (San Marino, Huntington Art Collections).[11]

A scene of a couple seated on a bench very similar to that on the front of vase .2 is painted on one of a pair of *pots pourris à bobèches,* circa 1759, sold at auction in 1895 and 1910 (see below), but the painter is unknown. This scene was commonly repeated by various Sèvres painters. Sometimes it was expanded to include additional figures seated around a table, and sometimes the couple was shown leaning back to the left rather than to the right. Vielliard painted this scene on a *plateau à tiroir* dated 1759 (Cambridge, Fitzwilliam Museum C.20A-1961), and on a *vase à compartiments* dated 1760 (London, Wallace Collection C228). Antoine Caton painted it on one of a garniture of three *cuvettes à tombeau* and on one of a pair of *cuvettes Courteille,* all dated 1760 (Wallace Collection C205, C208). Jean-Louis Morin painted it on a *cuvette à tombeau* dated 1760 (British Royal Collection);[12] on a *cuvette à fleurs Verdun* dated 1760, sold at auction in 1941;[13] on a *cuvette Courteille* dated 1762 (Northamptonshire, Boughton House); and on one of a pair of *cuvettes Courteille* dated 1763, on the London art market in the 1970s.

The Sèvres sales records from about 1760 on, in comparison to those of the 1750s, provide fewer details that allow one to identify the shapes, ground colors, and decoration of vases sold. On May 30, 1760, a pair of *pots pourris à bobèches* "en Trois Couleurs" was sold for 360 *livres* each.[14] The pair was part of a garniture with a similarly decorated *vase vaisseau* (now in the Musée du Louvre, Paris; see entry for no. 10 below) and the Getty Museum's pair of *pots pourris fontaine* (no. 11). They were all decorated with pink, green, and dark blue (*bleu lapis*) panels and painted with chinoiserie figure scenes by Dodin. The garniture was purchased by Mme de Pompadour, along with a similarly decorated pair of Sèvres porcelain wall lights, and was installed in the Hôtel Pompadour, Paris.[15] During the annual December sale of Sèvres porcelain held at Versailles in 1760, Louis XV purchased four "Vazes holandois Et à Bobèches" with pink and green grounds for 360 *livres* each.[16] All four presumably had painted reserves with figure scenes. The *pots*

pourris à bobèches were to form a garniture with a *pot pourri fontaine* sold to the king at the same time, and the *vases hollandois nouveaux* were to form a garniture with another, single, example included in the same sale. It is possible that the recorder hesitated over the correct description of four *pots pourris à bobèches*—and indeed four matching examples are known (see below)—but this seems unlikely. The price of 360 *livres* for a *vase hollandois* decorated with pink and green grounds and Teniers scenes is confirmed in the sales records by a pair given by the factory to the *controleur général* in December 1760.[17]

In June 1762 Mme de Pompadour purchased a pair of *pots pourris à bobèches* (referred to above) with decoration described as "verds, chinois" for 336 *livres* each.[18] They formed a garniture with a pair of *pots pourris à feuillages* now in the Walters Art Gallery, Baltimore (48.590-591) and a porcelain clock, which is either the example in the Musée du Louvre (OA.10899)[19] or, more probably, that sold at auction in 1988.[20] Another garniture that included a pair of *pots pourris à bobèches,* apparently also decorated with the light turquoise-blue (*petit vert*) ground and Dodin-style chinoiserie figures and flowers, is listed in the factory's sales records.[21] It was sold to Louis XV at the Versailles sale in December 1762, and the *pots pourris à bobèches* must have been slightly more elaborately decorated than Mme de Pompadour's since they cost 360 *livres* each. The garniture also contained three *pots pourris triangles* (also known as *pots pourris Choisy*), two of which are in the Detroit Institute of Arts (Dodge Collection 71.242-243). Another pair of *pots pourris à bobèches* were listed in the Sèvres factory's list of unsold wares in the Magasin de Vente after the end of 1773. They are described as having "chinois" decoration and were given a reduced value of 240 *livres* each.[22]

Mme de Pompadour's two garnitures including *pots pourris à bobèches* are listed in the inventory of her possessions, taken after her death in 1764. The set decorated with three ground colors, purchased in 1760, was in her bedroom in the Hôtel Pompadour[23] and was sold at auction in Paris in 1784 from the collection of the dealer Mme Legère.[24] The *pots pourris à bobèches* have not been recorded since then. The garniture decorated with *petit vert* ground, purchased in 1762, was sold at auction from the collection of the duc de Praslin in 1793.[25] In the catalogue the *pots pourris à bobèches* were described as "deux girandoles garnies de leurs bobéches découpés à jour, dont une est entièrement cassée" (two candelabra fitted with their candleholders of pierced work, one of which is entirely broken). This pair is in the Edmond de Rothschild collection, as is the pair from Louis XV's similarly decorated garniture, purchased in December 1762. Louis XV's pair was exhibited in London in 1862 when in the collection of William Goding, was sold in 1874,[26] and has been thought in the past to be Mme de Pompadour's pair.[27] The 1874 catalogue illustrates the more elaborate of

the two pairs in the Rothschild collection, however, surely Louis xv's. This also explains why Christie's in 1874 did not describe one vase as being badly damaged, as had been noted of Mme de Pompadour's in 1793.

At least fifteen examples of the *pot pourri à bobèches* are known, either in modern collections or from auction sales. The Museum's pair are the only examples known that are decorated with pink and green grounds and painted with Teniers figure scenes on their fronts and with landscapes on their backs. Four *pots pourris à bobèches* with pink and green grounds are known (dated 1759), but they are decorated by unknown painters with Teniers figure scenes on their fronts and with colored flowers in a white reserve on their backs. These four, which one would like to associate with Louis xv's purchase in December 1760, are now split into two pairs. One pair is in the Metropolitan Museum of Art (formerly in the Hillingdon collection, 58.75.94–95);[28] the other pair was sold at auction in 1895 and in 1910.[29] The *bobèches* of the latter pair have been replaced with gilt-bronze torsos and heads of putti; its present whereabouts are unknown.

A pair decorated with green and dark blue (*bleu lapis*) grounds and painted with Teniers figure scenes, circa 1760, are in a private collection in Illinois.[30] They form a garniture with a *cuvette Mahon* (see entry for no. 14 below); they are not, however, recognizable in the factory's documents. William Goode evidently owned a vase of this model (or possibly a pair) that had no *bobèches* (either by accident or by design). It had no ground color and was painted with flowers. The vase was illustrated in 1889, but its present whereabouts are unknown.[31] Another pair with pink and green grounds, dated 1759 and painted with putti on the front panels and with flowers and fruit on the backs, were exhibited in London in 1862.[32] They were subsequently sold at auction in 1902[33] and are probably the same pair offered at auction in 1986.[34] The latter vases are of eighteenth-century porcelain but have nineteenth-century decoration.

PROVENANCE: [Duveen Brothers, New York]; J. Pierpont Morgan, New York; J. Pierpont Morgan, Jr., New York (sold, Parke Bernet, New York, March 25, 1944, lot 647); Paula de Koenigsberg, Buenos Aires, 1945; Claus de Koenigsberg, Buenos Aires; [Rosenberg and Stiebel, New York, 1975]; J. Paul Getty, 1975.

EXHIBITIONS: The Metropolitan Museum of Art, New York, 1914–1915, on loan from J. Pierpont Morgan, Jr. *Exposición de obras maestras: Colección Paula de Koenigsberg,* Museo Nacional de Bellas Artes, Buenos Aires, October 1945, no. 206. *El arte de vivir en Francia del siglo XVIII,* Museo Nacional de Arte Decorativo, Buenos Aires, September–November 1968, no. 427.

Plaster model for the *vase pot pourri à bobèches.* Manufacture Nationale de Sèvres, Archives.

BIBLIOGRAPHY: P. G. Konody, "Die kunsthistorische Sammlung Pierpont Morgans," *Kunst und Kunsthandwerk,* no. 6 (1903), p. 158 (ill.); X. de Chavagnac, *Catalogue des porcelaines françaises de M. J. Pierpont Morgan* (Paris, 1910), no. 107; Wilson 1977, pp. 5–24; P. Ennès, "Essai de réconstitution d'une garniture de Madame de Pompadour," *The Journal of the Walters Art Gallery* 42–43 (1984–1985), pp. 70–82; Sassoon and Wilson 1986, p. 76, no. 166; L. Roth, in *J. Pierpont Morgan, Collector,* exh. cat. (Wadsworth Atheneum, Hartford, 1987), p. 203.

1. S.L., I.7, October 1, 1759 (for January–September 1759), fols. 7, 8 (valued at 24 *livres* each).
2. MNS Archives, 1814 Inventory, "Vase Flambeau", 1740–1760, no. 2 (one, height 26 cm).
3. B.K.R., July 27, 1759, fol. 134/132.
4. B.K.R., September 24, 1759, fol. 137/135.
5. G.K.R., December 29, 1759, fol. 5; May 24, 1760, fol. 10/9; August 14, 1761, fol. 14 (two).
6. S.L., I.7, 1761 (for October–December 1759 and 1760), fol. 16.
7. S.L., I.7, 1763 (for 1762), fol. 16; 1764 (for 1763), fol. 19; 1765 (for 1764), fol. 18; 1766 (for 1765), fol. 19; 1770 (for 1769), fol. 19.
8. For example, on a pair dated 1756 and on another pair dated 1757 (London, Wallace Collection C246–247, C249–250).
9. Ennès (see Bibliography), pp. 79–80.
10. Cordey 1939, p. 187, no. 2274.
11. Wark 1961, fig. 111 (top shelf, left).
12. De Bellaigue 1979, no. 90.
13. Collection of Mrs. Henry Walters, Baltimore (sold, Parke Bernet, New York, April 23, 1941, lot 652); ex-coll. Duke of Leeds, Hornby Castle, Yorkshire; sold to H. Symons, London; French and Company, New York, 1925 (JPGC French and Co. Archives, stock no. 13716).
14. S.R., Vy3, fol. 18v.
15. Cordey 1939, p. 59, no. 380.
16. S.R., Vy3, fol. 43v.
17. Ibid., fol. 46r.
18. Ibid., June 25, 1762, fol. 115v.
19. See Ennès (Bibliography) for a complete account of this garniture.
20. Christie's, Monaco, December 4, 1988, lot 49.
21. S. R., Vy3, fol. 114r.
22. S.L., I.8, 1774 (for 1773), fol. 40.
23. See above (note 15); P. Ennès, in *Nouvelles acquisitions du département des objets d'art, 1980–1984,* exh. cat. (Musée du Louvre, Paris, 1985), pp. 132–135.
24. Paris, December 15–17, 1784, lot 152. Information supplied by Jean-Dominique Augarde.
25. Paris, February 18, 1793, lot 338; see Ennès (Bibliography), pp. 79, 82, n.36.
26. *Special Loan Exhibition of Works of Art,* exh. cat. (South Kensington Museum, London, 1862), nos. 1412, 1413. Christie's, London, March 19, 1874, lot 99.
27. Ennès (Bibliography), pp. 79, 82, n.35.
28. Dauterman (1964, nos. 37a–b) incorrectly describes the ground colors as *rose Pompadour* and turquoise-blue. This error is repeated in Eriksen and de Bellaigue 1987, p. 320, no. 133, and is corrected by C. Le Corbeiller, in *A Guide to the Wrightsman Galleries at the Metropolitan Museum of Art* (New York, 1979), p. 46.
29. Collection of William J. Goode, London, deceased (sold, Christie's, London, July 17, 1895, lot 192); T. W. Waller, Esq., deceased (sold, Christie's, London, June 7 et seq., 1910, lot 173, to Partridge).
30. Undated; see *Antiques* 125 (March 1984), p. 528.
31. E. Garnier, *La Porcelaine tendre de Sèvres* (Paris, 1889), pl. xxxv.
32. London 1862 (note 26), nos. 1298, 1299 (lent by T. Baring, Esq., M.P.).
33. Collection of George Hibbert, Esq. (sold, Christie's, London, May 2, 1902, lot 33).
34. Christie's, London, October 6, 1986, lot 246, unsold.

10 Lidded Potpourri Vase

(vase *or* pot pourri vaisseau, deuxième grandeur)

Circa 1760
Sèvres manufactory, soft-paste porcelain; painting on front panel attributed to Charles-Nicolas Dodin

HEIGHT 37.5 cm (1 ft. 2¾ in.); WIDTH 34.8 cm (1 ft. 1¹¹⁄₁₆ in.); DEPTH 17.4 cm (6¹³⁄₁₆ in.)

MARKS: Painted in blue underneath with the factory mark of crossed L's (partly abraded); no incised marks.

75.DE.11

DESCRIPTION: The oval, boat-shaped vase is set on four scrolled feet and has a grotesque mask modeled with flowing hair and a mustache at each end. From each mask's open mouth emerges the tapered end of a bowsprit. The concave rim of the vase is pierced with fourteen circular holes, and the tall lid is elaborately pierced in imitation of rigging and furled sails. From the fluted masthead falls a long pennant modeled in folds and terminating in two points.

The exterior is decorated with two ground colors. A pink (*rose*) ground covers most of the body of the vase; the remaining areas feature broad, scrolling panels of green (*vert*) ground. On the front is a lobed reserve painted in colors with a rustic figure scene; a drunken man sits on the ground, supported by another man, and a standing woman scolds him. The white reserve on the back is painted with fruit (including crabapples, apples, and cherries) and flowers (including anemones, pink campanulas, cornflowers, a pink rose, and a parrot tulip).

Bands of thickly applied burnished gilding highlight the modeling of the feet, the molded masks, the piercing on the vase and lid, the rigging and sails, the pennant, and the knop. The pennant is decorated with gilded fleur-de-lys, partly matt, partly burnished. The bands of green ground are bordered by lines of gilding, half matt, half burnished, tooled with a zigzag line separating the different surfaces.

CONDITION: The vase and lid are unbroken, and their decorated surfaces are unworn. In some areas the pink ground has yellowed slightly where it has come into contact with the gilding. There are lines of firing weakness between the legs and within the rims of both the vase and the lid. At four places inside the rim of the vase, these firing cracks are concealed by gilded and tooled sprays of flowers and leaves.

The mast is slanted. On the underside of the pennant there is a long, shallow chip. The undersides of the feet were ground during manufacture to make the vase stand firmly.

COMMENTARY: The *vase* or *pot pourri vaisseau* was produced in two sizes at Sèvres; the Museum's example is of the smaller, second size.[1] A plaster model for this shape survives in the archives of the Sèvres factory.[2] As Svend Eriksen has shown, one half of this model displays the proportions of the first size, while the other half displays those of the second size.[3] It has the remains of an elaborate furled sail on its mast, as opposed to the pennant seen on known examples, and it does not incorporate the base with scrolled feet. Eriksen, Marcelle Brunet, and Geoffrey de Bellaigue have pointed out that this shape, probably designed by Jean-Claude Duplessis, was derived from an unlidded vase with a similar body and a flat base, called a *cuvette à masques*.[4] The earliest known *cuvette à masques*, dated 1754, is at Houghton Hall, Norfolk.[5] By 1756 the shape was being produced with scrolled feet;[6] an example dated 1757 is in the Wallace Collection, London (C225). These feet are of the same design as those employed on the *pot pourri vaisseau*. Similarly, the masks at each end of the *cuvette* are identical to those on the *vaisseau*, though they lack bowsprits.

The *cuvette*'s body, without the feet, also formed the basis for a shape of lidded tureen on a separate stand, the *terrine gondole*; two examples dated 1757 are in the Hofburg Palace, Vienna.[7] The *terrine gondole* has a scrolled handle at each end rather than a grotesque mask. The same body set on scrolled feet (introduced late in 1756) and fitted with a very elaborate pierced superstructure and flowered lid was produced as the *pot pourri gondole* during 1756. The two earliest surviving examples, which are dated 1756, were formed with separate feet (New York, Metropolitan Museum of Art 58.75.88a–c;[8] Leningrad, State Hermitage).[9] Examples survive with the scrolled feet incorporated; they are dated 1757 (Wallace Collection C248; Philadelphia Museum of Art 39.41.37).[10]

The *pot pourri vaisseau* was produced in the first size from 1757, and in the second size from 1759. The latter first appears in the factory's stock list of 1760 for work carried out during 1759.[11] The plaster model and mold are listed for the second size, while no mention is made of a larger size. The model is actually described as of the third size, but this is surely an error.[12] As Brunet has noted, the next new model and mold relating to the *pot pourri vaisseau* are recorded in the stock list of new work created during 1761.[13] They are for a "Pied du vaisseau 2ᵍʳ" (foot of a *vaisseau* of the second size) and no doubt relate to the new neoclassical-style base. An example with this base, dated 1761, is at Waddesdon

Manor (see below). In the same stock list there was also one "pot pourri Vaisseau" of unspecified size valued at 60 *livres* in the Magasin du Blanc; it was also listed there after the end of 1763 and 1764.[14] The biscuit and glaze kiln records show a "pot poury En Navire," which was surely of the first size, in October 1758.[15] One "pot poury à Vaisseau" is listed in the biscuit kiln records of July 1759.[16] One example seems to be noted in the glaze kiln records in December 1759, though the entry is unclear.[17] At least one additional example emerged from the glaze kiln on December 31, 1761, when eleven "Pots pouris à feuillages Et à Vaisseau" are listed.[18]

The scene painted on the front reserve of the Museum's *vase vaisseau* is based on engravings of *fêtes flamandes* by Jacques-Philippe Le Bas after paintings by David Teniers the Younger. Two such engravings in the archives at Sèvres show drunken men on the ground. One, entitled *La Quatrième Fête flamande* has on its reverse a drawing in ink of the drunken character painted on the Museum's vase (MNS D III, Teniers). Carl Christian Dauterman has attributed the ink drawing to the Sèvres painter Charles-Nicolas Dodin.[19] Gillian Wilson has shown that the painting on the Museum's *pot pourri vaisseau* is very close in style to another version of this scene signed by Dodin.[20] (Figures drinking and dancing were often added on the right if the shape of the space to be decorated required such lengthening.) The scene discussed by Wilson appears on a *cuvette Courteille* dated 1760 in the Musée Jacquemart-André, Paris (D.1170); it is the only known version signed by Dodin. The style of the painting on the Museum's vase also compares closely with that on the Museum's *pots pourris à bobèches* (no. 9), dated 1759 and marked by Dodin.

The same scene was also depicted on several other pieces of Sèvres porcelain between 1759 and 1769 by the painters André-Vincent Vielliard, Jean-Louis Morin, and Antoine Caton, and it is possible that one of them painted the present example. Wilson has identified nine versions of this scene on other pieces of Sèvres,[21] to which five more may be added. Two examples are dated 1759: one of a pair of unsigned *cuvettes à tombeau* with green ground (Northamptonshire, Boughton House, Rainbow Room; height 14.6 cm) and a *cuvette à tombeau* by Morin with pink and green grounds (Metropolitan Museum of Art 1976.155.37; height 18.5 cm).[22] The scene also appears on a *vase hollandois nouveau* attributed to Vielliard with pink ground overlaid with patterns in blue, circa 1761–1762 (Sussex, Firle Place; height 23.5 cm);[23] on a *cuvette Courteille* of 1764 signed by Morin (one of a pair with dark blue ground), on the London art market in the 1980s; and on a *vase hollandois* also signed by Morin (Detroit Institute of Arts 71.251).[24] Two other *pots pourris vaisseau* decorated with Teniers scenes on their front reserves are known (see below). The flower painting on the back of the Museum's vase is of very high quality, though possibly by another hand.

Only four *pots pourris vaisseau* are identifiable in the Sèvres factory's sales records. On December 30, 1758, at Versailles the prince de Condé purchased one with a pink ground, painted with children, for 1,200 *livres*.[25] At the December 1759 sale at Versailles Madame de Pompadour purchased one example with dark blue and green grounds ("saffre et verd")[26] painted with a Teniers scene for 960 *livres*.[27] One with three ground colors was sold for cash to an unnamed purchaser (acting on behalf of Mme de Pompadour) on May 30, 1760, for 720 *livres*.[28] The latter example was purchased as part of a garniture along with a pair of *pots pourris fontaine* (no. 11 below) and a pair of *pots pourris à bobèches* (of the same model as no. 9 above). Another unnamed purchaser bought a *vaisseau* with a green ground on September 11, 1762, for 720 *livres* as part of a garniture with a pair of *vases à éléphants*.[29]

Pots pourris vaisseau appear in two other contemporary documents; the inventory of Mme de Pompadour's possessions made after her death in 1764, and the sale of the possessions of her brother, the marquis de Marigny, after his death in 1781. In the 1764 inventory of Mme de Pompadour's *hôtel* in Paris, the *vaisseau* with three ground colors is recorded as being in her bedroom (see below and no. 11), and another *vaisseau* is listed as being in the Château de Saint-Ouen.[30] The catalogue of the auction of Marigny's possessions held in Paris in February 1782 lists "Un vase en forme navire, de meme porcelaine de Sèvre, à cartouche fond bleu et fleurs naturelles, de 17 pouces de haut sur 14 de long" (A boat-shaped vase, of the same Sèvres porcelain, with a blue ground and natural flowers in reserves, 45.9 cm high by 37.8 cm wide).[31] No known example fits this description, though Savill has pointed out that a nineteenth-century Minton porcelain copy at Elton Hall, Cambridgeshire, may be based on Marigny's now-lost *pot pourri vaisseau*.

Five *vaisseaux* of each size are known to have survived, including the present example. Those of the first size include the one originally purchased by the prince de Condé (see above), now in the Metropolitan Museum of Art;[32] an example dated 1758 with dark blue and green grounds, painted with a Teniers scene, originally sold to Mme de Pompadour (see above), now in the British Royal Collection;[33] and an example dated 1761 with turquoise-blue ground, painted with a military scene, now at Waddesdon

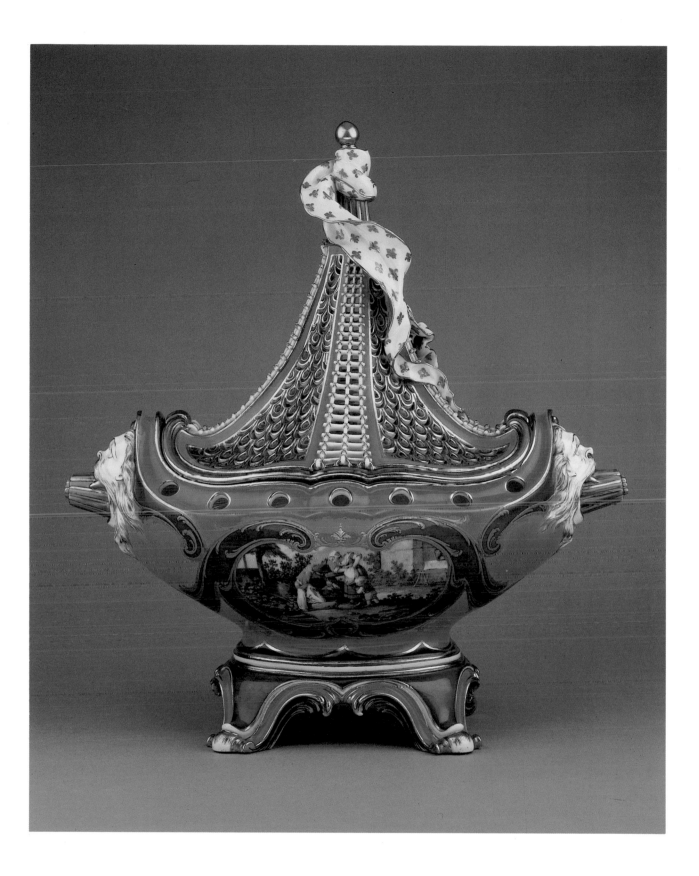

Manor.[34] Two undated examples with dark blue and green grounds, painted with birds, survive; one, datable to 1761, is in the Wallace Collection (C256), the other, datable to 1759, is in the Frick Collection, New York.[35]

Surviving examples of the second size, in addition to the Museum's vase, include a *pot pourri vaisseau* datable to 1760 with dark blue, green, and pink grounds, painted with chinoiserie figures, originally purchased on behalf of Mme de Pompadour (see above) and now in the Musée du Louvre, Paris.[36] An example dated 1761 with a light turquoise-blue (*petit vert*) ground, painted with a dock scene and set on a neoclassical-style base with architectural features, is at Waddesdon Manor.[37] An example dated 1764 with dark blue ground, painted with a dock scene, is in the Walters Art Gallery, Baltimore (48.559); it lacks porcelain feet and is set on gilt-wood scrolled feet of later date.[38] An undated example, circa 1761, with dark blue ground, painted with a Teniers scene, is also at Waddesdon Manor.[39]

The Museum's vase cannot be identified in the Sèvres documents. In 1874, however, it was sold at auction in London by the seventh Earl of Coventry from his estate of Croome Court in Worcestershire. Croome Court as it exists today was built by the sixth Earl of Coventry (d. 1809), who employed Robert Adam to design its interiors in the 1760s.[40] After the end of the Seven Years' War in 1763, Coventry did not wait long before visiting Paris.[41] On a visit in September of 1763 he purchased some furniture, including a *secrétaire en armoire* by Bernard van Risenburgh and a newly fashionable neoclassical *commode à la grec,* both from the *marchand-mercier* Simon-Philippe Poirier, whose bills survive at the Croome estate office. Coventry also ordered the famous *Tentures de Boucher* tapestries during this visit; they are now in the Metropolitan Museum of Art.[42] He returned to Paris with his new wife in 1765 and 1766, purchasing a *bureau [plat] à la grec* by the *ébéniste* René Dubois from Poirier in 1765.[43] It seems very possible that on one of these visits to Poirier's shop he purchased the Museum's *pot pourri vaisseau.* The Sèvres sales records show that Poirier's regular purchases from the factory included many unspecified vases ("pièces d'ornemens") at prices equivalent to that which the Museum's example would have commanded. For example, after June 1762 he purchased one vase for 600 *livres* and another for 840 *livres.*[44] Between October 1, 1763, and January 1, 1764, he also purchased individual vases costing 600 *livres* and 720 *livres.*[45]

In the nineteenth century and until 1944, the Museum's vase was considered part of a garniture along with a pair of *vases hollandois.* Though also decorated with pink and green grounds and painted with Teniers scenes, the *vases hollandois* have a different pattern of green ribbons and husks over the pink ground. These vases, dated 1759 but bearing no painter's mark, are now in the Museum of Fine Arts, Boston

(65.1799–1800).[46] It is possible that they were sold to the Earl of Coventry as a garniture with the Museum's vase, but it seems improbable that these pieces were intended to form a group since their decoration does not quite match. In the auction of 1874 the first Earl of Dudley paid 10,000 guineas for the Museum's vase along with the pair of *vases hollandois,* and they became well known as the "Coventry Garniture." There is a photograph of the garniture in Dudley House, circa 1880.[47] In 1885 or 1886 the Dudley family sold the garniture privately to the collector William J. Goode. Such was its celebrity, however, that the Countess of Dudley insisted that an exact copy of the vases be made before she parted with them, probably more for the sake of appearances than for the love of the vases. The Minton copies are now in an English private collection (illus.).[48]

The model was copied in England by the Flight and Barr factory in Worcester as early as about 1795.[49]

PROVENANCE: (?)6th Earl of Coventry, Croome Court, Worcestershire; 7th Earl of Coventry, Croome Court, Worcestershire (sold, Christie's, London, June 12, 1874, part of lot 150, for 10,000 gns.); 1st Earl of Dudley, Dudley House, Park Lane, London, 1874 (sold privately, 1885/86); William J. Goode, London (offered for sale, Christie's, London, July 17, 1895, part of lot 147, bought in for £8,400; sold, Christie's, London, May 20, 1898, part of lot 94b, to Pilkington for £6,450); [Asher Wertheimer, London, 1898]; [Duveen Brothers, New York]; J. Pierpont Morgan, New York, 1908/10 (purchased for £15,500); J. Pierpont Morgan, Jr., New York, 1913 (sold, Parke Bernet, New York, January 8, 1944, lot 486); Paula de Koenigsberg, Buenos Aires, 1945; Claus de Koenigsberg, Buenos Aires; [Rosenberg and Stiebel, New York, 1975]; J. Paul Getty, 1975.

EXHIBITIONS: The Metropolitan Museum of Art, New York, 1914–1915. *Exposición de obras maestras: Colección Paula de Koenigsberg,* Museo Nacional de Bellas Artes, Buenos Aires, October 1945, no. 205. *El arte de vivir en Francia del siglo XVIII,* Museo Nacional de Arte Decorativo, Buenos Aires, September–November 1968, no. 427.

BIBLIOGRAPHY: G. Redford, *Art Sales 1628–1887,* vol. 1 (1888), pp. 400, 438 (from the *Daily News,* May 21, 1886); X. de Chavagnac, *Catalogue des porcelaines françaises de M. J. Pierpont Morgan* (Paris, 1910), no. 109; F. Litchfield, "Imitations and Reproductions: Part I—Sèvres Porcelain," *Connoisseur* (September 1917), p. 6; G. Reitlinger, *The Economics of Taste,* vol. 2 (London, 1963), pp. 582–585; Dauterman 1964, p. 195; Wilson 1977, pp. 5–24; Wilson 1983, no. 29;

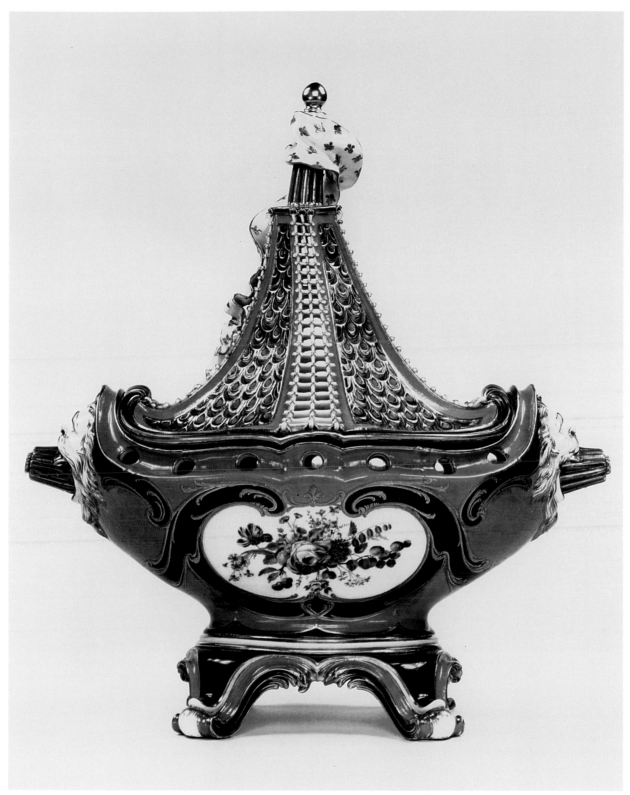

Back view

Detail of lid

Detail of base

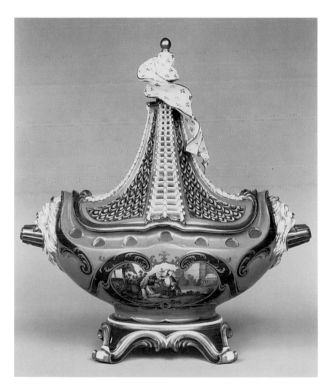

Minton copy of the *vase vaisseau,* circa 1885

P. Ennès, *Nouvelles Acquisitions du département des objets d'art, 1980–1984,* exh. cat. (Musée du Louvre, Paris, 1985), p. 135; J. Plumb, "The Intrigues of Sèvres," *House and Garden* (U.S.A.) (January 1986), pp. 44–54; Sassoon and Wilson 1986, p. 77, no. 167; L. Roth, in *J. Pierpont Morgan, Collector,* exh. cat. (Wadsworth Atheneum, Hartford, 1987), p. 34, fig. 8, pp. 162, 203; Savill 1988, pp. 55, n. 44, 117, n. 25, 192, 196, n. 3h.

1. Surviving examples of the first size range in height from 43.9 to 44.5 cm; those of the second size, from 37 to 38.9 cm.
2. MNS Archives, 1814 Inventory, "Vaisseau à mât," 1740–1780, no. 12 (height 37.0 cm, width 40.5 cm, depth 21.0 cm).
3. Eriksen 1968, p. 136.
4. Ibid.; Brunet, in Brunet and Préaud 1978, p. 66; De Bellaigue 1979, p. 62.
5. S. Eriksen, "Rare Pieces of Vincennes and Sèvres Porcelain and a New Source for the Study of the Manufacture Royale," *Apollo,* no. 87 (January 1968), pp. 34–38.
6. De Bellaigue 1979, p. 101.
7. Eriksen and de Bellaigue 1987, p. 307, no. 120.
8. Parker 1964, pp. 199–201, no. 35.
9. This example is now missing its feet, and it is possible that it never had any.
10. Dauterman 1964, pp. 199–201; De Bellaigue 1979, pp. 65–66, no. 59; Eriksen and de Bellaigue 1987, p. 309, no. 122.
11. S.L., I.7, October 1, 1759 (for January–September 1759), fols. 7–8 (valued at 36 *livres* each).
12. De Bellaigue 1979, p. 62.
13. S.L., I.7, 1762 (for 1761), fols. 6, 7 (valued at 15 *livres* each); see also Brunet and Préaud 1978, p. 70.
14. S.L., I.7, 1762 (for 1761), fol. 17; 1764 (for 1763), fol. 19; 1765 (for 1764), fol. 18 (again valued at 60 *livres*).
15. B.K.R., October 16, 1758, fol. 121/119; G.K.R., October 18, 1758, fol. 94.
16. B.K.R., July 27, 1759, fol. 134/132.
17. G.K.R., December 29, 1759, fol. 5.
18. G.K.R., December 31, 1761, fol. 17. The "pots pouris à feuillages" may have been of the shape known as *pot pourri myrthe;* a pair dating from 1761–1762 (Baltimore, Walters Art Gallery 48.590–591) have a light turquoise-blue (*petit vert*) ground, as does the *vase vaisseau* dated 1761 now at Waddesdon Manor (see below). The Baltimore vases are probably the

pair with *petit vert* ground sold to Mme de Pompadour
on June 25, 1762 (S.R., Vy3, fol. 115v), along with a *pendule*
(now in the Musée du Louvre, Paris) and a pair of *pots
pourris à bobèches* (see entry for no. 9); all were decorated with
petit vert ground and chinoiserie painting (see also P. Ennès,
"Essai de réconstitution d'une garniture de Madame de
Pompadour," *The Journal of the Walters Art Gallery* 42–43
[1984–1985], pp. 70–82). It is conceivable that these, along
with the *vaisseau* at Waddesdon, were among the eleven vases
listed in the glaze kiln records for December 31, 1761.

19. C. C. Dauterman, "Sèvres Figure Painting in the Anna
Thompson Dodge Collection," *Burlington Magazine* 118
(November 1976), pp. 753–762.

20. Wilson 1977, figs. 13, 14.

21. Ibid., pp. 23–24, nn. 12a–i. The following information can be
added to these notes: 12d is a *cuvette Courteille;* 12e is a *cuvette
à tombeau;* 12f was sold as part of a garniture with two *cuvettes
Mahon,* including the Getty Museum's example (no. 14
below); 12g is a *cuvette Courteille;* 12i is a *cuvette Courteille*
(Wallace Collection C209).

22. See Dauterman 1970, no. 86.

23. See Savill 1985, no. 405.

24. The central vase of a garniture of three *vases hollandois.* The
garniture has a turquoise-blue (*bleu céleste*) ground; Dauterman
(note 19) describes it as green (fig. 36, caption) and as
turquoise-blue (p. 758). He states that the same scene is
painted on a Sèvres porcelain tabletop illustrated in G.
Savage, *Seventeenth- and Eighteenth-Century French Porcelains*
(London, 1960), pl. 62B, but the latter is completely different.

25. S.R., Vy2, fol. 78r.

26. The term *saffre* describes a dark blue ground similar to *bleu
lapis,* which was used with other ground colors. Eriksen
notes that it withstood high firing temperatures (Eriksen and
de Bellaigue 1987, p. 52).

27. S.R., Vy3, fol. 7v.

28. Ibid., fol. 18v.

29. Ibid., fol. 100r.

30. Cordey 1939, p. 39, no. 380.

31. See Ennès (Bibliography), p. 135.

32. Dauterman 1964, no. 32.

33. De Bellaigue 1979, no. 55.

34. Eriksen 1968, no. 48.

35. Brunet 1974, pp. 224–232.

36. Ennès (Bibliography), pp. 132–135.

37. Eriksen 1968, no. 49.

38. See Brunet and Préaud 1978, p. 166, no. 125.

39. Eriksen 1968, no. 50.

40. Standen 1964, pp. 3–6.

41. H. Hayward and P. Kirkham, *William and John Linnell*
(London, 1980), pp. 103–106.

42. Standen 1964, pp. 7–57.

43. Hayward and Kirkham (note 41).

44. S.R., Vy3, fol. 92v.

45. Ibid., fol. 139v.

46. They were sold at auction in 1944 in a separate lot from the
Museum's vase; see also P. T. Rathbone, *The Forsyth Wickes
Collection* (Boston, 1968), pp. 29–30.

47. National Monuments Record, negative no. BB 70/3941. I
thank Frances Buckland for this information.

48. Plumb (see Bibliography), pp. 44–54.

49. H. Sandon, *Flight and Barr Worcester Porcelain, 1783–1840*
(Woodbridge, 1978), p. 47.

11 *Pair of Vases*
(pots pourris fontaine ou à dauphins)

1760
Sèvres manufactory; soft-paste porcelain; painting attributed to Charles-Nicolas Dodin

HEIGHT 29.8 cm (11¾ in.); WIDTH 16.5 cm (6½ in.); DEPTH 14.6 cm (5¾ in.)

MARKS: One vase painted in blue underneath the central section with the factory mark of crossed L's. No incised marks.

78.DE.358.1–2

DESCRIPTION: The tall, lidded vase is made in three parts: a base with holes, a tall central section with pierced shoulders, and a pierced lid. Each lobed panel of the base has a large hole, circular in the four side lobes and lozenge-shaped in the front and back. The central section fits into the base; its sides are concave, and the domed shoulder is pierced in imitation of canework lattice. The six-lobed lid is pierced with tapered ovals and surmounted by a knop modeled as a carnation with buds and leaves. The underside of each of the base sections has a kiln suspension hole.

These vases are decorated with panels of three different ground colors: pink (*rose*), dark blue (*bleu lapis* or *saffre*), and green (*vert*). The lower section of the base is pink, the middle panel is dark blue, and the molded area imitating water and the shoulder above are green. Four of the concave sides of the central section are painted with a green ground with tall foliate panels of pink. The two large panels at the front and back are painted in colors in a chinoiserie style over the white glaze. The fronts are painted with Chinese women and children in exotic gardens. Each of the back panels is painted with loose bunches of stylized flowers and fruits.

Lines of thick, burnished gilding highlight the modeling of the shape and the edges of the pierced areas. The waterlike modeling on the base section is thickly gilded, and the panel of dark blue beneath is overlaid with gilding in an elaborate trellis pattern. The tall foliate panels of pink ground on the central section are edged and highlighted with lines of burnished gilding.

CONDITION: These vases are in excellent condition, except for the lids. Lid .1 has been broken into four pieces and restored; lid .2 has a hairline crack. There are some minor scratches in the glaze on the shoulders of the base sections. The undecorated part of the central section of vase .1 that fits inside the base section was made too large and has been slightly ground at its sides. The lids do not fit neatly. It is probable that the vases were originally supplied with porcelain dolphins that fit into the lozenge-shaped holes in the base section; if so, they are missing.

COMMENTARY: This shape, the *pot pourri fontaine ou à dauphins,* was made at Sèvres in only one size. The name was derived from the shape of the vase, which resembles a fountain, and from the porcelain dolphins that were inserted into the base. The lower section was designed to contain flowering bulbs growing out of the four circular holes. These could be watered through the two lozenge-shaped holes, which were fitted with porcelain dolphins as stoppers. Though the dolphins are mentioned in a description of the Museum's vases written in 1764, they are not mentioned in a description published in 1784, nor subsequently (see below). Vases of this shape were also supplied with porcelain flowers on gilt-bronze stems, which could be placed in the circular holes when no bulbs were growing. The tall, pierced central section would have contained potpourri.

This model was first produced in 1759, and the design is attributed to Jean-Claude Duplessis *père*. In the stock list of work carried out during the first nine months of 1759 the plaster model and mold for this shape are listed as "Pot pourri à Dauphin";[1] the model survives in the archives of the factory (illus.).[2] A different model of vase with dolphins on its base, called the *vase à dauphins,* was in production from 1756. A pair dated 1756 is in the Wallace Collection, London (C215–216).[3] This model is difficult to distinguish from the *pot pourri fontaine ou à dauphins* in the factory's documents. For example, a "Vaze Dauphin" listed in the glaze kiln records of January 1756 is surely of the Wallace model.[4] The October 1759 stock list records a model and mold for the lid of a "vaze à Dauphin pour en faire un Pot pourry,"[5] which was surely a lid for a *vase à dauphins,* pierced to form a potpourri container. No such examples are known to have survived, but in January 1765 Louis XV purchased one "Couvercle de Vaze à Dauphins" for 24 *livres;*[6] whether it was a lid for a *pot pourri* like the Museum's or for a *vase à dauphins* cannot be determined. In the biscuit kiln records for July 1759 one "pot poury à dauphins," probably of the same model as the Museum's vases, is listed (in the same firing with one *vase vaisseau* and one *pot pourri à bobèches*).[7] The stock list compiled after the end of 1760 records two "pots

pourris à Dauphin en fontaine" in the Magasin du Blanc, valued at 60 *livres* each.[8] One example is listed in the same state in each of the following two years.[9]

The Museum's vases, along with the other five elements of the garniture from which they come, are the only known examples of Sèvres porcelain of this date to display three different ground colors. By 1758 the factory had begun to produce wares combining green (*vert*) and dark blue (*bleu lapis*) grounds.[10] From 1759 quantities of objects were produced combining the green and pink (*rose*) grounds, though they were not sold in large numbers until the December 1760 sale at Versailles (see entry for no. 8 above). Also in 1759 the factory began to use a dark blue ground called *saffre,* rather than *bleu lapis,* in combination with green.

Ronald Freyberger has shown that the Museum's vases are part of a small group of wares dating from 1760 to 1763, all painted in a distinctive famille rose-type palette with similar chinoiserie figure scenes.[11] Some are marked by the painter Charles-Nicolas Dodin, and the remainder are attributed to him.[12] The rarity of these wares could be explained in part by the fact that perhaps only Dodin was painting them. Tamara Préaud has proposed that Dodin may have derived this style of painting from examples of Chinese export porcelain in contemporary French collections. Most of the pieces in this group are, like the Museum's examples, painted in a muted range of colors, generally on a white background. Préaud has also suggested that Dodin based his figures on chinoiserie engravings after designs by François Boucher.[13] The figures also resemble those seen in engravings by Petrus Schenk.

These wares were not the first, or the last, examples of chinoiserie figure painting produced at Vincennes and Sèvres. Possibly the earliest are a *gobelet* of about 1745–1750 and a *pot de chambre* of about 1750, both painted in colors (the *gobelet* with no gilding), now in English private collections. The chamber pot's chinoiserie decoration is based on that of Meissen wares painted by J. G. Heroldt, whereas the *gobelet* is decorated in a contemporary French manner. Around 1750 the chinoiserie engravings after Boucher served as the inspiration for pink monochrome (*camaïeu rose*) decoration on wares such as a series of *seaux à bouteilles ordinaires,* a pair of which are in the Musée National de Céramique, Sèvres (MNC 16058.1–2),[14] and one of which is in the National Gallery of Victoria, Melbourne (D5/1976).[15] Gabriel Huquier's engravings of François Boucher's five chinoiserie Senses were the source for Dodin's painting on a pair of *vases à éléphants* dated 1760, possibly sold to Madame de Pompadour in 1762.[16] Painted in a contemporary French manner, they are now in the Walters Art Gallery, Baltimore (48.1796–1797). A *gobelet litron* dated 1773, with-

out a painter's mark, is painted in colors with chinoiserie figures more reminiscent in style of the *gobelet* of circa 1745 mentioned above (London, Victoria and Albert Museum, D. M. Currie Bequest, c.393-1921). Hard-paste Sèvres porcelain of the late 1770s displays more tightly painted chinoiserie decoration in harsher colors, for example, a pair of *vases bouc du Barry B* dated 1778 painted with Chinese naval battles, formerly at Althorp House, Northamptonshire,[17] and a pair of *vases Duplessis* dated 1779 painted with figures, now in the British Royal Collection.[18] The figure painting is totally different in style from Dodin's work of the early 1760s. Depictions of stylized oriental fruit and flowers similar to those painted on the back of the Museum's vases are found on other wares in this group.

The Sèvres sales records list only three examples of *pots pourris fontaine ou à dauphins.* On May 30, 1760, a pair were sold for cash to an unnamed purchaser.[19] They cost 480 *livres* each, and their decoration was described as "en Trois Couleurs." The two vases formed a garniture with a similarly decorated *vase vaisseau* (illus.) costing 720 *livres* and a pair of *pots pourris à bobèches* that cost 360 *livres* each (see entries for nos. 9, 10 above). The Museum's vases can be identified as this pair. The sales records also show that an example of this

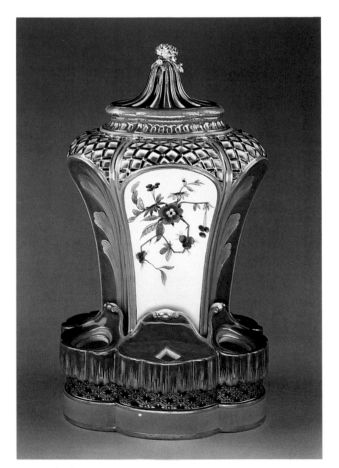

Vase .1, back view

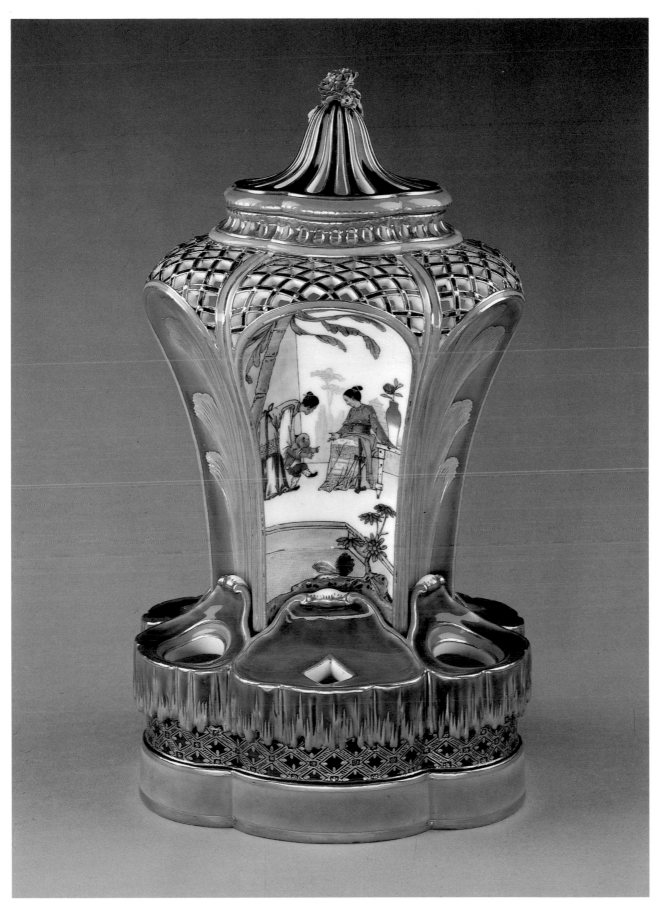

Vase . 1

model with pink and green grounds was bought by Louis XV in December 1760 at Versailles for 480 *livres*.[20] It is not known to have survived.

The garniture that included the Museum's vases can be identified in the inventory of Mme de Pompadour's possessions taken after her death in 1764. The five vases, along with a pair of similarly decorated Sèvres porcelain wall lights (*bras de cheminée*) (illus.), are listed as being in her Paris *hôtel*.[21] The vases were described as "une garniture de cheminée de cinq pieces de porcelaine de France, couleur de roze, verd et bleu lapis, à cartouche chinois, composé d'un vaisseau, deux pots pourris à dauphins et deux vases à deux bobêches. Prisés neuf cents livres" (a mantlepiece set of five pieces of Sèvres porcelain, colored pink, green, and dark blue, with chinoiserie reserves, consisting of a *vaisseau*, two potpourri vases with dolphins, and two vases with two candleholders. Valued at 900 *livres*). The *vase vaisseau* and the pair of wall lights are now in the Musée du Louvre, Paris,[22] but the *pots pourris à bobèches* are not known to have survived. The complete garniture was sold at auction from the collection of the dealer Mme Legère in Paris in 1784 (with no mention of the dolphin stoppers, however),[23] but by the mid-nineteenth century it had been separated. The 1764 inventory of Mme de Pompadour's collection at the Château de Saint-Ouen lists another pair of vases of this model, which probably formed a garniture with a *vase vaisseau* that she purchased in 1759 (see entry for no. 10 above).[24]

Three other *pots pourris fontaine ou à dauphins* are known. Rosalind Savill has identified a pair, dated 1759, in the collection of the Duke of Buccleuch at Boughton House, Northamptonshire.[25] They have dark blue and green grounds, and their front panels are painted in colors with Teniers scenes by Dodin. Savill has shown that these vases were probably the ones in Mme de Pompadour's collection at Saint-Ouen.[26] A single example, circa 1760, in the British Royal Collection, also has dark blue and green grounds, and the front panel is painted in colors with a putto.[27] The backs of these three vases are painted with flowers. The vase in the Royal Collection retains one of its porcelain dolphin stoppers, partly gilded with scales highlighted over the white. The vase is set on a gilt-bronze base supported by a ring of dolphins, which was added before it came to England in 1827. The Boughton vases have similar bases as well as gilt-bronze dolphin stoppers, all thought to have been copied from the Royal Collection vase by E. H. Baldock, circa 1827–1830.[28] The lozenge-shaped holes on the Royal Collection vase are unglazed, whereas on the Museum's vase they are glazed and highlighted with a band of gilding.

Even though this decoration would have been concealed by the stoppers, it appears from the inventory of Mme de Pompadour's collection that the vases originally had porcelain dolphins.

PROVENANCE: Marquise de Pompadour, Hôtel Pompadour, Paris, 1760–1764; Mme Legère, Paris (sold, Paris, December 15–17, 1784, part of lot 152); (?)Grace Caroline, Duchess of Cleveland (married the 6th duke 1815, died 1883); William Goding, before 1862 (sold, Christie's, London, March 19, 1874, lot 100, to [E. Rutter, Paris], for the Earl of Dudley, for £6,825); William Humble, 1st Earl of Dudley (offered for sale, Christie's, London, May 21, 1886, lot 194, bought in for £2,625, returned to Dudley House, London); Sir Joseph C. Robinson, Bt., Dudley House, London, circa 1920 (purchased with the contents of the house); Dr. Joseph Labia (son-in-law of Sir Joseph C. Robinson), London (sold, Sotheby's, London, February 26, 1963, lot 23); [The Antique Porcelain Company, London and New York, 1963]; Nelson Rockefeller, New York, 1976/77; the Sloan-Kettering Institute for Cancer Research, New York, 1976/77; the J. Paul Getty Museum, 1978.

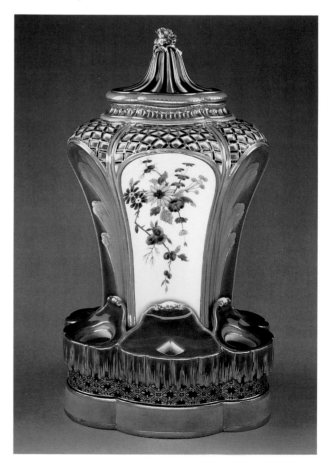

Vase .2, back view

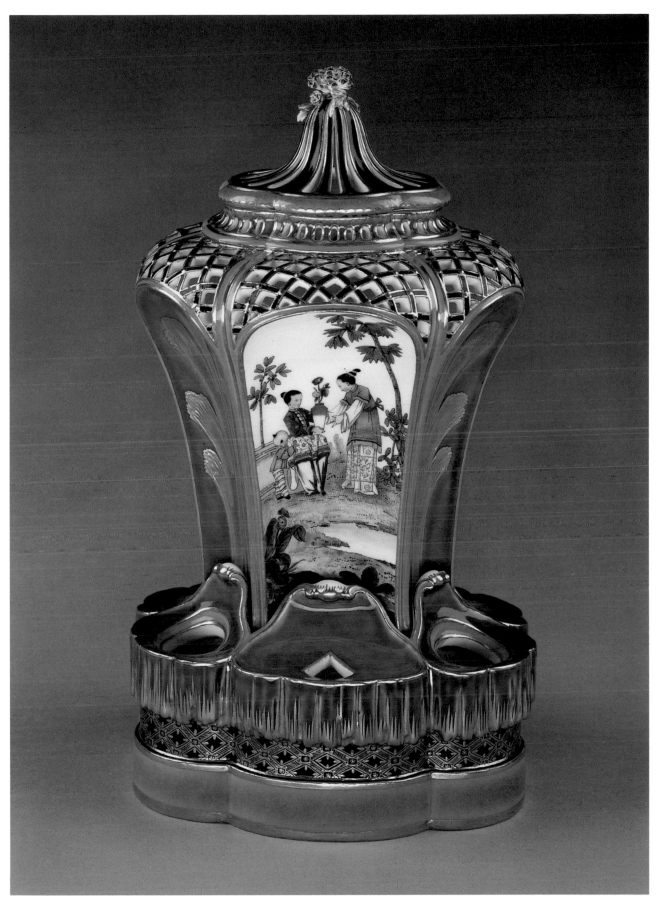

Vase . 2

EXHIBITIONS: *Special Loan Exhibition of Works of Art,* The South Kensington Museum, London, June 1862, nos. 1281, 1282, lent by W. Goding; *Louis XV and Madame de Pompadour: A Love Affair with Style,* Dixon Gallery and Gardens, Memphis, Tennessee, March 11–April 15, 1990, and Rosenberg and Stiebel, New York, May 3–June 15, 1990, no. 57 (one).

BIBLIOGRAPHY: G. Redford, *Art Sales 1628–1887,* vol. 1 (1888), pp. 193, 440; Cordey 1939, p. 59, no. 380; G. Reitlinger, *The Economics of Taste,* vol. 2 (London, 1963), pp. 582–583, 586; R. Freyberger, "Chinese Genre Painting at Sèvres," *American Ceramic Circle Bulletin,* no. 1 (1970–1971), pp. 29–44; Brunet and Préaud 1978, p. 68, pl. XXII (one); Wilson 1978–1979, pp. 44–45, no. 8; R. Savill, "Two Pairs of Sèvres Vases at Boughton House," *Apollo,* no. 110 (August 1979), pp. 128–133; M. Jarry, *Chinoiserie* (New York, 1981), p. 120 (detail of one vase); Wilson 1983, pp. 56–57, no. 28; P. Ennès, in *Nouvelles Acquisitions du département des objets d'art, 1980–1984,* exh. cat. (Musée du Louvre, Paris, 1985), pp. 132–135; Savill 1985, 397–398; Sassoon and Wilson 1986, pp. 78–79, no. 168; Savill 1988, pp. 29, 31, n. 75, 68, n. 29, 192, 197, nn. 14c, 17, 24.

1. S.L., I.7, October 1, 1759 (for January–September 1759), fols. 7, 8 (valued at 30 *livres* each).
2. MNS Archives, 1814 Inventory, "Vase fontaine à oignons," 1740–1780, no. 30 (height 32.5 cm, width 19 cm, depth 16.5 cm).
3. See Brunet and Préaud 1978, p. 50, pl. XI; Préaud and Faÿ-Hallé 1977, p. 142; de Bellaigue 1979, p. 93; Savill 1985, pp. 462–463; Eriksen and de Bellaigue 1987, no. 103, pp. 290–291.
4. G.K.R., January 15, 1760, fol. 7/8.
5. S.L., I.7, October 1, 1759 (for January–September 1759), fols. 58, 61 (as dating from 1755).
6. S.R., Vy4, January 25, 1765, fol. 56r.
7. B.K.R., July 27, 1759, fol. 134/132.
8. S.L., I.7, 1761 (for October–December 1759 and 1760), fol. 15.
9. Ibid., 1762 (for 1761), fol. 16; 1763 (for 1762), fol. 15.
10. Eriksen and de Bellaigue 1987, p. 52.
11. Freyberger ([Bibliography], pp. 29–44) states that the wares are marked only with date letters from 1761 and 1763, then demonstrates that the Museum's vases date from 1760.

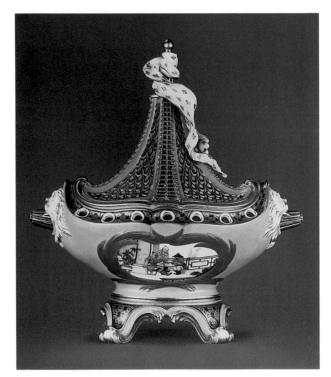

Pot pourri vaisseau, circa 1760. Sèvres manufactory, soft-paste porcelain, painting attributed to Charles-Nicolas Dodin. Paris, Musée du Louvre OA.10965.

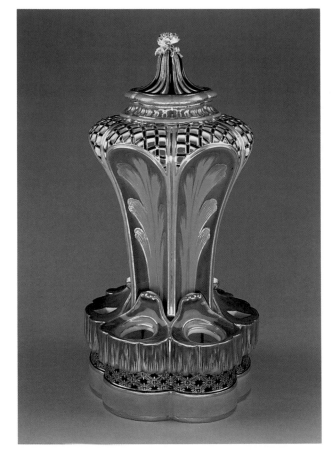

Vase .1, side view

12. Other known examples not listed by Freyberger (ibid.) are
 the miniature *gobelet Bouillard et soucoupe* that probably
 formed a *déjeuner carré* with a *plateau carré* (fig. 1), sold to
 Mme de Pompadour in 1762 (S.R., Vy3, June 25, 1762, fol.
 117r; sold, Sotheby's, Mentmore Towers, Buckinghamshire,
 May 24, 1977, lot 2052; now in Copenhagen, C. L. David
 Collection 14/1977); and a pair of *pots pourris à bobèches* with
 petit vert ground, which were probably part of a garniture
 sold to Mme de Pompadour in 1762 (collection of William
 Goding [sold, Christie's, London, March 19, 1874, lot 99
 (ill.)]; present location unknown); see also entries for no. 9
 and no. 10, note 18, above]. The pair of *vases hollandois
 nouveaux* illustrated by Freyberger (fig. 3) were sold from the
 collection of John Cockshut, deceased (Christie's, London,
 March 11, 1913, lot 64, to the dealer Harding).
13. See P. Jean-Richard, *L'Œuvre gravé de François Boucher dans la
 collection Edmond de Rothschild,* exh. cat. (Musée du Louvre,
 Paris, 1978), nos. 1125–1133, esp. no. 1129; examples
 from this series survive at Sèvres (MNS Archives, B 1, B 16).
14. See Préaud and Faÿ-Hallé 1977, nos. 246–247.
15. See M. Legge, in *Decorative Arts from the Collections of the
 National Gallery of Victoria* (Melbourne, 1980), p. 47.
16. S.R., Vy3, February 7, 1762, fol. 115r.
17. Eriksen and de Bellaigue 1987, p. 331, no. 142.
18. De Bellaigue 1979, no. 38.
19. S.R., Vy3, May 30, 1760, fol. 18v.
20. Ibid., December 1760, fol. 43v.
21. Cordey 1939, p. 39, nos. 379–380 (in the bedroom; the seven
 pieces were valued at 1,100 *livres*).
22. See Brunet and Préaud 1978, pl. XXIII; Ennès (Bibliography),
 pp. 132–135; Eriksen and de Bellaigue 1987, pp. 320–321,
 no. 134.
23. Paris, December 15–17, 1784, lot 152; information supplied
 by Jean-Dominique Augarde.
24. Cordey 1939, p. 96, no. 1311 (the three pieces were valued at
 230 *livres*).
25. Savill 1979 (Bibliography), pp. 128–133; Savill 1985, no. 397.
26. Savill 1979 (Bibliography); de Bellaigue 1979, no. 55.
27. De Bellaigue 1979, no. 97.
28. Savill 1979 (Bibliography), pp. 128–133; Savill 1985, no. 397.

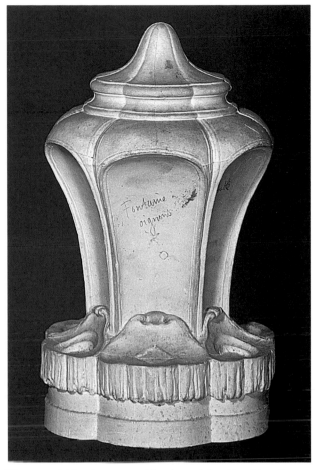

Plaster model for the *pot pourri fontaine ou à dauphins.* Manufacture Nationale de Sèvres, Archives.

Pair of *bras de cheminée,* circa 1760. Sèvres manufactory, soft-paste porcelain. Paris, Musée du Louvre OA.11027–11028.

12 Pair of Lidded Chestnut Bowls (marronnières à ozier)

Circa 1760
Sèvres manufactory; soft-paste porcelain

HEIGHT 13.4 cm (5¼ in.); WIDTH 27.0 cm (10⅗₆ in.); DEPTH 21.1 cm (8⅝₆ in.)

\dot{J} FR

MARKS: Bowl .1 incised underneath with the *répareur's* marks *J* and FR. No painted marks.

82.DE.171.1–2

DESCRIPTION: Each lidded oval chestnut bowl (*marronnière*) is fixed to its stand. The walls of both the bowl and the stand are pierced to create a pattern of interlocking chevrons wound with ribbons. Near the base of the bowl is a molding modeled with a wound binding. The outer border of the lid is similarly pierced. The interior of lid .1 is lightly incised with the outlines of ribbons wound through the chevrons. Each stand and lid has a kiln suspension hole underneath.

Each *marronnière* is decorated with turquoise-blue (*bleu céleste*) ground color on the areas imitating ribbons, around the rims, and on the wound bands at the base. The flattened dome of each lid is painted in colors with an oval trail of flowers and leaves.

Lines of brightly burnished gilding outline the rims, chevrons, and ribbons. Slashes of gilding accentuate the modeling of the handles.

CONDITION: Both chestnut bowls are in very good condition, with little wear to their decorated surfaces. The thin porcelain edges of the stands almost cracked in places during firing. These weak areas were held together by the glaze, which has gathered thickly in some corners of the piercing. On the rim of stand .2 there is a section about 1 cm in length that has been broken and repaired.

COMMENTARY: This shape of pierced basket was designed for serving roasted, and sometimes also sugared, chestnuts.[1] The bowls were generally sold singly, though they were also sold in pairs as part of dinner and dessert services. Several types of *marronnières* were designed at Sèvres in 1757 and 1758.[2] The Museum's bowls are of the shape known as the *marronnière à ozier,* for which two plaster models and molds are listed in the 1759 stock list under new work of 1758.[3] The shape was produced in one size. The plaster models and molds for this shape have not survived. The biscuit kiln records list several *marronnières* during 1758 and 1759; for example, in August 1758 a "maronnière forme pomp[r] [Pompadour]" with a separate *plateau*, and a "maronnière forme oval," also with a separate stand.[4] *Marronnières* with separate *plateaux* are listed on several occasions, and these are of a different model from the Museum's examples.[5] In a biscuit kiln firing of September 1759 three *marronnières* are listed without separate *plateaux,* perhaps indicating that they were fired as one piece.[6] In 1758 the glaze kiln records list one *marronnière* with a separate *plateau* and a "Platteau de Maronnière" on its own.[7] One "Maronnière tenant au plateau" appears in the glaze kiln records of February 1759,[8] and thereafter many are listed without separate stands.[9]

The factory's stock list of October 1, 1759, records one "Maronnière Pleine et ptteau [*plateau*]" (perhaps with an unpierced body) in the Magasin du Blanc; it was valued at 15 *livres*.[10] At the same time there were nine "Maronnière[s] à Jour" (with pierced bodies) and stands in the same state; they were valued at 24 *livres* each.[11] Their higher value reflects the added cost of piercing the porcelain walls, which was very laborious. In the stock list of 1761 one "Maronnier" was recorded as glazed but needing to be passed through the glaze kiln again; it too was valued at 24 *livres*.[12] In the same stock list four examples were recorded as glazed and awaiting decoration; they were valued at 18 *livres* each.[13] This indicates that various types of chestnut baskets and bowls were in production in the late 1750s and early 1760s. The stock lists also give the prices of finished examples in the factory's Magasin de Vente. In the list of wares produced during 1758 there were two "Marronniers" valued at 300 *livres* each, and one at 360 *livres*.[14] Three similarly priced examples, probably the same ones, were listed on October 1, 1759.[15] In the stock list of 1761 thirty-one examples, valued at 120, 144, 168, 192, 216, and 240 *livres* each, were recorded as being in the Magasin de Vente,[16] suggesting that the factory was either producing *marronnières* in much greater quantities than before or having difficulty selling them.

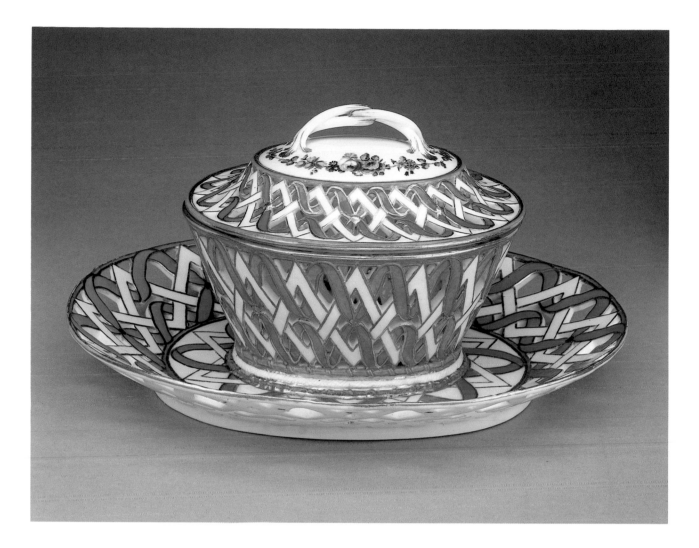

The *marronnière à ozier* is the most common model of Sèvres chestnut basket known, and it seems probable that the others were produced in limited numbers by comparison. The lids of the Museum's *marronnières* differ slightly from those of most known examples. They have a solid, flat central panel, painted with flowers, whereas most others are pierced over their entire surface. The lids of a pair at Longleat House, Wiltshire (see below), are similarly modeled; their flat panels are, however, undecorated. The handles of the lids of the Museum's examples are also unusual, having a double loop design rather than being modeled as bound canework. An interesting Sèvres porcelain dish sold at auction in 1965 is of the same form as the *plateau* for this model of *marronnière*. It has a similar pierced rim and panels of pink ground but is more than one inch wider than the stands of the Museum's examples.[17]

The Sèvres factory's sales records list more than fifty *marronnières* between 1758 and 1770 but specify only one pair with *bleu céleste* decoration; the bowls cost 168 *livres* each and were part of a dinner service sold in 1769 to a M. Boffauer.[18] This appears to have been the minimum price for *marronnières* decorated with a ground color. An example with a dark blue (*bleu lapis*) ground was sold for the same price to Madame de Pompadour at Versailles in December 1760.[19] A pair with a green ground, possibly painted with flowers, were sold for 168 *livres* each to M. Delaborde as part of a dinner service in July 1761.[20] Two pairs of *marronnières* with unspecified decoration, also costing 168 *livres* each, are listed in the sales records; one pair was sold for cash in September 1762,[21] and another was part of a dinner service purchased in March 1771 by the Ministry of Foreign Affairs.[22]

Marronnières were in production at Sèvres through the 1760s and were sold for prices ranging from 108 to 360 *livres* each. The decoration of those sold for 108 *livres* was not recorded,[23] but the majority of *marronnières* were sold for 120 *livres,* and their decoration was variously described as of painted flowers[24] or "filets bleus" (blue lines).[25] These examples were clearly not decorated with ground colors,[26] nor were the various examples sold for 144 *livres* each.[27] The latter were decorated with painted flowers[28] or "filets d'or" (gold lines),[29] except for one sold in 1758, which was described as "mediocre," probably a damaged example decorated with a ground color.[30] *Marronnières* decorated with "lapis" (dark blue) ground,[31] "lapis caillouté" (dark blue overlaid with gilded pebbles),[32] green ground,[33] as well as examples with blue lines,[34] and others painted with flowers,[35] were priced at 192 *livres* each. An example with unspecified decoration was sold for 216 *livres,*[36] while the pair decorated with a blue *mosaïque* pattern, included in the service given

by Louis XV to Elector Karl Theodor of Bavaria in 1760, cost 240 *livres* each.[37] Examples decorated with a pink ground are listed at 300, 336, and 360 *livres* each.[38] Some *marronnières* decorated with a green ground, for example, the pair included in the service given by Louis XV to Empress Maria Theresa of Austria, were also sold for 360 *livres* each.[39]

It appears that *marronnières* with decoration typical of the 1760s were still in the factory's Magasin de Vente in 1774. The stock list for that year includes one example decorated with pink ground, which was reduced in price to 192 *livres,* since it was then somewhat out of fashion.[40] In the same stock list there were four examples decorated with green and pink grounds, reduced in price to 168 *livres* each, as well as one example with "filet bleu" decoration, reduced to 120 *livres. Marronnières* also appear in the sales records of the late 1760s with unusually low prices of 84 and 96 *livres* each.[41] They were probably seconds.

The factory's sales records also list at least four "couvercles pour Maronnières" (covers for *marronnières*), which were presumably ordered as replacements for broken ones. One with unspecified decoration was sold to Tesnières in October 1761 for 42 *livres.*[42] In December 1763 Louis XV purchased a cover at Versailles, again with unspecified decoration, for 30 *livres.*[43] The king purchased two more covers for use at Versailles in 1773, both decorated with "filets bleu"; they cost 30 *livres* each.[44] One of Mme de Pompadour's *marronnières,* recorded in the Château de Saint-Ouen after her death, was described as "découpée" (broken). It was decorated with *bleu lapis* panels.[45] A similarly decorated example was among her possessions at Versailles,[46] and one of these was perhaps the one she purchased in 1760 for 168 *livres* (see above). The example decorated with a green ground that she purchased in 1760 does not appear in the inventory of her collection.

At least seventeen *marronnières à ozier,* including the Museum's examples, are now in known collections. The pair at Longleat House (see above) are similarly decorated with a turquoise-blue ground. Another example with turquoise-blue decoration, dated 1759, is in the Wallace Collection, London (C473). An example with turquoise-blue decoration was sold at auction in 1871 and again in 1881.[47] It is not the Wallace example, which entered that collection by 1872.[48] An undated pair with a green ground are in the collection of the Duke of Buccleuch at Boughton House, Northamptonshire. Four green-ground examples from the Duke of Parma's service are now in the Palazzo del Quirinale, Rome.[49] The pair presented by Louis XV to Karl Theodor are in the Residenz Museum, Munich, but the pair presented to Maria Theresa are not known to have survived. A pair with pink

and green ground panels, circa 1760, are in the Wadsworth Atheneum, Hartford (1917.1011).[50] A pair of similar description were sold from Lord Gwydir's collection in 1829,[51] and a similar single example was sold at auction in 1868.[52] Two *marronnières* with blue highlighting, each dated 1759, are known; one is in the Wadsworth Atheneum (1917.1010), and the other is in a private collection, Massachusetts.[53] Two similar examples with blue highlighting (possibly the very same ones) were sold at auction, one in 1882,[54] the other in 1869 and again in 1881.[55] In the same sale in 1869, of Lord Ashburton's collection, there was a *marronnière* with a dark blue ground; its present location is unknown.[56] An example painted with several colors, dated 1787, was in the Chappey collection, Paris, in 1905; its present whereabouts are also unknown.[57]

Copies of this shape made by the Meissen factory are at Chatsworth House, Derbyshire, and in the Art Institute of Chicago (1967.703).

Detail of stand

PROVENANCE: Swiss art market, 1980; [Armin B. Allen, New York, 1980]; the J. Paul Getty Museum, 1982.

BIBLIOGRAPHY: Wilson, Sassoon, and Bremer-David 1983, pp. 48–52; Sassoon and Wilson 1986, p. 79, no. 169; Savill 1988, pp. 759, 761, n. 4f, 762, n. 29.

1. G. de Bellaigue, in *J. Pierpont Morgan, Collector,* exh. cat. (Wadsworth Atheneum, Hartford, 1987), p. 171.

2. S.L., I.7, 1758 (for 1757), fols. 6, 7 ("maronnière à Compartimens" and "marronnière unie"); 1759 (for 1758), fol. 6 ("maronnière Contourné").

3. Ibid., 1759 (for 1758), fols. 6, 7 (valued at 5 *livres* each for the bowl and 4 *livres* each for the stand).

4. B.K.R., August 8, 1758, fol. 116/114.

5. B.K.R., August 8, 1758, fol. 117/115 (one); October 16, 1758, fol. 121/119 (one); December 9, 1758, fol. 124/122 (one); March 28, 1759, fol. 130/128 (one).

6. B.K.R., September 24, 1759, fol. 137/135.

7. G.K.R., October 18, 1758, fols. 94, 95/103.

8. G.K.R., February 12, 1759, fol. 97/105.

9. G.K.R., July 30, 1759, fol. 101/109 (four); October 1, 1759, fol. 3 (ten); May 24, 1760, fol. 8 (seventeen).

10. S.L., I.7, October 1, 1759 (for January–September 1759), fol. 18.

11. Ibid.

12. S.L., I.7, 1761 (for October–December 1759 and 1760), fol. 13.

13. Ibid., fol. 17.

14. S.L., I.7, 1759 (for 1758), fol. 27.

15. Ibid., October 1, 1759 (for January–September 1759), fol. 22.

16. Ibid., 1761 (for October–December 1759 and 1760), fol. 23.

Lid

17. Sotheby's, London, May 4, 1965, lot 100.

18. S.R., Vy4, December 1769, fol. 194v.

19. S.R., Vy3, December 1760, fol. 45v.

20. Ibid., July 10, 1761, fol. 58v.

21. Ibid., September 1, 1762, fol. 99r.

22. S.R., Vy5, March 25, 1771, fol. 2r.

23. S.R., Vy3, October 1, 1763–January 1, 1764, fol. 149v (one to the dealer Bachelier); Vy4, December 1764, fol. 20v (one to Louis xv); Vy4, July–December 1764, fol. 26r (one to the dealer Mme Lair).

24. S.R., Vy3, December 18, 1760, fol. 28v; December 1760, fol. 45r (three to unnamed purchasers).

25. Ibid., December 31, 1761, fol. 86r (two to the comte de Durfort as part of a dinner service).

26. S.R., Vy3, October–December 1761, fol. 75v (three to the dealer Machard); October 4, 1762, fol. 111v (one for cash); December 31, 1763, fol. 156v (two to Louis xv's fourth daughter, Madame Victoire, at Versailles); October 1, 1763–January 1, 1764, fol. 145r (one to the dealer Poirier); October 1, 1763–January 1, 1764, fol. 147v (two to Mme Lair); Vy4, July–December 1765, fol. 59r (one to Poirier); July–December 1768, fol. 170r (one to the dealer Tesnières); Vy5, March 31, 1772, fol. 2r (one to the Ministry of Foreign Affairs as part of a dinner service); August 1, 1772, fol. 33r (one for cash).

27. Examples recorded without details of the decoration include S.R., Vy3, October–December 1761, fol. 71r (two to Poirier).

28. For example, S.R., Vy3, December 1759, fol. 7r (one to Louis xv); January 1–April 1, 1760, fol. 15r (two to Machard); July–December 1760, fol. 41v (one to the dealer Rouveau).

29. Ibid., January 1–April 1, 1760, fol. 10r (one to the dealer Dulac).

30. S.R., Vy2, December 14, 1758, fol. 74r (one to M. De Masières).

31. Ibid., December 30, 1758, fol. 83v (two to M. Defontspertuis).

32. S.R., Vy3, October 28, 1761, fol. 80v (two to the dealer M. Bonnet, as part of a dinner service).

33. S.R., Vy3, December 1760, fol. 45v (one to Mme de Pompadour at Versailles); Vy4, May 14, 1765, fol. 37v (two to M. Bonnet, acting on behalf of the Duke of Parma, Louis xv's son-in-law, as part of a dessert service).

34. S.R., Vy3, January 1–April 1, 1760, fol. 13r (one to the dealer Sayde).

35. Ibid., November 4, 1760, fol. 27v (one for cash).

36. S.R., Vy4, July–December 1766, fol. 102r (one to Sayde).

37. S.R., Vy3, April 1760, fol. 29r.

38. S.R., Vy2, December 1758, fol. 82v (one to Dulac); Vy2, December 1, 1758–January 1, 1759, fol. 81r (one to Lazare Duvaux's widow); Vy3, October–December 1760, fol. 2v (one to Mme Lair).

39. S.R., Vy3, January 1–April 1, 1760, fol. 9r (one to Poirier); Vy2, December 1758, fol. 85r (for Maria Theresa).

40. S.L., I.8, 1774 (for 1773), fol. 20 .

41. S.R., Vy4, July–December 1766, fol. 94v (two to Poirier); Vy4, January–June 1766, fol. 76r (one to Poirier); Vy4, July–December 1768, fol. 166r (one to Poirier).

42. S.R., Vy3, October–December 1761, fol. 77v.

43. Ibid., December 1763, fol. 156r.

44. S.R., Vy5, April 6, 1773, fol. 132v. One wonders whether it was the king himself who broke the lids. According to the Sèvres sales records of 1756, a cup was given at no charge to Duvaux "pour en remplacer un cassé entre les mains du Roi" (to replace one broken in the king's hands) (S.R., Vy1, January 1–August 20, 1756, fol. 136v).

45. Cordey 1939, no. 1304.

46. Ibid., no. 688.

47. Property of a gentleman (sold, Christie's, London, May 14, 1871, lot 83, to Bale for £13 10/-); Property of Charles Sackville Bale, Esq. (sold, Christie's, London, May 23 et seq., 1881, lot 1342, to Goode for £120 15/- [probably William J. Goode]). I am grateful to Frances Buckland for this information and the following references to examples in nineteenth-century Christie's auctions.

48. I thank Rosalind Savill for this information.

49. A. D'Agliano, "Alcune considerazioni sulle porcellane di Sèvres delle collezione reale italiane," *Bollettino d'arte,* no. 35–36 (January–March 1986), pp. 67–70, fig. 4; see also note 33 above.

50. De Bellaigue (note 1).

51. Collection of the late Lord Gwydir (Sir Peter Burrell, 1st baron) (sold, Christie's, London, March 11 et seq., 1829, lot 171, to Wertheimer for £155).

52. Anonymous collection (sold, Christie's, London, February 28, 1868, lot 153, to Whitehead for £23).

53. Collection of Major General Sir George Burns, North Mymms Park, Hertfordshire (sold, Christie's, September 26, 1979, lot 652). See Wilson, Sassoon, and Bremer-David 1983, p. 50, n. 68, where attention is drawn to the Morgan family relationship that links the provenance of this example with that of the example now in the Wadsworth Atheneum (see above).

54. Collection of Francis Leyborne Popham, Esq. (sold, Christie's, London, March 15 et seq., 1882, lot 291, to Wertheimer for £78 15/-).

55. Collection of the late Rt. Hon. Lord Ashburton (sold, Christie's, London, February 24, 1869, lot 54, to Bale for £27 6/-); Property of Charles Sackville Bale, Esq., Deceased (sold, Christie's, London, May 23 et seq., 1881, lot 1343, to Fisher for £21).

56. Collection of the late Rt. Hon. Lord Ashburton (sold, Christie's, London, February 24, 1869, lot 53, to Attenborough for £14 3/-).

57. F. Masson, "La Porcelaine de Sèvres, collection Chappey," *Les Arts* 38 (February 1905), p. 31 (ill.).

13 Three Plaques Mounted on a Jardinière

Circa 1760
Sèvres manufactory; soft-paste porcelain mounted in gilt bronze; possibly painted by Charles-Nicolas Dodin

HEIGHT 16.6 cm (6%6 in.); WIDTH 29.2 cm (11½ in.); DEPTH 14.3 cm (5⅝ in.)

MARKS: None

73.DI.62

DESCRIPTION: The three plaques are of *bombé* form with curved edges and are glazed on both sides. The two smaller plaques have the same asymmetrical outline but are formed as mirror images of each other to fit the sides of the *jardinière*. Each has a kiln suspension hole in the back.

The border of each plaque has a strong green (*vert*) ground. The reserve on the central plaque is painted in colors with a group of eight figures in an interior. The scene represents the writing of a marriage contract. The two side plaques have white reserves painted with groups of flowers and leaves. The flowers on the left plaque include an exotic tulip, yellow and pink roses, anemones, blue campanulas, and blue morning glories. Those on the right plaque include blue clematis, poppy buds, orange and white anemones, yellow roses, morning glories, campanulas, and blue primulas with yellow centers.

Gilding is applied over the green ground, framing the reserves with a broad matt band, tooled with a bright zigzag line set within a narrower burnished band, and gilded trails of bellflowers, tied above by gilded bows. The central plaque is also gilded at the right and left edges with matt leafy fronds, tooled with bright zigzag lines.

CONDITION: The plaques are unbroken. The glaze and traces of green ground that overlap some of the edges indicate that they have not been cut down from larger objects. Each plaque has been slightly ground on a wheel in two or three places to enable it to fit into the gilt-bronze mount. The painting is unscratched, but the gilding is worn away in places.

COMMENTARY: The biscuit kiln records for 1755 and 1756 contain references to *plaques Hébert,* which, as Rosalind Savill has noted, could describe the type found on this *jardinière*.[1] Since other models from Vincennes and Sèvres that are named after the porcelain dealer Thomas-Joachim Hébert are all of *bombé* shape, it is likely that a *plaque Hébert*

would also be. There seems to be no model, mold, or design relating to this shape in the Sèvres archives. Plaques first appear in the glaze kiln records in 1761, and then, and in subsequent years, their shapes are not specified.[2]

From their style of decoration it appears that the Museum's plaques were made around 1760 or shortly afterward, but they cannot be identified in the sales records. The style of the figure painting is very similar to that of Charles-Nicolas Dodin, who painted this scene on at least one other piece of Sèvres porcelain (see below). In the painters' overtime records for 1761 Dodin is recorded as having received 96 *livres* for painting "1 Tableau à personnages" (one tableau with figures), though perhaps this was a flat plaque to be framed as a painting.[3] In the early 1760s other plaques with green ground and reserves painted with figure scenes were being produced; the list of stock awaiting sale at the end of 1761 includes "3 Plaques verds Tesniers," valued at 192 *livres* each.[4]

The scene on the central plaque is based on an engraving after a painting by Jean-Baptiste Greuze called *The Marriage Contract*. It appears, with variations in the arrangement of the cupboard and bed, on at least three other pieces of Sèvres porcelain: a *cuvette Courteille* dated 1760 painted by Dodin, in the Metropolitan Museum of Art, New York (Gift of R. Thornton Wilson, 43.100.31); an *écritoire à globes* in a French private collection; and a vase in the collection of Sir Alfred Beit, Ireland. The painting on the plaque is very similar in style to that on the Museum's *vases pot pourri à bobèches* (no. 9), which are signed by Dodin.

No other plaques of this shape are known. It is likely that the *jardinière* was made for a Parisian *marchand-mercier*, who would have had the porcelain plaques mounted by a *bronzier*. The gilt bronze is of high quality, and the surfaces are finely chased. The only other known *jardinière* of this model is in a private collection in Paris. It has additional gilt-bronze swags and is veneered with tortoiseshell, possibly replacing broken porcelain plaques.[5]

The Museum's *jardinière* is clearly identifiable in the sale of Miss Botham's possessions at Christie's in 1817.[6] It was bought by the Earl of Yarmouth (who became the third Marquess of Hertford in 1822) but cannot be traced in the 1842 inventory of his residence, St. Dunstan's Villa,[7] or in the sale of its contents in 1855.[8] It was not in the collection of the earl's mother after her death in 1834.[9] The earl made many purchases at auction on behalf of George IV,[10] but this *jardinière* cannot be identified in the lists of deliveries to the royal household in 1817–1818.[11]

Central plaque

PROVENANCE: Miss Botham (sold after her death, Christie's, London, May 5 et seq., 1817, lot 96, to the Earl of Yarmouth [later 3rd Marquess of Hertford], for £61 10/-); private collection, Paris; [Gaston Bensimon, Paris, 1970s]; J. Paul Getty, 1973.

BIBLIOGRAPHY: Sassoon and Wilson 1986, p. 79, no. 170; Savill 1988, pp. 191, n. 18, 838, 841, n. 11.

1. B.K.R., March 12, 1755, fol. 37/35 ("4 Plaques hebert," of which two had to be refired); April 12, 1756, fol. 57/60 ("2 grandes plaques hebert"; both were broken during firing).

2. G.K.R., February 28, 1761, fol. 12; and, for example, August 31, 1762, fol. 19.

3. P.O.R., F.6, 1761, Dodin, fol. 5. Rosalind Savill has shown that this may refer to a plaque in the Metropolitan Museum of Art, New York (54.147.19).

4. Listed under "Pieces Extraordinaires" in the Magasin de Vente (S.L., I.7, 1762 [for 1761], fol. 36).

5. Seen by Gillian Wilson, Paris, 1978.

6. Information kindly supplied by Peter Hughes of the Wallace Collection.

7. W. Phillips, "St. Dunstan's Villa Inventory," May 1842 (Wallace Collection Library).

8. July 9 et seq., 1855 (Wallace Collection Library).

9. "Inventory of Effects of Manchester Square," 1834 (Wallace Collection Library).

10. For example, see George IV and the Arts of France, exh. cat. (Queen's Gallery, London, 1966), nos. 42, 49, 56.

11. B. Jutsham, "Ledgers of Furniture and etc. Received."

Side plaques

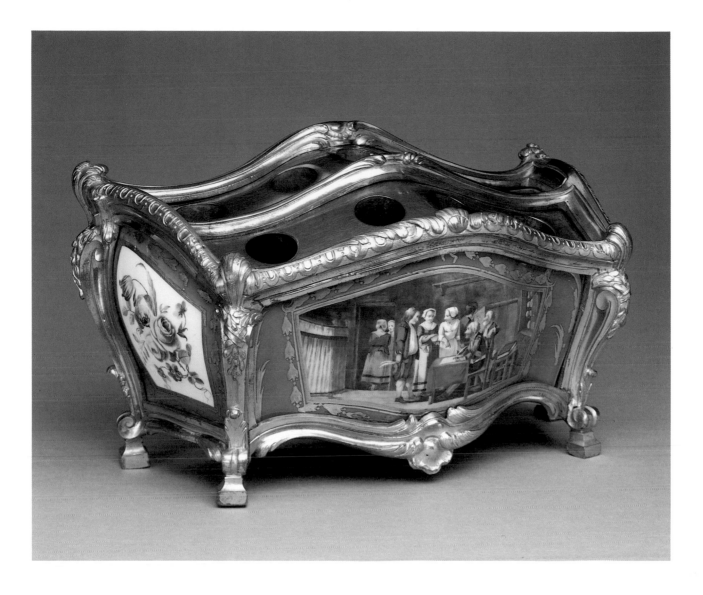

14 *Vase*
(cuvette Mahon, troisième grandeur)

1761
Sèvres manufactory; soft-paste porcelain; painted by Jean-Louis Morin

HEIGHT 15.0 cm (5⅞ in.); WIDTH 23.0 cm (9¹/₁₆ in.); DEPTH 11.9 cm (4¹¹/₁₆ in.)

MARKS: Painted in blue under one foot with the factory mark of crossed L's enclosing the date letter I for 1761, and with the painter's mark M. No incised marks.

.72.DE.65

DESCRIPTION: The open vase is composed of front and back walls of *bombé* form with narrow, curved and scrolled sides and an undulating rim. The cushion-shaped base rests on four scrolled feet.

The vase is decorated with a pink (*rose*) ground color bordered by dark blue (*beau bleu*) lines. On the front of the vase the pink ground is overlaid with a blue and gold trellis pattern. The sides are decorated with a *pointillé* pattern in the same colors, and the back, with a panel of *vermiculé* design over the ground. The colored reserve on the front panel is painted with a farmyard scene of fighting boys with women intervening.

Gilding highlights the molded contours of the vase and frames the painted reserve. This frame is tooled with inverted triangles, alternately matt and burnished. The gilding is applied over a ground of carmine when placed over the pink ground.

CONDITION: The vase is unbroken. The decorated surfaces have suffered some scratching and wear, and the gilding is worn in places. The pink ground was mistakenly not applied to the area enclosed by a scroll above the right rear foot.

COMMENTARY: The *cuvette Mahon* was probably designed by Jean-Claude Duplessis and was produced in three sizes; this example is of the third, and smallest, size.[1] The plaster model is preserved at Sèvres (illus.); it bears a nineteenth-century label marked *Caisse à fleurs A* (vase A).[2] The largest size was first produced in 1756, and its plaster model and mold are recorded in the stock list of 1757.[3] The models and molds for the second and third sizes were made between October 1, 1759, and the end of 1760.[4] A drawing for the two smaller sizes is in the Sèvres archives (illus.); it is inscribed *Caise à la Mhon segonde et 3ᵐᵉ grandeur fait au Mois daoust 1759* (*Cuvette Mahon* second and third sizes, made in the month of August 1759). In the stock list compiled at the end of 1761 two *cuvettes Mahon* of unspecified size, valued at 30 *livres* each, were recorded as being in the Magasin du Blanc; they were listed again at the end of 1762 and 1763 and in subsequent years.[5] *Cuvettes Mahon* appear five times in the biscuit kiln records for 1758 and 1759 (these records survive only up to September 1759).[6] They must all have been of the first size, and so must the two examples listed in the glaze kiln records in 1758 and in early 1759.[7] Eriksen has noted that this shape was named to commemorate the seizure by the French of the British-held town of Mahón on the island of Minorca in May 1756.[8]

The painted figure scene was copied from a detail of an engraving after a *kermesse* painting by David Teniers the Younger. The engraving by Jacques-Philippe Le Bas, entitled *Feste de village, d'après le tableau original du cabinet de Madame la comtesse de Verruë* (illus.), was based on a painting in the collection of Jeanne-Baptiste d'Albert de Luynes, comtesse de Verruë (1670–1736).[9] The painting was later in the collection of Etienne-François, duc de Choiseul (1719–1785). It can be seen in a miniature painting of the *premier cabinet* of the Hôtel de Choiseul in Paris, painted by the van Blarenberghes on the famous gold box commissioned by Choiseul in 1770.[10] Another engraving of the Teniers painting, a reverse image of the earlier version, was published in 1771.[11] The painting, along with the rest of Choiseul's collection, was sold to Empress Catherine II of Russia in April 1772; it is now in the State Hermitage, Leningrad.[12]

The same group of figures was painted by Antoine Caton on a Sèvres *cuvette à tombeau* of 1760; another vase from the same garniture is painted with other details from the same engraving (London, Wallace Collection C206–207). Another detail of figures from the engraving is painted on the front panel of a *vase vaisseau* of about 1761 at Waddesdon Manor, Buckinghamshire.[13] Eriksen has attributed the painting of the Waddesdon vase to André-Vincent Vielliard, so it seems that at least three Sèvres painters worked from this engraving.

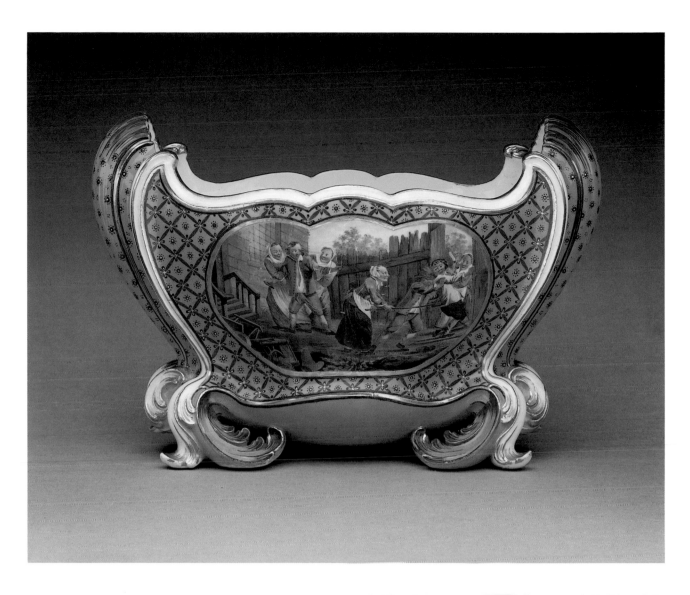

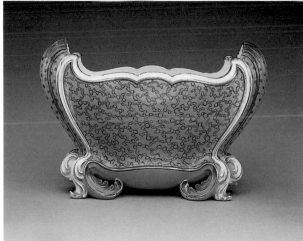

The decoration of three different patterns in blue and gold (trellis, *pointillé,* and *vermiculé*) over a pink ground is rarely seen on Sèvres porcelain. Examples combining just two of these patterns are more common, for instance, a *cuvette à compartiments* dated 1760 in the Tuck collection, which has panels of *pointillé* and *vermiculé* over a pink ground (Paris, Petit Palais no. 96). In the same collection there is a *cuvette à tombeau* dated 1760 and a pair of *vases Duplessis à fleurs uni,* circa 1760, all with panels of *pointillé* and trelliswork over a pink ground (nos. 91, 93). A *plateau Hébert* dated 1762 in a private collection, London, is also decorated with panels of *pointillé* and an elaborate trellis over a pink ground.[14] These trellis patterns can be found in blue over a pink ground on other pieces, but without additional patterns; examples include the Museum's *plateau Courteille* dated 1761 (no. 32 below); a ewer and basin dated 1760 at Luton Hoo, Bedfordshire;[15] and a cup and saucer of similar date at Alnwick Castle, Northumberland.[16] Interestingly, the *cuvette Mahon* in the British Royal Collection, circa 1760, is decorated with panels of an elaborate gilded trellis over a dark blue (*bleu lapis*) ground.[17]

Rosalind Savill has pointed out that the piece of Sèvres porcelain with decoration most comparable to that of the present example is a *cuvette à masques* (illus.) that was undoubtedly made as part of the same garniture.[18] It bears the crossed L's factory mark enclosing the date letter *J* for 1762 and the painter's mark for Jean-Louis Morin. The Sèvres sales records show that on March 30, 1763, M. Lemaitre purchased "1 cuvette à masque Roze" for 528 *livres* along with two *cuvettes Mahon* of the third size, with the same decoration, for 264 *livres* each.[19] This indicates that the Museum's *cuvette Mahon* was one of a pair, though the matching example is not known to have survived.

The factory sales records list eleven *cuvettes Mahon* between July 1757 and November 1776.[20] The first was sold to Lazare Duvaux in the second half of 1757 with "rubans" (ribbons of ground color) and in "défecteuse" (imperfect) condition for the high price of 432 *livres;*[21] it is probably the example now at Hillwood House, Washington, D.C., which has pink ribbons and defects.[22] On December 30, 1758, during the factory's annual year-end sale at Versailles, the duc d'Orléans purchased an example with pink ground for 480 *livres;*[23] it may be the one now at Harewood House, Yorkshire.[24] In the first quarter of 1760 the *marchand-mercier* Poirier purchased an example with green ground and depictions of children for 528 *livres;*[25] there are three known examples of the first size that could fit this description, one in the C. L. David Collection, Copenhagen (15/1977);[26] one at Waddesdon Manor;[27] and another sold in Paris in 1976.[28] Poirier bought another *cuvette Mahon* in the second half of

1760; this one had *mosaïque* decoration and was probably of the third size since its price was 132 *livres.*[29] In the same period of 1760 the dealer Mme Lair also purchased an example with *mosaïque* decoration for 192 *livres.*[30] A *cuvette Mahon* of the third size with blue and gold *mosaïque* panels sold in 1959 may be one of the two sold in the second half of 1760.[31] On September 11, 1762, an example with "lapis" (dark blue) ground was sold for cash to an unnamed purchaser for 432 *livres;*[32] an example, probably of the first or second size, sold in Paris in 1967 may fit this description.[33] Madame de Pompadour purchased a *cuvette Mahon* of the second size with "frizes colorées" for 300 *livres* on September 1, 1762, as the central vase of a garniture, along with two cuvettes Courteille of the third size.[34] Barry Shifman has pointed out that this may be identified as the vase dated 1760 that was sold in New York in 1974 and 1979.[35] The dimensions of this example show that it is of the third size, however. Since it seems to be described as being of the third size in the painters' overtime records, it is highly probable that the sales records are inaccurate on this point.[36]

When Lemaitre purchased the Museum's *cuvette Mahon* on March 30, 1763, he also purchased a single example of the second size.[37] This vase had a *bleu céleste* ground and is possibly the one now in an English private collection.[38] That these vases bear date letters for 1761 but were sold in 1763 is not unusual. The final reference to the purchase of a *cuvette Mahon* in the sales records is dated November 7, 1776, when M. de Prèle bought one, presumably of the third size, with "frize colorées" for 168 *livres;* this is probably the example decorated to match Mme de Pompadour's *cuvette Mahon* of 1762 (see above), also sold in 1974 and 1979.[39]

There are other known *cuvettes Mahon* that cannot be traced in the sales records. These include examples of the first size at Waddesdon Manor;[40] in the Metropolitan Museum of Art, New York (Sheaffer Bequest, 1974.356.592);[41] and in private collections in Illinois[42] and Massachusetts.[43] Examples of the second size are in the British Royal Collection[44] and in the Rijksmuseum, Amsterdam (R.B.K. 17512).[45] Examples of the third size include a pair in the British Museum, London (Sir Bernard Eckstein Bequest, M&LA 1948.12-3.316, 317);[46] a pair in a private collection, Paris;[47] and one that was sold in New York in 1972.[48] In the factory's stock list compiled at the end of 1773 two *cuvettes Mahon* are listed in the Magasin de Vente; they had presumably been made several years earlier.[49] Their sizes are not specified, but one was decorated with a pink ground and Chinese pastoral scenes ("rose chiné pastorales"), while the other had a *bleu lapis* ground with *caillouté* gilding and pastoral scenes; they were valued at 300 and 336 *livres,* respectively.

The model was reproduced in England by the Coalport factory in the mid-nineteenth century. Two examples were included in a dinner service that belonged to the Earls of Dudley at Himley Hall, Staffordshire.[50]

PROVENANCE: Sold by the Sèvres factory to M. Lemaitre, March 30, 1763, for 264 *livres;* De Bargigli collection (offered for sale, Christie's, Geneva, April 22, 1970, lot 18, bought in; sold, Christie's, London, October 4, 1971, lot 42); [Olivier Lévy, Paris]; [French and Company, New York]; J. Paul Getty, 1972.

EXHIBITIONS: The Detroit Institute of Arts, August–October 1973.

BIBLIOGRAPHY: Wilson 1977, p. 19, fig. 20, p. 22; Sassoon and Wilson 1986, p. 80, no. 171; Savill 1988, pp. 38, 42, n. 43, 93, 97, n. 15.

Plaster model for the *cuvette Mahon.* Manufacture Nationale de Sèvres, Archives.

1. Eriksen and de Bellaigue 1987, pp. 315–316. Surviving examples of the first size range in height from just under 20 cm to just over 21 cm and in width from 29.2 to 30.4 cm; examples of the second size measure about 17.3 cm in height and 27.3 to 28 cm in width; examples of the third size range in height from 14.9 to 15.9 cm and in width from 22.5 to 23.5 cm.

2. MNS, 1814 Inventory, "Caisse à fleurs à la Mahon," 1740–1780, no. 120(1) (height 21 cm, width 31 cm, depth 19 cm).

3. S.L., I.7, 1757 (for 1756), fols. 5–6 (valued at 10 *livres* each).

4. Ibid., 1761 (for October–December 1759 and 1760), fols. 5–6 (valued at 9 *livres* each for the second size and 8 *livres* each for the third). See Brunet and Préaud 1978, p. 58; de Bellaigue 1979, pp. 93–94, no. 98.

Design for the *cuvette Mahon.* Manufacture Nationale de Sèvres, Archives R.1, l.III, d.1, fol. 4.

5. S.L., I.7, 1762 (for 1761), fol. 17; 1763 (for 1762), fol. 15, 1764 (for 1763), fol. 18.

6. B.K.R., October 16, 1758, fols. 120/118, 121/119 (after a firing that took fifty-two hours, described as "tres juste" [just right]); January 18, 1759, fol. 126/124; February 15, 1759, fol. 128/126; March 28, 1759, fol. 131/129.

7. G.K.R., October 18, 1758, fol. 94; February 12, 1759, fol. 96.

8. Eriksen 1968, p. 88.

9. See B. Scott, "The Comtesse de Verruë, A Lover of Dutch and Flemish Art," *Apollo,* no. 97 (January 1973), pp. 20–24. The countess was the mistress of the Duke of Savoy, Victor Amadeus III, for ten years. Having begun collecting art in Turin, she spent more than thirty years, living in Paris and Meudon, amassing an exceptionally large and refined collection, which was sold in March 1737, following her death the previous year.

10. See F. Watson, *The Choiseul Box* (London and New York, 1963), p. 10, fig. 2.

11. *Recueil d'estampes gravées d'après les tableaux du cabinet de Monseigneur le duc de Choiseul,* pl. 38.

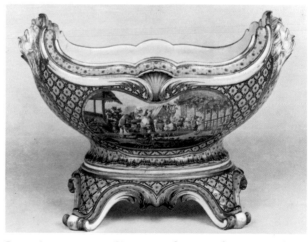

Cuvette à masques, 1762. Sèvres manufactory, soft-paste porcelain, painted by Jean-Louis Morin. Photo courtesy Sotheby's, London.

12. See N. Smolskaya, *Teniers* (Leningrad, 1962), pl. 21.

13. Eriksen 1968, p. 142, no. 50.

14. Sold, Sotheby's, London, December 10, 1974, lot 37; offered for sale, Christie's, London, April 6, 1981, lot 11, bought in; sold, Christie's, London, June 29, 1987, lot 157.

15. *Pot à eau ordinaire et jatte*, JPGC Photo Archives, no. 126816.

16. *Gobelet Hébert et soucoupe*, JPGC Photo Archives, no. 125807.

17. See de Bellaigue 1979, pp. 93–94, no. 98, ill. p 92.

18. Collection of Bethsabée de Rothschild, France (offered for sale, Sotheby's, Monaco, May 3, 1977, lot 23, bought in). This vase is fitted with a painted wooden lid and stand of later date, giving it the form of a *vase vaisseau*.

19. S.R., Vy3, fol. 122r.

20. Barry Shifman, "Eighteenth-Century Sèvres Porcelain: Two Rare *Cuvettes Mahon*," *Apollo*, no. 121 (January 1985), pp. 24 29

21. S.R., Vy2, fol. 48v.

22. Painted with sprays of flowers, 1757, width 29.3 cm. Collection of René Fribourg, New York (offered for sale, Sotheby's, London, June 23, 1963, lot 67, bought in; sold, Sotheby's, London, May 4, 1965, lot 173, to Mrs. Merriweather Post, Hillwood House).

23. S.R., Vy2, fol. 78r.

24. With pink ground and a pastoral scene after Boucher, undated, height 20.3 cm. See H. Tait, "Sèvres Porcelain in the Collection of the Earl of Harewood, Part I: The Early Period, 1750–60," *Apollo*, no. 79 (June 1964), p. 478 (ill.).

25. S.R., Vy3, fol. 9r.

26. Painted with putti on one side and a landscape on the other, undated, height 20.0 cm, width 29.5 cm. From the Rothschild-Rosebery collection, Mentmore Towers, Buckinghamshire (sold, Sotheby's, Mentmore, May 24, 1977, lot 2034).

27. Painted with pastoral scenes after Boucher, undated, height 20.5 cm, width 29.5 cm. See Eriksen 1968, no. 30 (ill.).

28. Painted with putti, apparently undated, height 20.5 cm, width 29.5 cm. Collection of Baron Philippe de Rothschild, France (sold, Palais Galliera, Paris, November 29–30, 1976, lot 87); present location unknown.

29. S.R., Vy3, fol. 33r.

30. S.R., Vy3, fol. 36v.

31. Painted with sprays of flowers, 1759, width 22.9 cm. Collection of Philip Hugh Nightingale (sold, Christie's, London, July 20, 1959, lot 29); present location unknown.

32. S.R., Vy3, fol. 99v.

33. Painted with pastoral scenes, undated, width 28 cm. Collection of Gilbert Lévy (sold, Hôtel Drouot, Paris, November 23, 1967, lot 108); present location unknown.

34. S.R., Vy3, fol. 117v.

35. With polychrome and gilded trellis panels, 1760, height 14.9 cm, width 22.9 cm. Collection of Mrs. Alan L. Corey (sold, Sotheby's, New York, December 5–6, 1974, lot 70); Mrs. John W. Christner, Dallas (sold, Christie's, New York, December 1, 1979, lot 178); art market, 1980s.

36. P.O.R., F.6, 1761, "Moireau [Méreaud] l'aîné," fol. 4 ("1 Cuvette Mahon 3ᵉ gᵉ 18 [*livres*]"). The piece is dated 1760, but such inconsistencies are common.

37. See above (note 19).

38. Painted by Morin with a military scene, 1759. London art market, 1985.

39. S.R., Vy6, fol. 136r. Height 14.9 cm, width 22.6 cm; same provenance as vase discussed in note 35.

40. With *bleu céleste* ground, painted with putti on the front and a trophy on the back, undated, height 20 cm, width 29.5 cm. See Eriksen 1968, no. 29.

41. With *bleu céleste* ground, painted with a pastoral scene on the front, undated, height 20.4 cm, width 30.4 cm.

42. Part of a garniture with a pair of *pots pourris à bobèches* (see no. 9 above); with *bleu lapis* and green grounds, painted with a Teniers scene on the front, undated, height 20.0 cm, width 29.2 cm. See *Antiques* 125 (March 1984), p. 528 (ill.)

43. With pink marbled (*rose marbré*) ground, painted with a pastoral scene on the front and with flowers and fruit on the back, 1762, height 19.7 cm, width 29.4 cm. Unpublished.

44. With *bleu lapis* and green grounds, painted with a Teniers scene on the front, circa 1760, height 17.3 cm, width 27.3 cm. See de Bellaigue 1979, pp. 93–94, no. 98, ill. p. 92.

45. With green ground, painted with a Teniers scene on the front, undated, height 18 cm, width 27 cm. Collection of Lord Brownlow (sold, Christie's, London, March 14, 1929, lot 58); Dr. F. Mannheimer, Amsterdam.

46. With *rose marbré* ground, painted with chinoiserie figures by Dodin, 1761, height 15 cm, width 23 cm.

47. With *bleu lapis caillouté* ground, painted with Teniers scenes on the fronts, 1760, width 23.5 cm. Collection of Baron James de Rothschild, Paris (sold, Palais Galliera, Paris, December 1, 1966, lot 32 [not ill.]).

48. With *bleu céleste* ground, painted with flowers and fruits on the front and back, 1760, width 22.8 cm. Collection of Mr. and Mrs. Deane Johnson, Bel Air, Calif. (sold, Sotheby's, New York, December 9, 1972, lot 9); present location unknown.

49. S.L., I.8, 1774 (for 1773), fol. 41.

50. JPGC French & Company Archives, August 1927, stock no. 30577.

Jacques-Philippe Le Bas (French, 1707–1783) after David Teniers
the Younger (Flemish, 1610–1690). *Feste de village*. Engraving.
Paris, Bibliothèque Nationale.

15 Cup and Saucer
(gobelet et soucoupe enfoncé, première grandeur)

1761
Sèvres manufactory; soft-paste porcelain

Cup: HEIGHT 9.1 cm (3⁹⁄₁₆ in.); WIDTH 10.7 cm (4³⁄₁₆ in.); DEPTH 8.6 cm (3⅜ in.). *Saucer:* HEIGHT 3.8 cm (1½ in.); DIAM. 15.6 cm (6⅛ in.)

MARKS: The saucer is painted in blue underneath with the factory mark of crossed L's enclosing the date letter I for 1761 and with a dot. The saucer is incised underneath *oo,* and the cup is incised underneath DU in two places.

79.DE.62

DESCRIPTION: The cup has straight sides that taper to a flat bottom, recessed underneath. The saucer has a broad, flat edge and a deep, vertical well in the center, into which the cup fits. There is a kiln suspension hole in the base of the saucer.

The outer wall of the cup and the flat upper surface of the saucer are decorated with a pink (*rose*) ground color overlaid with scrolling patterns in deep blue (*beau bleu*), highlighted with gold spots. Interspersed among the scrolls are panels of *pointillé,* trelliswork, and clusters of three and four gold dots in patterns over the blue. The two oval reserves on the cup and saucer are painted with bunches of fruit and flowers. On the cup these include grapes, round-headed buddleia, citrus fruits, pink cherries, and pink gooseberries or currants. The reserves on the saucer are painted with stylized flowers and anemones, chicory, peaches, plums, and a pepperlike fruit.

The rims are gilded with a dentil border. The reserves are framed with a band of gilding, tooled with alternately burnished and matt rectangles. The handle of the cup is highlighted with thick slashes of gilding along its branch-like form and displays a foliate motif where it joins the wall of the cup.

CONDITION: The cup and saucer are unbroken. The gilded line around the base of the cup and small areas of gilding on the rims of both pieces are worn. The tooling is no longer distinct on the gilded frames of the reserves on both pieces. There is dark spotting in the glaze on the underside of the saucer and in an area about 3 mm high on the outside of its base. The lack of wear to the rim of the cup suggests that it was not originally supplied with a lid.

COMMENTARY: Rosalind Savill has shown that this shape of cup and saucer was called a *gobelet et soucoupe enfoncé* at Sèvres.[1] It was produced in two sizes; this example is of the first, and larger, size.[2] The cup is of a shape produced at Vincennes and Sèvres from 1753 called a *gobelet à la reine;* when made with two handles, however, it was called a *gobelet à lait* (see no. 17 below). Both shapes were supplied with a saucer that had a flat base and a flat, sharply angled wall and were sometimes sold with a lid, as was the *gobelet enfoncé.* Three plaster molds for a "gobelet Antique" (presumably referring to the earlier *à la reine* shape) and three molds for a corresponding *soucoupe,* of which "Le Milieu Est enfoncé" (the center is recessed) are recorded in the stock list of new work of the first nine months of 1759.[3] The present saucer, with its deep well, meets this description.

Savill has noted that the same cup shape was used with another type of deep saucer at Sèvres. The latter has three large concave lobes within its high sides, with divisions that form buttresses to hold the cup in the center. This model may have been known at the factory as a *gobelet et soucoupe trembleuse;* examples of this type are in the Musée National de Céramique, Sèvres (MNC 22993),[4] and in the Victoria and Albert Museum, London (Joicey Bequest, C.1398-1919). No *gobelets* in the biscuit kiln records for 1759 (the final year covered) are specified as *enfoncé,* nor are any examples noted in the glaze kiln records or in the painters' overtime records for 1761.

The decoration of a pink ground thickly overlaid with dark blue appears on some wares of the early 1760s, either in scroll and trellis patterns, as on the Museum's example, or in imitation of marbling. Examples with similar decoration include a pair of *vases hollandois nouveaux,* circa 1761–1762, divided between Firle Place, Sussex, and the Museum of Fine Arts, Boston,[5] and a garniture of three *pots pourris myrthe,* circa 1761–1762, in the Frick Collection, New York.[6]

Savill has also pointed out that all the *gobelets et soucoupes enfoncés* listed in the factory's sales records from 1759 to 1764 were bought by Madame de Pompadour. If Mme de Pompadour did indeed have a monopoly on this form, the Museum's example is probably from her collection. The

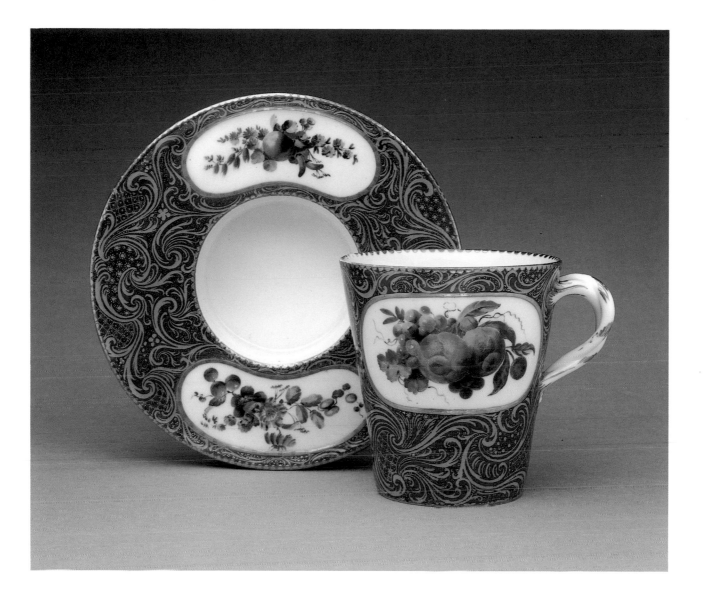

prices of these *gobelets* varied depending on their decoration. In August 1762 she paid 72 *livres* each for a pair with a *bleu lapis* ground.[7] On the same day an example with "frizes colorées" cost her 60 *livres;*[8] its decoration may have been similar to that of an example dated 1763 sold at auction in 1984.[9] In February 1763 she bought an example with unspecified decoration for 30 *livres*.[10] The Sèvres sales records of the early 1760s show many *gobelets et soucoupes* of unspecified shape and decoration, which must include some of this model. In the 1764 inventory of porcelain at Versailles from Mme de Pompadour's collection there are "trois gobelets à anses, soucoupe enfoncée; prise quatre vingt seize *livres*."[11] After Mme de Pompadour's death in 1764 the next specified example of this shape was sold in October 1765 to Madame Louise, a daughter of Louis XV.[12] While numerous examples of the *gobelet et soucoupe enfoncé* form have survived, varying widely both in date and in decoration, the Museum's is the only known example with this type of decoration.

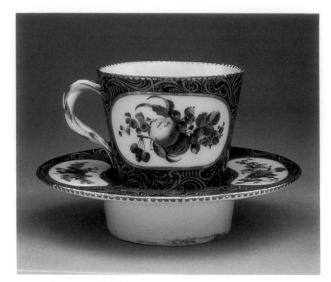

Cup and saucer, side view

PROVENANCE: [Olivier Lévy, Paris]; [French and Company, New York, early 1970s]; Mrs. John W. Christner, Dallas (sold, Christie's, New York, June 9, 1979, lot 241); the J. Paul Getty Museum, 1979.

BIBLIOGRAPHY: Wilson 1980, p. 19, item A; Sassoon and Wilson 1986, p. 80, no. 172; Savill 1988, pp. 675, 685, nn. 2b, 21.

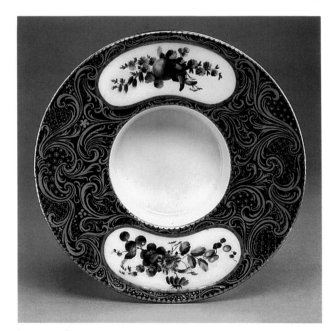

Saucer

1. Savill 1988, pp. 674–687.
2. Cups of the first size range in height from 8.6 to 9.1 cm; those of the second size, from 7.2 to 7.4 cm.
3. S.L., I.7, October 1, 1759 (for January–September 1759), fol. 7 (each valued at 10 *sous*).
4. See Brunet and Préaud 1978, p. 196, no. 215.
5. Savill 1985, pp. 469–470, no. 405.
6. Brunet 1974, pp. 246–255.
7. S.R., Vy3, August 10, 1762, fol. 117r.
8. Ibid.
9. Collection of Hugh Burton-Jones and Kathleen Gifford-Scott (sold, Sotheby's, London, June 12, 1984, lot 196).
10. S.R., Vy3, February 8, 1763, fol. 157r.
11. Cordey 1939, p. 62, no. 685.
12. S.R., Vy4, October 12, 1765, fol. 57r.

16 Lidded Bowl and Dish
(écuelle ronde et plateau rond)

1764
Sèvres manufactory; soft-paste porcelain; painted by Pierre-Antoine Méreaud *l'aîné*

Bowl: HEIGHT 12.4 cm (4⅞ in.); WIDTH 19.7 cm (7¾ in.); DEPTH 15.2 cm (6 in.). *Dish:* HEIGHT 3.9 cm (1⁹⁄₁₆ in.); DIAM. 21.1 cm (8⁵⁄₁₆ in.)

MARKS: The bowl and dish are painted in blue underneath with the factory mark of crossed L's enclosing the date letter L for 1764, and with the painter's mark S. The bowl is incised DU and O, and the stand is incised I.

78.DE.65

DESCRIPTION: The circular bowl has a slightly domed lid and a lobed circular dish. The foot ring is recessed underneath. The two handles are formed by intertwined branches, and the raised handle on the lid is in the form of a twisted branch with leaves and berries. There are kiln suspension holes underneath the bowl and the dish.

The bowl, lid, and dish are painted with narrow panels of royal blue (*beau bleu*) interrupted on the lid and dish by four berried laurel wreaths painted in colors. Two of these wreaths surround royal blue lozenges, one painted with an open crown and three fleur-de-lys, the other with the monogram *ML*. The handle of the lid is painted in natural colors.

Burnished interlocking C-scrolls of gilding border the blue and pink rosette patterns in the well of the dish. The panels of blue ground are overlaid with an elaborate gilded trellis pattern, and the rims are gilded with a dentil border. The laurel berries on the handle of the lid are brightly gilded, and slashes of gilding highlight the handles of the bowl.

CONDITION: The bowl and dish are unbroken. There is a small restored chip in the edge of the lid. The worn gilding on the rims has been restored in places.

COMMENTARY: Lidded bowls on dishes were produced in large numbers at Vincennes and Sèvres in a variety of shapes, sizes, and decorative schemes. Called *écuelles,* they were used for serving bouillon between meals. The Museum's bowl is an *écuelle ronde* and stands on a *plateau rond* (some examples stand on *plateaux ovales*). It is of the second of five regular sizes of this shape.[1] The factory's stock list of October 1, 1752, records forty-eight molds for *écuelles rondes* in various sizes.[2] *Ecuelles* were also made in lobed shapes and with finials modeled as fish or citrus fruits.[3] The model for an *écuelle ronde* of a smaller size than the present example survives in the factory's archives,[4] as does a drawing dated 1753 showing an *écuelle ronde* with handles like those on the Museum's bowl (the most common type made) and a *plateau* (MNS R.1, l.1, d.2, fol. 2). The drawing is inscribed *Ecuelle tourne no.3 Rectifie suivan L'ordre de la comande du 19 fevrye 1753* and *Plate pour L'ecuelle tourne no 3 Rectifie suivan L'ordre de la Comande du 19 fevrye 1753* (turned *écuelle* and tray for the *écuelle* no. 3, altered following the order of February 19, 1753). In the factory's stock list of January 1, 1753, *écuelles* are recorded "en Couverte Cuite" (glazed and fired but undecorated).[5] There were three examples of each of the first, second, and third sizes (valued at 30, 28, and 18 *livres* each, respectively) and forty-three of the fourth size (valued at 10 *livres* each). The incomplete biscuit and glaze kiln records shed no further light on the production of *écuelles* at Vincennes and Sèvres.

The Museum's *écuelle* is decorated with the monogram and coat of arms of a princess of France, a daughter of the king. Royal coats of arms appear very rarely on Sèvres porcelain, and monograms are almost as rare, except on certain dinner services.[6] A Sèvres porcelain inkstand of 1758 in the Wallace Collection, London (C488), bears the monogram of Louis XV's third daughter, Madame Adélaïde, for whom it was made, along with her coat of arms. A similar coat of arms is found on a Sèvres porcelain *cafetière* in the Musée Adrien Dubouché, Limoges. Pierre Verlet has shown that this coffeepot was made for Louis XV's fourth daughter, Madame Victoire, in 1786.[7]

The borders of the Museum's *écuelle* are decorated in a style that is found on other Sèvres porcelain wares, most of which date from 1760 to 1765. The use of panels of *beau bleu* with red painting and gilding to form a trellis frieze (described as a "frize colorée" in the factory's documents), with large areas left white, is a distinctive feature of this style. Comparable examples include a *cuvette Mahon* dated 1760 painted by Pierre-Antoine Méreaud *l'aîné* (probably sold to Madame de Pompadour in 1762);[8] a *mortier* and a *jatte à punch* dated 1761 painted by Méreaud (Stockholm, National Museum); a *seau à compartiments* dated 1763, also painted by Méreaud;[9] a part tea service dated 1763 and 1764 painted by Louis-Jean Thévenet;[10] a pair of *vases hollandois* dated 1765 painted by Méreaud;[11] and an *écuelle ronde et pla-*

teau dated 1769 painted by Méreaud (British Royal Collection).[12] It is interesting that Méreaud painted the majority of these and other similarly decorated Sèvres porcelain wares. The painters' overtime records show that in 1764 he received 30 *livres* for unspecified work on an *écuelle et plateau* of the first size and 18 *livres* for painting one of the third size.[13] Antoine d'Albis has pointed out that to achieve the strong color of the *beau bleu* panels on the Museum's *écuelle,* the pigment must have been applied and fired twice. It would have been fired with other enamel decoration, unlike the ground colors, which were fired separately. D'Albis has pointed out that the gilding was also applied in two layers.

The monogram *ML* is thought to be that of Louis xv's youngest daughter, Madame Louise. The Sèvres factory's sales records show that on February 24, 1764, she purchased one "Ecuelle et Platteau frize armoriée" (bowl and dish with an armorial frieze) for 240 *livres.*[14] This surely refers to the Museum's *écuelle,* which bears the date letter for that year.[15]

Madame Louise's *écuelle* appears to have been in the very fine collection of Sèvres porcelain formed by Mrs. Lyne Stephens. In the 1895 auction of her collection, following her death, there was "An Ecuelle, Cover and Stand, of dark blue and gold trellis pattern, wreaths of foliage in green and other decoration, and with shields-of-arms and initials in a lozenge." In 1938, when J. Paul Getty purchased it at the auction of Mortimer Schiff's collection, it was described as coming from the Seguier collection and bearing the monogram of Queen Marie Leszczyńska.

PROVENANCE: Madame Louise of France, 1764; Mrs. Lyne Stephens, Norfolk, London, and Paris (sold, Christie's, London, May 9 et seq., 1895, lot 733, to Boore for 130 gns.); (?)Seguier collection; Mortimer L. Schiff, New York (sold by his heir, John L. Schiff, Christie's, London, June 22, 1938, lot 25); J. Paul Getty, 1938.

BIBLIOGRAPHY: B. Shifman, "A Newly Discovered Piece of Royal Sèvres Porcelain," *GettyMusJ* 6–7 (1978–1979), pp. 53–56; Wilson 1983, no. 33; Sassoon and Wilson 1986, p. 81, no. 173; Savill 1988, pp. 648, 663, n. 33d, 665, n. 99c, 666, n. 109, 800, 804, n. 36.

Plateau, detail showing coat of arms

Plateau, detail showing monogram

7. P. Verlet, "Notes on Eighteenth-Century Objets d'Art," *Art Quarterly* 21 (1968), pp. 368–371.

8. See entry for no. 14 above, notes 35, 39; Méreaud also painted a *cuvette Mahon* dated 1776 to match the 1760 example.

9. Formerly in the Hillingdon collection (sold, Christie's, London, December 4, 1972, lot 184).

10. Ibid., lots 176–180.

11. Ibid., lot 183.

12. De Bellaigue 1979, no. 52.

13. P.O.R., F.7, "Moireau Lainé," 1764, fol. 16.

14. S.R., Vy4, fol. 21r.

15. Madame Louise was born on July 15, 1737; when she was one year old she was sent to live at the abbey of Fontevrault along with her sisters Marie-Adélaïde (b. 1732), Victoire (b. 1733), and Sophie (b. 1734). None of these sisters ever married. After staying at Fontevrault for twelve years, Louise returned to Versailles. On April 11, 1770, she left the court for the Carmelite convent of Saint-Denis, where she lived as Sister Thérèse of Saint Augustine until her death on December 23, 1787.

1. Examples of the second size generally range in height from 12 to 13 cm and in width from 19.2 to 19.9 cm. I thank Rosalind Savill for this information.

2. S.L., I.7, October 1, 1752, fols. 9, 10 (valued at 2 *livres* each).

3. Préaud and Faÿ-Hallé 1977, p. 51, nos. 480–482, 484.

4. MNS Archives, 1814 Inventory, 1740–1760, no. 1 (height 9.6 cm, diam. 16 cm).

5. S.L., I.7, 1753 (for October–December 1752), fol. 27.

6. For example, on the prince de Rohan service of 1772 and the Charlotte-Louise service of 1773.

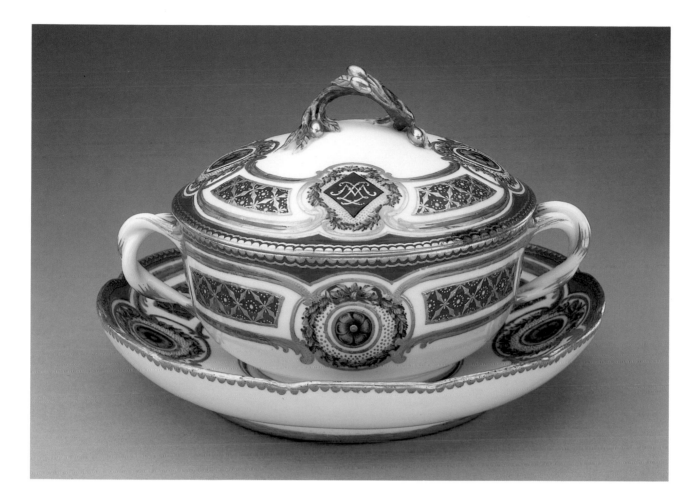

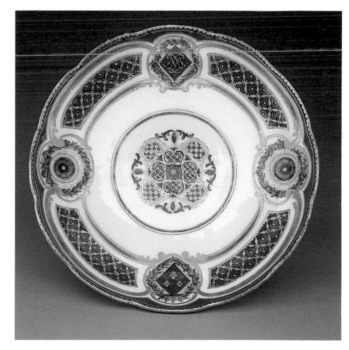

17 Covered Cup and Saucer
(gobelet à lait, couvercle et soucoupe, deuxième grandeur)

Circa 1760–1765
Sèvres manufactory; soft-paste porcelain

Cup: HEIGHT 12.7 cm (5 in.); WIDTH 12.7 cm (5 in.); DEPTH 9.7 cm (3¹³⁄₁₆ in.). *Saucer:* HEIGHT 4.3 cm (1¹¹⁄₁₆ in.); DIAM. 19 cm (7½ in.)

MARKS: Incised with a reverse S above a dot under the base of the cup.

87.DE.134

DESCRIPTION: The straight-sided cup has a broad molded handle at each side and a low-domed lid. The knop is modeled as a flower with leaves on a stem. The saucer has a broad, flat base and a flat, angled wall. All three pieces have kiln suspension holes within their bases.

Oval reserves depicting battle and military scenes are painted in tones of pink (*camaïeu rose*) on the cup (two), the lid (two), and inside the rim of the saucer (three). One scene on the cup shows senior military officers on horseback beside the river Elbe. In the background some of the major buildings of Dresden are visible, including the Japanese Palace, the cathedral of Saint Trinitas, the Frauenkirche, and the central bridge across the river. One of the reserves on the saucer shows the castle of Moritzburg, Saxony, while another reserve shows a fortress reminiscent of that in Meissen, Saxony. The center of the well of the saucer is painted with a military trophy, encircled by a ring of floral trails painted in pink.

Burnished lines of gilding highlight the base of the cup and the edges of the handles. The rims are gilded with a dentil border. The reserves are framed by a broad gilded band burnished with triangles set across its width.

CONDITION: The cup and saucer are unbroken. There is a chip in the rim of the lid, which has been restored. The leaves of the knop are also chipped, and one is missing. The base panel of the cup has cracked away from the wall in one place underneath the foot. The decorated surfaces are unscratched, but the tooling on the gilding is worn.

COMMENTARY: This shape was called a *gobelet à lait et soucoupe* at the factory. Plaster models in one size appear in the stock list of 1752.¹ During 1753 a second size was introduced; the Museum's example is of this smaller size.² A drawing showing two cups of this shape in two sizes survives in the factory's archives (MNS R.1, l.II, d.2, fol. 7). It is inscribed *gobelet au lait tourne no 1 fait suivan Lordre de la Comande du 19 fevryë 1753, pour le bain mari* (turned *gobelet à lait* no. 1, made following the order of February 19, 1753, for the bain-marie) and *fait* (made). Another drawing of this model, of the same date, depicts a far more elaborate handle and includes a design for the deep saucer (MNS R.1, l.II, d.2, fol. 7). In the 1760s these cups were sometimes sold with a *plateau corbeille* instead of a saucer. Examples are identifiable in the factory's sales records;³ one, dated 1764, is in the Metropolitan Museum of Art, New York (Jack and Belle Linsky Collection, 1982.60.180ab, 181).

The decoration on the Getty Museum's covered cup and saucer is unusual; no similar examples are known. The military scenes evidently relate to battles between Prussia and Saxony that took place in 1756 and 1757, at the start of the Seven Years' War.⁴ Frederick the Great of Prussia invaded Saxony in August 1756, occupying the Saxon capital of Dresden, but he failed to hold this territory. Since French troops were never deployed in this part of Europe, the decoration of this cup and saucer would be of little interest to a French buyer. The pieces could, however, have been commissioned by a Prussian wishing to commemorate the taking of Dresden or by a Saxon celebrating its recapture. The drawings or engravings upon which this decoration is based are not known.

The cup and saucer cannot be identified in the Sèvres factory's sales records. They were probably made for a German client and may have been entered without description among wares sold through a *marchand-mercier*. The Seven Years' War was settled in 1763, and their style of decoration suggests that these pieces were made between 1760 and 1765. Several *gobelets à lait* are clearly listed in the sales records for the early 1760s; all of them were sold singly. The least expensive, costing 30 *livres* each, had decoration of *filets d'or* (gilded lines).⁵ Examples of the second size with flowers cost 36 and 48 *livres* each.⁶ Others (with unspecified decoration) were sold for 54 *livres*,⁷ 60 *livres* (second size,

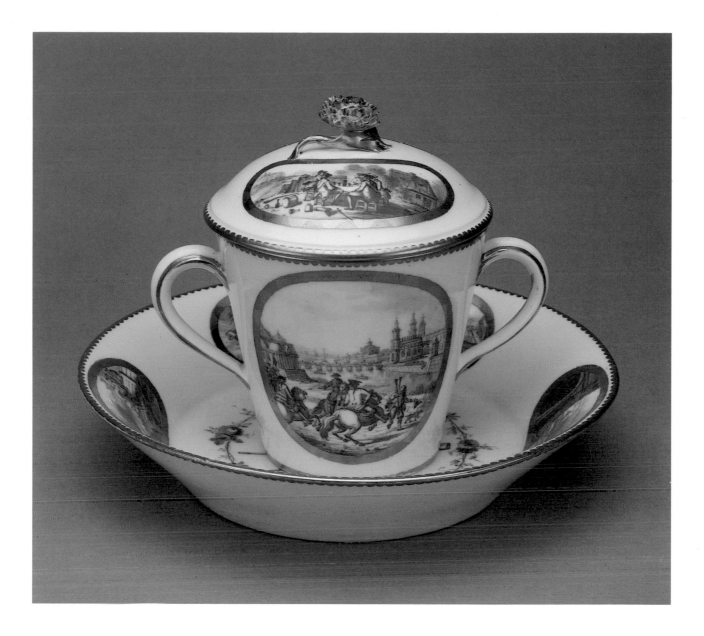

with flowers),[8] 66 *livres* (second size, with landscapes),[9] 90 *livres* (with *mosaïque* decoration),[10] 96 *livres* (with a *bleu lapis* ground),[11] 102 *livres* (with flowers),[12] 108 *livres* (second size, with "enfants camaïeu"),[13] 120 *livres* (with a *bleu lapis* ground),[14] 144 *livres* (with green ground and flowers),[15] 192 *livres* (second size, with a *bleu lapis* ground and flowers,[16] and with the same ground but unspecified painting[17]), 240 *livres* (second size, with *bleu céleste* ground and flowers).[18] One example (with unspecified decoration) was sold for 324 *livres*,[19] and the most expensive (with *bleu céleste* ground), for 360 *livres*.[20] It is possible that the Museum's example could be the one painted with landscapes, sold for 66 *livres* to the dealer Mme Lair in 1760.

Many cups and saucers of this model, displaying a wide variety of decoration, have survived, including examples in the Victoria and Albert Museum, London (C.111-1922); the Fitzwilliam Museum, Cambridge (C.20-1980); the Petit Palais, Paris (Tuck collection, nos. 106, 123); the State Hermitage, Leningrad;[21] the Wallace Collection, London (C438-440); and the Philadelphia Museum of Art (42-59-125).

Rosalind Savill has pointed out that the 1834 inventory of Hertford House, London, made after the death of the second Marchioness of Hertford, mentions a similar cup and saucer in the sitting room on the "Principal Floor."[22] It is described as "A cabinet cup & saucer with plan of the battle of Leipsic [*sic*] & its environs." Since the author of the inventory may not have been able to distinguish Leipzig from Dresden, it is possible that this is a reference to the Museum's cup and saucer. They do not appear to have passed to the third Marquess of Hertford, as they do not appear in the 1842 inventory of his home, St. Dunstan's Villa.[23]

PROVENANCE: (?)2nd Marchioness of Hertford, London, before 1834; sold, Christie's, London, March 25, 1985, lot 9; [Winifred Williams Ltd., London, 1985]; the J. Paul Getty Museum, 1987.

BIBLIOGRAPHY: Savill 1988, pp. 668, 672, nn. 3n, 25.

Cup, detail showing painted decoration

4. I am grateful to Charissa Bremer-David for information regarding the Seven Years' War.
5. S.R., Vy3, April 18, 1761, fol. 55v (for cash).
6. Ibid., January 1–April 1, 1760, fols. 13v (to the dealer Tesnières), 10r (to Dulac).
7. Ibid., June 1–October 25, 1761, fol. 74r (to Dulac).
8. Ibid., December 1760, fol. 7r (to Louis XV at Versailles).
9. Ibid., April 1–July 1, 1760, fol. 19v.
10. Ibid., July 1, 1760–January 1, 1761, fol. 42v (to Tesnières).
11. Ibid., fol. 37r (to Dulac).
12. S.R., Vy3, November 4, 1760, fol. 27v (for cash).
13. Ibid., November 2, 1759, fol. 5r (for cash).
14. Ibid., December 24, 1761, fol. 82v (to Louis XV at Versailles).
15. Ibid., October 2, 1760, fol. 26v (for cash).
16. See above (note 8).
17. S.R., Vy3, December 28, 1759, fol. 6v (to "Mesdames de France" [Louis XV's daughters]).
18. See above (note 10).
19. See above (note 9).
20. S.R., Vy3, December 28, 1759, fol. 6v (to the duc de Choiseul).
21. Now standing on a similarly decorated *plateau rond* for an *écuelle;* see JPGC Photo Archives, no. 14542.
22. "1834 Inventory of Hertford House," p. 17, no. 42 (Wallace Collection Library).
23. I thank Rosalind Savill for this information.

1. Préaud and Faÿ-Hallé 1977, p. 108.
2. Cups of the first size (with covers) range in height from 14.5 to 15.5 cm, and their saucers range in diameter from 21 to 22 cm. I thank Rosalind Savill for this information.
3. S.R., Vy3, July 1, 1760–January 1, 1761, fols. 37r ("1 Gobelet a Lait Et Corbeille fond vert" to the dealer Dulac for 240 *livres*), 39v ("1 Gobelet a Lait Et Corbeille oiseaux" to the dealer Machard for 132 *livres*).

Saucer

18 Pair of Lidded Vases
(vases à têtes de bouc)

Circa 1768
Sèvres manufactory; soft-paste porcelain; possibly modeled by Michel-Dorothée Coudray and finished by the *répareur* Nantier

HEIGHT 34.2 cm (13⁷⁄₁₆ in.); WIDTH 21.9 cm (8⅝ in.); DEPTH 16.8 cm (6⅝ in.)

MARKS: Each vase is incised within the base with the *mouleur*'s mark *c.d.* Vase .1 is incised with the *répareur*'s mark *N1* within the base, and vase .2 is incised *N 2*. No painted marks.

82.DE.36.1–2

DESCRIPTION: The globular vase has a tall, slender neck and rests on a splayed circular foot, which is modeled with alternate gadroons and strips of pendant husks. The fluted stopper is almost spherical. The handles are modeled as goat's heads from whose mouths hang branches of grapevines. Similarly modeled vine trails wind around the neck.

With the exception of features in relief, the vase is decorated with a deep blue (*beau bleu*) ground. The main area of the body is gilded with a regular pattern of eight-petaled flower heads tooled with stamens and pistils. On the base of the bowl are six large, thickly gilded acanthus leaves, partly matt, partly burnished, over a panel densely decorated with gold dots. The ram's heads and vines are highlighted with burnished gilding. The stopper is covered with a blue ground. Each flute is gilded, alternately burnished and matt, and the matt flutes are also tooled with irregular bright circles.

CONDITION: Both vases are in good condition. The tooling of the gilding is unusually bright, with only minor abrasions, and the bases show no sign of having been placed in gilt-bronze mounts. The vases are joined to their bases by a porcelain plug inserted from the interior of the bowl; both are intact. The gilding at the mouth of vase .1 is slightly worn, as is that on the tops of the stoppers. There is a very small chip at the base of vase .2.

COMMENTARY: This shape is described as a *vase à têtes de bouc* in the Sèvres factory's documents. It was made in a single size, and the plaster model and mold for it are recorded in the stock list of 1768, under new work of 1767.[1] Although no designs for this shape have survived, the plaster model is in the archives (illus.),[2] published by Albert Troude as a "vase bouc à raisins."[3] The name *vase à Raisins* appears in the factory's documents, but it is not clear whether it refers to vases of the same model as the Museum's example.[4] Several other types of vases modeled with goat's heads were designed at Sèvres, though it is not known whether all were produced. Prior to 1767 there was at least one such shape in production, a large potpourri vase that was called a "Vaze a tete de Bouc" when it was sold by the factory in 1763.[5] An example is in the Huntington Art Collections, San Marino.[6] The most numerous "vases à têtes de bouc" were the models produced from 1771, which were also called "du Barry A" and "du Barry B" (see no. 23 below).[7]

Vases of the same model as the present examples appear in the glaze kiln records from 1767. Listed in July of that year is one "[vaze] à Boucs,"[8] and in the following January, two "vazes Raisins," possibly of the same model.[9] In October 1768 two "vazes à têtes de Bouc" are listed in the glaze kiln records.[10] Some vases of this shape were no doubt among the seven "Vases a reliefs et têtes de Lyons et bouc" recorded in the Magasin de Blanc after the end of 1768.[11] They were valued at 72 *livres* each.

Svend Eriksen has suggested that the incised initials *c.d.* belong to the *mouleur* Michel-Dorothé Coudray (active circa 1753–1774/75).[12] This mark appears on a *vase à côtes torses* of 1767 in the British Royal Collection[13] and on a *vase console* of 1769 at Waddesdon Manor, Buckinghamshire.[14] Eriksen has also suggested that the incised mark *N* may be that of the *répareur* Nantier (active 1767–1776). This mark appears (without the numerals *1* and *2* found on the present examples) on a pair of vases of the same model at Waddesdon Manor (see below).

The distinctive decoration of the Museum's vases, bold patterns in gilding over a *beau bleu* ground, is of a style popular in the late 1760s. Simpler versions of this pattern are found on a *pot pourri ovale uni* dated 1766 in the Wallace Collection, London (C278), and on a *vase ovoïde* dated 1767 in the Walters Art Gallery, Baltimore (48.601).[15] The overglaze dark blue (*bleu nouveau* or *beau bleu,* the term used for this color from 1768) ground was introduced in 1763, replacing the underglaze blue (*bleu lapis*) ground that had been developed at Vincennes. The painters' overtime records show that in 1767 and 1768 several decorators were working on vases and other wares with blue grounds overlaid with various patterns of gilding. They included Jean-Pierre Boulan-

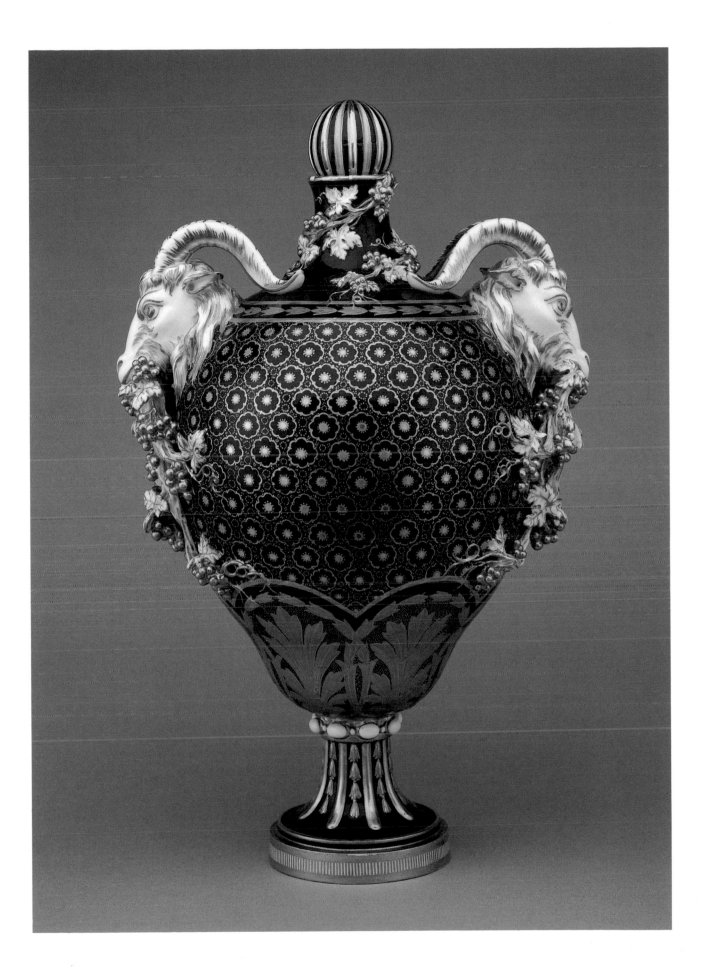

ger *père,* Drand, Etienne-Henri Le Guay *l'aîné,* Pierre-Antoine Méreaud *l'aîné,* Pierre-Nicolas Pierre *l'aîné,* and Henry-François Vincent.[16] The patterns were described as "sabler en or," "frizes d'or," "poids d'or," and "petite mozaïque." In the last six months of 1766 the dealer Bachelier paid 72 *livres* to the factory for "avoir décoré En Bleu Et or le vaze de Mylord Georges" (having decorated a vase belonging to Lord George with a blue ground and gilding).[17] This was presumably a simply decorated vase that was returned to the factory to be embellished in a more elaborate and fashionable manner.

There is only one vase identified as a "vase à têtes de Boucs" in the Sèvres sales records before the end of 1770 that is clearly of this shape.[18] It was sold in June 1770 to Lord Harcourt and was decorated with a green ground and figure scenes ("Mignatures"). It was the central vase in a garniture with two *vases Bachelier.*

Since the Museum's vases were sold from the collection of the Earls of Lincoln in 1937, they were probably among a set of vases purchased by Henry Pelham-Clinton, Lord Lincoln, from the Sèvres factory in October 1768. On the fifth of that month Sir John Lambert (known as Chevalier Lambert) purchased, on Lord Lincoln's behalf, three "Vazes En Beau Bleu Et or" for 600 *livres* each.[19] The third vase was probably the *vase Lézard* from the Lincoln collection now in the Saint Louis Art Museum.[20] If the Getty Museum's vases were indeed those sold to Lord Lincoln, it is worth noting other vases sold in 1768 for the same price, but not described in any detail. In December 1768 an unnamed member of the court purchased a set of five "vazes d'ornemens" for 600 *livres* each, and on the thirty-first of that month the dealers Bouffet and Dangirard purchased a set of three vases, also for 600 *livres* each.[21]

Henry Pelham-Clinton (1750–1778), the son of the second Duke of Newcastle-under-Lyme, was only eighteen years old when he purchased the Museum's vases. He predeceased his father and used the title Earl of Lincoln as a courtesy title. In 1774 he was given his family's house at 22 Arlington Street, London, as his residence.[22] Improvements to the building took until 1778, however, and in October of that year Lord Lincoln died while visiting France. Like several other English nobles, he made his purchases from the Sèvres factory through Lambert. There were two Sir John Lamberts, father and son, who lived in Paris and acted as bankers for English visitors,[23] receiving a dealer's discount of 9 percent on their purchases at Sèvres. Their clients included Lords Bolingbroke, Hervey, and Melbourne.

Several other eighteenth-century versions of this model of *vase à têtes de bouc* are known. An undated pair decorated with a dark blue ground, figure scenes on the front,

and flowers on the back are at Waddesdon Manor.[24] Their lids are taller and of a different shape than those on the Museum's vases. Eriksen has linked the Waddesdon vases to the pair of "vases a testes de bouc" with a blue ground purchased by Louis xv at Versailles in December 1772 for 432 *livres* each.[25] They formed a garniture with a *vase laurier* and may be the similarly described pair of vases sold at auction in 1880.[26] A single *vase à têtes de bouc* is in the British Royal Collection; it differs from the Museum's vases, however, lacking the modeled clusters of grapes.[27] Its lid is also stopper-shaped but is a plain sphere, without fluting. The undated vase is decorated with a dark blue ground, a scene of putti on the front, and a trophy on the back. An example of this shape from the collection of M. Berthet, illustrated in 1889,[28] had a dark blue ground and a reserve painted with flowers on one side. Another pair of vases of this model, decorated with a dark blue ground, formed part of a garniture of three vases sold at auction in 1933.[29]

A nineteenth-century Sèvres porcelain version of this model is at the Château de Fontainebleau.[30] The shape was copied by the royal porcelain factory in Naples, indicating that an example was possibly taken to Italy. A pair in Naples porcelain is in the Edward-Dean Museum, Riverside, California. In the nineteenth century the Samson factory also reproduced the model; an example was sold at auction in 1980.[31]

PROVENANCE: Possibly sold by the Sèvres factory to Henry Pelham-Clinton through Sir John Lambert, October 5, 1768, for 600 *livres* each; by descent to the Earls of Lincoln (sold, Christie's, London, June 9, 1937, part of lot 115); [J. Rochelle Thomas, London]; private collection, New York (sold, Parke Bernet, New York, January 12, 1957, lot 247); Christian Humann, New York (sold, Sotheby's, New York, April 22, 1982, lot 41); [Armin B. Allen, New York, 1982]; the J. Paul Getty Museum, 1982.

BIBLIOGRAPHY: Wilson, Sassoon, and Bremer-David 1983, no. 11; Sassoon and Wilson 1986, pp. 81–82, no. 175; Savill 1988, pp. 31, n. 72, 350, n. 12.

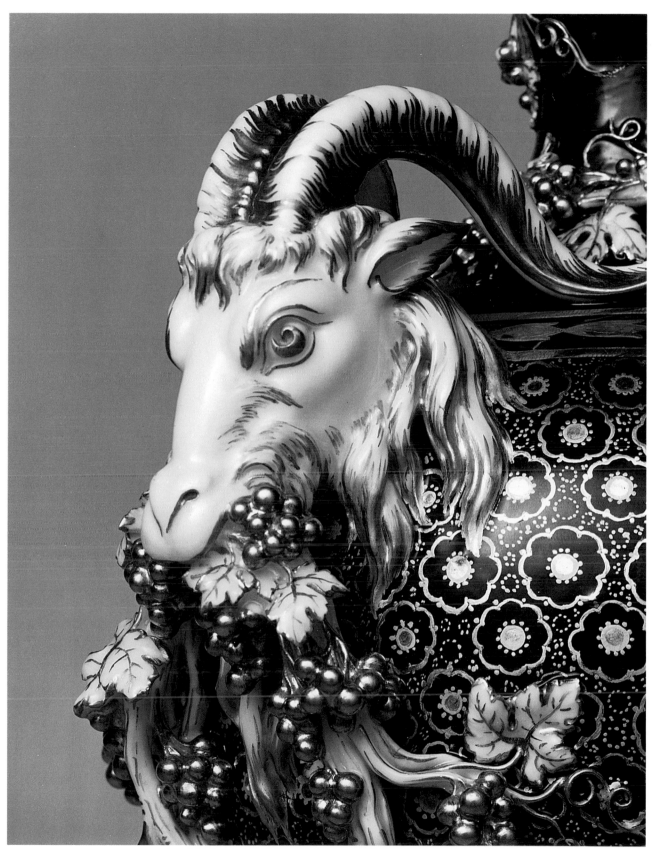

Detail of modeling

1. S.L., I.7, 1768 (for 1767), fols. 6–7 (valued at 60 *livres* each).

2. MNS Archives, 1814 Inventory, "Vase Boucs à Raisins", 1740–1780, no. 155 (height [without lid] 36.5 cm, width 25 cm).

3. Troude [1897], pl. 105.

4. G.K.R., January 1, 1768, fol. 40v.

5. S.R., Vy3, April 7, 1763, fol. 123v.

6. Wark 1961, fig. 102.

7. References to these models have sometimes been confused with references to the model under discussion; see Brunet and Préaud 1978, p. 107, no. 47; de Bellaigue 1979, pp. 111–112, no. 116. This confusion has been noted by R. Savill, in "A Pair of Sèvres Vases: From the Collection of Sir Richard Wallace to the J. Paul Getty Museum," *GettyMusJ* 15 (1987), p. 135, n. 6.

8. G.K.R., July 1, 1767, fol. 37/40.

9. See above (note 4).

10. G.K.R., October 1, 1768, fol. 43.

11. S.L., I.7. 1769 (for 1768), fol. 16.

12. Eriksen 1968, pp. 248, 322, no. 86A.

13. De Bellaigue 1979, p. 84, no. 88.

14. See above (note 12).

15. See Brunet and Préaud 1978, p. 171, no. 140.

16. P.O.R., F.9, 1767, fols. 51, 52, 56, 58; F.10, 1768, fol. 81.

17. S.R., Vy4, fol. 99r.

18. Ibid., June 8, 1770, fol. 208r.

19. Ibid., fol. 156v.

20. Sold, Christie's, London, June 9, 1937, part of lot 115; collection of Elinor Dorrance Ingersoll (sold, Christie's, New York, November 11, 1977, lot 37); sold, Sotheby's, New York, November 8, 1985, lot 227.

21. S.R., Vy4, fols. 161v, 163v.

22. D. Watkin et al., *A House in Town: 22 Arlington Street, Its Owners and Builders* (London, 1984), pp. 68–69, 119–120. I thank Rosalind Savill for bringing this to my attention.

23. See Savill 1985, p. 476, no. 411; and conversation with author.

24. Eriksen 1968, p. 274, no. 99 (height 35 cm).

25. S.R., Vy5, fol. 4v.

26. Sold, Christie's, London, July 28, 1880, lot 43. I thank Frances Buckland for this information.

27. De Bellaigue 1979, pp. 111–112, no. 116 (height 34 cm).

28. Garnier [1889], pl. XLI.

29. Collection of Baron Albert von Goldschmidt-Rothschild (sold, Ball and Graupe, Berlin, March 14, 1933, lot 108) (height [with gilt-bronze bases and lids] 39 cm).

30. Verlet 1953, pl. 129.

31. Christie's, London, June 16, 1980, lot 27 (height 36 cm).

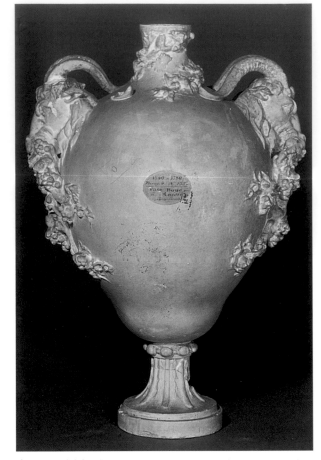

Plaster model for the *vase à têtes de bouc*. Manufacture Nationale de Sèvres, Archives.

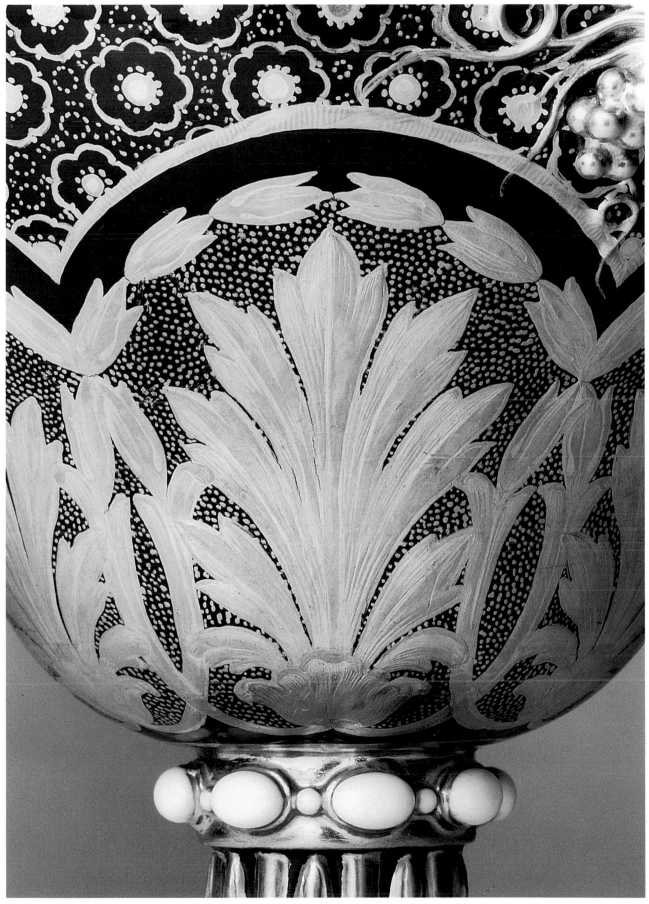

Detail of gilding

19 Pair of Lidded Vases
(vases œuf?)

Circa 1769
Sèvres manufactory; soft-paste porcelain set on a gilt-bronze base; figure painting attributed to Jean-Baptiste-Etienne Genest

HEIGHT (including base) 45.1 cm (1 ft. 5¾ in.); WIDTH 24.1 cm (9½ in.); DEPTH 19.1 cm (7½ in.).

4 C 4 9 2

MARKS: Vase .1 is incised 4 within the bowl and 4 within the foot. Vase .2 is incised 1 within the bowl and 3 within the foot. Lid .1 is incised 4 twice, and lid .2 is incised 2, all on the interior. No painted marks.

86.DE.520.1–2

DESCRIPTION: The egg-shaped vase rests on a tall, splayed foot, the neck and collar of which are molded with basket-work. The molding below the lid is wound with modeled bundles of straw, which are tied in large, thick knots to form handles. The domed lid is surmounted by a molded nest of straw, on which rests an egg, which forms a knop. Inside each lid is a kiln suspension hole, and there is a hole at the top to allow the passage of air from the hollow knop during firing.

The body of each vase is decorated with an uneven dark blue (*bleu Fallot*) ground, densely overlaid with gilded dots in close groups of four, which produce an uneven pattern. The oval reserves are painted in gray and white grisaille, as are the four putti who support the frames and the trails of gilded laurel leaves and berries that surround the reserves. The front reserves depict mythological scenes of sacrifices; the rear panels are painted with trophies.

Matt gilding is thickly applied over the molded straw on the lids and rims. On the handles the gilding is highlighted with lines of burnishing. A brightly burnished band of gilding straps the egg-shaped knop to its bed of straw. Borders of tooled gilding frame the painted reserves, suspended from a circular stud tooled as a stylized rosette. On the front the border has a matt surface, tooled along the center with a running S-scroll. The border of the back reserve also has a matt surface and is tooled with large burnished T's, alternately inverted.

The gilt-bronze base is composed of a ring of burnished "pearls," which encircles the foot of the vase, over a circular wreath of berries and laurel leaves. This is set on a burnished square plinth.

CONDITION: The decorated surfaces are in excellent condition, especially the tooling of the gilding on the back of each vase. Parts of the handles on vase .1 have been broken and recemented. There are some very small chips on the rim of each lid, caused by the fitting of gilt-bronze mounts in the nineteenth century; the mounts have been removed and the chips restored. The bowls became detached from their feet and have been recemented. The gilt-bronze base on vase .2 is missing a small length of beading.

COMMENTARY: These vases are of exceptional quality. Considering that the factory encouraged its decorators to sign their work, it is ironic that such extraordinary pieces bear neither decorator's marks nor date letters. Since the heads of the painting and gilding studios rarely signed their works, some of the grandest products are unmarked. Based on comparison between the style of the decoration of these vases and that of similar examples, they can be dated to the late 1760s. It has not been possible to identify the name given to this model in the factory's records. No other examples of this shape are in known collections, and the decorative scheme of the Museum's vases is clearly the result of careful planning and execution. The name *vases œuf* appears in the documents, referring to several egg-shaped vases produced at Sèvres in the eighteenth century, and may well have been the title given to the model under discussion. No design survives for this model, though there are drawings in the archives for other "egg vases," variously inscribed *Vase œuf à Monté* (1784), *Vase œuf* (1788), and *Vase œuf à griffes* (undated).[1] No plaster model survives in the factory's archives for a vase of this type. The stock list for new work of 1766 shows that a new model called a "vase en oeuf" or a "Vase forme de l'oeuf" was produced in that year.[2] In 1767 a second, smaller, version of this shape was introduced;[3] these were probably small, plain ovoid bowls made to be mounted with gilt-bronze feet, rims, handles, and knops.

In the eighteenth century the egg was acknowledged as an ancient symbol of the world.[4] The shape lends itself well to being incorporated as the bowl of a vase, and it was commonly used at Sèvres as the core of vases embellished with modeled handles and other features. What makes the Museum's vases distinctive is the use of modeled bundles of straw and the egg knop. One other Sèvres vase model of this period incorporates similar sheaves of straw, the *vase ruche,* represented by a pair in the Fitzwilliam Museum,

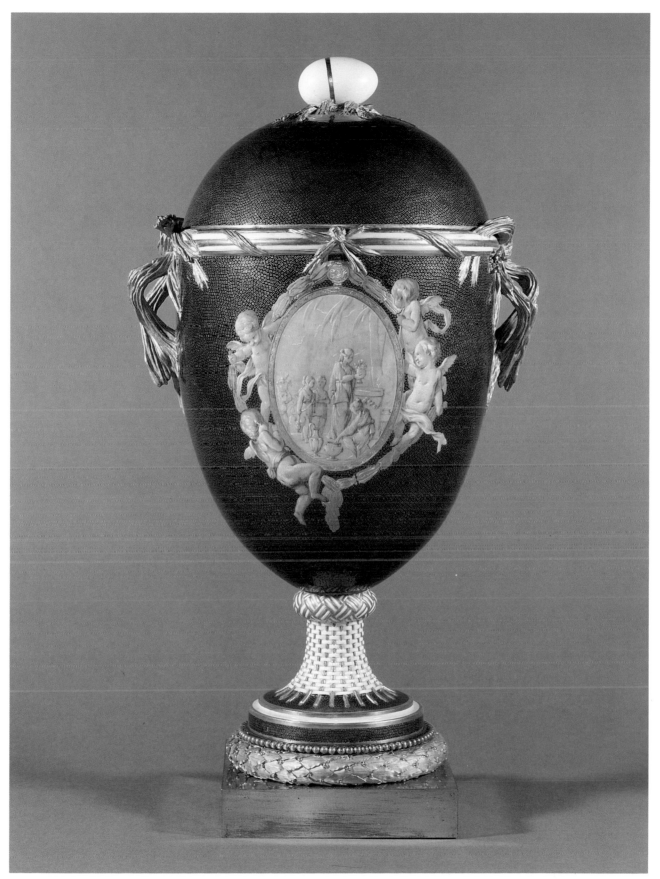

Vase . 1

Cambridge (C.3A&B-1955).[5] A plaster model of an egg-shaped vase set on the same basketwork foot as the Museum's vases survives in the factory's archives. It was called "Vase œuf Louis XVI garni" by Albert Troude, as it was also modeled with the king's profile and has large molded handles.[6] The designers of these vases are not known; by the late 1760s, however, both Etienne-Maurice Falconet and Jean-Jacques Bachelier were producing models for vases. So too, most probably, was Jean-Claude Duplessis, who was still responsible for training the throwers and *répareurs*.[7]

The incised marks on the Museum's vases indicate that they were probably intended to be part of a set of four. The numbers incised inside each section would have indicated how each vase should be assembled for firing, but the presence of different numbers on components of the same vase suggests that these guidelines were not followed.

The ground color, a distinctive tone of purplish dark blue called *bleu Fallot,* was introduced in 1764 and is found on pieces dating to 1771.[8] This color has been referred to as "Starhemberg blue," as it was used to decorate a dinner service presented by Louis XV to the Austrian ambassador Prince Starhemberg.[9] The Museum's vases display a highly unusual decoration of gilded dots in groups of four, applied over the ground color. This pattern is also found on a vase of unidentified shape, similarly dated to the late 1760s, now in a private collection, New York, and on a *vase Bachelier à serpent,* circa 1766, sold at auction in 1990.[10] A distinctive feature of Sèvres porcelain wares decorated with this ground color is that areas of the ground were often scraped off before firing. These areas were reserved to be painted with flowers in colors. The resulting decoration was described in the documents as "incrusté" (inlaid).[11] This technique seems to have been used only on pieces with this particular dark blue ground. The areas on the Museum's vases painted with putti in grisaille are similarly reserved—even a very small space for the fingertips of a putto who holds one of the gilded garlands.

The grisaille decoration on the vases is painted in imitation of stone bas-reliefs. The sales records for November 1768 list four vases with a green ground "Peints En Bas Relief"; they were given by Louis XV to the king of Denmark, forming a garniture with a *vase à médaillon du Roi.*[12] It seems likely that two of these four vases of unspecified shape were the pair, possibly of a model called "vases Dannemark à anses," now in the Walters Art Gallery, Baltimore (48.613).[13] These two vases are painted in grisaille with the same scene of a sacrifice found on vase .2, though reversed. Similar scenes are found on a pair of *vases chinois* dated 1769, forming a garniture with a *vase console,* in the Wallace Collection, London (C311–313), which have the same unusual dark blue

ground, and on a pair of undated *vases chinois* in the Victoria and Albert Museum, London.[14] The sources for these sacrificial scenes are unknown; there is, however, an engraving with a somewhat similar composition in the Sèvres factory's archives, which bears an eighteenth-century inventory number on its reverse (MNS C XIV). The engraving is after a painting by Noel Hallé depicting women at a sacrifice. A composition somewhat similar to that painted on vase .1, though reversed, shows an old man making a sacrifice at a round altar in front of a pyramid, also under palm trees. It is known in a terracotta relief signed by Alexis Loir and dated 1772; the onlookers are female, however.[15] The putti painted around the front reserves of each vase are taken from engravings after the work of François Boucher. For example, the putti at the top right of vase .2 and at the bottom left of vase .1 are from the frontispiece of the *Premier Livre de groupes d'enfans par F. Boucher, peintre du roy,* engraved by P. Aveline, a copy of which is still in the factory's archives (MNS B I, fol. 15).[16]

The Museum's vases are clearly the work of a very accomplished porcelain painter. The painters' overtime records show that a great deal of work of this type was executed in 1768 and 1769 by Jean-Baptiste-Etienne Genest, the head of the painters' studio at that time. In 1768 he painted three different plaques (presumably flat) with "bas reliefs d'enfans" and "bas reliefs d'attributs" (grisaille painting of children and of trophies). During the same year he also decorated unspecified pieces of porcelain with "cartouches" (reserves) of "bas reliefs d'enfans" (two, for 18 *livres* each), "bas reliefs de Trophées" (two, for 6 *livres* each) and "bas reliefs d'attributs" (four, for 5 *livres* each).[17] In 1769 Genest carried out more of this type of decoration, painting "Médaillons avec ornemens en Bas Relief" (roundels with ornaments in grisaille) on one *cuvette Roussel,* for which he was paid 26 *livres,* and painting the same decoration on two "Oeufs," for which he received 24 *livres* each.[18] It is probable that the latter entry refers to the trophies painted on the backs of the Museum's vases (in the absence of any other known similarly decorated egg-shaped objects) and provides a basis for dating them circa 1769. During the same year Genest also painted two *vases chinois* with two "Médaillons en Sacrifice, 2 têtes Et ornemens" (reserves showing sacrifices, two heads, and trophies), for which he was paid 46 *livres* each.[19] "Têtes" (heads in profile) were painted on the sides of the pair of *vases chinois* and a *vase console* in the Wallace Collection (see above). Geoffrey de Bellaigue has noted that in the 1750s Genest was the principal supplier to the factory of sketches for scenes to be reproduced on porcelain.[20] In 1784 Antoine Régnier, the director of the factory, noted that Genest was by then in charge of determin-

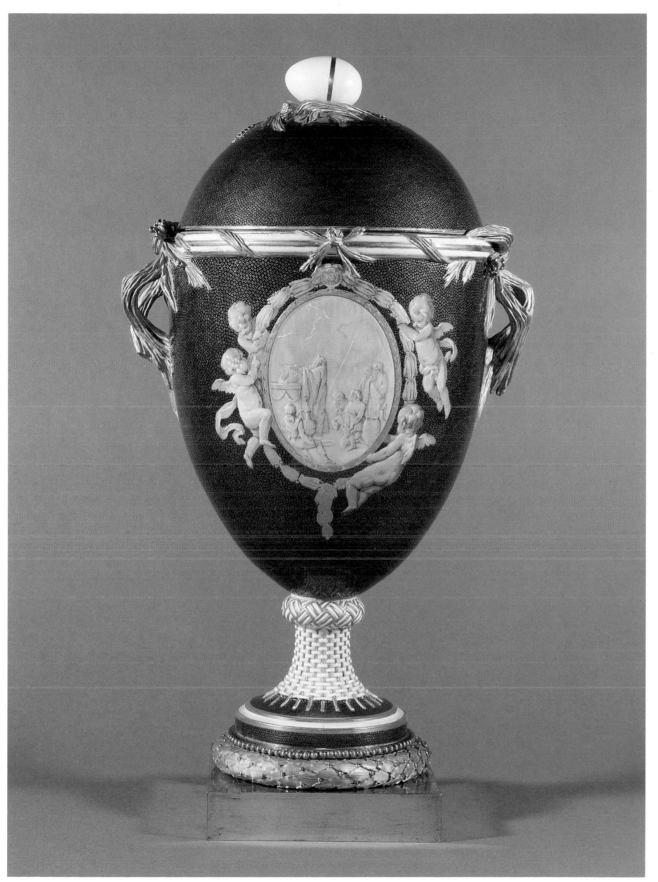

Vase .2

ing which painter would paint a particular composition on a piece of porcelain.[21]

The border gilded with a tooled pattern of inverted T's on the back of the Museum's vases is also found on a pair of *vases étrusques à cartels,* circa 1768, in the Musée du Louvre, Paris (OA.10256–10257);[22] on a pair of vases of similar date at Firle Place, Sussex; and on a *vase à glands,* circa 1770, in the Huntington Art Collections, San Marino.[23]

The Museum's vases are not identifiable in the factory's sales records. A vase of this model, decorated with a pattern of dark blue strokes in groups of four over the white glaze (or possibly gold strokes over a ground color) and with similar gilding on the modeled areas, was published in 1914 as at the Gatchina Palace, outside Saint Petersburg.[24] The caption to the illustration states that it was a single vase made at the Saint Petersburg porcelain factory around 1787. If the vase was indeed of Russian porcelain, it must have been a copy of a Sèvres original.[25] When Grand Duchess Maria Feodorovna and Tsarevitch Paul Petrovitch of Russia visited Paris in 1782, traveling as the comte and comtesse du Nord, the Russian ambassador chose for them a quantity of Sèvres porcelain wares, which they purchased from the factory and took back to Russia. These included a garniture of five "vases œufs monté en Bronze," which cost 3,600 *livres,* and two "Vases œufs beau bleu et or," which cost 480 *livres* each.[26] The former were of a plainer shape, mounted in costly gilt-bronze fittings, while the latter may have been of the same shape as the Museum's vases. If so, the latter pair could have been the prototype for the Russian porcelain vase that was later at Gatchina.

A pair of Sèvres vases of this model dated 1768 but lacking the egg and bed of straw on the lids are in the Fine Arts Museums of San Francisco (1927.184–185). The vases are also decorated with a dark blue ground and are *incrusté* with large groups of flowers in colors.[27]

It is not known whether the Museum's vases were part of a garniture. De Bellaigue and Rosalind Savill have identified them in various nineteenth-century documents. They were purchased in Paris from the dealer Rocheux on September 22, 1819, by Sir Harry Fetherstonhaugh of Uppark, Sussex, along with other Sèvres wares.[28] They were described as "2 Grands Vases [en porcelaine Vieux Sevres] fond bleu Changeant piqués en or Medaillons à enfants et sacrifice. Le tout en grisaille, des œufs pour boutons Sur des épis de bled. montées comme le précédent [gorges à jours ciselées et dorés au mat]" (Two large vases [of old Sèvres porcelain] with a mottled blue ground, pinpricked in gold, with reserves of children and sacrifices, all in grisaille, with

eggs as knops set on sheaves of wheat. Mounted like the preceding [a pierced neck chased and matt-gilded]). Apparently the pieces had been fitted with gilt-bronze galleries to form potpourri vases, though perhaps only shortly before 1819. The vases are identifiable in an outline drawing in the inventory of the Sèvres porcelain at Uppark made by the dealer John Webb in 1859.[29] They are shown with pierced gilt-bronze galleries between the rims of the bowl and the lid, presumably added in the early nineteenth century, and their foot mounts are not shown. By 1859 the vases were considered part of a set of three vases along with a *pot pourri Hébert,* also illustrated in the Webb inventory; that vase, however, was not purchased with the egg vases in 1819. Later illustrations of the *pot pourri Hébert* show that its scheme of decoration is similar to that of the vases, though its reserves are painted with a military scene on the front and a trophy on the reverse. It stood on a foot mount identical to those of the vases (shown in the 1859 drawing), which appears to be original, but was fitted with a pierced gilt-bronze gallery with ram's heads, apparently of later date. The *pot pourri Hébert* seems to be too short (47.5 cm high including the foot mount and the later gallery) to have originally formed a garniture with the egg vases. They stood 48.2 cm high in 1859 when fitted with the gallery but no foot mount and now are almost 45.1 cm high with no gallery and with the foot mounts restored.[30]

The three vases must have been sold from Uppark in the late nineteenth or early twentieth century. They were in Lionel de Rothschild's large and important collection of Sèvres porcelain at Exbury, Hampshire. Following his death in 1942, they were sold at auction in 1946 to the dealer Frank Partridge. He sold the Museum's vases to Lord Wilton, who later sold them, with the gilt-bronze gallery mounts removed, to Sir Charles Clore.[31] The *pot pourri Hébert* was bought at auction in 1971 by Rory Cameron.[32]

The Coalport factory in England copied this shape between 1851 and 1861, though the prototype is unknown.[33]

PROVENANCE: Sold by the *marchand-mercier* Rocheux, Paris, to Sir Harry Fetherstonhaugh, Uppark, Sussex, September 22, 1819; Leopold de Rothschild, Ascott, Buckinghamshire, before 1918; Lionel de Rothschild, Exbury, Hampshire; by descent to Edmund de Rothschild, Exbury, Hampshire, 1942 (sold, Christie's, London, July 4, 1946, part of lot 90); [Frank Partridge, London]; [Lord Wilton, London]; Sir Charles Clore, London and Monte Carlo (sold after his death, Christie's, Monaco, December 6, 1985, lot 6); the J. Paul Getty Museum, 1986.

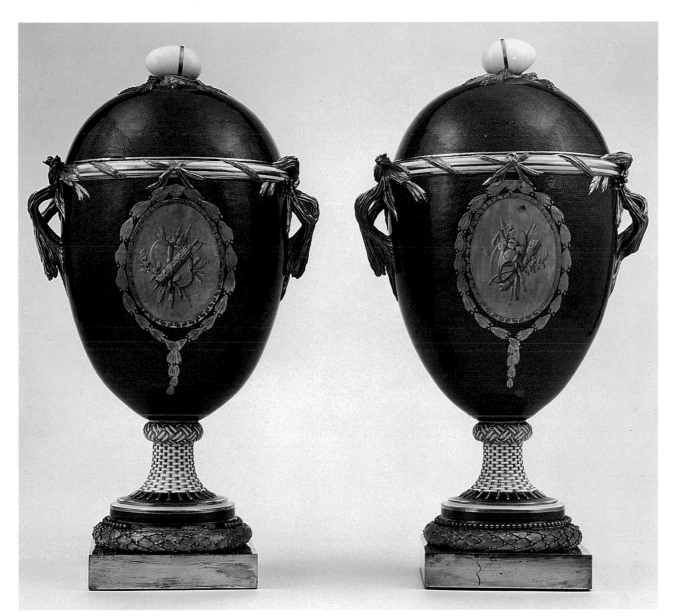

Back view

BIBLIOGRAPHY: J. Sassoon, "The Art Market, Sèvres and Vincennes," *Apollo,* no. 125 (June 1987), p. 440; Savill 1988, pp. 184, 190, n. 2j, 377, 383, n. 9.

1. MNS R.1, l.III, d.5, fols. 17(1), 16(1), 83, 83 *bis,* respectively.
2. S.L., I.7, 1767 (for 1766), fols. 6–7, 13 (the model and mold were each valued at 30 *livres,* which is much less than one might expect for vases as elaborate as the Museum's examples).
3. S.L., I.7, 1768 (for 1767), fols. 6–7 (the model and mold were each valued at 27 *livres*).
4. *Dictionnaire universel français et latin, vulgairement appellé, Dictionnaire de Trévoux* (Paris, 1771), vol. 6, s.v. "œuf." I thank Susan Newell for this reference.
5. See Brunet and Préaud 1978, p. 175, no. 153; they are undated, but a pair of this model were sold in December 1769 to the duc de Praslin for 240 *livres* each (S.R., Vy4, fol. 193r).
6. Troude [1897], pl. 117.
7. Eriksen and de Bellaigue 1987, pp. 113–114.
8. Ibid., p. 132.
9. Ibid., p. 53.
10. Bought by French and Company, New York, 1954, from Bensimon Inc. (JPGC French and Co. Archives, stock no. 55475-K); sold 1962; Hôtel Drouot, Paris, May 3, 1990, lot 173 (I am grateful to Gillian Wilson for bringing this vase to my attention).

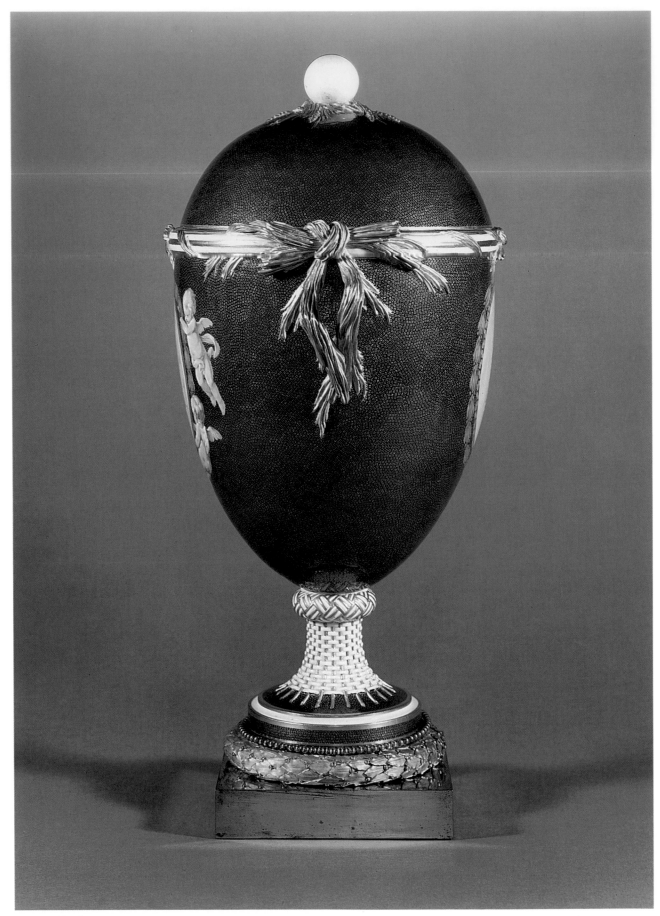

Vase .2, side view

11. For example, Bertrand painted "sur fonds bleu les fleurs incrustées" (inlaid flowers on blue grounds) on eight *gobelets litron et soucoupes* of the third size, for which he received 2 *livres* each (P.O.R., F.10, 1768). A *gobelet et soucoupe enfoncé* dated 1768 with this type of decoration is in the Victoria and Albert Museum, London (C.77&A-1909).

12. S.R., Vy4, November 9, 1768, fol. 158r ("Présents fait par Le Roy à Sa Majesté Danoise").

13. See *Catalogue of an Important Collection of Old Sèvres Porcelain, Louis XV and Louis XVI Period, Belonging to E. M. Hodgkins* (Paris, n.d.), nos. 39–40; Brunet and Préaud 1978, p. 180, no. 167.

14. W. King, *Catalogue of the Jones Collection*, pt. 2, *Ceramics* (London, 1924), p. 20, no. 149.

15. *Exhibition of European Sculpture and Works of Art,* exh. cat. (Trinity Fine Art, London, 1988), no. 43.

16. Published by Huquier; see P. Jean-Richard, *L'Œuvre gravé de François Boucher dans la collection Edmond de Rothschild,* exh. cat. (Musée du Louvre, Paris, 1978), pp. 86–87, no. 235.

17. P.O.R., F.10, 1768, "Le Sr. Genest chef des Peintres," fol. 65.

18. P.O.R., F.11, 1769, "Le Sr. Genest Chef d'attelier de Peinture," fol. 93.

19. Ibid.

20. G. de Bellaigue, "Sèvres Artists and Their Sources I: Paintings and Drawings," *Burlington Magazine* 122 (October 1980), p. 668.

21. G. de Bellaigue, "Sèvres Artists and Their Sources II: Engravings," *Burlington Magazine* 122 (November 1980), p. 751.

22. See Brunet and Préaud 1978, p. 175, no. 154.

23. Wark 1961, fig. 103.

24. *Starye Gody* 23 (July–December 1914), p. 75. I am grateful to Barbara Roberts for this reference.

25. Gillian Wilson believes that the vase was incorrectly captioned and is of Sèvres porcelain. The author's inquiries to the Soviet Union have unfortunately proved fruitless.

26. S.R., Vy8, "Etat des Porcelaines choisies par Son Excellence Le Prince Bariatinsky pour les Comte et Comtesse du Nord," fol. 181r.

27. Height (including mount) 30 cm. The vases form a garniture with a *vase à panneaux* (1927.186). The three vases also appear to be identifiable in the 1859 inventory of Sèvres porcelain at Uppark, Sussex; see below (note 29).

28. Uppark papers; the total bill was 20,000 francs. I thank Sir Geoffrey de Bellaigue for this reference. Rocheux's shop was at 8 rue Royale, Paris.

29. Webb file, Victoria and Albert Museum, C.24.6.1870, no. 25575. I thank Rosalind Savill for this reference.

30. Fetherstonhaugh was a friend of George IV and purchased works of art on his behalf when he traveled to Paris (M. Beurdeley, *La France à l'encan 1789–1799* [Fribourg, 1981], p. 104; I am grateful to Gillian Wilson for this reference). George IV also purchased at least one object from Rocheux (G. de Bellaigue, conversation with author).

Vase .2, knop

Vase .2, detail of gilding

31. Lord Wilton, conversation with Charissa Bremer-David.

32. Sotheby's, London, March 30, 1971, lot 177; private collection; Paris art market, late 1980s.

33. G. Godden, *British Porcelain: An Illustrated Guide* (London, 1986), p. 173, no. 189. I thank Rosalind Savill for this information.

20 Cup and Saucer
(gobelet Bouillard et soucoupe, première grandeur)

1770
Sèvres manufactory; soft-paste porcelain; painted by
Jacques Fontaine

Cup: HEIGHT 6.3 cm (2½ in.); WIDTH 9.2 cm (3⅝ in.);
DEPTH 7.1 cm (2¹³⁄₁₆ in.). *Saucer:* HEIGHT 3.2 cm (1¼ in.);
DIAM. 13.5 cm (5⁵⁄₁₆ in.)

MARKS: The cup is painted in blue underneath with the fac-
tory mark of crossed L's enclosing the date letter *r* for 1770,
and with the painter's mark of five dots. The cup is incised
C, and the saucer is incised *6,* under each base.

79.DE.65

DESCRIPTION: The cup is set on a short, vertical foot, re-
cessed underneath. The curved handle is formed of a single
thick, tapering strap. The circular saucer is also set on a
short, vertical foot, recessed underneath.

Both the cup and saucer are decorated with a pale
turquoise-blue ground interrupted by a *pointillé* pattern of
small, regularly spaced circles of white, each bordered by
six or seven dark blue dots. The cup has three oval white re-
serves, which are linked by broad, curved white bands dec-
orated with colored garlands of laurel leaves and berries.
Four of the five reserves on the saucer are similarly linked.
The larger circular reserves on the cup and saucer are
painted in gray and white grisaille with a winged putto. The
kidney-shaped reserves on the saucer are painted with mil-
itary trophies.

Thick, burnished lines of gilding frame the reserves,
the bands of white, and the edges of the handle of the cup.
The wide borders that frame each painted reserve are tooled
with bright slashes at each side of a bright central line over
the matt ground. This pattern forms a double crossover at
the top and bottom of each frame.

CONDITION: Both pieces are unbroken. There is some
scratching on the base of the saucer caused by the foot of the
cup. The tooling is a little rubbed.

COMMENTARY: This cup and saucer are of a common model
made at Vincennes and at Sèvres from 1753. A design for
the cup survives in the archives of the factory, inscribed *go-
blet pour le dejeune boilliard fait suivan La Comande du 18 fevryë*
(cup for the Bouillard tea service, made following the order
of February 18) and *fait* (made; MNS R.1, l.III, d.2, fol. 6).
The shape was made in three sizes, though the second size
was possibly introduced later.[1] The Museum's cup and sau-
cer are of the first size.[2] The shape was named after Antoine-
Augustin Bouillard, a *fermier-général* and *marchand-mercier*
who was a shareholder in the factory. Although the inscrip-
tion on the drawing mentions a *déjeuner Bouillard,* the design
for the tray that would have been part of such a set is not
known.

Gobelets Bouillard first appear in the biscuit kiln records
for September 1753, when 15 were fired, of which 6 were
faulty.[3] In March 1754 33 cups of this shape were fired (of
which 11 broke in the kiln) along with 41 accompanying
saucers (of which 5 were to be refired and another 5 were
broken).[4] The shape is listed in the glaze kiln records of De-
cember 1753, when 9 were fired.[5] The painters' overtime
records show that various *tourneurs* received 4 *sous* for their
work on each *gobelet Bouillard* in 1769.[6] The *tourneurs* Danet
père, Charles Defey, and one of the Delatres made at least
2,182 cups of this shape in 1769. Clearly, large numbers
were being produced by 1770, when the Museum's example
was made. In the factory's stock list after the end of 1773
there were 794 *gobelets Bouillard* (and 703 accompanying
saucers) in the Magasin du Blanc of soft-paste porcelain.[7] By
contrast, at the same time there were only 4 cups and 3 sau-
cers of this shape awaiting decoration in the Magasin du
Blanc of hard-paste porcelain.[8]

The decorative scheme of the Museum's cup and saucer
is found on tableware of the early 1770s. The overtime rec-
ords indicate that Jacques Fontaine painted many pieces
with monochrome putti. In 1768 he painted fifty-two "en-
fans Terrasses camayeux" (monochrome children in set-
tings), for which he was paid 4 *livres* each.[9] In 1769 he re-
ceived the same sum for similarly described work on fifteen
pieces and 1 *livre* 10 *sous* for each of 160 "Médaillons Et
Trophés En gris" (grisaille medallions and trophies).[10] The
overtime records for 1770 do not survive. Those for 1768
show that Dominique Joffroy was also engaged in painting
monochrome putti on clouds ("sur des nues") and in set-
tings ("sur des terrasses").[11] He was paid 3 *livres* each for
fifty-six scenes of the former type, and 4 *livres* each for six-
teen of the latter. The records show that in 1768 Vincent
Taillandier "Fait en fonds a petits ronds bleu pointillé une
roze dans le milieu du rond entourée d'une guirlande"
(made a ground of small circles and dots over blue with a
rose in the middle of a circle surrounded by a garland) on a

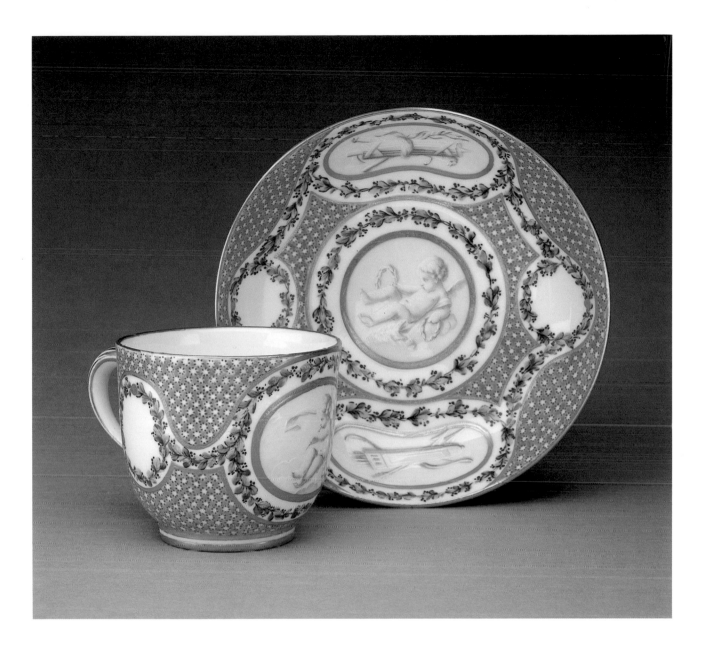

series of wares.[12] Their decoration was surely similar to that of the Museum's cup and saucer. In 1769 Taillandier painted "fond de Couleurs petits Ronds pointillés sur pieces peintes En Cartouches" (ground colors with small dotted circles on pieces painted with reserves).[13] This decoration, which probably included *pointillé* grounds of pale blue, pale green, and pink, was painted by Taillandier on a large variety of shapes, including forty *gobelets Bouillard* (more than of any other shape of cup); for this work he received 2 *livres* per cup. This ground decoration was usually applied after the reserves had been painted. Since it was a specialty of Taillandier and his wife, Geneviève, it is often recorded as "fond Taillandier" in the documents.

The factory's sales records of the 1770s are not very precise about cups and saucers; cups tend to be listed as *gobelets,* with no further description of either the shape or the decoration. In 1770 prices for cups and saucers ranged from 1 *livre* 10 *sous* to 96 *livres* each.[14] The Museum's cup and saucer may well have been sold as part of a *déjeuner,* and in that case its price would not be easily identifiable. The stock list of 1774 shows that a *gobelet litron* of the first size (see nos. 22, 24 below) with *pointillé* ground and depictions of children was in the Magasin de Vente, valued at 72 *livres*.[15]

Several similarly decorated cups and saucers of this model are known. One very close example, also of the first size, forms part of a *déjeuner tiroir* dated 1770, also painted by Fontaine, in the Wadsworth Atheneum, Hartford (1917.1066–1069).[16] A pair of similarly decorated cups and saucers of this model form part of a *dejéuner lozange* of circa 1775 in the Wallace Collection, London (C396–400). Their reserves, however, are painted with baskets of flowers in colors rather than monochrome putti and trophies. A cup and saucer very similar to the Getty Museum and Wadsworth Atheneum examples, also dated 1770 and painted by Fontaine, was on the San Francisco art market in 1984. Similarly described examples have been sold at auction; one in 1870,[17] and two in 1884.[18] An example with a pale green *pointillé* ground, described as painted by Fontaine, was sold at auction in 1873.[19] A covered *gobelet enfoncé* dated 1772 (see no. 15 above), decorated in the same manner as the Museum's cup and saucer, is in the Musée National de Céramique, Sèvres (MNC 23.006).

PROVENANCE: Sold, Christie's, London, June 21, 1976, lot 151; Mrs. John W. Christner, Dallas (sold, Christie's, New York, June 9, 1979, lot 227); the J. Paul Getty Museum, 1979.

BIBLIOGRAPHY: Wilson 1980, p. 19, item B; Sassoon and Wilson 1986, p. 82, no. 176.

Cup, front view

1. I thank Rosalind Savill for this information.

2. Cups of the first size range in height from 5.8 to 6.9 cm, and the saucers range in diameter from 13 to 14.3 cm.

3. B.K.R., September 22, 1753, fol. 13.

4. B.K.R., March 18, 1754, fol. 18.

5. G.K.R., December 31, 1753, fol. 15/17.

6. P.O.R., F.11, 1769, "Danet, Defey, Delatre," fol. 109.

7. S.L., I.8, 1774 (for 1773), fol. 61.

8. Ibid., fol. 77.

9. P.O.R., F.10, 1768, "Le Sr. Fontaine," fol. 76.

10. P.O.R., F.11, 1769, "Fontaine," fol. 107.

11. P.O.R., F.10, 1768, "Le Sr. Joffroy," fol. 75.

12. Ibid., "Le Sr. Taillandier," fol. 69.

13. P.O.R., F.11, 1769, "Taillandier," fol. 95.

14. S.R., Vy4, fol. 205v et seq.

15. S.L., I.8, 1774 (for 1773), fol. 14.

16. See G. de Bellaigue, in *J. Pierpont Morgan, Collector,* exh. cat. (Wadsworth Atheneum, Hartford, 1987), p. 185.

17. Sold, Christie's, London, February 24, 1870, lot 71, to Boore for £33 12/-. I thank Frances Buckland for this and the following information from nineteenth-century sale catalogues.

18. Property of the Hon. the Marquess of Donegal (sold, Christie's, London, March 12, 1884, lot 52, to Agnew for £21), and another (sold, Christie's, London, March 27, 1884, lot 91, to Grindlay for £24 13/-).

19. Property of John James, Esq., deceased (sold, Christie's, London, May 13 et seq., 1873, lot 389, to Smith for £27).

21 Lidded Vase
(vase à panneaux, première grandeur)

Circa 1766–1770
Sèvres manufactory; soft-paste porcelain with a gilt-bronze base

HEIGHT (including base) 47.6 cm (1 ft. 6¾ in.); WIDTH 26.0 cm (10¼ in.); DEPTH 20.5 cm (8¹⁄₁₆ in.)

2

MARKS: Incised 2 inside the neck. No painted marks.

85.DE.219

DESCRIPTION: The egg-shaped vase stands on a splayed foot and has shaped panels, front and back, recessed within borders. The neck is molded with a ring of large "pearls," each set into a cup. Beneath this ring, on the front and back, is a single pearl set on a raised disk. The domed lid is modeled with alternate tapering gadroons and pearls. The knop is oval. Thick, molded straps run down each side of the vase from the neck, folding over to form handles. The outer surfaces of the straps are set with pearls in cups. At each side a swag of leaves and berries in relief hangs from ribbons tied to nails. The lower part of the vase has applied gadroons of alternating length, which rise from a plain circular collar at the top of the foot. The base of the foot is molded with bound canework.

The body, lid, and foot are decorated with a dark blue (beau bleu) ground. On the front is an oval reserve painted with a pastoral scene. The oval reserve on the back is painted with a large bunch of flowers and leaves. The flowers include tulips, narcissi, primulas, roses, ranunculuses, pink stock, and anemones.

Thick bands of gilding highlight the sides of the handles, the foot, and other raised features such as the pearls, knop, swags, nails, and ribbons. The leaves on the swags are tooled with veins. The raised panels on the front and back of the neck have a gilded trellis pattern, laid over the ground color. The squares formed by the trellis are filled with an arrangement of dots. The main panels are framed with bands of gilding tooled with zigzag lines. At the front, tied by a gilded ribbon bow, two gilded branches of leaves

with berries fall to either side of the paneled reserve and pass beneath the handles to the back of the vase, where they merge into a similar foliate frame surrounding the reserve. The front reserve is framed by three gilded borders: a broad inner band, a central band of alternating long ovals and circles, and an outer border formed by bright dots. The longer gadroons around the lower part of the vase are densely tooled with wavy lines. The ground color on the gadroons of the lid is gilded with thick, burnished slashes rising from the base to accentuate the curved shape.

The vase is glued to a square gilt-bronze stand, with a circular laurel wreath around the base of the vase. The stand rests on four paw feet and is decorated on each side panel with fretwork over a cross-hatched ground.

CONDITION: The vase is in excellent condition. The foot has been separated from the base and recemented (they were made as separate pieces and fired together). The tooling of the gilding and the decorated surfaces of the vase are unworn. There is wear to the base caused by the gilt-bronze mount. The gilding is worn on five of the pearls surrounding the neck. On the front raised panel there is a shallow, round hole in the glaze filled with old, perhaps even original, painting.

COMMENTARY: This model was called the vase à panneaux at the Sèvres factory, though it was sometimes also referred to as a vase à perles. The plaster model survives in the factory's archives but does not appear in the stock lists of the 1760s, as one might expect (illus.).[1] The date of this shape's introduction cannot be established in the documents, but the earliest known examples bear the date letter for 1766.[2] It was made in two sizes; the Museum's example is of the first, and larger, size.[3] There are two drawings relating to this shape in the factory archives, one inscribed à panneaux, the other, vase à panneaux (MNS R.1, l.1, d.5, fols. 18, 19; illus.). References to this shape appear in the glaze kiln records in 1768 and in 1770,[4] and in the tourneurs' records in the 1770s.[5]

The decoration of the Museum's vase is typical of the grandest vases produced at Sèvres in the second half of the 1760s. The pastoral scene on the front reflects the taste for seventeenth-century Dutch landscape painting in contemporary France. Carolyn Gay Nieda has published the source for this scene, an untitled engraving in the archives at Sèvres (illus.), which bears an eighteenth-century factory inventory number (p.f. no. 14). The print is English and bears a notice stating that it was "Printed for & sold by J. Dubois at ye Golden Head near Cecil Street in ye Strand." It appears to be one of a set of three copies after a Dutch engraving of this composition.[6] A painting of this subject signed by Ni-

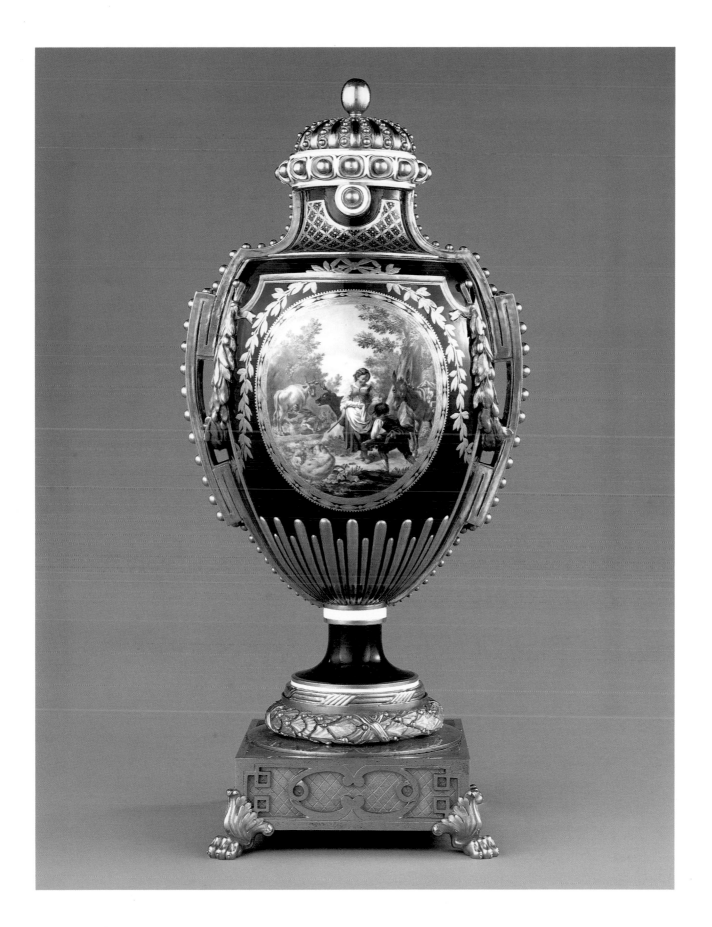

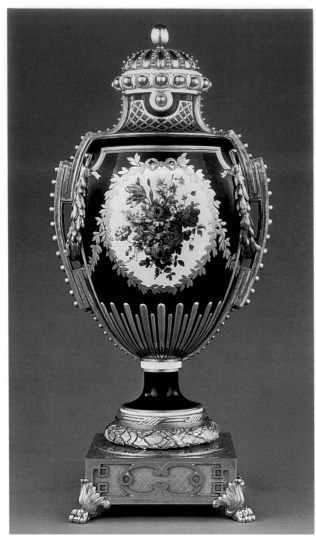

Back view

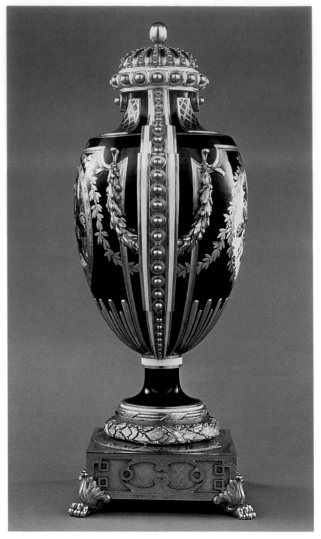

Side view

colaes Berchem (1620–1683) was sold at auction in 1975.[7] The only other known piece of Sèvres porcelain painted with the main figures from this engraving is an undated *vase à bâtons rompus* in the Musée National de Céramique, Sèvres (MNC 25084), which has flowers and leaves painted in a white reserve on the back. Like the Museum's example, this vase bears no painter's mark and cannot be attributed to any Sèvres painter based on documentary evidence.

The gilding on the Museum's vase is of outstanding quality, and it is noteworthy that the overtime records for 1767 indicate that the gilder Etienne-Henri Le Guay was paid 6 *livres* "Pour avoir Bruni un Vaze a perles 2e gdeur" (for having burnished the gilding on a *vase à panneaux* of the second size).[8] No other Sèvres *vases à panneaux* with the same painted and gilded decoration are known, and no *vases à panneaux* (or *vases à perles*) are identifiable in the factory's sales records of the late 1760s. A great number of vases were listed simply as "pièces d'ornements," and they were sold for a range of high prices. In 1767 one "Grand Vaze Bleu Marine" (large vase with a blue ground painted with a marine scene) was sold for 750 *livres* cash.[9]

There are many other *vases à panneaux* in museum collections, including examples in the Wallace Collection, London (C297–300);[10] the Victoria and Albert Museum, London (Jones Collection, 785&A-1882 [a pair]); the Metropolitan Museum of Art, New York (Kress Collection, 58.75.80–84 [two pairs and one single example]); the Rijksmuseum, Amsterdam (R.B.K. 17514 [a pair]); the Musée National de Céramique (MNC 25.173 [a pair]); the Israel Museum, Jerusalem (120.75a–b [a pair]); and the California Palace of the Legion of Honor, San Francisco (1927.186).[11] Examples are in the British Royal Collection;[12] at Schloss Wilhelmshöhe, Kassel (20487);[13] in private collections in Paris.[14] Others have been sold at auction in 1907, 1935, and 1980.[15]

The Museum's vase stood on its gilt-bronze base when it was sold in 1946 (see Provenance). In 1884, however, when it was in the collection of Alfred de Rothschild, it was photographed standing on a gilt-bronze base of another model (see Bibliography). A *vase à panneaux* in the Wallace Collection (C300) is set on a base of the same model as that now fitted, but lacking the paw feet at the corners. It was almost certainly fitted with its base before 1848.[16] The Museum's vase may be the one sold at Christie's in 1876 from the collection of the comte de Jarnac.[17] It was purchased by the first Earl of Dudley, much of whose collection was sold in the 1880s (see entries for nos. 10, 11 above). By 1884 the vase had entered the collection of Alfred de Rothschild, one of the greatest nonroyal holdings of Sèvres porcelain ever formed. Following his death the collection was divided between his illegitimate daughter Almina Wombwell, fifth

Countess of Carnarvon, and his nephew Lionel de Rothschild. She inherited Alfred's house in Seymour Place, London, and its contents, while Lionel inherited Halton House, Buckinghamshire, and its contents. Numerous Sèvres porcelain vases and other objects from Alfred de Rothschild's collection are now in American museums.

The *vase à panneaux* was copied by several nineteenth-century porcelain factories, including Coalport[18] and other English factories,[19] and at Limoges.[20]

PROVENANCE: (?)Comte de Jarnac, Thomastown Castle, Ireland (sold, Christie's, London, June 23, 1876, lot 89, to William Humble, 1st Earl of Dudley); possibly sold by his widow; Alfred de Rothschild, Halton, Buckinghamshire, by 1884; by descent to Lionel de Rothschild, Exbury, Hampshire, 1918; by descent to Edmund de Rothschild, Exbury, Hampshire, 1942 (sold, Christie's, London, July 4, 1946, lot 87, to [Frank Partridge Ltd., London]); Colonel Norman Colville, England; private collection, California (sold, Christie's, New York, January 30, 1985, lot 137); [The Antique Porcelain Company, New York, 1985]; the J. Paul Getty Museum, 1985.

BIBLIOGRAPHY: C. Davis, *A Description of the Works of Art: Collection of Alfred de Rothschild,* vol. 2 (London, 1884), fig. 87; C. G. Nieda, "A Sèvres *Vase à Panneaux,*" *GettyMusJ* 14 (1986), pp. 127–134; Savill 1988, pp. 244, n. 31, 278, 281, n. 19, 325, 332, n. 3c, 380, 383, n. 21, 1125.

1. MNS Archives, 1814 Inventory, "Vase à panneaux," 1740–1780, no. 135. See Troude [1897], pl. 3 (height of second size 34 cm).
2. De Bellaigue (1979, pp. 30–31, no. 10) corrects Laking's error in identifying the earliest dated examples.
3. Examples of the first size range in height from 46.2 to 49.5 cm; those of the second size, from 32.0 to 33.4 cm.
4. G.K.R., January 1, 1768, fol. 40 ("2 Vazes à perles"); October 1, 1770, fol. 50 ("1 [Vaze] à perles").
5. I thank Tamara Préaud for this information.
6. Information kindly supplied by Maxime Préaud, Bibliothèque Nationale, Paris.
7. Sold, Weinmüller, Munich, June 25, 1975, lot 1017. I thank Frances Buckland for this information.
8. P.O.R., F.9, 1767, "Le Guay [gilder]," fol. 51.
9. S.R., Vy4, October 20, 1767, fol. 122v.
10. A pair and two single examples; one (C300) forms a garniture with a pair of *vases ferrés* (C301–302).
11. The vase, dated 1768, forms a garniture with a pair of *vases œuf.*

12. F. Laking, *Sèvres Porcelain of Buckingham Palace and Windsor Castle* (London, 1907), nos. 38, 39, 70, 92, 93; De Bellaigue 1979, nos. 10, 33 (two pairs and one single example).

13. This vase forms a garniture with two *vases Fontanieu cylindre*. I am grateful to Dr. Stubenvoll of the State Museums, Hessen, for information regarding this garniture. See also S. Eriksen, *Early Neo-Classicism in France* (London, 1974), p. 369.

14. Ader, Picard, Tajan, Paris, December 9, 1981, lot 275 (a pair); see also P. Chapu, in *Les porcelainiers du XVIIIᵉ siècle français* (Paris, 1964), p. x (a pair).

15. These include a single example from the Chappey collection (sold, Paris, April 29–May 3, 1907, lot 60); a pair and a single example from the Edward Steinkopff collection (sold, Christie's, London, May 22–23, 1935, lots 9–10); a single example from a California collection (sold, Christie's, New York, November 21, 1980, lot 303; previously sold from the collections of Alfred and Lionel de Rothschild, Christie's, London, July 4, 1946, lot 88, to Mrs. Chester Beatty; offered for sale as property of Sir Arthur Chester Beatty, Sotheby's, London, November 15, 1955, lot 125, unsold).

16. I thank Rosalind Savill for this information.

17. Removed from Thomastown Castle, Ireland. It was described as " 'A gros-bleu Sevres vase and cover,' of oval form, with white and gold strap handles raised gilt festoons of foliage and flutings, beautifully painted with a large medallion of two pastoral figures and cattle after Berghem, on one side, and a group of flowers and implements on the other side." I thank Frances Buckland for this information. Michael Hall believes, however, that Alfred de Rothschild purchased this vase on a visit to Russia in the 1870s.

18. Sotheby's, New York, April 16–17, 1982, lot 162.

19. Sotheby's, Chester, September 29, 1982, lot 123.

20. Sotheby's, Belgravia, December 2, 1971, lot 282.

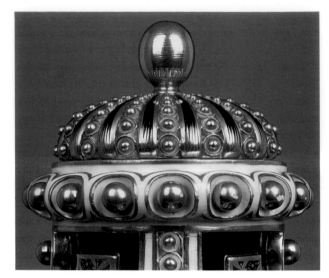

Detail of lid

After Nicolaes Berchem (Dutch, 1620–1683). *Untitled.* Engraving. Manufacture Nationale de Sèvres, Archives C XIII.

Design for the *vase à panneaux*. Manufacture Nationale de Sèvres, Archives.

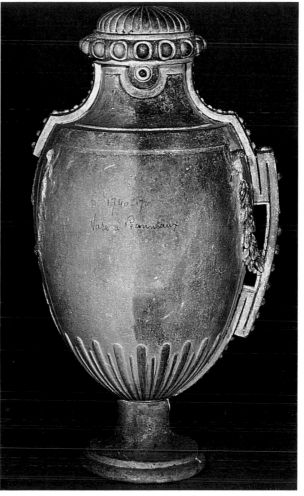

Plaster model for the *vase à panneaux*. Manufacture Nationale de Sèvres, Archives.

Detail of gilding

22 *Cup and Saucer*
(gobelet litron et soucoupe, deuxième grandeur)

1773
Sèvres manufactory; soft-paste porcelain; painted by Etienne-Jean Chabry; gilded by Michel-Barnabé Chauvaux *aîné*

Cup: HEIGHT 6.7 cm (2⅝ in.); WIDTH 8.9 cm (3½ in.); DEPTH 6.6 cm (2⁹⁄₁₆ in.). *Saucer:* HEIGHT 3.9 cm (1⁹⁄₁₆ in.); DIAM. 13.9 cm (5⁷⁄₁₆ in.)

MARKS: Both the cup and saucer are painted in blue underneath with the factory mark of crossed L's enclosing the date letter U for 1773 and with the painter's mark *ch;* marked in gold with the gilder's mark #. The saucer is incised *da*.

79.DE.64

DESCRIPTION: The cup has straight sides; a flat bottom, recessed underneath; and an ear-shaped handle that divides into two sections, one curving upward and the other downward to join the wall of the cup. The deep saucer has straight, sharply angled walls and a flat bottom, recessed underneath. Each piece has a kiln suspension hole in its base.

The cup and saucer are decorated with a turquoise-blue (*bleu céleste*) ground with a *pointillé* pattern of small white circles, each bordered by eight darker blue dots. On the front of the cup is an oval reserve painted in colors with a scene of a shepherdess and sheep. The circular reserve in the center of the saucer is painted in colors with a putto in a landscape with an open book inscribed *LAVARE*. A pair of comedic masks, a tambourine, and a jester's stick are on the ground in front of him.

Thick, burnished gilding is applied in plain bands and dentil patterns to the rims of both pieces and around the base of the cup. The handle is highlighted with gilding, and its upper surface is decorated with three trefoils and four dots of diminishing size. The reserves of both pieces are framed with a band of gilding tooled with alternate matt and bright bands; the matt areas are edged with a zigzag line.

CONDITION: Both pieces are unbroken. There are minor scratches on the base of the saucer caused by the movement of the cup. The gilding is in fine condition, though the tooling is a little rubbed.

COMMENTARY: By 1752 this model, called a *gobelet litron et soucoupe,* was being produced in five standard sizes (though larger ones were also made).[1] The Museum's cup and saucer are of the second size. No models or molds for the shape survive in the archives at Sèvres, but plaster molds for the cups and saucers of the first and second sizes are recorded in the factory's stock list for 1752.[2] The shape was produced in large numbers[3] and with various handles. Drawings relating to this shape survive at Sèvres, including one dated 1782 that shows a handle of the same design as that on the Museum's cup.[4] This type of handle is slightly less common; it is also found on a *gobelet litron* of 1772 in the British Royal Collection.[5]

The painted scene on the cup is taken from an engraving by Jean-Jacques-André Le Veau after a painting by Philip James de Loutherbourg entitled *L'Agneau chéri* (The cherished lamb). At the time the engraving was made, the painting was in the collection of M. Foulquier of Toulouse. A copy of the engraving, with an eighteenth-century inventory number on the reverse, is in the archives at Sèvres (C XV, Loutherbourg). The same scene was used by the painters Charles-Nicolas Dodin in 1777,[6] Claude-Charles Gérard in 1778,[7] and by unknown painters circa 1772–1773[8] and in 1780.[9] The scene on the saucer refers to the comedy *L'Avare* by Molière, first produced in 1688. It is probably based on an engraving since it appears on other pieces of Sèvres porcelain, including one of a pair of *vases Fontanieu* of 1773 painted by Dodin in the British Royal Collection,[10] one of a pair of *vases chinois* circa 1765–1770,[11] and a *gobelet litron* by Etienne-Jean Chabry dated 1772 (London, Victoria and Albert Museum, D. M. Currie Bequest, C.466&A-1921).

Carl Christian Dauterman has suggested that the incised mark *da* may be for the *tourneur* Danet *père*.[12] The painters' overtime records do not provide detailed information about Chabry's and Michel-Barnabé Chauvaux's work in 1773.[13] In 1774, however, Chabry painted "pastorals et attributs" (pastoral scenes and trophies) on *gobelets litron* of the first and second sizes. For those of the first size, which had five reserves on each cup and saucer, he received 18 *livres,* while for those of the second size, which had three reserves, he was paid 9 *livres*.[14] After the end of 1773 two *gobelets litron* of the second size painted with "fonds Taillandier" (*pointillé* decoration) and flowers were recorded as

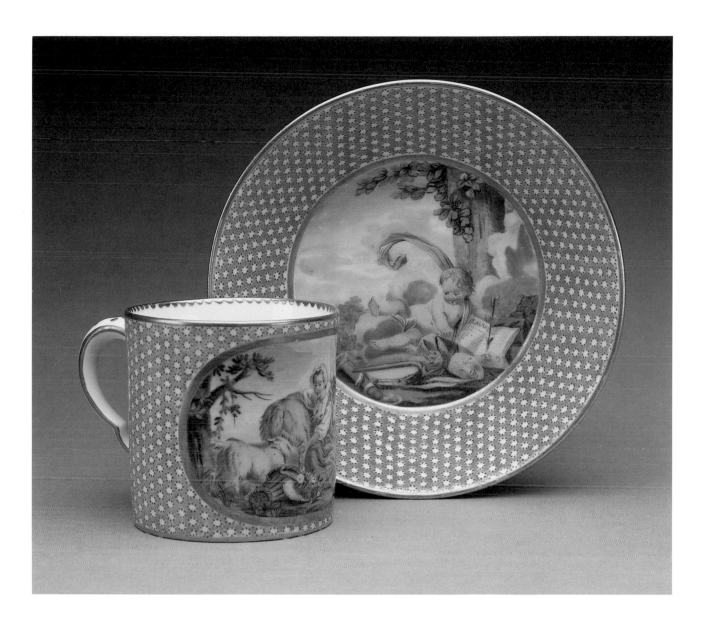

being in the Magasin de Vente.[15] They cost 48 *livres* each. At the same time a *gobelet litron* of the first size was listed, also with "fond Taillandier" and with depictions of children.[16] Whether the children were painted in colors or in grisaille was not recorded, but that cup and saucer cost 72 *livres*. Thus the Museum's example would probably have sold for between 48 and 72 *livres*.

PROVENANCE: Sold, Sotheby's, London, July 26, 1977, lot 345; Mrs. John W. Christner, Dallas (sold, Christie's, New York, June 9, 1979, lot 226); the J. Paul Getty Museum, 1979.

BIBLIOGRAPHY: Wilson 1980, p. 19, item C; Sassoon and Wilson 1986, p. 82, no. 177.

1. Eriksen and de Bellaigue 1987, p. 279; de Bellaigue 1979, p. 114.
2. S.L., I.7, 1752 (up to October 1), fol. 9 (valued at 15 *sous* each).
3. Ibid., fol. 27; in 1752 there were 158 *gobelets* and 156 *soucoupes* (valued at 50 and 30 *sous* each, respectively) in the Magasin du Blanc and many more in the Magasin de Vente (fols. 37, 39), priced between 3 and 7 *livres* per cup and saucer.
4. Inscribed *no. 18 gobelet litron donné affaires par M. Vautrin Le 28 Mai 1782 et sa soucoupe* (Vautrin was the keeper of the Magasin du Blanc; MNS R.1, l.II, d.2, fol. 13).
5. See de Bellaigue 1979, p. 114, no. 118, ill. p. 113.
6. A *gobelet litron,* collection of Mr. and Mrs William E. Wiltshire III, Richmond, Virginia (sold, Sotheby's New York, December 1, 1977, lot 235).
7. A *gobelet litron* (London, Victoria and Albert Museum, J. G. Joicey Bequest, C.1356&A-1919).
8. A *gobelet Bouillard,* unmarked; the saucer is painted with a scene similar to that on the saucer in note 6 above (Art Institute of Chicago 1966.513 a–b).
9. In an expanded version, with a boy standing to the right, on the basin of a *pot à eau et jatte à la Romaine* from the collections of Alfred de Rothschild and later of his daughter Almina, Countess of Carnarvon (sold, Christie's, London, May 19–21, 1925, lot 244, to Lewis and Simmons); London art market, 1988.
10. See de Bellaigue 1979, pp. 87–88, no. 91.
11. Collection of vicomtesse Vigier (sold, Paris, April 24, 1970, lot 34); later in the collection of Mrs. John W. Christner, Dallas (sold, Christie's, New York, June 8–9, 1979, lot 225).
12. Dauterman 1986, pp. 65, 189.
13. P.O.R., F.15, 1773, "Chabry fils ainé," fol. 117 (206 *livres*); "Chauvaux Se," fol. 119 (147 *livres*).
14. P.O.R., F.16, 1774, "Chabry," fol. 128.
15. S.L., I.8, 1774 (for 1773), fol. 15.
16. Ibid., fol. 14.

Cup, painted reserve

23 Pair of Vases
(vases bouc du Barry B)

1778
Sèvres manufactory; hard-paste porcelain; painted by Fallot, gilded by Jean Chauvaux *le jeune*

HEIGHT 29.5 cm (11⅝ in.); WIDTH 17.9 cm (7 in.); DEPTH 12.0 cm (4¾ in.)

MARKS: Each vase is marked underneath in gold with the factory mark of crossed L's beside the date letters *AA* for 1778, underneath a crown for hard paste. One is marked in gold with the painter's mark of an F (abraded), and both bear the gilder's mark *IN*. No incised marks.[1]

70.DE.99.1–2

DESCRIPTION: Each vase stands on a plain, round, incurving foot, recessed underneath. A molding around the collar of the neck conceals a join. At each side, below the shoulder of the vase, is a goat's head, with horns and a beard. Beneath each head hangs a goat's pelt. The four legs of each pelt are tied together in the centers of the front and back walls. Modeled garlands of flowers and leaves hang from four molded studs on the neck of the vase.

Painted on the front of each vase is a blue vase filled with stylized flowers, set on scrollwork. In the center is an oval panel painted with a landscape in tones of pink (*camaïeu rose*). Two stylized birds are perched on the scrolls. Above is a similar arrangement, with another stylized bird in the center. Garlands of stylized flowers and leaves hang from the scrollwork, and small sprays of flowers are found at the edges and base of the panel. Butterflies and birds are found on the foot and neck. On the back of each vase is an arrangement of flowers in a basket, which is suspended from a blue ribbon bow. Between the tied legs of the goatskins are military trophies.

Thick, burnished gilding is applied to the garlands, goat's heads, pelts, and neck molding. The top of the neck and the edges of the base are also gilded. On the goat's heads and skins the gilding is partly tooled with hair motifs. The areas painted with enamel colors are bordered by thin gold lines. The basket on the rear panel is in gilding, as are the studs, tooled with rosettes, to which the ribbons are "tied."

Silver is used to form a trellis between the *pointillé* areas on the lower panels of the fronts and a dotted reserve around the small landscape panels.

CONDITION: Each vase has a repaired foot rim. The silver has tarnished to a dull black, and some of the silver trelliswork has worn away. The gilding is worn in areas, particularly around the bases, which were once held in metal mounts. There are several vertical firing cracks inside the neck of vase .1.

COMMENTARY: This model, called the *vase bouc du Barry B,* was introduced in 1771. The factory's stock list compiled after the end of that year shows several new models and molds for vases named in honor of Louis XV's mistress.[2] A plaster model survives in the archives at Sèvres (illus.).[3] The shape was made in three sizes, though known examples seem to range in height between 29.5 and 32 cm. Rosalind Savill has pointed out that the shape was made in three versions, in both hard- and soft-paste porcelain. There was also a closely associated shape called the *vase bouc du Barry A.*[4] While all three versions have goat's heads and a molding around the neck, the more elaborate versions are distinguished by the addition of goatskins and by the further addition of garlands of flowers in relief (as on the present examples).

The Museum's vases provide an interesting example of early decoration on hard-paste porcelain. First produced at Sèvres in 1769, hard paste achieved dominance over soft paste only gradually. The application of ground colors to hard-paste porcelain was not entirely successful at first, so the wares were often left white. Antoine d'Albis has pointed out that in the 1770s decoration on hard-paste porcelain was sometimes executed in the reverse order of that on soft-paste porcelain.[5] Thus the gilding was applied first, and the enamel colors were painted into the structure of the gilded patterns in a cloisonné manner. Savill has noted that this work was usually carried out by one decorator; another decorator would gild broad areas such as the goat's heads and rims on the present examples. The use of silver is rare. As Savill has shown, various decorators were recorded using it in 1778 and 1779.[6] Since silver tarnishes, it was not practical for this type of decoration, and by 1779 platinum was being used instead (see no. 30 below).[7]

Savill and Geoffrey de Bellaigue have identified the Museum's vases in the painters' overtime records for Fallot in 1778 and in the kiln records. In the latter Fallot's name is

entered against "2 vases à testes de Bouc" fired on November 16, 1778; they were painted with "corbeilles" (baskets) and "oiseau" (bird[s]).[8] Earlier Fallot was recorded as having decorated two vases (of unspecified shapes), for which he was paid 60 *livres* each.[9] In the same year the decorator Jean-Jacques Dieu received 60 *livres* each for his work on two *vases bouc du Barry B;* presumably Fallot would have received about the same sum.

Savill has pointed out that a pair of hard-paste vases of this model were sold for 360 *livres* each in 1777 to Louis XVI, who presented them to his brother-in-law the emperor of Austria.[10] Thus one might expect the Museum's vases, which were fired in November 1778, to be sold for a similar sum, and not before early 1779. Savill has identified nine vases sold during 1779 for 360 *livres* each; one pair and a set of three were purchased by Louis XVI,[11] Louis XV's daughter Madame Victoire purchased a pair,[12] and an unnamed member of the court purchased the final pair at the end of 1779.[13] The Museum's pair were surely among these vases. Louis XVI's sister-in-law the comtesse d'Artois apparently owned examples of this model; in Year III of the Republic (1794–1795), "Deux Vases formes d'oves avec Guirlandes et Draperie têtes de béliers formant anses . . . et dorés sur fond blanc en porcelaine de Sèvres" (two egg-shaped vases with garlands, drapery, and goat's heads as handles . . . gilded on a white ground of Sèvres porcelain) were listed among her possessions.[14] This could have been either the pair purchased by a member of the court or that purchased by the king, which was then given to his sister-in-law.

At least nine other examples of this model are in known collections. A pair in the Musée du Louvre, Paris (OA.6237), without the skins and garlands modeled in relief, may be the pair sold at auction in 1887.[15] A pair with skins, but without molded garlands, was sold at auction in 1963 as part of a garniture with a *vase à feuilles de laurier.*[16] This garniture may be that sold at auction in 1871 and 1886.[17] A single vase of the same model is in a New York private collection; it may be that sold at auction in 1874.[18] A pair decorated with chinoiserie naval battles was formerly at Althorp House, Northamptonshire.[19] Another pair of this model was sold at auction in 1977.[20]

A large agate vase of this form, fitted with gilt-bronze mounts of the same design as the relief decoration on the Museum's vases, was sold at auction in 1980 and is in a private collection, Paris.[21] Two smaller pairs of similarly mounted agate vases have also been sold at auction, one in 1961 and the other in 1987.[22] The shape was copied at the Samson factory in Paris in the late nineteenth century.[23]

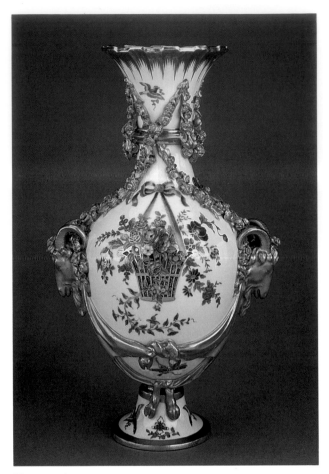

Alternate view

PROVENANCE: Sir Richard Wallace, Paris, probably acquired after 1870; by descent to Lady Wallace, Paris, 1890; by descent to Sir John Murray Scott, Paris, 1897; by descent to Victoria, Lady Sackville, Paris, 1912; Jacques Seligmann, New York, 1916–1917; Mortimer L. Schiff, New York (sold by his heir, John L. Schiff, Christie's, London, June 22, 1938, lot 26); J. Paul Getty.

BIBLIOGRAPHY: Sassoon and Wilson 1986, p. 83, no. 178; R. Savill, "A Pair of Sèvres Vases: From the Collection of Sir Richard Wallace to the J. Paul Getty Museum," *GettyMusJ* 14 (1986), pp. 136–142; Savill 1988, pp. 442, 446, n. 45, 1021, 1022, n. 2.

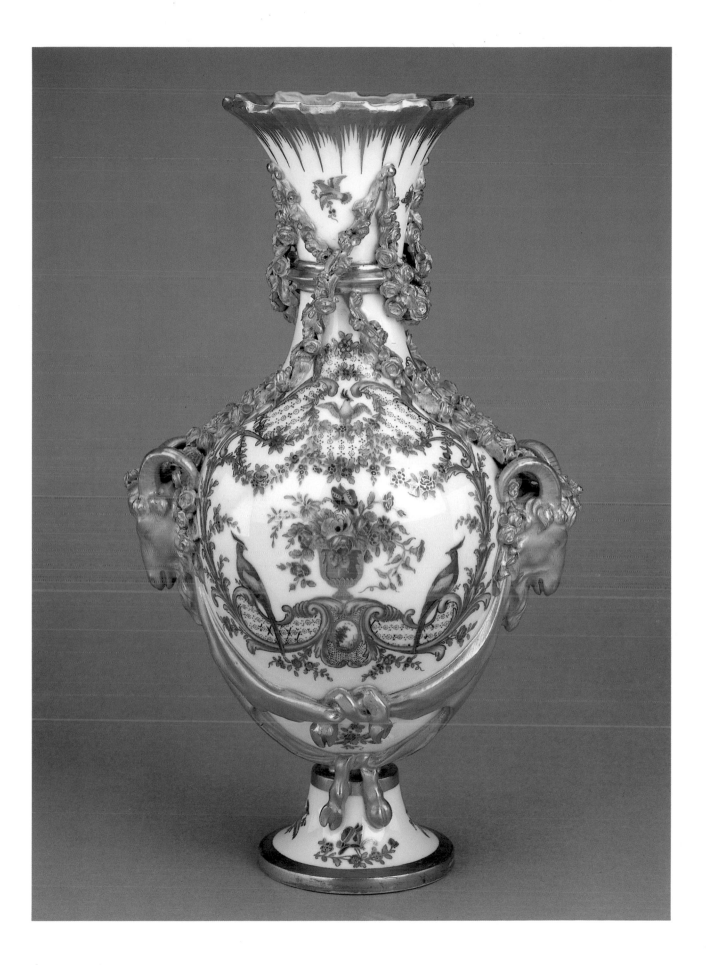

1. These vases were previously mounted on nineteenth-century marble plinths, each with a label inscribed *29 R. Wallace*.

2. S.L., I.8, 1772 (for 1771), fols. 7, 9. The models were valued at between 40 and 150 *livres* each, and the molds, between 96 and 300 *livres* each.

3. MNS Archives, 1814 Inventory, "Vase du Barry B," 1740–1780, no. 154 (height 35 cm). See Troude [1897], pl. 98.

4. Much of this information about the Museum's vases is from Savill 1986 (Bibliography).

5. Conversation with the author.

6. Savill 1986 (Bibliography).

7. Ibid.

8. K.R., Vl1, fol. 31r.

9. P.O.R., F.20, 1778.

10. Savill 1986 (Bibliography); S.R., Vy6, April 30, 1777, fol. 207v.

11. S.R., Vy7, fol. 178v.

12. Ibid., fol. 181v.

13. Ibid., December 24, 1779, fol. 190r (at Versailles).

14. J. Riesener, M.-E. Lignereux, and P. Julliot, *Inventaire et extraits de procés-verbaux des Commissaires Estimateurs des Commission des Revenues Nationaux et de Commerce et d'Approvisionnement,* no. 28. Information kindly supplied by Jean-Dominique Augarde.

15. Soft-paste porcelain, circa 1775; property of the comtesse de Jarnac (sold, Christie's, London, May 18, 1887, lot 124, to the dealer Davis for £136 10/-). I thank Frances Buckland for this and the following references from nineteenth-century auction catalogues.

16. Soft-paste porcelain, circa 1775; collection of René Fribourg, New York (sold, Sotheby's, London, October 15, 1963, lot 455); present location unknown.

17. Property of a Lady of Rank (sold, Christie's, London, February 28, 1871, lot 297, to Manning); 1st Earl of Dudley (sold, Christie's, London, May 21, 1886, lots 188, 189).

18. Paste unknown, late 1770s, with a dark blue marbled ground; collection of A. B. Mitford (sold, Christie's, London, June 12, 1874, lot 132).

19. Hard-paste porcelain, 1778, modeled with goatskins and garlands; on the London art market since 1986. See Eriksen and de Bellaigue 1987, pp. 331–332, no. 142.

20. Hard-paste porcelain, dated 1780, with a dark blue marbled ground; collection of Alphonse de Rothschild; Dr. Annella Brown, Boston (sold, Sotheby's, New York, April 23, 1977, lot 56); now on the New York art market.

21. Sotheby's, Monaco, May 26–27, 1980, lot 711.

22. Collection of the Countess of Craven (sold, Sotheby's, London, November 20, 1961, lot 144); Leo Spik, Berlin, March 19–21, 1987, lot 1945. I am grateful to Bernard Dragesco for pointing out the latter reference. It is possible that these are the same pair, but those sold in 1961 were in good condition, whereas those sold in 1987 had broken rims concealed by later gilt-bronze mounts.

23. Christie's, London, March 3, 1980, lot 37.

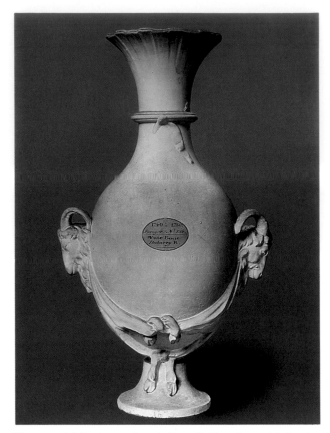

Plaster model for the *vase bouc du Barry B.* Manufacture Nationale de Sèvres, Archives.

24 Cup and Saucer

(gobelet litron et soucoupe, deuxième grandeur)

1781

Sèvres manufactory; soft-paste porcelain; ground color painted by Antoine Capelle, painted reserve and cameos attributed to Pierre-André Le Guay, flat gilding by Etienne-Henri Le Guay, "jeweling" by Philippe Parpette

Cup: HEIGHT 6.9 cm (2¾ in.); WIDTH 9.4 cm (3¹¹⁄₁₆ in.); DEPTH 9.3 cm (3¹¹⁄₁₆ in.). *Saucer:* HEIGHT 3.6 cm (1⅜ in.); DIAM. 13.6 cm (5⁵⁄₁₆ in.)

MARKS: The cup and saucer are painted in blue underneath with the factory mark of crossed L's enclosing the date letters DD for 1781, and with the mark of a triangle for the ground color painter. The saucer is also painted in blue with the gilder's mark *LG*. The saucer is incised underneath *44;* the cup is incised *36a* over *6*.

PAPER LABEL: The saucer bears a paper label under the base inscribed *Coll. of the Marchioness of Conyngham 1908. R. M. Wood Esq.*

81.DE.28

DESCRIPTION: The cup and saucer are of the same shape as those described above (see entry for no. 22), but the handle of the cup has an inverted, hipped curve at its base.

Both pieces are decorated with a thick matt brown (probably *merde d'oie*) ground. The cup has a lobed reserve at the front painted in colors with a scene of a Sacrifice to Cupid. On the two sides of the cup and in two places on the wall of the saucer, there are small, slightly domed oval plaques of porcelain, painted in imitation of stone cameos with profiles of classical busts in tones of brown and white. Those on the cup depict Juno and Ammon; those on the saucer, Jupiter Capitolinus and Omphale.

The cup and saucer are decorated with raised gold foils applied over the ground color with a blue fixative. Some of the foils are set with globules of enamel in imitation of jewels. The opaque white enamel drops imitate pearls, and translucent enamels in red, orange, yellow, and green imi-

tate precious stones. On the cup the foils form an elaborate frame for the painted reserve consisting of foliate C- and S-scrolls with branches of green laurel leaves, red berries, and orange flowers at each side, all surrounded by a string of white "pearls." Larger translucent enamels are fired to gold surfaces that are themselves stamped and tooled. Two strings of circular foils, set with alternating drops of white and orange enamel, wind around the cup, forming large and small ovals over the ground color. The two smaller ovals each frame an oblong gold foil set with an orange enamel jewel. The two large ovals each contain a large oval gold foil, overlaid with orange enamel. The cameo-style plaques are set on similar gold foils, and although these plaques are opaque, the foil is impressed and tooled underneath with an elaborate rosette.

The saucer is similarly decorated with two painted cameo-style plaques set on gold foils of the same form as those on the cup. A string of circular foils, set with alternating drops of white and orange enamel, surrounds the well of the saucer; this feature is also used around the base of the cup. In the center of the well is a burnished rosette in flat gilding. The rims of the cup and saucer are edged with burnished gilding in a dentil pattern. The sides of the handle are gilded, as is the foliate decoration on its outer surface.

CONDITION: The cup and saucer are in excellent condition. The oval plaque of porcelain painted with the profile of Omphale has become detached from the saucer, exposing the tooling on the gold foil underneath. The glaze in the well of the saucer is worn, and a number of enamel jewels are missing from both pieces.

COMMENTARY: This model, the *gobelet litron et soucoupe,* is discussed above (see entry for no. 22). The present example is of the second size.

This lavishly decorated cup and saucer can be traced in detail in the Sèvres factory's documents. The decoration can be divided into five elements: the ground color, the painted cameos, the painted reserve on the cup, the flat gilding, and the jeweling (described as *émaillé* [enameled] in the factory records).

The Sèvres painters' records for 1781 show that Antoine Capelle applied brown grounds to a number of *gobelets litron et soucoupes.*[1] The colors included "fond nouveau," "fond boue de Paris" (Parisian mud), and "fond merde d'oie" (goose droppings). By process of elimination, the ground of the Museum's cup and saucer can be identified in the documents as *merde d'oie.* Capelle is recorded as having applied this color to one *soucoupe* for a *gobelet litron* of the second size by January 18, 1781.[2] Brown grounds were a

novelty at Sèvres at this date. In the painters' overtime records of March 1781 Louis-Antoine Le Grand is recorded as gilding and silvering a tea service that had a "fond brun" (brown ground).[3] A hard-paste *déjeuner du Roy* (two cups and saucers, a sugar bowl, and a teapot), dated 1779 and 1781, sold at auction in 1985, may be similar to those decorated by Le Grand.[4] Their ground color is brighter than that of the Museum's cup and saucer.

The painted scene on the front of the cup has been identified by Edith Standen as based on an engraving entitled *Offrande à l'amour* by C.-L. Jubier after a composition by Jean-Baptiste Huet (illus.).[5] This scene is also painted on one of a pair of unmarked *vases chinois ou pied de globe* at Boughton House, Northamptonshire. The painters' records of 1781 show that Pierre-André Le Guay had by January 21 painted "Enfants et sujets Mignatures" (children and figure scenes) on five *gobelets litron* of the second size (the Museum's saucer does not have a painted reserve).[6] On the basis of factory documents the four painted cameo-type plaques attached to the Museum's cup and saucer can be attributed to Le Guay. Rosalind Savill has pointed out that in September 1781 he is recorded as having painted six "Camés Émaillés, Peinture en grisaille" and six "Camées Émaillés bas relief en Grisaille," for which he received 6 *livres* each.[7]

Savill has shown that the cameo profiles are based on designs created in 1776 for the celebrated turquoise-blue-ground dinner service ordered by Catherine II of Russia.[8] A sheet printed with twelve different outline designs for these profiles survives in the archives at Sèvres (illus.). A notation on the reverse explains that the designs were placed on a piece of porcelain and fired so that the paper would burn away, leaving an outline for the painter to fill in. Cameos such as these are found on other jeweled Sèvres wares of similar date, for example, a *gobelet litron et soucoupe* with dark blue ground, circa 1780, in the National Museum, Stockholm (cxv 1602). On the Museum's example the cameos are painted on oval pieces of porcelain molded with a rosette on their reverse, which fits into the raised gold rosette of conforming design that is the central feature of the framing foil. It is difficult to explain why such work would be carried out and then concealed; on other examples the gold rosette is covered with translucent enamel, allowing one to see the gold work beneath. A jeweled *gobelet litron* with dark blue ground, formerly in the Chester Beatty collection, has similar cameo-style profiles painted on porcelain plaques set into the flat central panel of a simpler gold foil; again this can be seen where the cameos have become detached.[9] Cameo-style profiles were also painted directly onto the body of pieces, for example, a *vase royal,* circa 1768–1770, in the British Royal Collection.[10]

Cup, front view

C.-L. Jubier after Jean-Baptiste Huet (French, 1745–1811). *The Worship of Cupid.* Engraving. London, Courtauld Institute of Art.

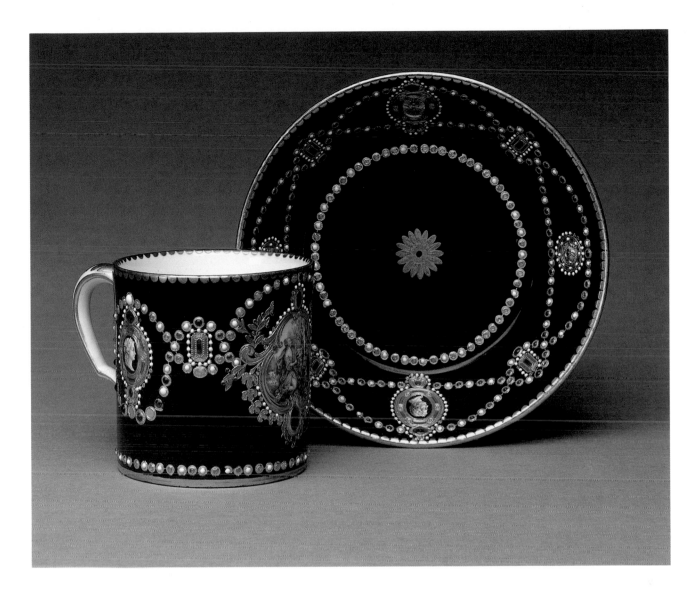

The documents reveal that the jeweling on the Museum's cup and saucer was carried out by Philippe Parpette. He would have been responsible for forming the gold foils, decorating them with enamel, and attaching them to the porcelain. The painters' records show that Parpette decorated several jeweled *gobelets litron* and saucers of the second size with *merde d'oie* grounds in 1781. In January he was paid 36 *livres* each for "Émaillé Riche" (rich jeweling) of two cups, and 12 *livres* for one saucer of this type.[11] In April he was paid 42 *livres* each for jeweling two *gobelets litron* of the second size with *merde d'oie* grounds, which had been painted by Le Guay.[12] This strengthens the attribution of the painting of the Museum's cup to Le Guay. The painters' overtime records show that in April 1781 Parpette also jeweled two *gobelets* of unspecified size for 36 *livres* each, one saucer for 12 *livres*, and two cups of the third size for 30 *livres* each, all of which had *merde d'oie* grounds.[13] In August 1781 he jeweled another pair of *gobelets et soucoupes* of the second size but with unspecified ground "peinte en Mignature par le Sr le Guay" (painted with figures by Le Guay).[14]

These references are confirmed by the surviving enamel kiln records for 1781. These records generally list an object and its painter and gilder; for jeweled wares, however, the painter's name is often replaced by that of the author of the elaborate jeweling. Since saucers are not listed separately, it seems likely that references to *gobelets* here also included an accompanying saucer. In the firing of January 22, 1781, one *gobelet litron* of the second size and one of the third size are listed with "fond merde d'oie" and jeweling by Joseph Coteau (see below).[15] In the firing of February 4, 1781, there were two *gobelets litron* of the second size and two of the third, all decorated with "fond merde d'oie" and jeweling; the decorators were listed as Parpette and the gilder Etienne-Henri Le Guay.[16] It seems very likely that one of the two cups and saucers of the second size in the February firing was the Museum's example. Another *gobelet litron* of unspecified size and ground color with jeweling "et or" (and additional gilding) was fired on May 7, 1781; its decorators were Parpette and the gilder Le Guay.[17] That Le Guay worked on the Museum's pieces is confirmed by the presence of his mark on the saucer. His work was surely confined to the gilding of the rims, the handle, and the rosette in the base of the saucer.

The jeweled decoration on this cup and saucer and on the three lidded vases also in the Museum's collection (no. 25 below) involves an extraordinary combination of techniques used at Sèvres chiefly between 1780 and 1785. Tamara Préaud and Geoffrey de Bellaigue have shown that the two artists responsible for most of this work were Coteau and Parpette.[18] De Bellaigue has shown that in about 1782 Coteau, who was also an enamel painter,[19] and Parpette both claimed to have invented this technique for Sèvres.[20] The gold foils that were glued to the porcelain were formed by stamping in steel dies engraved by Jean-Pascal Le Guay. Designs for these dies (a few of which survive in the factory's archives) were supplied by Jean-Baptiste-Etienne Génest, the head of the painters' studio at this date.[21] A letter from comte d'Angiviller (the king's *commissaire* at the factory from 1779) to Antoine Régnier (the director of the factory, also from 1779) dated June 2, 1781, discusses a design by Génest for ten dies to be used for this type of decoration.[22] It seems that Coteau's and Parpette's work was subject to Génest's control.

Coteau executed this type of work at Sèvres between 1780 and 1782. A pair of dark blue-ground vases from the Faubourg Saint-Denis porcelain factory in Paris display similar jeweled decoration by Coteau; they are signed and dated 1783 (Paris, Musée du Louvre OA.7738–7739). He was responsible for the jeweling of the extensive toilet service, which included a porcelain mirror frame, presented to the future Tsarina of Russia, Maria Feodorovna, when she visited Paris in 1782 as the comtesse du Nord.[23] It was a gift from Marie-Antoinette and cost 75,000 *livres*, a very high price.[24] Even then there was concern that the jeweling was not securely fixed to the porcelain. Baronne d'Oberkirch recorded that the comtesse du Nord made sure that the service was well protected during its journey to Russia.[25]

The dies used to create the gold foils on the Museum's cups and saucers were used for other jeweled porcelains at Sèvres. The oval cartouches framing the grisaille profiles, for example, are also found on the Museum's *vases des âges* (no. 25), as are the circular bosses in the border of the saucer. Both the oval framing foil and these circular bosses are seen on the *gobelet litron et soucoupe* in Stockholm (see above). The elaborate scrollwork framing the painted reserve on the Getty Museum's cup is notably rococo in style for this date, and it too is found on other examples of jeweled Sèvres porcelain, including a *gobelet litron* formerly in the Chester Beatty collection,[26] and another with a green ground dated 1781, formerly in the collection of the Marchioness of Conyngham.[27] The same scrollwork frame appears on a pair of vases with dark blue ground dated 1780, of the model possibly called *vase Falconet cannelé à guirlandes*, but is inverted (Musée du Louvre OA.10945–10946).

Cup, painted head of Juno

Cup, painted head of Ammon

Although probably fired in January 1781, the Museum's cup and saucer cannot be identified in the factory's sales records. Cups and saucers described as *émaillé* do not appear until October 22, 1781, when the duchesse de Civrac purchased one for 120 *livres*.[28] Its ground color and painted decoration were not specified, and as is the case with the other *gobelets émaillés* listed, the shape and size are not stated. Since surviving jeweled cups and saucers of this date are almost all of the *litron* shape, it seems safe to assume that most of these references are to *gobelets litron*. Other cups and saucers specified as *émaillés* in the sales records during 1781 and 1782 each cost 192 *livres* (to the comte de Creutz),[29] 144 *livres* (to the duc de Polignac),[30] 96 *livres* (to M. de Vezelai),[31] and 72 *livres* (two *gobelets* to Madame Adélaïde).[32] In the records of the Versailles sale of December 1782 to January 1783 there are many very expensive *gobelets* whose decoration is not described, many of which were no doubt jeweled. Louis XVI purchased examples costing 120, 144, and 216 *livres*,[33] and other expensive *gobelets* were sold for 144 *livres* (to the comtesse de Provence, Madame Elisabeth, and the princesse de Lamballe), 168 *livres* (to the dauphin), 192 *livres* (to Madame Elisabeth, Madame Victoire, the comte de Creutz, and the comte d'Adhémar), and 240 *livres* (to Madame Victoire).[34]

Saucer, painted head of Jupiter Capitolinus

The cup and saucer are identifiable in the auctions of the collections of the third Marchioness of Conyngham and R. M. Wood, Esq., in 1908 and 1919, respectively. Elisabeth, first Marchioness of Conyngham, was a mistress of George IV, who presented her with many works of art, including some Sèvres wares. This cup and saucer cannot be identified among these gifts, however.[35] Other cups and saucers with brown grounds and jeweling are identifiable in late nineteenth- and early twentieth-century sales. A pair with painted grisaille heads said to come from Horace Walpole's collection at Strawberry Hill were sold in 1867 from the collection of Joseph Maryatt,[36] and a cup with similar decoration was sold in 1901.[37] In 1876 a cup and saucer with jeweling and a brown ground was sold from a nobleman's collection.[38] A cup and saucer with a brown ground and jeweling, incorporating a frame probably similar to that on the Museum's cup, was sold from the collection of the late J. Pierpont Morgan in 1944.[39]

PROVENANCE: Jane, Marchioness of Conyngham (married the 3rd marquess 1854, died 1907), London and Ascot, Berkshire (sold, Christie's, London, May 4, 1908, lot 289, to the dealer Harding for 162 gns. 15/-); R. M. Wood, London (sold, Christie's, London, May 27, 1919, lot 96, to Mallett's, London, for 152 gns. 12/-); Henry Walters, New York (sold by his widow, Parke Bernet, New York, November 30, 1943, lot 1009); private collection, New York (sold, Christie's, New York, December 3, 1977, lot 166); [Armin B. Allen, New York, 1977]; the J. Paul Getty Museum, 1981.

BIBLIOGRAPHY: Sassoon 1982, pp. 87–90; Wilson 1983, no. 40; Sassoon and Wilson 1986, pp. 83–84, no. 179.

1. Vj2, 1781, "Capelle," fol. 72r..
2. Ibid.
3. P.O.R., F.23, March 1781, "Le Grand," fol. 252; he was paid 48 *livres* for his work.
4. Sotheby's, London, March 5, 1985, lots 118–120.
5. E. A. Standen, *European Post-Medieval Tapestries and Related Hangings in the Metropolitan Museum of Art,* vol. 2 (New York, 1985), pp. 638–639, no. 103.
6. Vj2, January 21, 1781, "Le Guay," fol. 143r.
7. P.O.R., F.23, September 1781, "M. Le Guay [Peintre]," fols. 272, 274.
8. R. Savill, " 'Cameo Fever': Six Pieces from the Sèvres Porcelain Dinner Service Made for Catherine II of Russia," *Apollo,* no. 116 (November 1982), pp. 304–311; Sassoon 1982, p. 88.
9. Sold, Sotheby's, London, November 16, 1955, lot 108; present location unknown.
10. De Bellaigue 1979, pp. 29–30, no. 9.

11. Vj2, January 1781, "Parpette," fol. 200r; at the same time he received 30 *livres* each for jeweling two *gobelets litron et soucoupes* of the third size with *merde d'oie* ground.
12. Vj2, April 1781, "Parpette," fol. 200r.
13. P.O.R., F.23, April 1781, "Parpette," fol. 256.
14. Ibid., August 1781, "Parpette," fol. 270.
15. Vl1, January 22, 1781, fol. 143r; sent to be burnished on February 13, 1781.
16. Vl1, February 4, 1781, fol. 148r.
17. Vl1, May 7, 1781, fol. 156v; sent to be burnished on May 16, 1781.
18. T. Préaud, "Sèvres Enamelled Porcelain: Eight Dies (and a Quarrell), Rediscovered," *Burlington Magazine* 128 (June 1986), pp. 391–397; Eriksen and de Bellaigue 1987, p. 139.
19. For one of several known enamel clock faces signed by Coteau, see W. Edey, *French Clocks in North American Collections,* exh. cat. (Frick Collection, New York, 1982), no. 84.
20. Eriksen and de Bellaigue 1987, p. 139; MNS Archives, D 3.
21. G. de Bellaigue, "Sèvres Artists and Their Sources I: Paintings and Drawings," *Burlington Magazine* 122 (October 1980), pp. 667–676.
22. MNS Archives, H 2, l.II. The foils were fired to the porcelain with an enamel base that is a deep powdery blue color, visible when a foil has become detached.
23. *La France et la Russie au siècle des Lumières,* exh. cat. (Grand Palais, Paris, 1986–1987), nos. 487–491.
24. S.R., Vy8, fol. 216r.
25. "Toute la peur de Mme la comtesse du Nord était que, pendant la route, on ne brisait ces magnificences. Elle en fit prendre tous les soins possibles" (The comtesse du Nord's greatest fear was that during the journey these magnificent things would be broken. She made sure that every possible care was taken; Parker 1964, p. 110).
26. Photo, Wallace Collection archives, London.
27. Later sold, Christie's, Geneva, November 17, 1980, lot 41.
28. S.R., Vy8, fol. 108v.
29. Ibid., December 10, 1781, fol. 115r.
30. Ibid., December 1781–January 1782, fol. 150v (at Versailles).
31. Ibid., June 17, 1782, fol. 179r.
32. Ibid., June 14, 1782, fol. 183v.
33. Ibid., fols. 225r, 256r.
34. Ibid., fols. 256r, 256v, 257r, 257v, 258v, 259r.
35. I thank Geoffrey de Bellaigue for this information.
36. Sold, Christie's, London, February 13, 1867, lot 634.
37. Sold, Christie's, London, November 29, 1901, part of lot 36.
38. Sold, Christie's, London, May 10, 1876, lot 135, to Mills.
39. Sold, Christie's, London, March 22–29, 1944, lot 312, to Nyberg.

Painted head of Omphale, now detached from saucer

Back of oval porcelain plaque with head of Omphale

Gold foil on which the oval plaque with head of Omphale was mounted

Engraved designs for profile portraits of mythological figures. Manufacture Nationale de Sèvres, Archives I 2, 5ème division.

25 Three Lidded Vases

(vases des âges, première et deuxième grandeurs)

1781

Sèvres manufactory; soft-paste porcelain; models designed by Jacques-François Deparis; at least one vase modeled by Etienne-Henry Bono; painted by Antoine Caton; flat gilding by Etienne-Henri Le Guay; "jeweling" by Philippe Parpette

Vase .1: HEIGHT 47.0 cm (1 ft. 6½ in.); WIDTH 27.7 cm (10⅞ in.); DEPTH 19.3 cm (7⅝ in.). *Vase .2:* HEIGHT 40.8 cm (1 ft, 4 in.); WIDTH 24.8 cm (9¾ in.); DEPTH 18.4 cm (7¼ in.). *Vase .3:* HEIGHT 40.5 cm (1 ft. 3¹⁵⁄₁₆ in.); WIDTH 25.4 cm (10 in.); DEPTH 18.3 cm (7³⁄₁₆ in.)

MARKS: Both vase .2 and vase .3 are painted in gold underneath with the factory mark of crossed L's adjacent to the gilder's mark *LG.* No painters' marks. Vase .1 is incised *.1.0 B* inside the neck, and *10 B* and *age 1e g* underneath. Vase .2 is incised *A 16* inside the neck and *39 A* underneath. Vase .3 is incised *Bono* over a *B* inside the neck, and *age 2eg* underneath.

84.DE.718.1–3

DESCRIPTION: Each egg-shaped vase is set on a circular splayed foot with a stepped base on a square plinth. At each side is a tapered strap, topped by a scroll that supports a flat bracket upon which there is a bust. On the largest vase the busts depict elderly bearded men, while those on the smaller vases depict young women with garlands of flowers in their hair. The lids of the smaller vases have an egg-shaped knop. The domed lid of the larger vase has a knop formed as a cone, modeled with leaves and berries. Lid .2 has a kiln suspension hole.

The body, lid, base, and upper part of the plinth of each vase are decorated with a dark blue (*beau bleu*) ground. On the front of each vase is a large oval reserve painted in colors. The reserve on vase .1 depicts Minerva protecting

Telemachus from Cupid's darts. The reserve on vase .2 depicts Telemachus in the deserts of Oasis, consoled by Termosiris, the priest of Apollo. The reserve on vase .3 depicts Venus bringing Cupid to Calypso in order to punish Telemachus.

On the other side of each vase is a large white oval reserve painted in colors with fruit and flowers. On vase .1 these include a bunch of grapes, delphiniums, hollyhocks, nasturtiums, and poppies. Vase .2 is painted with anemones, campanulas, cornflowers, daisies, primulas, roses, and a tulip. Vase .3 is painted with a similar bunch of flowers, including poppies.

The ground color is overlaid with numerous stamped gold foils, some set with drops of colored enamel imitating jewels. Above and below each reserve there is an oval foil set with an imitation moss agate, bordered by thin rectangular panels of translucent orange enamel. Strings of "pearls," some with orange enamels, frame the painted reserves and decorate the lid, collar, foot, and plinth of each vase. Around each painted reserve are eight large circular foils. Circular jeweled foils are also found at each corner of the plinth. Four are placed around each foot and collar and on the lids. A trail of orange leaves and red berries, all set on small gold foils, is woven between the circular foils surrounding the reserves.

The handles and knops are covered with burnished gilding in imitation of gilt-bronze. The busts are partly matt, with tooling indicating skin, cloth, and hair. The vertical walls of the base of each foot and the plinth are gilded over the white with vertical lines in imitation of milled gilt bronze. A broad band of tooled gilding frames each painted reserve.

CONDITION: The base of vase .1 has been broken and restored. Its lid is a nineteenth-century copy, which has also been broken and restored. Vases .2 and .3 each have a metal pin holding the bowl to the foot, and .2 has a repaired chip on a corner of the plinth. There are a number of repaired chips and touched-up areas of gilding. A number of jewels have fallen off, and some of them, as well as some of the missing foils and "moss agates," have been replaced. The tooling of the gilding is worn on the front of vase .1, and the glaze on this vase is pitted in places. The painted surfaces are in excellent condition.

COMMENTARY: This model, produced at Sèvres from 1778, was called the *vase des âges.*[1] It was made in three sizes, those of the first size with heads of elderly men at each side, those of the second size with heads of young women, and those of the third size with heads of small boys. The model was apparently designed by Jacques-François Deparis, and two

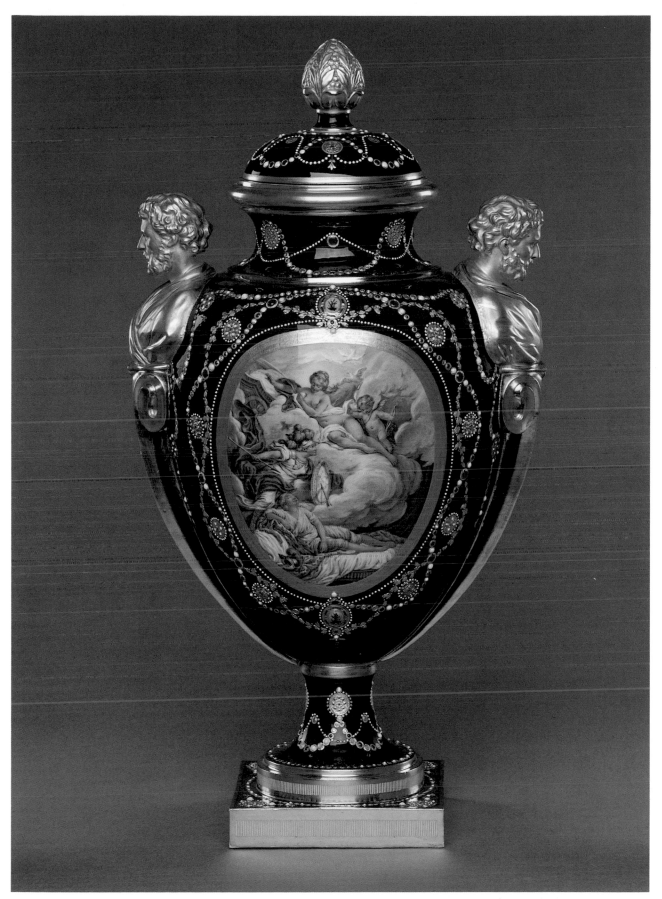

Vase . 1

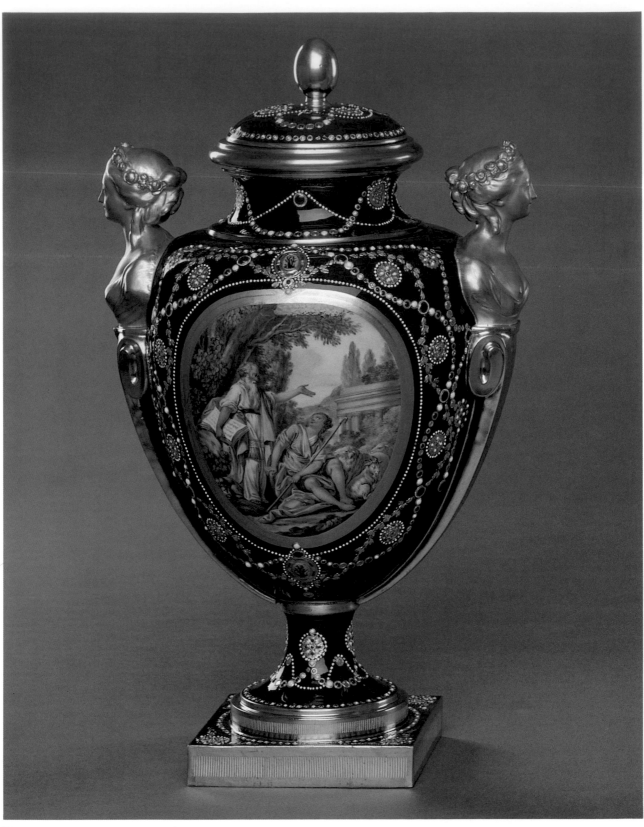

Vase .2

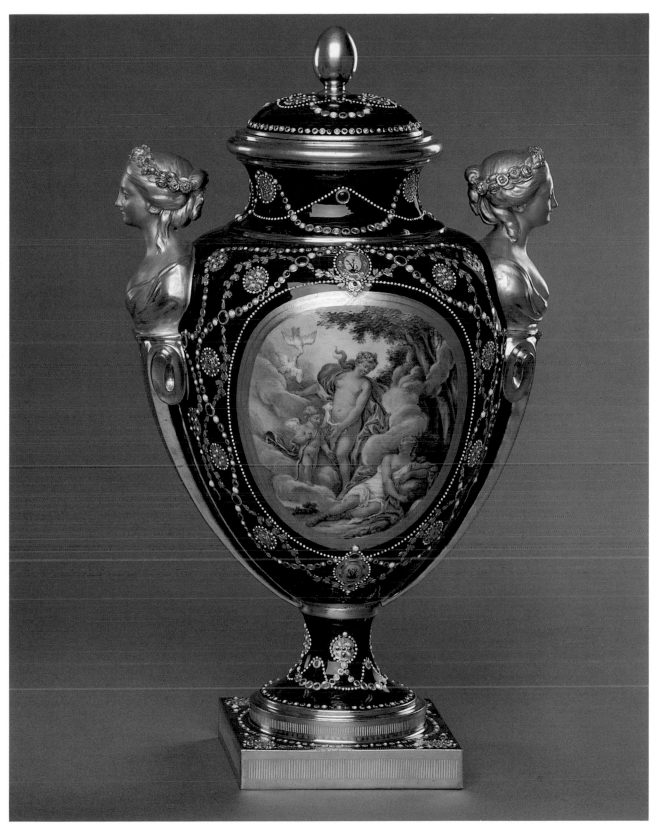

Vase . 3

designs survive in the factory's archives (MNS R.1, l.III, d.5, fols. 50, 51). Two plaster models survive, one of the second size,[2] and one possibly of the third size, but without handles (illus.).[3] The factory's stock list of unfired wares compiled in March 1780 records six molded examples and one on which the *répareurs* had finished their work.[4]

The incised mark *Bono* over a *B* inside the neck of vase .2 indicates that this vase was finished by the *répareur* Etienne-Henry Bono. The same mark is found on several other large Sèvres porcelain vases of similar date, including a *vase des âges* of the third size and three of the second size in the British Royal Collection,[5] and one of a pair of *vases à côtes de Paris,* circa 1775–1785, at Waddesdon Manor, Buckinghamshire.[6] The marks *.1.0 B* and *10 B* incised inside the neck and foot of vase .1 are probably reference marks for the *répareurs*. They were intended to identify the components of each vase (the foot and bowl) before assembly. The incised inscriptions *age 1e g* (*première grandeur*) and *age 2eg* (*deuxième grandeur*) are also found on several other known *vases des âges* (including those in the British Royal Collection), indicating their relative sizes. Incised marks inside the foot or neck indicating the model and size of a vase appear on a number of examples produced in the early 1780s.[7]

Geoffrey de Bellaigue has shown that the Getty Museum's vases come from a garniture of five *vases des âges* that were begun in 1780 and completed during 1781.[8] The other two vases, of the third size, are now in the Walters Art Gallery, Baltimore (illus.). De Bellaigue has also shown that all five are painted with scenes based on engravings published beginning in 1773 by Jean-Baptiste Tilliard (1740–1813), after designs by the painter Charles Monnet (1732–after 1808). These engravings illustrated an edition of François de Salignac de La Mothe-Fénelon's book *Les Aventures de Télémaque*. The scene on vase .1 is entitled *Minerve protege Télémaque et le préserve des traits de l'Amour* (Minerva protects Telemachus and preserves him from Cupid's darts; illus.); that on vase .2 is entitled *Télémaque dans les déserts d'Oasis est consolé par Termosiris prêtre d'Apollon* (Telemachus is consoled by Termosiris, priest of Apollo, in the deserts of Oasis; illus.); and that on vase .3 is entitled *Venus pour satisfaire son ressentiment contre Télémaque amene l'Amour à Calypso* (Venus brings Cupid to Calypso, in order to satisfy her resentment against Telemachus; illus.). Scenes based on these illustrations appear on many pieces of elaborately decorated Sèvres porcelain from the 1780s, including much of the dinner service produced for Louis XVI's use at Versailles (see no. 29 below). Indeed the scenes painted on vases .2 and .3 are found on pieces of the Louis XVI service.[9] The scene showing Telemachus with Termosiris is painted on a *seau à bouteille* of 1788, and the scene depicting Venus and Calypso is

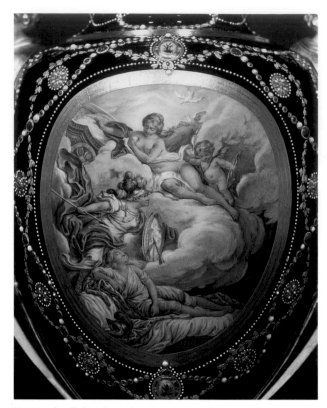

Vase .1, detail showing painted reserve

Jean-Baptiste Tilliard (French, 1740–1813) after Charles Monnet (French, 1732–after 1808). *Minerve protege Télémaque et le préserve des traits de l'Amour.* Engraving. Williamstown, Mass., Williams College, Chapin Library of Rare Books.

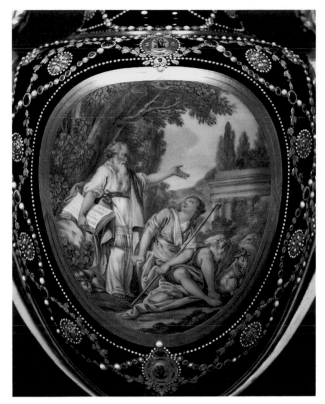

Vase .2, detail showing painted reserve

Vase .3, detail showing painted reserve

Jean-Baptiste Tilliard (French, 1740–1813) after Charles Monnet (French, 1732–after 1808). *Télémaque dans les déserts d'Oasis est consolé par Termosiris prêtre d'Apollon.* Engraving. Williamstown, Mass., Williams College, Chapin Library of Rare Books.

Jean-Baptiste Tilliard (French, 1740–1813) after Charles Monnet (French, 1732–after 1808). *Venus pour satisfaire son ressentiment contre Télémaque amene l'Amour à Calypso.* Engraving. Williamstown, Mass., Williams College, Chapin Library of Rare Books.

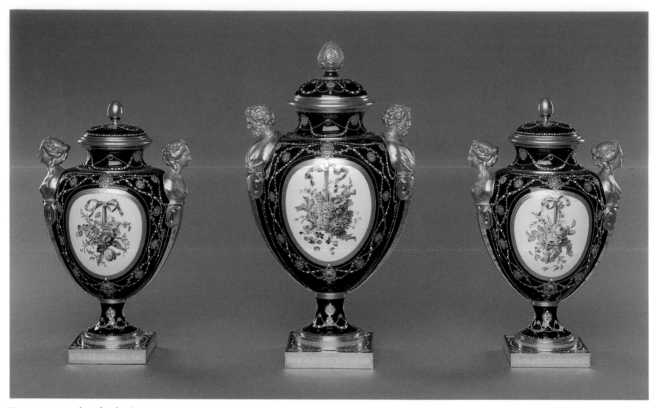

Vases .2, .1, and .3, back view

painted on a *seau à bouteille* of 1783, both attributed to Pierre-André Le Guay.[10] The former scene was also painted, by Le Guay on a *gobelet litron*, circa 1780–1785, in the Museum of Fine Arts, Boston (Forsyth Wickes Collection, 65.1808 a, b), and it is also painted on a Sèvres porcelain plaque mounted on the underside of an enameled gold snuffbox at Waddesdon Manor (105A).

In addition to the *répareur* Bono and the gilder E.-H. Le Guay (whose marks these vases bear), other decorators who worked on the vases can be identified through surviving documents. The kiln records for June 25, 1781, list two "Vases ages" of the second size and two of the third size, all with *beau bleu* grounds and "Mignature et emailles par M Parpette" (figure painting, with jeweling by M. Parpette).[11] They were recorded as having been painted by Caton and gilded by E.-H. Le Guay. The painters' records show that before May 22, 1781, Caton received 600 *livres* for painting "Mignature" (figures) on "5 Vases ages de trois grandeurs dont un cuit en premier feu en 1780 . . . Beau bleu" (five *vases des âges* in three sizes, of which one was first fired in 1780 . . . dark blue ground).[12] The vase of the first size is not identifiable in the kiln records for 1780 since they document final gilding firings only. There are no further references in the factory's documents to Le Guay's work on the flat gilded surfaces, so we do not know what he was paid. There are,

however, further references to Parpette's work on the stamped gold foils and jewels on these vases. The painters' records for April 1781 show that he received 750 *livres* for his work on a "Garniture de Cinq Vases age peinte par M Caton, richement Emaillé (set of five *vases des âges*, painted by M. Caton, and richly jeweled).[13] In the margin it is noted that Parpette had received 400 *livres* on account in April, and this information is duplicated in the painters' overtime records,[14] which also note that in June 1781 he received the balance of the 750 *livres* for his work on this garniture.[15] It is worth noting that Caton's and Parpette's payments for work on these vases were considerable—1,350 *livres* between them.

Three of the factory's most experienced and accomplished decorators were involved in producing this exceptional garniture. No directly comparable sets of vases are known, although other garnitures of five *vases des âges* were made. Large-scale pieces of jeweled Sèvres porcelain were not produced in great quantity, chiefly, no doubt, because of their immense cost. Similarly decorated Sèvres porcelain vases include a pair of *vases Falconet cannélés à guirlandes* jeweled with oval foils of the same model as those found above each reserve on the Museum's vases, some with imitation moss agates (Paris, Musée du Louvre, OA.10945–10946).

Vase .1, side view

The Museum's vases were sold by the factory to Louis XVI along with a smaller pair of the third size. The sale, for the high price of 6,000 *livres,* is recorded among the king's purchases paid for in 1782.[16] De Bellaigue has noted, however, that Louis XVI made this purchase on November 2, 1781.[17] Christian Baulez has shown that Louis XVI displayed this garniture in his private library at Versailles,[18] which had been redecorated for him by Ange-Jacques Gabriel in 1774.[19]

This model is fairly rare; in addition to the Museum's garniture, about twenty examples are known. Two examples of the first size are in the Metropolitan Museum of Art, New York (Gift of Mrs. Alexander Hosack, 1886; 86.7.1 AB, 86.7.2 AB). Although their decoration is very similar, they may not be a pair since one is dated 1782 and the other is dated 1789.[20] Each has a dark blue (*bleu nouveau*) ground and is painted with a figure scene on the front panel; one scene is set in an interior, the other in a garden. They bear the painter's mark of Charles-Nicolas Dodin and the gilder's mark of E.-H. Le Guay. There are five *vases des âges*—three of the second size and two of the third—all with dark blue grounds, in the British Royal Collection.[21] They display similar painted and gilded decoration, are dated 1782, and bear the same painter's and gilder's marks as the vases in the Metropolitan Museum of Art. It seems likely that four of them (two of the second size and the pair of the third size) are from a garniture of five vases of this model in three sizes listed in the kiln records on December 16, 1782.[22] The garniture probably also included one of the vases now in the Metropolitan Museum of Art. The remaining vases of the first and second sizes may have formed part of another similarly decorated garniture. Also in the British Royal Collection is a pair of *vases des âges* of the third size, decorated with a green ground and with scenes of figures in interiors painted on their front panels.[23] They are undated but bear the painter's mark of Pierre-André Le Guay and the gilder's mark of Henri-François Vincent. They probably formed a garniture with a *vase des âges* of the first size and two of the second, which are in the Musée Ile-de-France, Collection Ephrussi-Rothschild, Saint-Jean-Cap-Ferrat.[24] They all have very similar decoration, except for slight differences in the gilding on the vertical surfaces of the plinths and bases. The vase of the first size now in the Ephrussi-Rothschild collection, or a very similar one, was illustrated when it was sold at auction in 1855.[25] A set of three *vases des âges* dated 1786—one of the first size and two of the second—is at Woburn Abbey, Bedfordshire.[26] They have a dark blue ground and are painted with birds on the fronts and with landscapes on the backs. Two sets of three *vases des âges,* each consisting of one vase of the second size and two of the third, were on the Paris art market, one set in 1961,[27] and the other in 1989.[28] The former had a *pointillé* ground, were

Plaster model for the *vase des âges*. Manufacture Nationale de Sèvres, Archives.

Pair of *vases des âges,* 1781. Sèvres manufactory, soft-paste porcelain. Baltimore, Walters Art Gallery 48.566.AB, 48.567.AB.

Detail showing "jeweled" decoration

Vase .2, detail

painted with landscapes in oval reserves on the fronts, and were set on gilt-bronze plinths. The latter were dated 1780, had a pale yellow *pointillé* ground, and were painted in oval reserves with landscapes on their fronts and with bouquets of flowers on their backs.

The Museum's vases were in the collection of Lionel de Rothschild at Exbury, Hampshire, and were sold at auction in 1946, following his death in 1942. They are not illustrated in the catalogue of works of art belonging to his uncle Alfred, some of which were bequeathed to Lionel,[29] so he may have inherited them from his father.[30] It is not known when the three vases were separated from the pair now in the Walters Art Gallery. The latter were formerly in the Park Heirlooms Collection, and by the end of the nineteenth century they were in the collection of E. M. Hodgkins, Paris.[31] Much of the Hodgkins collection of Sèvres porcelain was subsequently purchased by Mr. and Mrs. Henry Walters of Baltimore.

PROVENANCE: Sold by the Sèvres factory to Louis XVI, Château de Versailles, November 2, 1781; Lionel de Rothschild, Exbury, Hampshire; by descent to Edmund de Rothschild, Exbury, Hampshire, 1942 (sold, Christie's, London, July 4, 1946, lot 89, to FP [(?)Frank Partridge] for 1,575 gns.); [The Antique Porcelain Company, London, by 1951]; the J. Paul Getty Museum, 1984.

BIBLIOGRAPHY: P. Verlet, "Orders for Sèvres from the French Court," *Burlington Magazine* 96 (July 1954), p. 205; Sassoon 1985, pp. 98–104, no. 4; Eriksen and de Bellaigue 1987, p. 139, no. 147; pp. 338–339; G. de Bellaigue, *Sèvres Porcelain in the Collection of Her Majesty the Queen: The Louis XVI Service* (Cambridge, 1986), p. 12, fig. 8; p. 24, n. 2; Savill 1988, pp. 458, 462, n. 25, 1016, 1017, n. 16, 1056, 1057, n. 10.

1. See Brunet and Préaud 1978, p. 204, no. 241.
2. MNS Archives, 1814 Inventory, "Vase Age de Paris, garni," 1780–1800, no. 73B (height 45 cm, width 27 cm, depth 21 cm); see also Troude [1897], pl. 117 ("Vase Pâris Garni").
3. MNS Archives, 1814 Inventory, "Vase Age de Paris, garni," 1780–1800, no. 73A (height 37 cm, diam. 17 cm).
4. S.L., I.8, 1780 (March 1, 1780), fol. 55 (no values given).
5. De Bellaigue 1979, p. 95, no. 100.
6. Eriksen 1968, p. 278, no. 100.
7. Another example is the garniture of three *vases C de 1780* in the Huntington Art Collections, San Marino (see Wark 1961, p. 92, fig. 111); that of the first size is incised *1780 vaze C prmr grndr 25,* and one of the second size is incised *1780 Vaze C 2me grdr 25* (revealed by Barbara Roberts and Linda Strauss of the J. Paul Getty Museum, who removed the mounts, which were later additions, from the bases of the vases for conservation purposes in 1987/88).
8. Letters in JPGM file 84.DE.718.
9. De Bellaigue (Bibliography), p. 183, no. 108; p. 79, no. 7.
10. See also G. de Bellaigue, "Sèvres Artists and Their Sources II: Engravings," *Burlington Magazine* 122 (November 1980), pp. 756–759.
11. K.R., Vl1, fol. 166r.
12. A.L., Vj2, January–May 22, 1781, "Caton," fol. 68r.
13. Ibid., on or after April 3, 1781, "Parpette," fol. 200r.
14. P.O.R., April 1781, "Parpette," fol. 256 (400 *livres* "à Compter sur une Garniture de Cinq Vases âge richement Emaillés [on account for a set of five richly jeweled *vases des âges*]).
15. P.O.R., June 1781, "Parpette," fol. 264.
16. S.R., Vy8, fol. 146v.
17. Archives Nationales, K.506, no. 21, *pièce* 18; see Eriksen and de Bellaigue 1987, p. 339.
18. Information kindly supplied to Gillian Wilson.
19. C. Mauricheau-Beaupré, *Versailles: History and Art* (Paris, 1949), p. 53.
20. I thank Clare Le Corbeiller for the information about these vases.
21. Brunet and Préaud 1978, p. 205, nos. 241–242; de Bellaigue 1979, pp. 94–96, no. 100.
22. K.R., Vl2, fol. 41v.
23. Brunet and Préaud 1978, pp. 204–205, no. 241.
24. See JPGC Photo Archives nos. 98306–98309, 98316–98320.
25. Collection of Ralph Bernal, Esq., Deceased, 93 Eaton Square (sold, Christie's, London, March 5 et seq., 1855, lot 597). The two vases of the second size now in the Ephrussi-Rothschild collection were not in this sale.
26. G. de Bellaigue, "Sèvres at Woburn Abbey," *Apollo,* no. 127 (June 1988), pp. 418–426.
27. Vandermeersch; see *Mostra Mercato Internazionale dell'Antiquariato,* sale cat., Palazzo Strozzi, Florence, 1961, stand 49 (ill.).
28. Formerly in the Boin-Taburet collection; collection of Madame C. (sold, Paris, Drouot-Richelieu, December 8, 1989, lot 70).
29. C. Davis, *A Description of Works of Art, Forming the Collection of Alfred de Rothschild* (London, 1884).
30. I thank Michael Hall for this verbal information.
31. *Catalogue of an Important Collection of Old Sèvres Porcelain, Louis XV and Louis XVI Period, Belonging to E. M. Hodgkins* (Paris, [c. 1928]).

26 Plate

(assiette)

1782

Sèvres manufactory; soft-paste porcelain; ground color painted by Antoine Capelle, flowers painted by Jacques-François-Louis de Laroche, gilding by Henri-Martin Prévost

HEIGHT 2.6 cm (1 in.); DIAM. 23.0 cm (9¹/₁₆ in.)

MARKS: Painted underneath in blue with the factory mark of crossed L's enclosing the date letters EE for 1782, adjacent to the flower painter's mark *Lr*; painted near the rim with the ground color painter's mark, a blue triangle, and marked in gold with the gilder's mark, *HP*. Incised underneath, within the rim, *31 a*.

88.DE.2

DESCRIPTION: The circular plate has a lobed rim; the central well is recessed underneath and bears a kiln suspension hole.

The plate is decorated with a brown ground, sprinkled with gilding. There is one circular white reserve and three lobed white reserves on the rim. The centers of the reserves are painted in colors with leaves and sprays of pink roses and rosebuds, cornflowers, poppies, and mauve daisies.

Bands of gilding, variously decorated and burnished, frame the reserves, form borders, and encircle the rim. From the sides of the lobed reserves on the rim, gilded sprays of partly burnished laurel leaves spread over the ground color.

CONDITION: The plate is unbroken, and its decorated surfaces are unworn. The tooling is bright and well preserved.

COMMENTARY: Plates (*assiettes*) were made in very large quantities at the Vincennes and Sèvres factories from the commencement of production of soft-paste porcelain, and later in hard paste as well. They displayed a wide variety of decoration, and each type was usually produced in quantity, either as a set of matching plates or as part of a dinner or dessert service. This example, however, is one of a relatively

Detail showing decoration

small number of individually decorated plates, described in the factory's documents as *assiettes d'échantillon* (sample plates).

The decorator's marks on the Museum's plate support its identification as one of a group of *assiettes d'échantillon* produced at Sèvres in 1782.[1] The brown ground was applied by Antoine Capelle, as was the deeper brown ground on the Museum's cup and saucer (no. 24 above). These colors are among the many unusual colors that Capelle applied to various wares in the early 1780s. No plates are listed among Capelle's work in the artists' ledgers for 1781–1783,[2] but to other wares he applied "fond nouveau," "fond boue de Paris," and "fond merde d'oie," all of which may have been brown; the latter description is associated with the Museum's cup and saucer.

In April 1782 Jean-François-Louis de Laroche is recorded as having painted "décorations Riches et différentes" (elaborate and varied decoration) on ten *assiettes*.[3] Of these ten, four had "fond diff[érent]" (various grounds), two had a turquoise-blue ground, and two pairs were decorated in "en fond Capelle" (with a ground of Capelle's). It is possible that the Museum's plate was among the latter. Henri-Martin Prévost's name can be found in the kiln registers for 1782 as the gilder of at least two *assiettes d'échantillon* decorated by Laroche. Recorded in the firing of July 9, 1782, was one example with a red ground, painted with flowers by Laroche and Prévost.[4] In the firing of July 29, 1782, there was an *assiette d'échantillon* which could be the Museum's plate. It was described as having decoration of "Bordure Riche" (elaborate borders) and was painted by Laroche and gilded by Prévost.[5] In addition, in a firing of September 2, 1782, Laroche is recorded as having painted three *assiettes d'échantillon* with "Guirlandes" (garlands of flowers), with unspecified ground colors.[6] Although the gilder's name was

not recorded, these three plates surely had gilded decoration, otherwise they would not have been in a kiln firing along with other wares with gilded decoration.

The plate was illustrated by Edouard Garnier in 1889 as part of a group of *assiettes d'échantillon* dated 1782 with various decorative schemes, all from the collection of William J. Goode.[7] In the catalogue of the sale of Goode's collection in 1895, these plates were described as "formerly the property of the Director of the Sèvres Porcelain Factory." Although this plate cannot be identified in the factory's sales records, David Peters has noted that the *marchand-mercier* Daguerre purchased a number of examples that were not part of dinner services from the factory during the second half of 1782.[8] These plates were sold, both singly and in pairs, for prices ranging from 30 to 60 *livres* each.

PROVENANCE: William J. Goode, London (sold, Christie's, London, June 17, 1895, lot 19, to Gibson for 29 gns.); private collection, England; [Dragesco-Cramoisan, Paris, 1987]; the J. Paul Getty Museum, 1988.

BIBLIOGRAPHY: Garnier [1889], pl. XXVI.

1. First identified by David Peters.
2. A.L., Vj2, fols. 72r, 72v.
3. Ibid., April 21, 1782, "La Roche," fol. 132r.
4. K.R., Vl2, July 9, 1782, fol. 20r.
5. Ibid., July 29, 1782, fol. 22r.
6. Ibid., September 2, 1782, fol. 29r.
7. Garnier [1889] attributed the painter's mark on this plate to "Huny."
8. See JPGM file 88.DE.2.

PLATE 137

27 *Pair of Vases*

(vases hollandois nouveaux, deuxième grandeur)

1785
Sèvres manufactory; soft-paste porcelain; painted by Jacques-François-Louis de Laroche, gilded by Antoine-Toussaint Cornaille

HEIGHT 25.3 cm (10 in.); WIDTH 22.5 cm (8⅞ in.); DEPTH 15.9 cm (6¼ in.)

MARKS: Each vase is painted in blue underneath the base section with the factory mark of crossed L's and with the painter's mark *Lr*. The base of each upper section is incised *25,* and one base section is incised *O*.

83.DE.341.1–2

DESCRIPTION: Each oval vase is composed of two pieces. The tall, flaring upper section has a narrower extension, which fits into the lower section. This extension is pierced with ten round holes near the base. The lower section has broad, concave shoulders, which are pierced at the four sides with double-lobed openings bordered by narrow, pierced slashes.

Each vase is decorated with a turquoise-blue (*bleu céleste*) ground. The walls of both sections have large white shaped reserves, which are painted in colors with garlands of flowers. In the center, on a shaftlike support, is a blue vase filled with flowers and leaves. Beneath the vase are two brightly colored birds (the same birds are painted on all four front and back panels).

Broad bands of gilding, partly burnished and partly matt, follow the rims and edges of the two sections. The bands framing the panels of ground color are tooled with a zigzag line.

CONDITION: Both vases are unbroken, and their decorated surfaces are largely unscratched, though the tooling of the gilding is somewhat worn. Vase .1 has a hairline crack that extends across the base of the upper section and high up the side of one wall.

COMMENTARY: This shape, called the *vase hollandois nouveau,* was designed to contain flowering plants and soil in its upper section. Water, added through openings in the lower section, fed the plants through small holes pierced near the base of the soil container. The model was based on a shape called the *vase hollandois,* whose upper section had straight-sided, angled walls, whereas the new shape had flaring walls. The original shape was produced in several sizes from 1754.[1] A drawing dated 1758 depicting the *vase hollandois nouveau* in two sizes survives in the factory's archives (MNS R.1, l.III, d.1, fol. 1). The two designs, inscribed *Vase à L'hollandeze Rond et à 8 pans n° 4 fait en 1758* and *Vase à L'holandoeze et à 8 pans n° 5 fait en 1758,* show no details of the piercing at the shoulder of the base section or of the feet on which it stands. The inscriptions refer to round and eight-lobed versions of the shape, although the majority of surviving examples, like the Museum's vases, are oval. A plaster model survives in the archives, dated 1782 in the early nineteenth century.[2] The Museum's vases are of the second-largest size of this model.[3]

The factory's stock list of January 1, 1759, lists under new work of 1758 ten molds for the *vase hollandois nouveau* in five sizes, each in both round and oval versions.[4] The biscuit kiln records, which survive up to January 1759, do not list any examples, nor is the shape identifiable in the glaze kiln records. The stock list of October 1, 1759, lists fifteen *vases hollandois nouveaux* of the first, second, and third sizes in the Magasin du Blanc,[5] valued at 24 *livres* each for the second and 15 *livres* each for the third. In the stock list of 1761 there were nine examples of the second size recorded under "Pieces en Couverte" (presumably also glazed but undecorated) valued at 24 *livres* each.[6] The stock list of 1774, recording old stock in the factory's showroom in 1773, gives an indication of the prices for decorated examples of this shape.[7] Two "Vases holandois Nouvelle forme" of unspecified size with pink grounds and painted with chinoiserie children were valued at 216 *livres* each.[8] Another example, again of unspecified size, decorated with carmine-colored children and fitted with porcelain flowers on metal stems ("garni de fleurs"), was valued at 216 *livres*. A similarly decorated example of the fourth size was valued at 108 *livres*. An example of the third size decorated with a green ground and painted with flowers was valued at 156 *livres*. An example of unspecified size, decorated with a dark blue (*bleu lapis*) ground overlaid with gilding in *caillouté* patterns and painted with birds, was valued at 144 *livres*. An example of the second size painted with carmine-colored children, but without porcelain flowers, was valued at 96 *livres*.

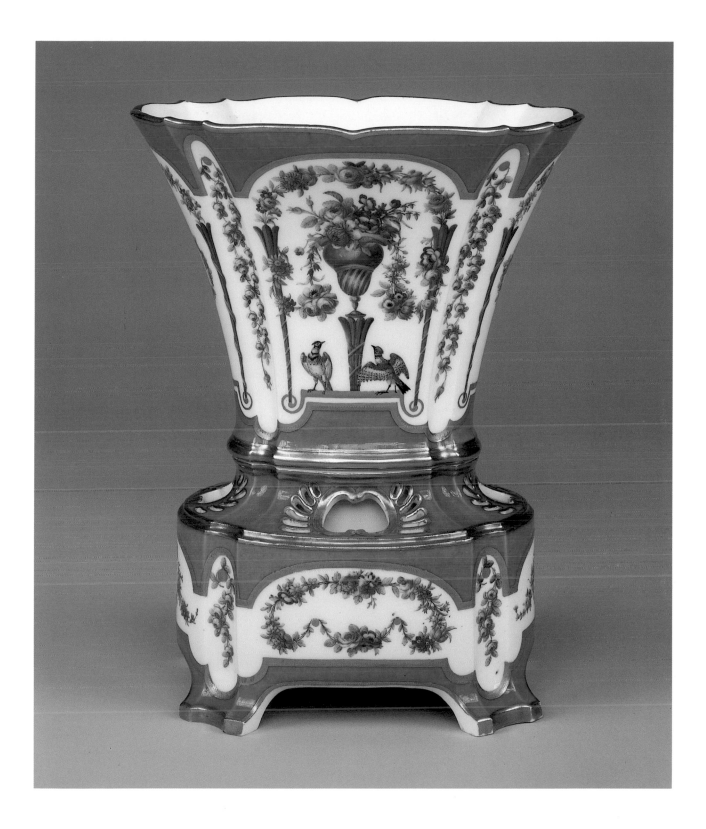

The Museum's vases display a neoclassical decorative scheme that does not seem appropriate to their rococo shape. They are undated, but their harsh turquoise-blue ground suggests that they were made in the 1780s. This can be confirmed by linking information in the factory's documents to the painter's mark. Rosalind Savill has pointed out that in the painters' records of October 1785 Jacques-François-Louis de Laroche is recorded as having painted "arabesques riches" on two "vases hollandoise" with *bleu céleste* grounds and on one with a green ground.[9] The Museum's vases could fit this description. The painters' overtime records for December 1785 show that Laroche received 66 *livres* for decorating one "vase hollandois,"[10] and he would probably have received a similar sum for decorating the Museum's vases. This outmoded shape is not known to have been produced in any quantity during the 1780s, and no examples of similar date or with comparable decoration are known.

The kiln records give further information on Laroche's vases. In the firing of December 21, 1785, there were four vases of this shape of the first and second sizes, some with green and some with blue grounds,[11] decorated with "arabesques" and gilded by Antoine-Toussaint Cornaille. Cornaille was principally a painter of relatively simple flowers and birds but was also a gilder. The painters' overtime records show that in December 1785 he gilded four *vases hollandois,* for which he received 42 *livres* in total.[12] That the gilding on the Museum's vases was not executed by a top gilder is obvious upon close inspection. The tooling is unusually careless for work of the 1780s, and it does not always follow the lines of gilding in a precise manner. Given the absence of other known examples of this type, it is likely that these vases and a similar but now unknown pair with a green ground correspond to the references quoted above. The *répareurs'* records also provide some background information relating to this model; the *répareur* Laurent Henry received 18 *livres* for his work on each of six "vases holandois" of the third size during 1784.[13]

There are many *vases hollandois nouveaux* in various collections, dated between 1758 and 1765, all with decoration typical for those years. Examples of the first, third, and fifth sizes are in the Metropolitan Museum of Art, New York (Gift of R. Thornton Wilson, 50.211.158–159; Wrightsman Collection, 1976.155.59–60; Kress Collection, 58.75.85–87). Examples of the second size are in the Detroit Institute of Arts (Dodge Collection, 71.258–259, 71.244–245), and were formerly at Mentmore Towers, Buckinghamshire.[14] Examples of the third size are in the British Royal Collection; at Firle Place, Sussex;[15] and in the Museum of Fine Arts, Boston (Forsyth Wickes Collection, 65.1799–1800). Examples of the fourth size are in the Musée des Arts Décoratifs, Paris (Gould Bequest, 28703), and have appeared at auction.[16] Examples of the fifth size are in the Wallace Collection (c232–233) and in the Rijksmuseum, Amsterdam (R.B.K.17510 A&B).

In the factory's sales records of January 1786 there is a reference to two "vases holandois" of unspecified size, shape, and decoration, costing 360 *livres* each.[17] They were sold to Louis xvi for his aunt Madame Louise. Presumably these vases were a gift to Madame Louise, Louis xv's youngest daughter, who had been in a Carmelite convent since 1770 and who died in 1787. Although the Museum's vases cannot be linked to Madame Louise's, the reference provides a possible indication of their price.

The Museum's vases may be those sold from the collection of the late Lord Ashburton at Buckenham, Norfolk; they were described as "A pair of very fine eventail *jardinières* and perforated s[t]ands, white ground with turquoise borders, richly gilt, exquisitely painted with birds, quivers, vases and wreaths of flowers," when they appeared at auction in 1869.[18]

PROVENANCE: (?)The Rt. Hon. Lord Ashburton, Bucken-ham, Norfolk (sold, Christie's, London, February 24, 1869, lot 64, to Rhodes for 819 gns.); Baroness Alexis de Goldschmidt-Rothschild, Switzerland; [Lovice Reviczky A.G., Zurich, 1983]; the J. Paul Getty Museum, 1983.

BIBLIOGRAPHY: Wilson, Sassoon, and Bremer-David 1984, no. 12; Sassoon and Wilson 1986, p. 85, no. 180; Savill 1988, pp. 111, 116, nn. 2h, 18, p. 1040, n. 5.

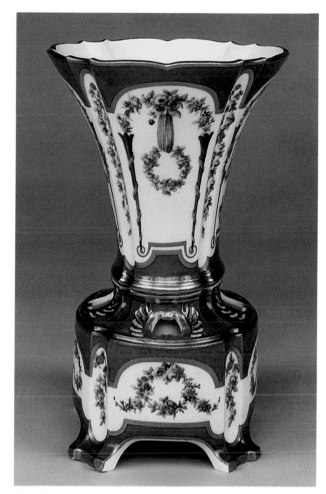

Side view

1. Brunet and Préaud 1978, pl. XVIII, fig. 63.
2. MNS Archives, 1814 Inventory, "Vase Hollandais de 1782," 1780–1800, no. 52.
3. A known example of the first size is 29.2 cm high; those of the third size range in height from 24 to 21.5 cm; those of the fourth size, from 20 to 19 cm; and those of the fifth size, from 18.3 to 17 cm.
4. S.L., I.7, 1759 (for 1758), fols. 5, 6; for each shape the molds of the first size were valued at 30 *livres* each; those of the second size, at 24 *livres* each; those of the third size, at 18 *livres* each; those of the fourth size, at 15 *livres* each; and those of the fifth size, at 10 *livres* each.
5. Ibid., October 1, 1759 (for January–September 1759), fol. 16.
6. Ibid., 1761 (for October–December 1759 and 1760), fol. 12.
7. S.L., I.8, 1774 (for 1773), fols. 39, 40.
8. Possibly decorated in the same manner as no. 11 (above).
9. P.R., Vj3, October 1785, "De La Roche," fol. 127r.
10. P.O.R., F27, December 1785, "De La Roche," fol. 442.
11. K.R., Ve2, December 21, 1785, fol. 163r.
12. P.O.R., F27, December 1785, "Cornaille," fol. 443.
13. R.R., January–February 1784, "Henry."
14. Sold, Sotheby's, Mentmore, May 24, 1977, lot 2035.
15. See de Bellaigue 1979, no. 89; Savill 1985, no. 405.
16. Nelson Rockefeller (sold, Sotheby's, New York, April 11, 1980, lot 250); Mrs. John W. Christner, Dallas (sold, Christie's, New York, November 30, 1979, lot 193).
17. S.R., Vy10, January 1786, fol. 49r.
18. I thank Frances Buckland for this information.

28 Pair of Lidded Bowls
(vases cassolettes à monter)

Circa 1785
Sèvres manufactory; hard-paste porcelain; gilt-bronze mounts attributed to Pierre-Philippe Thomire

HEIGHT 37.5 cm (14¾ in.); WIDTH 34.3 cm (13½ in.); DEPTH 26.1 cm (10¼ in.) (dimensions include mounts)

MARKS: None.

73.DI.77.1–2

DESCRIPTION: The circular bowl has a curved base that rises to a wide, concave shoulder. The lid is formed as a flattened dome. The bowl and lid are pierced in the center for the attachment of metal mounts. Each vase is decorated with an even dark blue (*beau bleu*) ground and has a pierced gilt-bronze collar between the lid and the bowl, which enabled it to be used to contain potpourri. Each vase is set on a gilt-bronze and *rouge griotte* marble base.

CONDITION: The vases are unbroken, and their exterior surfaces are unworn.

COMMENTARY: A design for the *vase cassolette à monter* in the archives of the Sèvres factory shows that the model was made to be held in metal mounts attached through holes in the center of the lid and the bowl (illus.).¹ One, incorporating a porcelain foot, is inscribed *Vase Casollette pour Etre Monté par M. Tomier [Thomire]* (cassolette vase to be mounted by M. Thomire) and dated April 20, 1784 (MNS R.1, 1.III, d.16, fol. 3). Another design for a vase similar in shape to the Museum's example is inscribed *Vase Bassignoire 1ᵉ demandé par M. Salmon . . . ce 10 aoust 1787 . . . pour mettre En Bleu* (basin-shaped vase of the first size ordered by M. Salmon . . . August 10, 1787 . . . to be given a blue ground; MNS R.1, l.III, d.16, fol. 4). A plaster model survives in the archives as well, though it is much smaller than the Museum's vase and has a knop and a base.² An oval version was also produced.

Plain vases designed to be placed in gilt-bronze mounts were produced at Sèvres from the mid-1760s. In the factory's stock list of 1765 "gobelets à Monter" and "Vases Antiques à monter" are recorded.³ These may have been of the straight-sided shape produced with various types of decoration, now found in many collections.⁴ The stock list of

1771 shows, among the new work of the previous year, a plaster model and a mold for a "vaze à gobelet monté," with the high values of 84 and 168 *livres*, respectively.⁵ These were surely for a much larger vase than the Museum's version. The factory's stock list of February 2, 1773, shows that the Parisian *marchands-merciers* Poirier and Daguerre had two pairs of *gobelets à monter* on consignment.⁶ Their decoration is not specified, but the smaller pair were valued at 48 *livres* each, and those of the first size, at 72 *livres* each. A stock list dated February 4, 1773, shows that the dealer Mme Lair had two "vazes en œuf à monter avec couvercle" on consignment, valued at 72 *livres* each.⁷ These may have been of the same shape as the pairs decorated with a purple (*violet*) ground now in a private collection in Sèvres and at Chatsworth House, Derbyshire. Similar egg-shaped vases, decorated with a dark blue ground, were made to be placed in metal mounts. The factory's stock list of 1774 shows ten such vases, in three sizes, among the wares decorated with "Bleuë du Roy" in the Magasin de Porcelaine [Tendre].⁸

The painters' overtime records for 1774 show that a decorator called Nozet was paid from 1 *livre* 10 *sous* to 2 *livres* "pour metre en Bleu" (for applying a blue ground) to thirty-two "vases goblet à monter" in three sizes.⁹ In the *répareurs'* records of 1784 there are several references to vases, some of which may have been similar to the Museum's examples. The *répareur* Joseph-François Binet received 15 *livres* for his work on ten "Vases fond Bleu pour M Thomire" (vases with blue ground for M. Thomire).¹⁰ Also in 1784 the *répareur* Canary *fils aîné* was paid 54 *livres* for his work on eighteen "Vases pour M Thomire de totes gʳ et forme" (vases for M. Thomire of all sizes and shapes).¹¹ The factory's stock list of February 19, 1785, notes two "vases Cassolettes, montés en Bronze" but gives no value.¹² Four pairs of similarly described *cassolettes* are recorded in the stock list of March 30, 1786, valued individually at 2,400, 900, and 480 *livres*.¹³

Whether this model was developed inside the Sèvres factory or by an outside source is not clear. Geoffrey de Bellaigue has pointed out that a shape called a "vase à monter Daguerre" in the factory's documents may have been based on either wood or terracotta models supplied by Daguerre.¹⁴ Although vases intended to be fitted with metal mounts were sold to *marchands-merciers* unmounted, such wares were also fitted with mounts at the Sèvres factory. Jean-Claude Duplessis, who began working with the Vincennes factory in the 1740s, produced metal mounts for porcelain

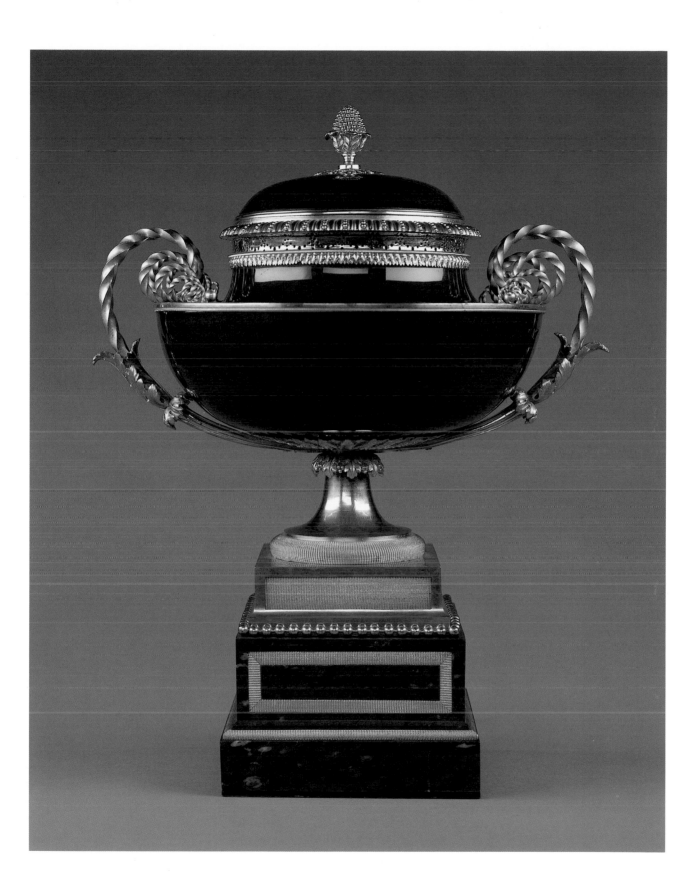

at the factory. His son Jean-Claude-Thomas Duplessis took over this function after his father's death in 1774. After the younger Duplessis' death in 1783 the *bronzier* Pierre-Philippe Thomire assumed responsibility for designing and fitting mounts for porcelain at the factory. Based on the evidence of drawings of similar vases with annotations linking them to Thomire, the mounts of the Museum's vases can be attributed to him.

The factory's sales records from the latter part of 1785 list *vases à monter* that were sold to Daguerre at various prices. In the last six months of 1785 he purchased ten *vases à monter* of unspecified shape and decoration for 120 *livres* each.[15] In the same period of 1786 Daguerre purchased four *vases à monter* for 96 *livres* each,[16] eighteen for 120 *livres* each, and four for 144 *livres* each.[17] Their shapes and decoration were not described, and all were clearly sold unmounted. In comparison, two "lyres beau bleu" purchased from the factory by Louis XVI on January 4, 1786, cost 192 *livres* each.[18] These were lyre-shaped porcelain frames, decorated with a dark blue ground, which were to be fitted with gilt-bronze mounts and a clock mechanism. Several examples of this model of clock are known, including one in the Musée du Louvre, Paris (OA.R.483), and another in the Musée National de Céramique, Sèvres (21649). Since the porcelain lyre and its stepped oval base are of a more elaborate shape than the vases, the latter would probably have been less expensive.

Round and oval vases similar to the Museum's examples, fitted with gilt-bronze mounts and pedestals of various forms, include pairs in the Musée Condé, Chantilly, and the British Royal Collection,[19] and single examples in the Wallace Collection, London (C342), and the Museum of Fine Arts, Boston (1944.74). Examples have also been sold at auction.[20]

PROVENANCE: Mrs. H. Dupuy, New York (sold, Parke Bernet, New York, April 3, 1948, lot 404); [P. Cei and E. Lugli]; [French and Company, New York, 1973]; J. Paul Getty, 1973.

BIBLIOGRAPHY: Sassoon and Wilson 1986, p. 85, no. 181; Savill 1988, pp. 476, 480, n. 5.

1. One bears a postrevolutionary inscription (MNS, R.1, l.III, d. 16, fol. 5).
2. MNS Archives, 1814 Inventory, "Vase Cassollette à Monter," 1740–1780, no. 151 (height 15 cm, diam. 19.5 cm).
3. S.L., I.7, 1765 (for 1764), fols. 11, 12.
4. For three examples, see S. Eriksen, *Early Neo-Classicism in France* (London, 1974), pl. 242.
5. S.L., I.8, 1771 (for 1770), fols. 6, 7; the model's value was double that of the mold.
6. Ibid., February 2, 1773, fol. 14.
7. Ibid., February 4, 1773, fol. 25.
8. Ibid., 1774 (for 1773), fols. 73, 74 (described as of the second, third, and fourth sizes, yet all valued at 48 *livres* each).
9. P.O.R., F.16, 1774, "Nozet," fol. 131; he was paid 2 *livres* each for his work on twelve of the first size, and 1 *livre* 10 *sous* each for his work on twenty of the second and third sizes. Nozet is not recorded among the Sèvres workers in Brunet and Préaud 1978 or in Dauterman 1986.
10. R.R., Va series, April 1784, "Binet."
11. R.R., Va series, April 1784, "Canary."
12. S.L., I.8, February 19, 1785, fol. 18.
13. Ibid., March 30, 1786 (for February 20, 1785–March 30, 1786), fol. 16; in the Magasin de Peinture et Dorure, therefore possibly not yet finished.
14. Eriksen and de Bellaigue 1987, p. 115.
15. S.R., Vy9, fol. 265v.
16. S.R., Vy10, fol. 96r.
17. Ibid., fol. 96v.
18. Ibid., fol. 13v.
19. De Bellaigue 1979, no. 26.
20. For example, Christie's, London, March 17, 1886, lot 71; Palais Galliera, Paris, March 14, 1970, lot 59; Sotheby's, Monaco, May 26, 1975, lot 211.

Design for the *vase cassolette à monter*. Manufacture Nationale de Sèvres, Archives R.1, l.III, d.16, fol. 6.

29 Wine Bottle Cooler
(seau à bouteille ordinaire)

1790
Sèvres manufactory; soft-paste porcelain; painting attributed to Charles-Eloi Asselin, gilding attributed to Etienne-Henri Le Guay

HEIGHT 18.9 cm (7⁷⁄₁₆ in.); WIDTH 25.8 cm (10³⁄₁₆ in.)

MARKS: The bowl is incised underneath *38,* and the foot ring is incised *5.* The monogram *WJG* is scratched into the glaze under the bowl and inside the foot ring. No painted marks.

82.DE.5

DESCRIPTION: The circular bowl has a low stepped foot ring, recessed underneath. The molded lip of the bowl is overlaid at each side by a scalloped form at the top of each scrolled handle.

The exterior of the bowl and the foot ring are decorated with a dark blue (*beau bleu*) ground. There is a large, round reserve on each side, painted in colors with a mythological scene. One side shows Mentor holding an olive branch as he proposes peace to soldiers besieging the town of Salentum, which can be seen in the background. The other side shows Hercules fighting King Diomedes of Thrace and his man-eating mares.

There are burnished bands of gilding around the moldings of the rim, at the junction of the bowl and the foot ring, and around the bottom of the foot. Thick, burnished gilding highlights the modeling of the handles and is used in a foliate pattern where the handles spread against the flat sides. The two painted reserves are each framed by a broad band of matt gilding, the center of which is tooled with a running piastre pattern, bound with matt bands at the four cardinal points. Beneath each handle the ground color is decorated with gilded branches of laurel leaves and berries that interlock and develop into arabesques. From these arabesques, and from the upper sections of the handles, gilded sprays of flowers and oak leaves emerge. Suspended beneath each painted reserve is a gilded garland of husks and berries. On the upper edge of the rim, above each handle, is a short, gilded line of leaves on a band of white.

CONDITION: The decorated surfaces are in exceptional condition. The foot ring once became separated from the bowl and has been pinned through the base and cemented. The scratched initials *WJG* suggest that the two pieces broke apart between 1877 and 1895, when William J. Goode owned the cooler. Some of the worn gilding around the base has been restored.

COMMENTARY: This model of wine bottle cooler was in production at Vincennes by early 1753. It was developed from a variety of similarly shaped wine bottle and wine-glass coolers, which the factory had been making since about 1750 in various sizes and with different handles.[1] A drawing for this model in the factory's archives is inscribed, possibly by the designer Jean-Claude Duplessis, *Trait de [Seaux] à bouteille ordinaire rabaisee par ordre de Mons Boelo Le 27 Mars 1753, du 30 du dit mois il a etee dessidee par Les mesieurs Verdun et Companie, de le baize seulament de 4 lignes, et de la ratressir de deux lignes* (outline of a regular wine bottle cooler reduced on M. Boileu's order of March 27, 1753, on the 30th of the same month Messieurs Verdun and Company decided to lower it by four *lignes* [8 mm], and to narrow it by two *lignes* [4 mm]) and *fait* (done; MNS R.I, l.1, d.5, fol. 1). Another drawing in the Sèvres archives shows ten outline designs for this model in diminishing sizes (illus.). It is not dated, but on the reverse is an outline of a smaller version of the model entitled "Seau a verre ordinaire du Roy." A plaster model for this shape survives in the factory's archives.[2] The Museum's cooler is of the model produced from about 1770, which has slightly modified moldings at the rim and the base. The model was produced in many sizes (for a slightly smaller pair, see no. 30) and with a variety of decorative schemes. It was supplied in pairs and was included in the dessert section of most dinner services for the next five decades. *Seaux à bouteille* first appear in the biscuit kiln records in October 1752, when three examples were fired.[3]

Although the Museum's wine bottle cooler bears no date letter, Geoffrey de Bellaigue has shown that it was made in 1790 (see below). The stock list for that year shows that in the Magasin du Blanc of soft-paste porcelain there were 102 *seaux* valued at 24 *livres* each (this example is probably of that size); there were also 24 valued at 18 *livres* each, and many more in smaller sizes for lesser amounts.[4] The *répareurs'* records show that in 1788 Danet *neveu,* David *père,* and Rémy were paid 1 *livre* 10 *sous* to 2 *livres* each for their work on each *seau à bouteille ordinaire.*[5] In the stock list of May 1, 1790, there were also many *seaux* in varying sizes with a "beau bleu" ground color awaiting further decoration.[6] There were 12 valued at 192 *livres* each, 6 valued at 144

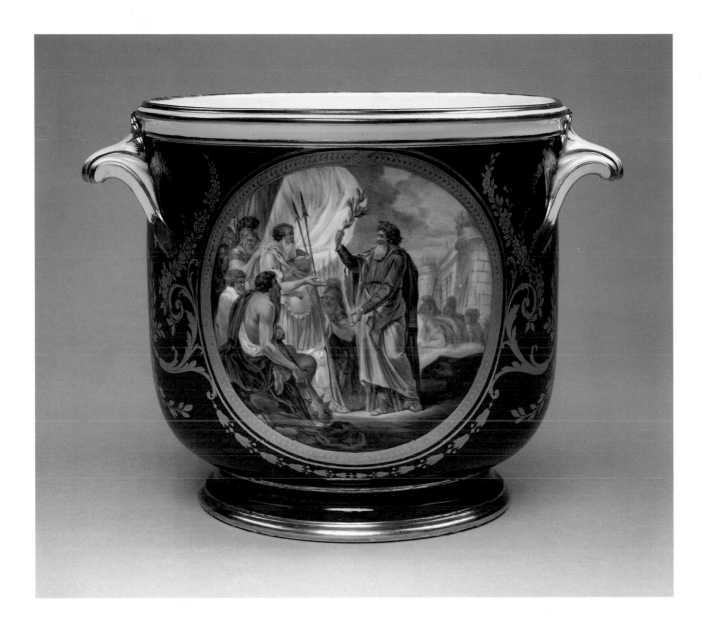

livres each, 11 valued at 120 *livres* each, and others for lesser sums. At the same time there were more "Seaux diff[éren]ts" in the Magasin de Peinture et Dorure (being painted and gilded), including 2 valued at 240 *livres* each, 4 at 144 *livres* each, 21 at 120 *livres* each, and 5 at 108 *livres* each.[7] De Bellaigue has shown that the painting on the Museum's cooler was probably finished on January 19, 1790, and that it was fired on September 22, 1790; therefore it was probably among those in the gilders' workshops on May 1 of that year.

De Bellaigue has published extensively on the service to which the cooler belonged (see Bibliography).[8] The service was commissioned from the Sèvres factory by Louis XVI on January 3, 1783, for his use at Versailles. It was intended primarily for display and was to comprise 422 pieces when finished. A schedule drawn up by the king shows that the production was to be spread over twenty-three years. This was partly so that the enormous cost of the service (164,390 *livres*) could be divided into annual payments of about 7,000 *livres*. Moreover, only the best artists at Sèvres were to work on the service. Less than half of the service—198 pieces—was completed by the time of Louis XVI's execution in 1793.[9] A manuscript preserved in the factory's archives states that the painted decoration was to consist of "miniature, sujets histoire Romaine, Thelemaque, mithologie; histoire grec, la fable etc." The painting on the completed pieces was by only eight artists—Charles-Nicolas Dodin, Charles-Eloi Asselin, Nicolas-Pierre Pithou, Pierre-André Le Guay, Pierre-Nicolas Pithou, Charles-Antoine Didier, Claude-Charles Gérard, and François-Pascal Philippine—the latter two of whom worked only on minor decoration. Exceptional care was taken at every stage of production, and the painted decoration was fired in at least three stages to achieve the finest coloring.

The service was intended to have twenty-four *seaux à bouteille* like this example. Only nine of these were completed by 1792, when production was suspended. De Bellaigue has attributed the painting of the cooler to Asselin on stylistic grounds, and this is supported by the documents. In the artists' ledgers Asselin is recorded on January 19, 1790, as having painted one "Seau à Bouteille, Beau bleu" with "miniatures, service du Roi."[10] The kiln records show that this cooler was fired on September 22, 1790, and that the gilder was Etienne-Henri Le Guay,[11] who gilded the vast majority of the pieces for this service. Another clue that dates the cooler to 1790 or 1791 is the gilding. De Bellaigue has pointed out that the trail of gilded husks under each reserve is found only on this example and on two other *seaux à bouteille,* which date from 1790 and 1791.

Jean-Baptiste Tilliard (French, 1740–1813) after Charles Monnet (French, 1732–after 1808). *Mentor propose la paix aux ennemis qui venoient assieger Salente.* Engraving. Williamstown, Mass., Williams College, Chapin Library of Rare Books.

Georg Haas after Jean-Baptiste-Marie Pierre. *Hercule et Diomede,* 1782. Engraving. Paris, Bibliothèque Nationale.

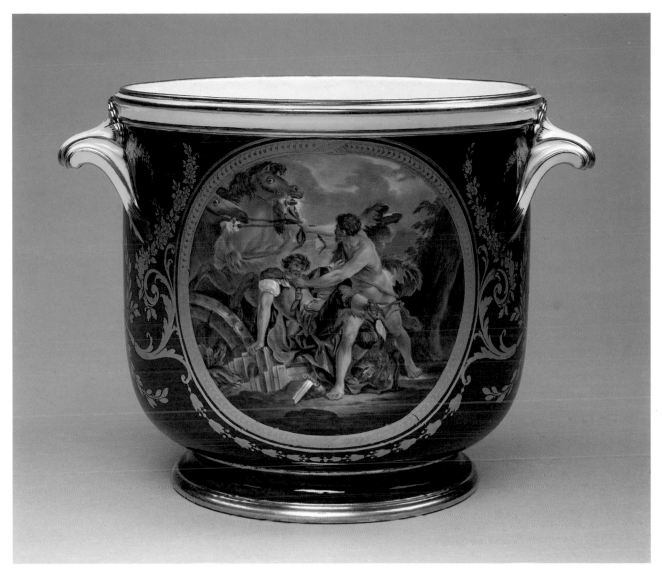

Alternate view

The scene of Mentor at Salentum was copied by Asselin from an engraving by Jean-Baptiste Tilliard after a painting by Charles Monnet (illus.). It was published as plate 30 of the 1773 illustrations to François de Salignac de La Mothe-Fénelon's *Les Aventures de Télémaque*. The scene of Hercules and King Diomedes is based on an engraving by Georg Haas published in 1782, after a painting by Jean-Baptiste-Marie Pierre (illus.).[12] Pierre's painting, now in the Musée Fabre, Montpelier, was his *morceau de réception* for the Académie Royale in 1742.[13] A smaller version of the painting was in the collection of Ange-Laurent de La Live de Jully in 1764 and was sold to an envoy from Dresden in 1770.[14]

More than 140 of the 198 pieces made for this service are now in the British Royal Collection at Windsor Castle. This group includes five *seaux à bouteille;* two more are in the Bearsted collection at Upton House, Warwickshire, and the present location of another is unknown. George IV purchased most of the pieces now in the Royal Collection in 1810 in London, and in 1811 in Paris. De Bellaigue and Christian Baulez have shown that the 12 pieces he purchased in 1810 were probably from a group of 18 that were sold in Paris in 1797–1798. This small group included five coolers of various sizes, possibly including the present example. The 18 pieces sold were in a depot of the Musée National, later renamed the Musée du Louvre, Paris, and were sold for the museum's benefit. The Getty Museum's cooler was in the "Shandon Collection," which belonged to Robert Napier of Glasgow, in 1862, when it was exhibited in London. Napier owned several pieces from the Louis XVI service, and they were sold after his death, in 1877. The cooler was subsequently in the collection of William J. Goode of London, along with several other pieces from the service.

The cooler is the only piece from the Louis XVI service on public display in the United States. Other pieces are on view in the Château de Versailles;[15] in the Musée du Louvre (OA.10.365); the Fitzwilliam Museum, Cambridge (C.55-1961); the Danske Kunstindustri Museum, Copenhagen;[16] and the Museu Calouste Gulbenkian, Lisbon (342). Additional pieces are in various English houses and in private collections in the United States.[17]

PROVENANCE: Made for Louis XVI, Château de Versailles, ordered 1783, delivered December 1790; Musée National(?), Paris, sold 1797/98; Robert Napier, Glasgow, the "Shandon Collection," by 1862 (sold, Christie's, London, April 12, 1877, lot 347, to William J. Goode for £262 10/-); William J. Goode, London (sold, Christie's, London, July 17, 1895, lot 136, to T. W. Waller, Esq., for 230 gns.); T. W. Waller, Esq. (sold, Christie's, London, June 8, 1910, lot 171,

to Asher Wertheimer for £630); [Asher Wertheimer, London] (sold, Christie's, London, June 16, 1920, lot 30, to Clements for £84); private collection (sold, Sotheby's, Belgravia, April 24, 1980, lot 162 [erroneously dated to the nineteenth century]); private collection, England (sold, Sotheby's, London, October 21, 1980, lot 207); [Winifred Williams Ltd., London, 1980]; the J. Paul Getty Museum, 1982.

EXHIBITIONS: *Special Loan Exhibition of Works of Art,* The South Kensington Museum, London, June 1862, no. 1323; *National Exhibition of Works of Art at Leeds,* Leeds, Yorkshire, 1868, section U, Foreign Porcelain, no. 2102 or 2103.

BIBLIOGRAPHY: J. C. Robinson, *Catalogue of the Works of Art Forming the Collection of Robert Napier* (London, 1865), p. 260, nos. 3501, 3502; Sassoon 1982, pp. 91–94; Wilson 1983, no. 48; G. de Bellaigue, *Sèvres Porcelain in the Collection of Her Majesty the Queen: The Louis XVI Service* (Cambridge, 1986), no. 149, pp. 28, fig. 19, 45, 52, 55–56, 64, 222, 255, 259, 264; Sassoon and Wilson 1986, p. 86, no. 182.

1. See Eriksen and de Bellaigue 1987, p. 230, no. 49; p. 265, no. 80; p. 267, no. 82.
2. MNS Archives, 1814 Inventory, "Seau à bouteille ordinaire," 1760–1780, no. 5 (height 23 cm, diam. 22 cm).
3. B.K.R., October 18, 1752, fol. 1.
4. S.L., I.8, 1790 (for March 13, 1789–May 1, 1790), fol. 49.
5. R.R., February–June 1788.
6. S.L., I.8, 1790 (for March 13, 1789–May 1, 1790), fol. 51.
7. Ibid., fols. 15–16.
8. The information on this service presented here comes from the sources cited in the Bibliography and directly from de Bellaigue, who identified the Museum's wine bottle cooler.
9. This figure has often been published as 197 pieces, but de Bellaigue has shown that two *tasses à glace* have in the past been counted as one piece.
10. A.L., Vj5, "Asselin," fol. 1r.
11. K.R., fol. 175v.
12. This scene was identified by Maxime Préaud, Bibliothèque Nationale, Paris.
13. I thank Pierre Rosenberg, Musée du Louvre, for this information.
14. See C. B. Bailey, in *Ange-Laurent de la Live de Jully: Facsimile Reprint of the Catalogue Historique and the Catalogue Raisonné des Tableaux* (New York, 1988), pp. LX–LXI, 22, 99.
15. Acquired since the publication of de Bellaigue's catalogue (see Bibliography); it is either no. 59 or no. 166 (see Sotheby's, New York, December 9, 1986, lot 409).
16. De Bellaigue (see Bibliography), no. 175 (see Sotheby's, New York, December 9, 1986, lot 407).
17. These are all listed in de Bellaigue's catalogue (see Bibliography); either no. 59 or no. 166 (see note 15 above) is now in a private collection in New Orleans (see Sotheby's, New York, December 9, 1986, lot 408).

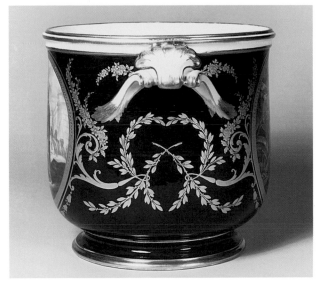

Side view

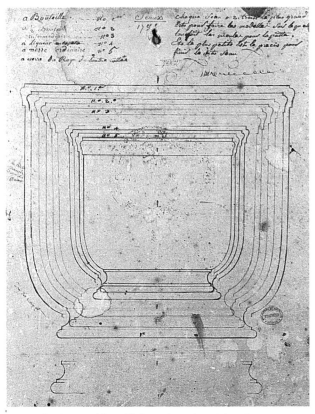

Design for the *seau à bouteille* in various sizes. Manufacture
Nationale de Sèvres, Archives R.I, l.1, d.5, fol. 5a.

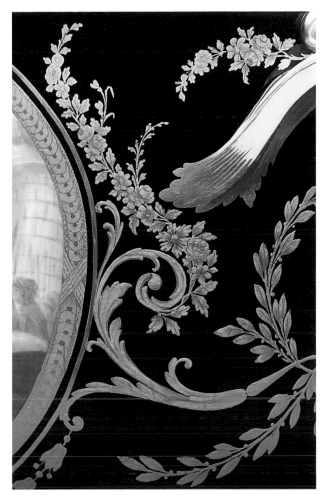

Detail of gilding

30 Pair of Half Wine Bottle Coolers
(seaux à demi-bouteille ordinaires)

1791
Sèvres manufactory; hard-paste porcelain; model designed
by Jean-Claude Duplessis, gilded by Jean-Jacques Dieu

HEIGHT 16.3 cm (6⁷⁄₁₆ in.); WIDTH 23.4 cm (9³⁄₁₆ in.);
DEPTH 18.6 cm (7⁵⁄₁₆ in.)

MARKS: Each cooler is marked in gold under the base with
the factory mark of crossed L's flanked by the date letters
OO for 1791/92 under a crown for hard paste, adjacent to
the gilder's mark of a triangle (indistinct on one cooler).
Cooler .1 is incised *AB* under the base, and cooler .2 is in-
cised *BS*.

72.DE.53.1–2

DESCRIPTION: These half wine bottle coolers are of the
same model as that described above (see no. 29).

The exterior of each bowl and foot ring is decorated
with a dark blue-black ground. The ground color is bluer at
the extreme edges, where it is more thinly applied over the
white body.

Burnished gilding covers the raised profile of the upper
rims, the foot ring, and the junction between the base of the
bowl and the foot ring. Gilding also highlights the scrolling
of the handles. The ground color is overlaid with chinoi-
serie scenes in two colors of matt and burnished gold and
elaborately tooled platinum.

CONDITION: The foot ring on cooler .1 almost became de-
tached during a firing after the ground color had been ap-
plied. Thin spots of the blue-black ground have seeped
through the join and are visible at the seam within the base.
Cooler .2 has a hairline crack running halfway around the
interior at the base of the bowl, from beneath one handle to
beneath the other. There is some wear to the gilding on the
rims of both coolers, but the tooling on the gold and plat-
inum decoration is very sharp. One foot ring is more deeply
recessed under the base than is usual for this model; the shal-
lower foot ring was probably molded rather than thrown.

COMMENTARY: These hard-paste half wine bottle coolers,
called *seaux à demi-bouteille ordinaires,* are smaller than the
similar *seaux à bouteille ordinaires.*[1] Geoffrey de Bellaigue and
David Peters have shown that the date letters OO, found on
the Museum's coolers, probably apply to part of the pro-
duction of both 1791 and 1792.[2] The factory's stock list of
1790 shows that there were eighteen *seaux à demi-bouteille* in
the Magasin du Blanc of hard-paste porcelain, valued at 12
livres each,[3] and the stock list of 1791 records ten *seaux,*
probably of this size, valued at 12 *livres* each, in the hard-
paste Magasin du Blanc.[4] It is worth noting that this model
had been introduced by 1753 and was still in production
forty years later.

The decoration of the Museum's half wine bottle cool-
ers is of great interest. The blue-black ground was produced
using oxides of iron, cobalt, and manganese.[5] It was devel-
oped at Sèvres for use on hard-paste porcelain by the early
1780s. Fallot is recorded as having decorated *gobelets litron*
and saucers with gilding on a black ground in November
1782.[6] They probably had no painted decoration but were
gilded with birds in a manner similar to the Museum's cool-
ers. In the factory's stock list of 1791 there was a complete
range of hard-paste porcelain dinner service wares deco-
rated with a black ground awaiting further decoration.
They included ten *seaux* of unspecified shapes and sizes,
valued at 24, 36, and 72 *livres* each.[7] The use of platinum
decoration on the Museum's coolers is noteworthy. Silver
was sometimes used on Sèvres porcelain during the 1770s
and 1780s.[8] Since it would inevitably tarnish (see entry for
no. 23 above), platinum was occasionally used instead,
chiefly on wares with black or brown grounds. This type of
chinoiserie decoration is found on cups and saucers, other
useful wares, and vases,[9] as well as on dinner service wares
(see below).

The kiln records show that Jean-Jacques Dieu was one
of perhaps three gilders who executed the decorative
scheme of such pieces. The records also make it clear that
often one gilder was responsible for the decoration over the
ground color panels, while another would gild only the
rims and highlights of the modeling. Dieu is recorded in
1790 as having decorated with "chinois" (chinoiseries) two
seaux crénelés, which were also gilded by L. Weidinger *père*
(recorded as "Vindiquer" in the documents),[10] as well as
two cups and saucers, six plates, and fourteen *tasses à glace,*
all with a black ground.[11] In 1791 Dieu was the sole deco-
rator of various *compotiers* and *plateaux* and at least twelve
plates, all with similar decoration.[12] In 1790 and again in
1791 he is recorded as having decorated pairs of *seaux cré-
nelés* also gilded by Weidinger.[13] The Getty Museum's *seaux
à demi-bouteille* are not identifiable in the kiln records for
1791 or 1792. In a firing in September 1790 two examples

Cooler . 1

of this shape, part of a "service chiné" (service with chinoiseries), are recorded as gilded by Weidinger.[14] A pair of "seaux à ½ Bouteille ovale" with similar decoration were fired in March 1791;[15] they were decorated by Charles-Antoine Didier, and their gilding was finished by Henri-Martin Prévost.

Individual records for gilders' work have not survived, so Dieu's work cannot be identified further, but the artists' records show a number of painters doing similar work in gold and platinum. In 1791 and 1792 they included Didier,[16] Julien l'aîné,[17] Louis-François Lecot,[18] Pierre-André Le Guay,[19] Pierre Massy,[20] J. B.(?) Nouailhier fils,[21] F.-A. Pfeiffer,[22] François-Pascal Philippine,[23] and Pierre-Joseph Rosset.[24] The kiln records for 1791 and early 1792 also show that a large number of dinner service wares were decorated by L. Girard,[25] H.-M. Prévost,[26] Louis-Antoine Le Grand,[27] and Nicolas Bulidon.[28]

The factory's sales records identify remarkably few pieces decorated with chinoiserie motifs and a black ground. The artists' and kiln records indicate that during 1790, 1791, and to a lesser extent 1792, many dinner service wares with this type of decoration were produced. Pierre Verlet has noted that in 1791 the diplomat Hughet de Sémonville purchased a service described as "fond noir, chinois en or de couleur et platine, fleurs émaillés" (black ground, with chinoiseries in colored gold and platinum, with enamel colored flowers).[29] The plates from this service cost the high sum of 45 livres each; no seaux à bouteille were included, however.

Among the surviving dinner service wares of this type, some, like the Museum's coolers, have a black ground and chinoiseries over their entire outer surfaces. For example, there are a number of plates in known collections whose entire upper surfaces are decorated, including examples in the Metropolitan Museum of Art, New York (Gift of Lewis Einstein, 62.165.2, 3, 5, 9);[30] the Nelson-Atkins Museum of Art, Kansas City (Gift of Arnold Seligmann, Rey & Co., 33-1369-70);[31] and in the State Hermitage, Leningrad.[32] On other pieces only the outer rim and an octagonal reserve in the center are decorated with the black ground and chinoiserie motifs, and there is a white panel around the reserve, which is painted with stylized chinoiserie flowers in enamel colors framed in a cloisonné manner by gilded lines. Examples are in the Metropolitan Museum of Art (62.165.13, 21, 24, 25);[33] the Bowes Museum, Barnard Castle (1960.408.1-6);[34] and in the State Hermitage.[35] The examples in the Hermitage come from a service dated 1791-1792 that was in the Yusupov family collections. Many of the pieces in this service bear Dieu's mark. It was probably purchased by Prince Nikolay Borisovich Yusupov (1750-1831), who owned several Sèvres services, one of which he

bought from the factory in 1784.[36] It is likely that many of the black-ground service wares produced in the 1790s were sold abroad, since the political situation in France had reduced the number of clients able to afford such pieces.

Other dinner service wares with decoration similar to that of the Museum's coolers have been on the art market at various times. In 1931 a pair of seaux à glace, a pair of seaux crénelés, and a seau à liqueurs were on the New York art market.[37] The seaux crénelés were sold at auction again in 1977.[38] It seems likely that the pair of plates now in the Nelson-Atkins Museum of Art also came from a group that belonged to Arnold Seligmann, Rey and Co. in the early 1930s. Given the number of similarly decorated dinner service wares that have been on the New York art market since then (including the Museum's examples), it is possible that Seligmann split up a service and sold the pieces separately. Other such wares include thirty-four plates in the Metropolitan Museum of Art (62.165.1-34)[39] and a pair of plates sold at auction in 1984.[40]

PROVENANCE: [Dalva Brothers, New York, 1972]; J. Paul Getty, 1972.

BIBLIOGRAPHY: Sassoon and Wilson 1986, p. 86, no. 183.

1. Half wine bottle coolers range in height from about 16 to 17.1 cm, and in width from about 22.4 to 23.5 cm.
2. I thank Rosalind Savill for this verbal information.
3. S.L., I.8, 1790 (for March 13, 1789–May 1, 1790), fol. 40. Full-size models were valued at 18 livres each in hard paste, and 12 livres in soft paste; half-size examples were valued at 8 livres each.
4. S.L., I.8, 1791 (for May 2, 1790–March 1, 1791), fol. 41.
5. I thank Antoine d'Albis for this verbal information.
6. K.R., Ve, November 5, 1782, fol. 34r.
7. S.L., I.8, 1791 (for May 2, 1790–March 1, 1791), fol. 45.
8. For example, on a pot à eau et jatte à la Romaine and two pots de chambre ovales decorated with a bleu céleste ground and "frize d'argent" purchased by the duc d'Orléans on April 12, 1781 (S.R., Vy8, fol. 66v).
9. For example, a théière Calabre dated 1790, decorated by Etienne-Henri Le Guay (New York, Metropolitan Museum of Art 54.147.16ab); a gobelet Litron et soucoupe dated 1792, decorated by C.-C. Gérard (Sèvres, Musée National de Céramique MNC 22952); a pot à eau et jatte à la Romaine, circa 1792, the ewer decorated by Gérard, the basin by Le Guay (MNC 5291); a pair of vases ovoïde à cornet dated 1792 (Metropolitan Museum of Art 1971.206.23–24; see Dauterman 1970, no. 91).
10. K.R., November 24, 1790, fol. 178v.
11. K.R., December 13, 1790, fols. 179r, 180r; December 26, 1790, fol. 180v.

Cooler .2

12. K.R., February 7, 1791, fol. 181v; February 28, 1791, fol. 183r; May 24, 1791, fol. 188r; August 17, 1791, fol. 192v.

13. K.R., November 24, 1790, fol. 178v; July 21, 1791, fol. 192r.

14. K.R., September 22, 1790, fol. 175r.

15. K.R., March 28, 1791, fol. 184v.

16. A.L., September 1791, fol. 104v, "Didier" ("6 Grandes tases a thé fond noir, Chinois"); July 13, 1791, fol. 105r ("2 Vases pot poury a fond noir, Chinois en or de Couleurs").

17. A.L., before April 18, 1791, fol. 118r, "Julien" (five "assiettes," one "jatte à punch," one "seau à glace," one "plateau à 2 pots," one "sucrier sans plat[eau], fond noir, Chinois").

18. A.L., August 24, 1791, fol. 129v, "L'Ecot" ("4 Vases flacons fond noir, Chinois or et Platine"); December 6, 1791, fol. 129v ("12 Assiettes fond noir, chinois").

19. A.L., August 19, 1792, fol. 137v, "Le Guay Peintre" ("2 Vases à Bandeau fond noir, Sujets Chinois").

20. A.L., March 4, 1791, fol. 144r, "Massy" ("4 Seaux," "4 Sucriers," all "fond noir, Chinois et fleurs").

21. A.L., before April 16–July 6, 1791, fol. 164v, "Noailhier" (twenty "assiettes," two "sucriers" with "plateaux," two "bateaux," two "saladiers," twenty "tasses à glaces" with two "plateaux de tasses à glaces," eight "compotiers rond," four "compotiers quarré," four "compotiers coquilles," and four "compotiers ovales, Service noir, Chinois").

22. A.L., before June–September 16, 1791, fols. 169r–169v, "Pheiffer" (seven "assiettes," one "jatte à punch et mortier," and one "seau à glace . . . fond noir, chinois en or et Platine"; two "Seaux ovales" and four "compotiers quarrés . . . fond noir plein, chinois en or de Couleur"; six "assiettes fond noir, chinois").

23. A.L., before May 2–July 1, 1791, fol. 177r, "Philippine L'[aîné]" (four "assiettes fond noir," six "assiettes fond noir plein," one "beurier," two "saladiers," one "saucière sans plat," all "chinois").

24. A.L., January 11–May 12, 1791, fol. 190v, "Rosset," (six "assiettes," one "beurier," twelve "tasses à glace," all "fond noir, Chinois"); June 4 and September 5, 1791, fol. 191r (nineteen "assiettes unies noirs, chinois en or de Couleurs").

25. K.R., February 28, 1791, fol. 183v (seven "assiettes," three "beuriers, fond noir, chinois," with gilding by François Baudouin *père*).

26. K.R., March 28, 1791, fol. 184v (one "assiette fond noir, chinois" [sole decorator]).

27. K.R., July 5, 1791, fol. 189v (one "plateau a deux pot fond noir, chinois en or" [sole decorator]).

28. K.R., July 21, 1791, fol. 192r (four "compotiers coquille [fond Noir, chinois]" with gilding by Weidinger).

29. S.R., Vy11, May 6, 1791; see Verlet 1953, p. 23; Eriksen and de Bellaigue 1987, p. 54.

30. See C. Le Corbeiller, in *A Guide to the Wrightsman Galleries at the Metropolitan Museum of Art* (New York, 1979), p. 36, ill. p. 30.

31. Decorated by Dieu and dated 1791/92.

32. See K. Butler, "Sèvres from the Imperial Court," *Apollo,* no. 101 (June 1975), pp. 452–457, 456.

33. See Le Corbeiller (note 30), p. 37, ill. p. 30.

34. Six plates dated 1791/92, one with the mark of P.-J. Rosset.

35. Butler (note 32).

36. Ibid.; S.R., Vy9, September 17, 1784, fol. 138r.

37. All bought in 1931 by French and Company, New York, from Arnold Seligmann, Rey & Co. (JPGC French and Co. Archives, stock nos. 38434, 38547). The two *seaux à glace* and the *seau à liqueurs* were sold in 1931 to Mrs. Mary Duke Biddle; they were apparently decorated by Le Guay. The two *seaux crénelés* were bought in 1933 by Robert Woods Bliss, Dumbarton Oaks, Washington, D.C. (they had spent six months on approval to the Minneapolis Institute of Art in 1932).

38. Dr. Annella Brown, Boston (sold, Sotheby Parke Bernet, New York, April 23, 1977, lot 79).

39. Le Corbeiller (note 30), pp. 36, 37.

40. Christie's East, New York, June 5, 1984, lot 129 (painted by Le Guay).

Cooler .1, alternate view

Cooler .2, alternate view

Vase .1, detail showing decoration

Vase .2, detail showing decoration

31 Teapot
(théière litron)

Late eighteenth-century porcelain, with nineteenth-century French or English decoration
Sèvres manufactory; soft-paste porcelain

HEIGHT 8.8 cm (3⁷⁄₁₆ in.); WIDTH 11.9 cm (4¹¹⁄₁₆ in.); DEPTH 6.8 cm (2¹¹⁄₁₆ in.)

MARKS: Painted in blue under the base with the factory mark of crossed L's; incised *26* and *48*.

79.DE.63

DESCRIPTION: The circular teapot has straight sides with a flat base, recessed underneath. The rim has two quarter circles cut into it, which lock with similarly shaped projections under the lid. The lid is slightly domed and has a conical knop. Liquid passes into the spout through five small holes pierced inside the pot. The double-curved handle is molded with a stylized leaf in low relief on its uppermost surface.

Each side of the teapot is painted in pink (*camaïeu rose*) with landscapes and ruins. The lid is painted with a ring of roses and other stylized flowers and leaves.

Burnished gilding highlights the shape of the teapot, with a simple band at the base, bands of long strokes and dots, dentil lines, and leaves. The body of the spout is scattered with gilded stars.

CONDITION: The teapot is unbroken except for a small chip in the spout, which has been covered by new gilding.

COMMENTARY: This model was called a *théière litron* in the factory's documents. A drawing in the archives shows the outline of the body but not the spout and handle (fig. 31c). It is inscribed *theyere Litron grandie de plus que La 1er. gr. D'un 10e. et demandé par M. Basin Le 8 avril 1788* (Litron teapot enlarged from the first size by a tenth, ordered by M. Basin on April 8, 1788). A plaster model survives for a large size of this model.[1] The stock list of 1788 records many "Theyeres Litron" in the Magasin du Blanc of soft-paste porcelain.[2] There were fifty-seven of the first and second sizes, valued

at 4 *livres* each, and seventy-two of the third and fourth sizes, valued at 3 *livres* each. Six "Theyeres très grande," valued at 6 *livres* each, may relate to the drawing in the archives. Four drawings dated 1753 for another shape of teapot, inscribed "teyere pour Les Litrons," and a matching lidded sugar bowl survive in the factory's archives (MNS R.1, l.11, d.4, fol. 2). This teapot has angled walls and a larger double-curved handle than the Museum's example.

The style of the *camaïeu rose* landscape painting on this teapot is very typical of the early 1750s, when the factory was still at Vincennes.[3] Since it is undated, this teapot was previously thought to have been made before the introduction of date letters in 1753. Yet there are many indications that the porcelain is not from Vincennes, but from Sèvres, and that its decoration is later, and not necessarily French. First, the model was probably not introduced until the 1780s; the earliest known examples date from 1786 (see below). In addition, the incised marks *26* and *48* are too high to be from Vincennes or from the earlier period at Sèvres, and the design of the lid, which locks onto the teapot, is not characteristic of Vincennes pieces. The knop is of a plain conical shape, whereas most Vincennes knops are molded in the form of a flower. The painting of the stylized flowers around the lid is too sterile for Vincennes, and although the painting of the landscapes is very fine, it is not characteristic of the 1780s. Finally, the gilding is not typical of wares produced at Vincennes or Sèvres. Such redecoration was common in both France and England in the nineteenth century.

There are many known *théières litron* of the same model as the Museum's example. Although this model was often the vehicle for exercises in the redecoration of Sèvres porcelain in the nineteenth century, many examples with original decoration survive, including one dated 1786 in the Bearsted collection at Upton House, Warwickshire; one dated 1787, sold at auction in 1980,[4] one dated 1788 in the Art Institute of Chicago (Gift of Mrs. Albert Beveridge, 1966.510); one dated 1790, sold at auction in 1974;[5] and one dated 1794 in the Kunstgewerbemuseum, Cologne (E1274 a,b). All of these display neoclassical decoration.

There are many other examples of this model that have less plausible decoration and marks. An example bearing the date letter for 1767 was sold at auction in 1981.[6] It is unmarked but is decorated with a pink ground and birds in reserves. This example, like the Museum's, has lines and dots of gilding along the edge of its handle. Two *théières litron* of this model, each dated 1767 and with the false painter's mark *va,* are in the Bowes Museum, Barnard Castle (Founder's Bequest, X 2475, X 1278). One of them has no ground color and is painted in colors with sprays of flowers and has gilded

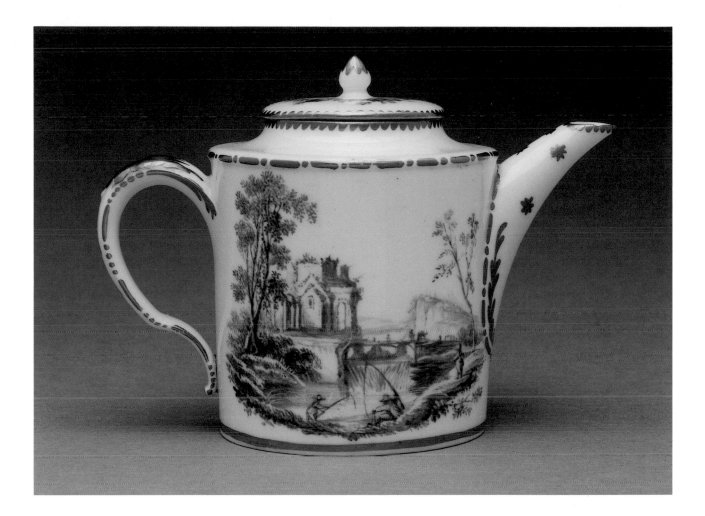

patterns.[7] The other has similar painted and gilded decoration but also has panels of green ground on the body and extra patterns of gilding framing the reserves. Three examples are known painted with the date letter *P* for 1768. One, sold at auction in 1979,[8] has the same pattern of gilded lines and dots around the edge of the handle found on the Museum's teapot and was painted with a green ground and colored reserves of landscapes. The above examples, with their gilded decoration so similar to that of the Museum's teapot, were probably all originally white or plainly decorated.

Very few examples of the *théière litron* shape depicted in the 1753 drawing are known. One dated 1758, with no ground color and painted with sprays of flowers, is in an English private collection, and a similarly decorated example, circa 1753, is in the Musée de la Céramique, Rouen.[9]

PROVENANCE: Mrs. John W. Christner, Dallas (sold, Christie's, New York, June 9, 1979, lot 204); the J. Paul Getty Museum, 1979.

BIBLIOGRAPHY: Wilson 1980, p. 19, item D; Sassoon and Wilson 1986, p. 81, no. 174.

1. MNS Archives, 1814 Inventory, "Théière Litron Ancienne," 1760–1780, no. 1 (height 17 cm).
2. S.L., I.8, 1788 (for March 30, 1786–May 23, 1788), fol. 46.
3. See, for example, Préaud and Faÿ-Hallé 1977, nos. 24, 246, 247, 335.
4. Collection of Nelson Rockefeller (sold, Sotheby's, New York, April 11, 1980, lot 245 [height 14 cm]).
5. Sold, Sotheby's, New York, October 22, 1974, lot 354 (height 12.1 cm).
6. Sold, Christie's, London, October 5, 1981, lot 9 (height 9.5 cm).
7. I thank Sarah Medlam and the late David Garlick, Bowes Museum, for their help.
8. Collection of Mrs. John W. Christner, Dallas (sold, Christie's, New York, March 8, 1979, lot 248 [height 9 cm]).
9. I thank Bernard Dragesco for pointing out the existence of this example. It has the factory mark of crossed L's enclosing a dot and over a dot, typical of the period before date letters were introduced.

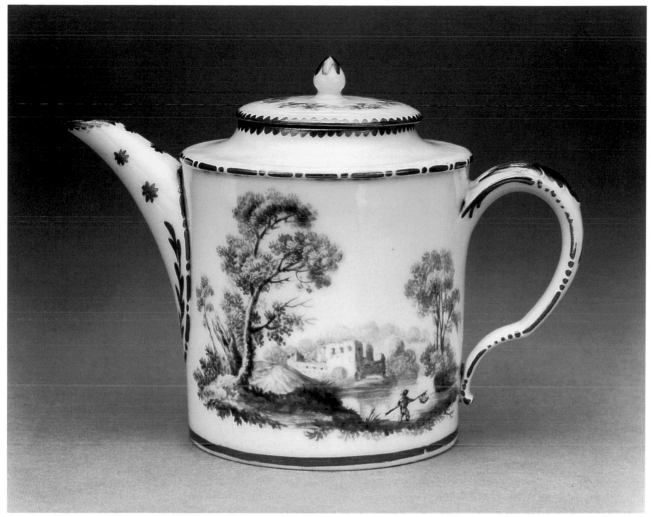

Alternate view

32 Plaque for a Tabletop
(plateau Courteille ou de chiffonière)

1761

Sèvres manufactory; soft-paste porcelain; painted by Charles-Nicholas Dodin; mounted on a table by an imitator of Bernard van Risenburgh

HEIGHT 2.5 cm (1 in.); WIDTH 34.3 cm (1 ft. 1½ in.); DEPTH 24.5 cm (10 in.)

MARKS: Painted in blue under the base with the factory mark of crossed L's enclosing the date letter I for 1761, above the painter's mark k. No incised marks.

70.DA.85

DESCRIPTION: The flat, rectangular plaque has shaped edges that curve up to a rim. It stands on a foot ring and is glazed underneath.

The top of the plaque is decorated with a pink (*rose*) ground with a large, four-lobed colored reserve in the center. The ground is overlaid with a trellis pattern in blue (*beau bleu*) with maroon stylized flowers. In the center of each square formed by the trellis is a flower with leaves painted in blue. The curved edges of the plaque are thickly painted over the ground with a narrow band of dark blue, allowing C- and S-scrolls in pink to show through. The painted reserve shows a man and a woman seated in a pastoral setting, with a partly overgrown ruin on the left.

Short, slashed lines of gilding highlight the trellis and flowers. There are groups of gilded dots on the blue band at the edges. The rim is gilded, and the gilded band framing the reserve is set on a carmine red ground and tooled with rectangles, alternately burnished and crosshatched.

CONDITION: The plaque has been broken in half, and one of the halves broke into three smaller pieces. It has been restored more than once. There are filled holes on the underside where metal staples were once placed to hold the restoration. The tooling of the gilding is very worn.

COMMENTARY: This type of plaque was produced both without handles, for mounting on a tabletop, and with handles, for use as a tray.[1] It was called the *plateau de chiffonière* or *plateau de Courteille ou de chiffonière* when produced without handles, and the *plateau Courteille* when made with handles. The shape was named after one of Louis XV's *intendants des finances*, Dominique-Jacques de Barberie, marquis de Courteilles, who from August 1751 represented the king's interest in the Sèvres enterprise.[2] The shape was first produced during 1758 in two sizes, and the molds are recorded in the stock list compiled at the end of that year.[3] There are no *plateaux* specified as being of this shape in the stock list of the Magasin de Vente, but the list for work of 1758 records three *plateaux Courteille*, valued at 24 *livres* each, in the Magasin du Blanc.[4] In 1762 seven "Platteaux Courteilles ou Duplessis" are listed in the Magasin du Blanc; this may refer to a mixture of two different shapes.[5]

The *marchand-mercier* Simon-Philippe Poirier purchased at least eight plaques between 1761 and 1764, presumably for mounting on *tables en chiffonières*.[6] In the quarter commencing in October 1761 he purchased one "plateau Courteille ou de Chifonniere" for 300 *livres*,[7] while others purchased through the end of 1763 cost 168, 216, 300, 360, and 432 *livres* each.[8] A very firm link between Poirier and this model of table is established by an example in a French private collection that bears a contemporary inscription that includes his name.[9] These plaques were also produced in pairs, one of which would serve as the tabletop and the other as a shelf between the table's legs.[10] The lower plaques had indented corners, which enabled them to fit between the legs. Such pairs can be seen on a table in the Metropolitan Museum of Art, New York;[11] a pair now split between the Wallace Collection (C489) and the Victoria and Albert Museum (1069-1882), London;[12] and a pair sold at auction in 1976.[13]

The scene painted in the reserve of the Museum's plaque is copied from an engraving by André Laurent after a painting by François Boucher, entitled *Le Pasteur galant* (illus.). The original overdoor painting was commissioned by Prince Hercule-Mériadec, duc de Rohan-Rohan, for the Hôtel de Soubise, Paris, and was installed in 1738.[14] The engraving was published in 1742 and was advertised in the *Mercure de France* in December of that year. An example in the archives at Sèvres bears an eighteenth-century inventory number on its reverse.[15]

Painters other than Charles-Nicholas Dodin used this engraving as a source for painted scenes on Sèvres porcelain. Examples by unknown painters include a detail on a *cuvette Courteille* from a garniture, circa 1761, in the collection

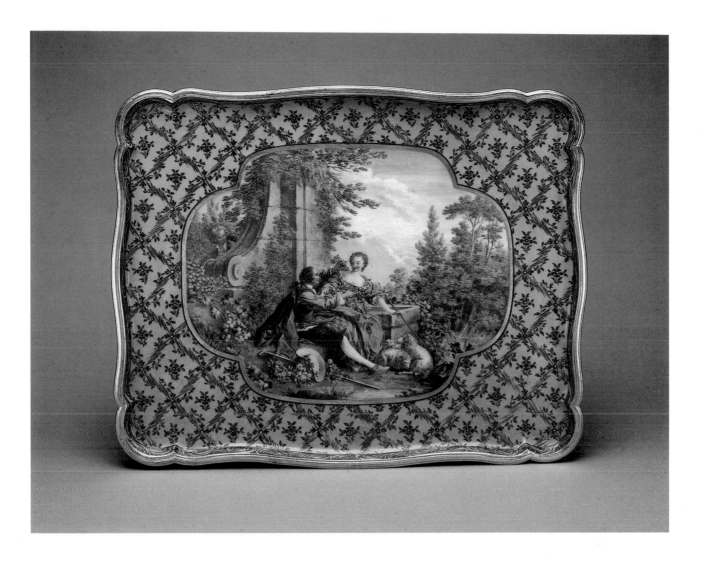

of the Duke of Buccleuch, Bowhill, Scotland,[16] a *vase hollandois* from a garniture of three dated 1762 in the Wallace Collection,[17] and on the *déjeuner losange à jour à anses* of a tea service dated 1764, sold at auction in 1925.[18] The engraving was used as a source for a rectangular *plateau à tiroir* of 1766 painted by Etienne-Jean Chabry *fils,* in the British Museum, London (Sir Bernard Eckstein Bequest, M&LA 1948.12.38), and for the saucer of a *gobelet Calabre* dated 1768, also by Chabry, in the Victoria and Albert Museum (Jones Collection, 778&A-1882). Dodin painted the scene on other pieces of Sèvres, such as one of a pair of *pots pourris myrthe* of 1763 at Waddesdon Manor.[19] The engraving was also used at Vincennes for the design of a glazed figure group entitled *Le Berger galant,* an example of which is in the Musée National de Céramique, Sèvres (MNC 25135).[20]

Similar decoration of a trellis in blue over a pink ground appears on two other works in the Museum's collection: the *cuvette Mahon* and the *gobelet enfoncé* (nos. 14, 15 above), both also dated 1761. Perhaps the earliest dated *plateau Courteille ou de chiffonière* similar to this example is from 1757; it has a pink ground and is painted with garlands of flowers by Denis Levé *père* (Boston, Museum of Fine Arts 65.1784).[21]

It seems very likely that the Museum's plaque was purchased from the factory by Poirier, who would have commissioned a table to fit it from an *ébéniste* such as Bernard van Risenburgh. Poirier and his successor, Dominique Daguerre, had a near-monopoly on the purchase of Sèvres porcelain plaques for mounting on furniture.[22] Other plaques in the Museum's collection (nos. 33–35, 37–40 below) may also have been commissioned by Poirier or Daguerre, who would have consulted with the factory about the design of shapes to fit specific pieces of furniture.

The present author has suggested that this plaque was originally mounted on a table attributed to van Risenburgh bequeathed to the Musée du Louvre, Paris, in 1922 (illus.; see Bibliography). The Getty Museum's table undoubtedly dates to the late nineteenth or early twentieth century; its drawer panel bears the genuine stamp BVRB taken from another piece of furniture. The Louvre table is painted in *vernis Martin* with a colored trellis pattern matching the plaque, and it has a similarly painted lower shelf. No matching plaque with indented corners is known. In 1892 an "Oblong plateau of old Sèvres porcelain with shaped raised border, the center painted with a garden scene, figures, and sheep, in the style of Boucher, on rose-coloured ground—in metal gilt frame" was offered for sale in London from the collection of Miss H. Cavendish-Bentinck.[23] It measured 9¾ by 12 inches and could very possibly be the Museum's example. An "Oblong Plateau" sold at auction in 1913 from the collection of John Cockshut could also be the Museum's

André Laurent after François Boucher (French, 1703–1770). *Le Pasteur galant.* Engraving. Manufacture Nationale de Sèvres, Archives D VII, Boucher.

example. According to the catalogue, it was dated 1761 and painted by Dodin "with a shepherd and shepherdess seated by a fountain, in a quatrefoil panel, on pink ground with trelliswork and flowers in blue and gold—13½ in. by 9¾ in."

PROVENANCE: Porcelain plaque only: (?)Miss H. Cavendish-Bentinck (offered for sale, Christie's, London, March 3, 1893, lot 123, bought in for 95 gns.); (?)John Cockshut, Esq. (sold, Christie's, London, March 11, 1913, lot 92, to [Harding]); complete table: [Rosenberg and Stiebel, New York, 1949]; J. Paul Getty, 1949.

BIBLIOGRAPHY: Dauterman 1964, p. 165; A. Sassoon, "New Research on a Table Stamped by Bernard van Risenburgh," *GettyMusJ* 9 (1981), pp. 167–174; D. Guillemé-Brulon, "Un Décor pour les meubles," *L'Estampille* 165 (January 1984), p. 28; Sassoon and Wilson 1986, p. 35, no. 75; A. Faÿ-Hallé, in *François Boucher, 1703–1770,* exh. cat. (Metropolitan Museum of Art, New York, 1986), pp. 354–355; Savill 1988, p. 812, n. 2f.

Table, late nineteenth or early twentieth century. By an imitator of Bernard van Risenburgh.

Table, circa 1761. Attributed to Bernard van Risenburgh. Paris, Musée du Louvre OA.7626.

1. Eriksen and de Bellaigue 1987, p. 315, no. 128, ill. p. 316.
2. Ibid., p. 35.
3. S.L., I.7, 1759 (for 1758), fol. 6 (valued at 26 *livres* for the first size and 20 *livres* for the second).
4. Ibid., fol. 15.
5. S.L., I.7, 1762 (for 1761), fol. 16 (valued at 21 *livres* each).
6. P. Verlet, "Le commerce des objets d'art et les marchand-merciers à Paris au XVIIIᵉ siècle," *Annales: Economies, sociétés, civilisations* 13, no. 1 (1958), pp. 10–29; Dauterman 1964, pp. 162–167, nos. 29–30.
7. S.R., Vy3, fol. 71v.
8. Ibid., fols. 92r, 145v.
9. See *Louis XV: Un Moment de perfection de l'art français,* exh. cat. (Hôtel de la Monnaie, Paris, 1974), no. 432.
10. Sassoon (Bibliography).
11. Dauterman 1964, pp. 165–167, no. 30.
12. See Sassoon (Bibliography).
13. From the collections of Miss Mabel Gerry, Mrs. Meyer Sassoon, Sir Alfred Chester Beatty, sold by the comtesse d'Aubigny (Sotheby's, London, July 1, 1976, lots 99, 100); the plaques were mounted on a pair of later tables.
14. A. Laing, in *François Boucher, 1703–1770* (Bibliography), no. 30.
15. R. Savill, "François Boucher and the Porcelains of Vincennes and Sèvres," *Apollo,* no. 115 (March 1982), pp. 167, 170.
16. See Christie's, London, October 6, 1986, lot 257 (unsold).
17. See Savill (note 15) pp. 167, 170, fig. 12.
18. Collection of the late Sir Edward Scott (sold, Sotheby's, London, July 10, 1925, lot 47). I thank Rosalind Savill for this information.
19. Eriksen 1968, no. 56.
20. See Faÿ-Hallé, in *François Boucher, 1703–1770* (Bibliography), pp. 354–355.
21. See P. T. Rathbone, *The Forsyth Wickes Collection* (Boston, 1968), p. 69.
22. Eriksen and de Bellaigue 1987, pp. 129–130.
23. I thank Theodore Dell for this information.

33 Four Plaques for a Table
(plaque ronde *and three* quarts de cercles)

1764
Sèvres manufactory; soft-paste porcelain; mounted on a table attributed to Martin Carlin, circa 1766–1770

Circular plaque: DIAM. 36.5 cm (1 ft. 2⅜ in.); THICKNESS 1.3 cm (½ in.). *Curved plaques:* HEIGHT 4.6 cm (1¾ in.); WIDTH 27.7 cm (10⅞ in.); THICKNESS 0.6 cm (¼ in.)

MARKS: The circular plaque is painted in blue on its reverse with the factory mark of crossed L's enclosing the date letter L for 1764.

70.DA.74

DESCRIPTION: A circular plaque is mounted on the top of the table, and three curved rectangular plaques are set below, on the frieze. The curved plaques are glazed on both sides.

The plaques are painted in colors with groups of flowers over the white glaze. The circular plaque is painted with a bunch of flowers and grapes in the center and five smaller groups of flowers around the edge, including parrot tulips, roses, blue primulas, blue morning glories, anemones, a daisy, honeysuckle, and viburnum. Each curved plaque is painted with five smaller sprays of similar flowers. There is no gilded decoration.

CONDITION: The circular plaque has sustained numerous scratches in the glaze. None of the plaques is broken, and those in the frieze are unworn.

COMMENTARY: These plaques and those described below (nos. 34–40) are all of shapes produced specifically for furniture,[1] whereas the Museum's *plateau* (no. 32) is of a model adapted from a tableware shape. The production of plaques for furniture at Sèvres was closely related to the activities of the *marchand-mercier* Simon-Philippe Poirier and his successor, Dominique Daguerre. Furniture plaques are identifiable in the sales records, though few details of their size and decoration are given. Plaques were also produced for boxes of various sizes (*tabatières* and *coffres*), for inkstands, and as reproductions of paintings (*tableaux*), all of which were intended to be placed in metal mounts or gilt-wood frames. Geoffrey de Bellaigue has noted that from 1760 to 1793

about 1,700 furniture plaques were sold to Poirier and Daguerre but that only about 170 were sold to other customers. This suggests that Poirier initiated the use of painted Sèvres porcelain plaques on furniture and that he coordinated their conception with the design and execution of the furniture by various *ébénistes*. Most of the comparatively few pieces of rococo furniture bearing Sèvres plaques were made by Bernard van Risenburgh and Joseph Baumhauer.[2] Much of the neoclassical furniture mounted with Sèvres plaques was made by Martin Carlin.

The factory's stock lists do not record models or molds for furniture plaques. In the Magasin de Vente after the end of 1765, seventeen "plaques de Bureau" (plaques for a writing table or desk) were listed, priced variously at 9, 18, 24, and 36 *livres* each.[3] Their decoration was not described. One year later, after the end of 1766, forty-six plaques were listed for sale at an even wider range of prices: 9, 12, 15, 18, 21, 30, 36, 42, 54, 66, 72, and 144 *livres* each.[4] In the same year forty-eight "plaques pour Tableaux ou meubles" (plaques for paintings or furniture [presumably in a variety of sizes]) were listed in the Magasin du Blanc, all valued at 6 *livres* each,[5] and there were sixty plaques in the biscuit state, valued at 3 *livres* each.[6] After the end of 1767 similarly priced plaques were in the Magasin de Vente, as well as examples costing 24, 39, 48, 120, 204, and 240 *livres* each.[7] These variations in price reflect differences not only in the sizes of the plaques but also in their decoration. Many, like the present examples, did not have colored borders.

The biscuit kiln records indicate that large numbers of plaques were fired in the 1760s. In December 1761 twenty-nine "Plaques de Table" were listed,[8] and in July 1763 there were fifty more of the same description in a biscuit kiln firing.[9] In December 1765 ninety "Plaques differentes" are listed, some of which were surely for furniture.[10] The painters' overtime records show that in 1764 (the year in which the Museum's circular plaque was made) Charles-Louis Méreaud *le jeune* was paid 30 *livres* for painting one "Platteau rond en Table p.[our] M. Poirier,"[11] which was probably of the same type as the Museum's example. In 1766 he was again paid 30 *livres* for painting one "Grande plaque ronde Poirier."[12]

The Sèvres sales records show that in the last six months of 1764 Poirier purchased one "Grande plaque Ronde" for 72 *livres,* and another for 168 *livres.*[13] In the last six months of 1765 he purchased one plaque of unspecified type for 168 *livres* and two for 72 *livres* each.[14] He purchased two plaques for 72 *livres* each during the final six months of 1766,[15] and one "Plaque Ronde" for the same price during January 1767.[16] Given the number of surviving circular plaques similar to the Museum's example (see below, and no. 34), they probably correspond to these and later references for plaques costing 72 *livres*. The more expensive circular plaques were probably decorated with flowers as well,

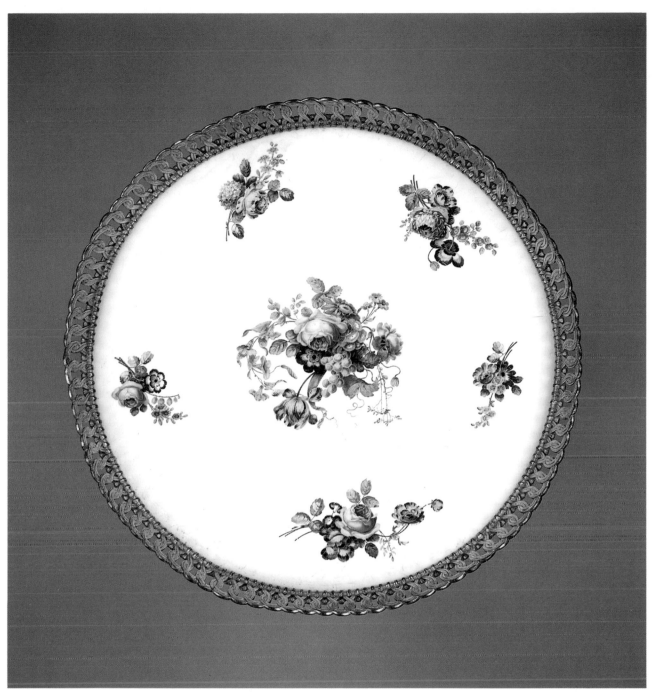

Tabletop
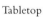

but they may have commanded higher prices because the flowers were in elaborately painted baskets, or because they had colored borders and gilding. In 1763 Poirier purchased two "petites plaques . . . ronde" with green borders for 72 *livres* each, though they were obviously smaller than those discussed above.[17] It seems likely that the top plaque of the Museum's table was either mounted on another piece of furniture in the mid-1760s or not used for a few years after it was made, since Carlin did not become a *maître-ébéniste* until 1766.

The curved rectangular plaques are identifiable by the 1770s as "quarts de cercles" in the factory's documents. They, unlike flat plaques, were always glazed on their reverse to help prevent distortion during firing. In the stock list of February 1773 seven examples of this shape were recorded among stock held by Poirier and Daguerre for sale on consignment; they cost 15 *livres* each.[18] No *quarts de cercles* are listed by name in the sales records until 1771, when Poirier purchased three for 15 *livres* each.[19] During 1764, when Poirier purchased the *plaques rondes* mentioned above, there were no other plaques costing 15 *livres* among his purchases. There were, however, 112 plaques for 12 *livres* each, which may have included *quarts de cercles* if they were being produced in the 1760s.[20] In 1765 Poirier purchased 4 plaques costing 15 *livres* and 14 for 12 *livres* each.[21] During 1766 he bought 70 at 12 *livres* each,[22] possibly including some *quarts de cercles*.

The 1771 auction catalogue of François Boucher's possessions describes a table with a circular plaque similar to the Museum's example: "Une table à trepied. . . . le dessus est de porcelaine de France, à bouquets & fleurs colorées" (a table with three feet . . . the top of Sèvres porcelain, with colored bouquets and flowers).[23]

Several round plaques of similar size and decoration are known to have survived. Some are mounted on similar tables, both with and without curved plaques in the frieze (see no. 34). One similar circular plaque, dated 1765 and bearing the painter's mark of Jacques-François Micaud *père,* is mounted on a table with no frieze plaques in the Musée du Louvre, Paris (Grog collection).[24] Examples mounted with three frieze plaques were sold at auction in 1891 and 1933,[25] and are in the Musée du Louvre (Salomon de Rothschild Bequest, OA.7624) and in the Musée Nissim de Camondo, Paris (133). Tables with three frieze plaques but with no top plaque are also known. It is possible that the porcelain tops were broken and replaced with veneered tops. Tables of this type were sold at auction in 1941 and 1978.[26] Similarly decorated circular plaques were also mounted on tables of different shapes that were not intended to have frieze plaques.[27] None of the above-mentioned *quarts de cercles* is recorded as bearing a date letter or other useful marks, and it seems that these plaques were rarely, if ever, marked, even with the factory mark of crossed L's.

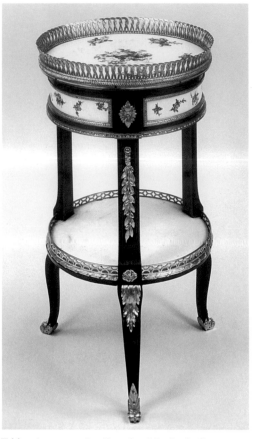

Table, circa 1770. Attributed to Martin Carlin.

PROVENANCE: Alfred de Rothschild, Halton, Buckinghamshire; by descent to Almina Wombwell (daughter of Alfred de Rothschild; Countess of Carnarvon, married the 5th earl 1895, died 1969), 1918; [Henry Symons and Co., London, 1919]; [French and Company, New York, 1919]; Mortimer L. Schiff, New York, 1919 (sold by his heir, John L. Schiff, Christie's, London, June 22, 1938, lot 52); J. Paul Getty, 1938.

BIBLIOGRAPHY: J. P. Getty, *Europe in the Eighteenth Century* (Santa Monica, Calif., 1949), ill. facing p. 56; F. J. B. Watson, *The Wrightsman Collection,* vol. 1, *Furniture* (New York, 1966), p. 282; Sassoon and Wilson 1986, p. 32, no. 68; Savill 1988, pp. 877, 900, nn. 35, 38.

1. Many authors have described the production at Sèvres of porcelain plaques designed for mounting on furniture; see Parker 1964, pp. 105–115; Eriksen and de Bellaigue 1987, pp. 94–95, 129–130.
2. *Louis XV: Un Moment de perfection de l'art français,* exh. cat. (Hôtel de la Monnaie, Paris, 1974), nos. 431–433; sales cat., Sotheby's, London, December 13, 1974, lot 25; see also no. 32 above.
3. S.L., I.7, 1766 (for 1765), fol. 39; possibly these were made for a *bureau plat* like one stamped by Joseph and Saunier in the Huntington Art Collections, San Marino (Wark 1961, fig. 54). Its plaques are dated 1763.

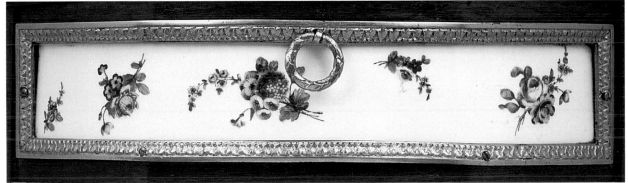

Frieze plaques

4. S.L., I.7, 1767 (for 1766), fol. 30.

5. Ibid., fol. 19.

6. Ibid., fol. 14.

7. S.L., I.7, 1768 (for 1767), fol. 36.

8. B.K.R., December 31, 1761, fol. 17.

9. B.K.R., July 1, 1763, fol. 22.

10. B.K.R., December 31, 1765, fol. 31/34.

11. P.O.R., F.7, 1764, "Moireau [Méreaud] Le jeune," fol. 18.

12. P.O.R., F.8, 1766, "Moireau [Méreaud] Le jeune," fol. 39.

13. S.R., Vy4, fol. 24v.

14. Ibid., fol. 60v.

15. Ibid., fol. 96r.

16. Ibid., fol. 107v.

17. S.R., Vy3, October 1, 1763–January 1, 1764, fol. 145v.

18. S.L., I.8, February 2, 1773, fol. 14.

19. S.R., Vy5, fol. 20v.

20. See above (note 13).

21. See above (note 14).

22. See above (note 15).

23. Sold, Musier, Paris, February 18 et seq., 1771, lot 1017.

24. D. Alcouffe, in *Cinq Années d'enrichissement du patrimoine national, 1975–80,* exh. cat. (Grand Palais, Paris, 1980–1981), no. 87.

25. Collection of Sir William Richard Drake, deceased (sold, Christie's, London, June 30, 1891, lot 157, to Duveen); collection of Baron Albert von Goldschmidt-Rothschild (sold, Ball and Graube, Berlin, March 14, 1933, lot 30).

26. Collection of the late M. Dubois Chefdebien (sold, Hôtel Drouot, Paris, February 13–14, 1942, lot 112); collections of Alphonse and Edouard de Rothschild (sold by their descendants Mme Bethsabée de Rothschild and Mme Jacqueline Piatagorsky, Sotheby's, Monaco, May 21–22, 1978, lot 15).

27. For example, see Sotheby's sale above (note 26), lot 18.

34 *Four Plaques for a Table*
(plaque ronde *and three* quarts de cercles)

1773
Sèvres manufactory; soft-paste porcelain; circular plaque painted by Jacques-François Micaud, mounted on a table stamped by Martin Carlin, circa 1773

Circular plaque: DIAM. 37.2 cm (14⅝ in.); THICKNESS 0.9 cm (⅜ in.). *Curved plaques:* HEIGHT 4.7 cm (1⅞ in.); WIDTH 28.2 cm (11⅛ in.); THICKNESS 0.7 cm (¼ in.)

MARKS: The circular plaque is painted in blue on the reverse with the factory mark of crossed L's, the date *1773* in numerals, and the painter's mark of a Saint Andrew's cross. No incised marks.

70.DA.75

DESCRIPTION: A circular plaque is mounted on the top of the table, and three curved rectangular plaques are set below, on the frieze. The curved plaques are glazed on both sides.

The plaques are painted with groups of flowers in colors over the white glaze. The circular plaque is painted with a large group of flowers, including tulips; yellow, pink, and white roses; honeysuckle; cornflowers; purple delphiniums; grasses; morning glories; and primulas. The curved plaques are each painted with four small sprays of slightly stylized flowers, including roses. There is no gilded decoration.

CONDITION: The circular plaque has suffered from use; the glaze and the painting are very scratched and worn. There is a chip about 1.5 cm in diameter next to the edge, which has been filled. The frieze plaques are unworn.

COMMENTARY: These plaques are of the same shapes as those discussed above (see no. 33). The circular plaque bears the date in numerals, rather than the date letter *U* for 1773.

Although the circular plaque bears the mark of the painter Jacques-François Micaud *père,*[1] there is no relevant entry in the painters' overtime records for Micaud, and the artists' ledgers for 1773 do not survive. The sales records show that during the last six months of 1773 Poirier (who had become associated with Daguerre in the previous year) purchased ten *quarts de cercles* costing 15 *livres* as well as two unspecified plaques costing 78 *livres* each.[2] In the same period Poirier and Daguerre purchased one "Table ronde à groupe de fleurs" for 72 *livres,* which may have been similar to the Museum's circular plaque.[3] During 1774 Poirier purchased five plaques for 72 *livres* each and one for 78 *livres,* as well as six *quarts de cercles* for 15 *livres* each.[4]

In the surviving list of objects supplied by Poirier to Madame du Barry between 1768 and 1774 there is one table with plaques similar to the present examples.[5] It was described as "Une table ronde en bois rose, le dessus & les parcloses en porcelaine de France" (A round table in tulipwood, the top and sides of Sèvres porcelain), and it cost 840 *livres.* Another table with a similar top, from the collection of the actress Mme De Laguerre, was sold at auction in 1782. It was described as "une table ronde, plaquée en bois satiné, le dessus de porcelaine de Sève, à fleurs" (a round table, veneered in *bois satiné* [a type of mahogany], the top of Sèvres porcelain, with flowers).[6]

One of a pair of framed plaques in the J. Pierpont Morgan collection painted in colors with an elaborate group of flowers in a basket has marks similar to those on the Museum's circular plaque.[7] It has crossed L's enclosing Micaud's mark of a Saint Andrew's cross (though this could be the date letter for 1775), and next to it the date 1774 in script.

PROVENANCE: Alfred de Rothschild, Halton, Buckinghamshire; by descent to Almina Wombwell (daughter of Alfred de Rothschild; Countess of Carnarvon, married the 5th earl 1895, died 1969), 1918; [Henry Symons and Co., London, 1919]; [French and Company, New York, 1919]; Mortimer L. Schiff, New York, 1919 (sold by his heir, John L. Schiff, Christie's, London, June 22, 1938, lot 51); J. Paul Getty, 1938.

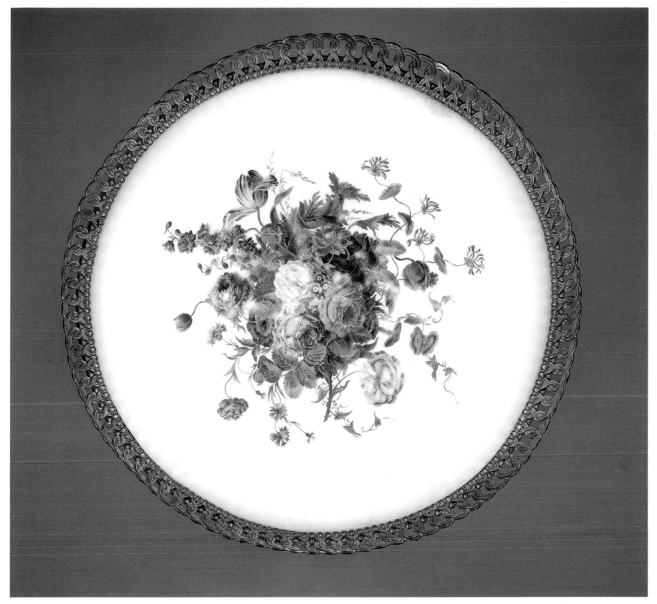

Tabletop

BIBLIOGRAPHY: J. P. Getty, *Europe in the Eighteenth Century* (Santa Monica, Calif., 1949), ill. facing p. 56; idem, *Collector's Choice* (London, 1955), p. 82; F. J. B. Watson, *The Wrightsman Collection,* vol. 1, *Furniture* (New York, 1968), p. 282; D. Guillemé-Brulon, "Un Décor pour les meubles," *L'Estampille* 165 (January 1984), p. 30; Sassoon and Wilson 1986, p. 32, no. 69.

1. Eriksen and de Bellaigue 1987, p. 170; it is possible that this mark was also used by Philippe Xhrowet until his death in 1775.
2. S.R., Vy5, fols. 109r, 109v.
3. Ibid.
4. S.R., Vy5, fols. 188v, 201r, 201v.
5. G. Wildenstein, "Simon-Philippe Poirier, fournisseur de Madame du Barry," *Gazette des beaux-arts* 2 (1962), p. 377.
6. Girardin, Paris, April 10, 1782, lot 22.
7. X. de Chavagnac, *Catalogue des porcelaines françaises de M. J. Pierpont Morgan* (Paris, 1920), pp. 120–121, no. 150. Micaud is recorded as having received 480 *livres* for painting "2 Plaques 1ere gr fond de Tableaux et fleurs," which may be these examples (P.O.R., F.16, 1774, "Micaud," fol. 131).

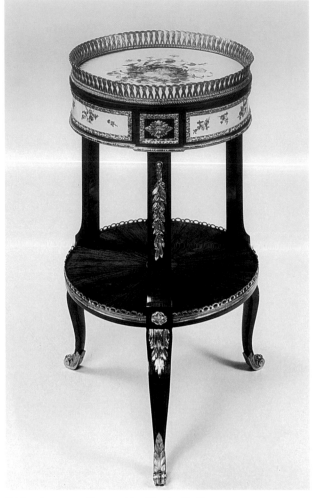

Table, circa 1773. Stamped by Martin Carlin.

Frieze plaques

35 *Eight Plaques for a* Secrétaire (plaque ronde, plaque bombée, *and six other plaques*)

1775

Sèvres manufactory; soft-paste porcelain; circular plaque painted by Jean-Jacques Pierre *le jeune*; two of the frieze plaques and two of the spandrel plaques painted by Claude Couturier; the central frieze plaque gilded by Etienne Henri Le Guay, mounted on a *secrétaire* stamped by Martin Carlin.

Circular plaque: DIAM. 37.0 cm (1 ft. 2⁹⁄₁₆ in.). *Spandrel plaques:* WIDTH 10.3 cm (4¹⁄₁₆ in.); LENGTH 10.1 cm (4 in.). *Side frieze plaques:* WIDTH 6.6 cm (2⁹⁄₁₆ in.); LENGTH 14.0 cm (5½ in.). *Central frieze plaque:* HEIGHT 18.4 cm (7¼ in.); WIDTH 13.6 cm (5⁵⁄₁₆ in.)

MARKS: All the plaques except for two of the spandrels are painted in blue on their reverses with the factory mark of crossed L's. On all but the central frieze plaque these enclose the date letter *X* for 1775. The circular plaque bears the painter's mark P, in blue. Two spandrel and the two side frieze plaques bear the painter's mark in blue. The central frieze plaque bears a gilder's mark *LG* in gold, partly rubbed. The circular plaque is inscribed in ink with the price *216* [*livres*]. No incised marks.

65.DA.2

DESCRIPTION: A large circular plaque is mounted on the fall front of the *secrétaire*. Four spandrel-shaped plaques are set into the pendentive spaces of the fall front. Two rectangular plaques and a U-shaped plaque are mounted on the drawer front in the frieze below. The U-shaped plaque is bombé in profile. Except for the circular plaque, all of the plaques are glazed on the reverse.

Each plaque is decorated with a border of turquoise-blue (*bleu céleste*) ground. On the circular and U-shaped plaques this border contains regularly spaced circular white reserves, which are painted with pink roses and buds with stems and flowers. The large white reserve on the circular plaque is painted with a canework basket suspended from a pink ribbon, filled with flowers and leaves. The flowers include honeysuckles, pink primulas, anemones, blue delphiniums, hollyhocks, morning glories, narcissi, and blue hyacinths. The U-shaped plaque is also painted with a loose bunch of flowers held by an orange-yellow ribbon bow. The flowers include a striped tulip, pink and yellow roses,

honeysuckles, daisies, and anemones. The remaining six plaques are each painted with groups of flowers and leaves, including some of those mentioned above as well as campanulas and viburnums.

The reserve on each plaque is framed by a gilded band, tooled with zigzag lines. The circular white reserves on the two larger plaques are framed with gilt wreaths. The colored borders of the six smaller plaques carry a gilded band of long ovals alternating with dots. Gilded studs hold the ribbon bows on the two larger plaques; the stud on the circular plaque is tooled with a rosette.

CONDITION: The plaques are unbroken and unscratched. Some of the tooling on the gilding is a little worn.

COMMENTARY: These eight plaques were designed specifically for this model of *secrétaire*. The circular plaque was called a *plaque ronde* at the Sèvres factory, and Rosalind Savill has pointed out that the U-shaped plaque mounted on the frieze may have been called a *plaque bombée*.[1] The names of the other plaques cannot be identified in the factory's documents. The two long plaques on the frieze have shaped ends without ground color borders and are intended to appear to continue underneath the central U-shaped plaque.

Evidence of plaques being made especially for *secrétaires* appears in the painters' overtime records for 1767, when Etienne-Henri Le Guay received 16 *livres* for "avoir doré 16 plaques Bleu Céleste destinées à faire un Secrétaire" (having gilded sixteen turquoise-blue plaques intended for a *secrétaire*).[2] The factory's documents also contain information relevant to the large *plaque ronde* mounted on the fall front of the Museum's *secrétaire*. In the artists' ledgers of 1777 Jean-Jacques Pierre *le jeune* is recorded as painting another plaque that must have been similar to the Museum's example. It was described as one "plaque ovale 1ᵉʳᵉ grand.ʳ, Bouquets noué avec un Ruban" (an oval plaque of the largest size, painted with bouquets of flowers tied by a ribbon).[3] The amount that Pierre was paid for painting the oval plaque is not recorded.

The factory's sales records indicate that in the first six months of 1775 Poirier purchased two *plaques rondes* for 216 *livres* each, and another plaque for the same amount.[4] Priced plaques in the Museum's collection that are close in size to the smaller ones on this *secrétaire* (see nos. 38, 39 below), also decorated with a turquoise-blue ground and flowers, cost 30 and 36 *livres* each. The spandrel and rectangular plaques probably would have cost the same, or possibly less, since they are no larger. In the first six months of 1775 Poirier purchased many plaques of unspecified shape and decoration, costing various amounts, including 24, 27, 33, and 36 *livres* each.[5]

Circular plaque and four spandrel-shaped plaques

Mme du Barry purchased two *secrétaires* with Sèvres porcelain plaques from Poirier. They are recorded among her purchases of 1772 and 1773.[6] Both had plaques decorated with green grounds, however, which may have been slightly cheaper than examples with turquoise-blue grounds. They cost 2,400 and 2,600 *livres* each and were probably fairly similar to the Museum's example.

Another *secrétaire* by Martin Carlin, of the same form as the present example and with Sèvres porcelain plaques of the same shapes, is in the Wallace Collection, London (F304, C502). Dated 1775–1776, it has eight plaques with green borders and with a slightly plainer scheme of decoration than the Museum's example. A plaque with a decorative scheme very close to that of the circular one on the Museum's *secrétaire* is mounted on top of a table stamped by Martin Carlin in the Victoria and Albert Museum, London (Jones Collection, 1058-1882). The table was given by Marie-Antoinette to Mrs. William Eden (later Lady Auckland) in 1787. The plaque also bears the date letter for 1775, the painter's mark of Pierre, and the inked price of 216 *livres,* as well as the gilder's mark of Jean-Baptiste-Emmanuel Vandé.

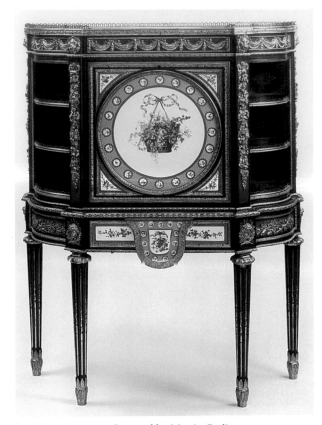

Secrétaire, circa 1775. Stamped by Martin Carlin.

PROVENANCE: Baron Nathaniel de Rothschild, Vienna; Baron Alphonse de Rothschild, Vienna; Baroness Clarice de Rothschild, Vienna and New York, 1942; [Rosenberg and Stiebel, New York, 1950]; J. Paul Getty, 1950.

BIBLIOGRAPHY: N. de Rothschild, *Notizen über einige meiner Kunstgegenstände* (Vienna, 1903), no. 319; J. P. Getty, *Collector's Choice* (London, 1955), pp. 76–77, 81; P. W. Escher, *Art Quarterly* 18, no. 2 (1955), pp. 131, 134; G. Reitlinger, *The Economics of Taste,* vol. 2 (London, 1963), p. 426; F. J. B. Watson, *The Wrightsman Collection,* vol. 1, *Furniture* (New York, 1966), p. 190; J. P. Getty, *The Joys of Collecting* (New York, 1965), p. 156; M. Stürmer, *Handwerk und höfische Kultur: Europäische Möbelkunst im 18. Jahrhundert* (Munich, 1982), p. 47; G. Zick, "Die russische Wahrsagerin," *Kunst und Antiquitäten* 4–5 (1984), pp. 36–37; Sassoon and Wilson 1986, p. 21, no. 46; Savill 1988, pp. 612, 613, nn. 45, 46, pp. 877, 901, n. 45.

1. I thank her for this information.
2. P.O.R., F.9, 1767, "Le Guay [gilder]," fol. 51.
3. A.L., Vj1, June 18, 1777, "Pierre," fol. 219r.
4. S.R., Vy6, fols. 3v, 5r.
5. Ibid., fol. 1r.
6. G. Wildenstein, "Simon-Philippe Poirier, fournisseur de Madame du Barry," *Gazette des beaux-arts* 2 (1962), pp. 376–377.

Three plaques mounted on drawer front

36 One Plaque for a Piece of Furniture (plaque ronde)

Circa 1775–1780
Sèvres manufactory; soft-paste porcelain; mounted on a nineteenth-century *secrétaire* bearing the false stamp of Jean-François Leleu

DIAM. 38 cm (1 ft. 3 in.)[1]

MARKS: Painted in blue on the reverse with the factory mark of crossed L's. No incised marks.

63.DA.1

DESCRIPTION: The large plaque is mounted on the fall front of a *secrétaire* together with seven nineteenth-century plaques.

The plaque is decorated with a broad border of turquoise-blue (*bleu céleste*) ground with regularly spaced circular white reserves, each painted in colors with a pink rose, its stem, and leaves. The central reserve is painted in colors with a large canework basket suspended from a twisted blue ribbon tied in a bow at the side. Flowers and leaves, including lilacs, honeysuckles, roses, narcissi, and jasmine, fill the basket. Above, at the left, is a pale yellow butterfly and, at the far right, a black ant and a small dragonfly.

The reserve is framed by a gilded band, which is tooled with a zigzag line. The small circular reserves are framed by gilded wreaths. The ribbon holding the basket hangs from a gilded stud.

CONDITION: The plaque is unbroken, and its painted surfaces are unworn. The tooling of the gilding is slightly rubbed. The three painted insects conceal small imperfections in the glaze. The blue ground is mottled by many small bubbles. The plaque is not glazed on the reverse.

COMMENTARY: The circular plaque was called a *plaque ronde* at the Sèvres factory (see also nos. 33–35 above). Its decoration is very similar to that of the Museum's *plaque ronde* dated 1775 (no. 35), though the latter is a little less elaborate. The present example has twenty-four as opposed to only twenty painted reserves in its colored border, and the basket of flowers is larger and more boldly painted. It was probably intended for mounting on the fall front of a *secrétaire* or as a tabletop. At present it is mounted on the fall front of a much later *secrétaire,* which was probably made during the nineteenth century, either in England or in France. It bears a false stamp of the *ébéniste* Jean-François Leleu and is painted with *MA* under a crown, a false mark for Marie-Antoinette. The seven nineteenth-century plaques were made and decorated to imitate Sèvres porcelain.

It seems reasonable to date the plaque to about 1775–1780 based on its similarity to examples dated 1775 in the Getty Museum (no. 35) and in the Victoria and Albert Museum, London (see entry for no. 35). The flowers on both those plaques are exceptionally well painted, and both are marked by the painter Jean-Jacques Pierre *le jeune.* The artists' ledgers record that Jean-Baptiste Tandart, Michel-Gabriel Commelin, and Edmé-François Bouillat also painted various *plaques rondes* of the first size in 1777–1779. Tandart painted "1 Plaque Ronde 1ᵉʳᵉ gr." (one circular plaque of the largest size) with "fleurs" (flowers) in September 1777,[2] a large oval plaque with a basket of flowers in February 1778,[3] and a circular plaque of the largest size with flowers in June 1779.[4] Commelin painted a circular plaque of the largest size with flowers in August 1779.[5] No further details of the decoration of these plaques are given, however. In May 1779 Bouillat was recorded as painting "Petites roses" (small roses) onto two "Plaques ronde 1ᵉ Bordure bleu celeste" (circular plaques of the largest size with turquoise-blue borders).[6]

Given its similarity to the plaque described above (no. 35), which cost 216 *livres,* this example probably would have cost 216 *livres* as well or perhaps slightly more because of its more elaborate decoration. The sales records show that during the first half of 1777 Daguerre purchased one plaque of unspecified shape and decoration for 240 *livres* (probably more than this example would have cost).[7] During the first half of 1778 he purchased two plaques for 216 *livres* each,[8] and during the second six months of that year he purchased another for the same price.[9]

PROVENANCE: Leopold de Rothschild, Ascott, Buckinghamshire; Lionel de Rothschild, Exbury, Hampshire; by descent to Edmund de Rothschild, Exbury, Hampshire, 1942; [Frank Partridge Ltd., London]; J. Paul Getty, 1950.

BIBLIOGRAPHY: Sassoon and Wilson 1986, p. 24, no. 52; Savill 1988, pp. 879, 901, n. 49.

Secrétaire, nineteenth century.

1. Dimensions are approximate since the plaque could not be removed from the *secrétaire.*
2. A.L., Vj1, "Tandart," September 9, 1777, fol. 254r.
3. Ibid., February 9, 1778, fol. 254v.
4. Ibid., June 6, 1779, fol. 255v.
5. A.L., Vj1, "Commelin," August 19, 1778, fol. 329v.
6. Ibid., "Bouillat," May 10, 1779, fol. 30v.
7. S.R., Vy6, fol. 228r.
8. S.R., Vy7, fol. 42r.
9. Ibid., fol. 81r.

37 *Four Plaques for a* Secrétaire (plaques carrées)

1776

Sèvres manufactory; soft-paste porcelain; two of the plaques painted by Jean-Baptiste Tandart and two by Edmé-François Bouillat, all four plaques gilded by François Baudouin *père,* mounted on a *secrétaire* stamped by Claude-Charles Saunier, set on a replacement stand stamped by F. Durand *fils*

HEIGHT 33.1 cm (1 ft. 1 1/16 in.); WIDTH 25.8 cm (10 1/8 in.)

MARKS: Each plaque is painted in blue on the reverse with the factory mark of crossed L's. On the two front plaques this encloses the date letter Y for 1776, and below is the painter's mark of three dots for Tandart. On the two side plaques the factory mark is flanked by the date letter Y for 1776 and the painter's mark Y for Bouillat. Each plaque bears the gilder's mark *BD* in gold. No incised marks.

PAPER LABELS: Each plaque bears a factory price label, printed with crossed L's. Only one is intact; it is inscribed in ink 132 [*livres*].

67.DA.7

DESCRIPTION: Four rectangular plaques, all of the same size, are mounted on the upper section of the *secrétaire.* Two are mounted on the fall front, and one is mounted on each side.

The two plaques on the front are painted with canework baskets, filled with flowers and leaves, hanging from ribbons tied in large bows. The side plaques are each painted with a large bouquet of flowers and leaves, tied at their stems by a bow. The flowers painted on these four plaques include parrot tulips, cornflowers, roses, honeysuckles, red-and-white and purple anemones, pink campanulas, daisies, ranunculuses, hyacinths, hollyhocks, pink delphiniums, primulas, and narcissi.

The plaques on the front have gilded studs, tooled with rosettes, from which the ribbons hang. Each plaque is framed by two broad matt gilded bands, tooled with a zig-zag line.

CONDITION: The plaques are unbroken, and there is very little wear to their surfaces. There are two small areas near the base of the left front plaque where the glaze is abraded.

COMMENTARY: These plaques, called *plaques carrées* (or *quarrées*) at the Sèvres factory, are of the first size. The four plaques were decorated to be mounted vertically. The earliest recorded example of this shape was probably very small; it was described as a "plaque quarré, B.C. [bleu céleste] attributs" (square plaque with turquoise-blue ground, painted with trophies) and was sold in 1760 for 60 *livres* to the dealer "Ducrolet." The buyer was presumably the goldsmith Jean Ducrollay (*maître,* 1734–1764/65), who mounted Sèvres plaques on snuffboxes. "Plaques quarées" next appear in the Sèvres sales records among purchases made by Poirier during the last six months of 1769; these include various examples costing 96 *livres* each and less.[1] Many are also listed in subsequent years, all intended for mounting on furniture. The first mention of *plaques carrées* in the factory's stock lists is in that compiled after the end of 1779. Among those then in the Magasin du Blanc were six of the first size and five of the second.[2] They were valued at 18 and 12 *livres* each, respectively.

During 1776 the painter Edmé-François Bouillat adopted a manner of placing his mark, a Y, on one side of the crossed L's factory mark, with the date letter for that year, also a Y, on the other side. This arrangement is also found on two other plaques in the Museum's collection (see no. 38 below). Two very similar pairs of plaques are listed in the artists' ledgers for 1777. In June of that year Bouillat is recorded as having painted two "Plaques quarés 1ᵉʳᵉ gʳ, Corbeilles et fleurs attachees avec un Ruban" (square plaques of the largest size, baskets and flowers held with a ribbon).[3] These were surely like the two the front of the *secrétaire,* which were painted by Jean-Baptiste Tandart. Also in June 1777 Tandart is recorded as having painted two "plaques quarées 1ᵉʳᵉ gʳ, Bouquet noué d'un Ruban" (square plaques of the largest size, bouquet of flowers tied by a ribbon).[4] These were undoubtedly like the two side plaques painted by Bouillat. The artists' ledgers do not record how much each of them was paid for this work. The painters' overtime records show that in the second half of 1776 and in January 1777 Bouillat was paid 24 and 30 *livres* per plaque for painting two pairs of plaques; their shapes and decoration are not specified, however.[5]

Since one of the plaques painted by Tandart bears a paper label inscribed *132,* this could be one of the pair purchased by Daguerre for 132 *livres* each during the first six months of 1776. During the same period he also bought a pair for 120 *livres* each, which may be Bouillard's plaques on the Museum's *secrétaire*.[6]

The carcass of the *secrétaire* is inscribed in pencil *Saunier le Jeune 1776.* The original stand would have had a frieze drawer and four tapering octagonal legs. A similar *secrétaire* by Claude-Charles Saunier, missing its porcelain plaques, was on the London art market before the 1970s.[7]

Secrétaire, circa 1776. Stamped by Claude-Charles Saunier

PROVENANCE: (?)Prince Narishkine, New York; Henry Walters, New York (sold by his widow, Parke Bernet, New York, May 3, 1941, lot 1399, to Duveen); J. Paul Getty, 1941.

BIBLIOGRAPHY: Sassoon and Wilson 1986, p. 22, no. 47; Savill 1988, pp. 612, 613, n. 45.

1. S.R., Vy4, fol. 197r.
2. S.L., I.8, 1780 (for 1779), fol. 38.
3. A.L., Vj1, "Bouillat," June 26, 1777, fol. 27v.
4. Ibid., "Tandart," June 26, 1777, fol. 254v.
5. P.O.R., F.18, "Bouillat," June 1, 1776–February 1, 1777, fol. 168.
6. S.R., Vy6, fol. 102v.
7. See JPGM file 67.DA.7.

Paper price label affixed to the back of one of the plaques

38 *Five Plaques for a* Secrétaire
(plaques carrées *and* plaques longues)

1776 and 1777
Sèvres manufactory; soft-paste porcelain; the two large plaques painted by Edmé-François Bouillat, the two small plaques painted by Raux *fils aîné,* mounted on a *secrétaire* stamped by Martin Carlin

Large plaques: HEIGHT 30.2 cm (11⅞ in.); WIDTH 22.6 cm (8⅞ in.). *Long plaque:* HEIGHT 5.6 cm (2³⁄₁₆ in.); WIDTH 25.7 cm (10⅛ in.). *Small plaques:* HEIGHT 4.4 cm (1¾ in.); WIDTH 9.5 cm (3¾ in.)

MARKS: Each of the plaques is painted in blue on the reverse with the factory mark of crossed L's. On the two large plaques this is flanked by a *Y* on each side; one is the date letter for 1776, the other is the painter's mark. The two small plaques are each painted in black with the painter's mark of a circle of dots; the long plaque bears an unidentified painter's mark. The long plaque in the frieze and the small one on the right are painted in blue with the date letter *Z* for 1777. The latter plaque is also marked in gold with *X* and *10.* No incised marks.

PAPER LABELS: The long plaque in the frieze bears a paper label printed with the factory mark of crossed L's and inscribed in ink *36 [livres].*

81.DA.80

DESCRIPTION: Two large rectangular plaques are mounted on the fall front of the *secrétaire.* Three narrow rectangular plaques, one long and two short ones, are mounted on the drawer front below.

Each of the plaques is decorated with a border of turquoise-blue (*bleu céleste*) ground color. The two short frieze plaques have this border on only three sides. Each of the two large plaques is painted with a marble urn filled with flowers standing on a red marble wall. The flowers on the left-hand plaque include roses in several colors, pink and orange poppies, blue morning glories, and forget-me-nots.

Those on the right-hand plaque include a peony, anemones, orange primulas, blue morning glories, white hollyhocks, narcissi, honeysuckles, roses, and tulips. The three plaques on the frieze are painted with small sprays of pink campanulas, grass, primulas, cornflowers, daisies, delphiniums, and roses.

Tooled gilding frames the white reserves. A gilded line of matt and tooled ovals and circles decorates the ground color borders.

CONDITION: All of the plaques are unbroken. The tooling of the gilding is slightly worn.

COMMENTARY: The two large rectangular plaques are *plaques carrées* of the first size. The three narrow rectangular plaques are called *plaques longues* in the factory's documents. The two smaller *plaques longues* may have been called *plaques échancrées* (notched plaques). They have no ground color border on one side, so that, when mounted, they appear to form one continuous plaque, partly concealed by the central plaque. The decoration of the two large *plaques carrées* is of a type found on a variety of Sèvres wares of the mid-1770s, although the execution is generally less meticulous than that of the Museum's examples. A pair of *vases des âges* of the second size dated 1782 and 1789 (New York, Metropolitan Museum of Art, Bequest of Celine B. Hosack, 1886.7.1–2) have similarly painted reserves on their backs (their front panels are painted with elaborate figure scenes by Charles-Nicolas Dodin). Similar vases of flowers set on marble walls appear on a *déjeuner Courteille* dated 1775 and painted by Guillaume Noël (London, private collection).[1]

On the two *plaques carrées* the painter's mark *Y* and the date letter *Y* are placed on either side of the factory mark. A similar arrangement of marks is seen on two other plaques in the Museum's collection (see no. 37 above), also painted by Edmé-François Bouillat in 1776. None of the plaques on this *secrétaire* can be identified in the painters' records. As noted above (see entry for no. 37), during the second half of 1776 and January 1777 Bouillat was paid 24 and 30 *livres* per plaque for painting two pairs of plaques;[2] it seems likely that he would have received at least that much for his work on the two large plaques. In October 1778 he painted "Bouq[uets] detachés" (separate bunches of flowers) on four *plaques longues* and six "plaques quarées" (small square plaques), receiving 3 *livres* per plaque.[3] In 1777 Raux is recorded as having painted "bouquets" on two "petites plaques échanchres," which may have been of the type at each end of the frieze of the Museum's *secrétaire.*[4]

The central *plaque longue* mounted on the frieze drawer is dated 1777 and bears, on its reverse, a paper label inscribed *36,* its price in *livres.* In 1777 Daguerre purchased

 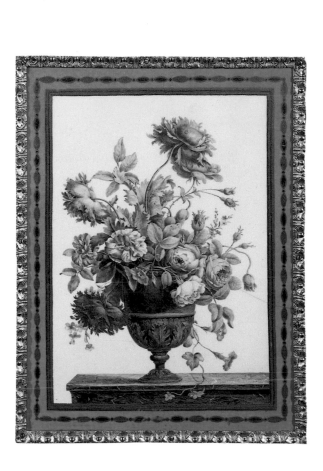

Large plaques

eight plaques for 36 *livres* each during the first six months, and one more during the last six months.[5] He also purchased two plaques for 30 *livres* each,[6] which may have been the price for the two smaller frieze plaques. We do not know how much the two *plaques carrées* cost, but it would have been considerably more than the 132 *livres* of the *plaques carrées* discussed above (see no. 37), since their decoration is much more elaborate and they have colored borders. Their price may have been closer to the 216 *livres* of the Museum's *plaque ronde* of 1775 (see no. 35 above). The sales records show that from 1776 to 1778 Daguerre purchased eight plaques (not including those specified as *ronde* or *ovale*) for prices higher than 132 *livres* each. They included a single "plaque quarrée" for 216 *livres,* which surely had a ground color border and elaborate painted decoration, in 1776,[7] and two pairs of plaques of unspecified shape and decoration, also for 216 *livres* each, in 1778 (these may have included the pair mounted on the front of the Museum's *secrétaire*).[8] He also purchased one plaque during 1777 for 240 *livres*,[9] and two during 1778 for 288 *livres* each.[10]

No similarly decorated *plaques carrées* mounted on furniture are known, but in 1784 Louis XVI presented a framed Sèvres porcelain plaque intended to be hung on a wall (called a *tableau* at the factory) to King Gustav III of Sweden. It is painted with an elaborate vase containing a variety of flowers, also set on a marble wall, and it bears the mark of the painter Jacques-François Micaud.[11]

In 1782 Grand Duchess Maria Feodorovna and Tsarevitch Paul Petrovitch of Russia, traveling as the comte and comtesse du Nord, visited Daguerre and purchased several pieces of furniture with Sèvres porcelain plaques decorated with turquoise-blue borders.[12] Among them was a table now in the Getty Museum (no. 39 below) and at least two *secrétaires*. One of them, now in the Metropolitan Museum of Art (1976.155.110), has a plaque dated 1776 that is fairly similar to the *plaques carrées* on the present example.[13] It is decorated with a turquoise-blue border and is painted with a simpler group of various flowers in a basket, suspended from a ribbon bow. It is apparently marked with a price of 96 *livres*.

The fourth Marquess of Hertford, the founder of the Wallace Collection, London, purchased the Museum's *secrétaire* at auction in Paris in 1870.[14] It was among the last acquisitions made by this remarkable collector (he died later that year), and it remained in Paris. The bulk of his collection is now in public ownership in England, known as the Wallace Collection.

PROVENANCE: (?)Don Francesco de Borja Alvarez de Toledo, 16th Duke of Medina-Sidonia and 12th Marquess of Villafranca; (?)Don Pedro de Alcantara Alvarez de Toledo, 17th Duke of Medina-Sidonia (sold by his heir, the Marquess of Villafranca, Hôtel Drouot, Paris, April 21, 1870, lot 23, to Nieuwenhuys, for Richard, 4th Marquess of Hertford, Paris); by descent to Sir Richard Wallace, Paris, 1870; by descent to Lady Wallace, Paris, 1890; by descent to Sir John Murray Scott, Paris, 1897; by descent to Victoria, Lady Sackville, Paris, 1912; [Jacques Seligmann, Paris]; Baron and Baronne Edouard de Rothschild, Paris; Mr. and Mrs. Habib Sabet, Paris, early 1970s; the J. Paul Getty Museum, 1981.

BIBLIOGRAPHY: Wilson 1982, pp. 63–66, no. 1; D. Guillemé-Brulon, "Les Plaques en porcelaine de Sèvres dans le mobilier," *L'Estampille* 163 (November 1983), pp. 42–43; Wilson 1983, pp. 78–79; Sassoon and Wilson 1986, pp. 22–23, no. 48; Savill 1988, pp. 877, 901, n. 44, 1063, 1064, n. 3.

1. Savill 1988, pp. 615–616, 620, n. 30.
2. P.O.R., F.18, "Bouillat," June 1, 1776–February 1, 1777, fol. 168.
3. A.L., Vj1, "Bouillat," October 7, 1778, fol. 29v.
4. Ibid., "Raux," October 5, 1777, fol. 134v. I thank Rosalind Savill for this information.
5. S.R., Vy6, fols. 227v, 228r, 228v, 258r.
6. Ibid., fol. 227v.
7. Ibid., January–June 1776, fol. 102v.
8. S.R., Vy7, July–December 1778, fol. 42r.
9. Ibid., fols. 41r, 42r.
10. Ibid.
11. It is still in the Swedish Royal Collection, on loan to the Nationalmuseum, Stockholm, from the Drottningholm collection (no. 99).
12. Henriette Louise, baronne d'Oberkirch, *Mémoires de la Baronne d'Oberkirch sur la cour de Louis XVI et la société française avant 1789, . . .* vol. 2 (Paris, 1853), p. 44.
13. See F. J. B. Watson, *The Wrightsman Collection,* vol. 1, *Furniture* (New York, 1966), no. 105. It had belonged to the Parisian actress Marie-Joséphine Laguerre and was not new when bought by the future tsarina.
14. Information kindly pointed out by John McKee, librarian, the Wallace Collection.

Three plaques mounted on drawer front

Secrétaire, circa 1776–1777. Stamped by Martin Carlin.

Paper price label affixed to the back of the central frieze plaque

39 Fourteen Plaques for a Table (bureau plat) (plaques longues, plaques carrées, plaques centrées?, *and* quarts de cercles)

1778
Sèvres manufactory; soft-paste porcelain; at least seven plaques gilded by Jean-Baptiste-Emmanuel Vandé *père,* mounted on a table stamped by Martin Carlin

End drawer plaques: HEIGHT 11.5 cm (4⁹⁄₁₆ in.); WIDTH 30.4 cm (11¹⁵⁄₁₆ in.). *Curved plaques:* HEIGHT 4.6 cm (1¾ in.; WIDTH 13.8 cm (5⁷⁄₁₆ in.). *Short frieze plaques.* HEIGHT 6.4 cm (2½ in.); WIDTH 14.7 cm (5¹³⁄₁₆ in.). *Long frieze drawer plaques:* HEIGHT 4.8 cm (1⅞ in); WIDTH 24.2 cm (9½ in.)

MARKS: At least seven plaques painted in red on the reverse with the factory mark of crossed L's adjacent to the date letters *AA* for 1778 and with the gilder's mark *VD.* No incised marks.

PAPER LABELS: At least seven of the plaques have paper labels printed with the factory mark of crossed L's on the reverse. On the end drawer plaques they are inscribed *96* [*livres*], on the four short frieze plaques they are inscribed *30* [*livres*], and the label on one of the long frieze drawer plaques is inscribed *30* [*livres*] (two have not been examined). The carcass of the table bears a *marchand-mercier*'s trade label, which reads "DAGUERRE, MARCHAND, Rue St-Honoré, vis-à-vis l'Hôtel d'Aligre. TIENT Magasin de Porcelaines, Bronzes, Ebénisterie, Glaces, Curiosités, & autres Marchandises. A PARIS."

INVENTORY MARKS: The carcass of the table is painted with the Russian inventory marks *1098* in gray, and *M.N. 2586* and *6397* in red. The frieze drawer bears a paper label inscribed *29615,* possibly Duveen's stock number.

83.DA.385

DESCRIPTION: The fourteen plaques are mounted on the frieze of a rectangular table, which has curved ends. On the front of the table are two long rectangular plaques forming a drawer front, and two similar ones are mounted as a blind drawer on the back. These are flanked, front and rear, by four shorter and higher rectangular plaques. At each of the curved ends a correspondingly curved plaque is mounted on a drawer front; these plaques are rectangular, but their lower edges drop in a low curve. These plaques are each flanked by two rectangular plaques that are curved to form an arc one-eighth the circumference of a circle. The four curved plaques are glazed on the reverse.

All the plaques have borders of turquoise-blue (*bleu céleste*) ground color. The four short curved plaques are bordered on only three sides. The white reserves of the rectangular plaques are painted in colors with three sprays of mixed flowers (*bouquets detachés*), including roses, yellow hollyhocks, daisies, and campanulas. The two larger shaped plaques are each painted with a bunch of flowers and leaves hanging from a blue ribbon bow. These flowers include lilacs, cornflowers, roses, honeysuckles, campanulas, yellow hollyhocks, anemones, daisies, pinks, and primulas.

Tooled gilding frames the white reserves. The colored borders are decorated with matt and tooled gilded ovals and circles.

CONDITION: The decorated surfaces are unworn. One of the long rectangular plaques mounted at the back of the table has been broken across one corner and restored. One end of the large shaped plaque at the left side of the table has also been broken and restored. The tooling on all the plaques is very bright.

COMMENTARY: The curved rectangular plaques with curved lower edges may have been called *plaques centrées* at the Sèvres factory. The clerk recording work carried out by the painter Edmé-François Bouillat in October 1786 (long after these plaques were made) in the artists' ledgers was obviously unsure of the proper name for this shape;[1] he has simply written the word *plaque,* followed by an outline drawing of the shape. The curved eighth-circle plaques are each half of a plaque shape called a *quart de cercle* in the factory's documents (see nos. 33, 34 above), but there are no known references to plaques called *huitièmes de cercles.* The four shorter rectangular frieze plaques are *plaques carrées,* and the four longer plaques mounted on the front and rear frieze are *plaques longues.*

The plaques are mounted in conforming recesses in the carcass of the table, and they are held in place by gilt-bronze frames screwed to the carcass. Three plaques are so firmly

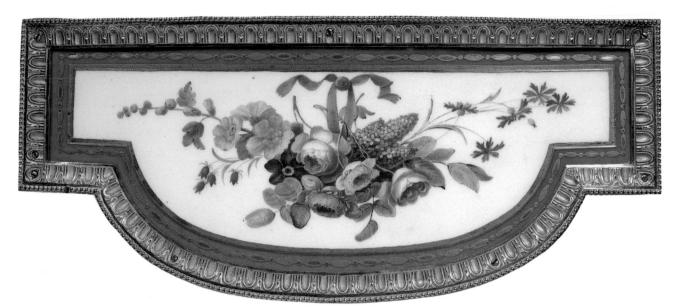

Plaque centrée(?) from the right end of the table

attached that they have not been unmounted for examination. These three include one of the eighth-circles and two of the long rectangular plaques. The remaining six flat rectangular plaques bear the mark of the gilder Jean-Baptiste-Emmanuel Vandé *père* on their reverses. Although no gilder's records survive, these plaques can probably be identified in the kiln registers for 1778. In the firing of September 15, 1778, Vandé is recorded as the gilder of three *plaques longues* with *bleu céleste* ground and painted with "Bouquets" (groups of flowers) by Bouillat.[2] Vandé also gilded eight "plaques diff[érentes]" (of various shapes) by the same painter, also with *bleu céleste* borders, which were fired on October 21, 1778.[3] The same hands carried out the same decoration on six "petites plaques quarrées" (small square plaques) fired on November 16, 1778.[4] One of the curved end plaques on the Museum's table also bears Vandé's mark, but none of the plaques bears a painter's mark. The kiln records show that during 1778 Bouillat painted similar bouquets and groups of flowers on many other plaques also decorated with *bleu céleste* borders. These include twenty-three "plaques diff[érentes]" gilded by François Baudouin *père*, fired on September 15, 1778.[5]

The artists' ledgers show that Bouillat painted flowers on a variety of plaques with *bleu céleste* borders during 1778. On June 1 he was paid 4 *livres* each for painting "fleurs groupes" (groups of flowers) on three *plaques longues* with *bleu céleste* borders.[6] On July 31, 1778, he received 4 *livres* each for painting flowers on five variously shaped plaques with *bleu céleste* borders.[7] The artists' ledgers also show that Vincent Taillandier painted bunches of flowers on similar plaques during 1778. On July 24 he was recorded as having decorated five "petites plaques," which had *bleu céleste* borders.[8] None of the six *quarts de cercles* in the Museum's collection (see nos. 33, 34) or the four eighth-circle plaques on the table bears any marks. They are all glazed on their reverse sides, possibly to help them retain their shape during firing.

The paper labels on some of the plaques indicate their prices. Daguerre purchased a number of plaques costing 30 and 96 *livres* in 1778, although no description of their shape or decoration is given. He bought three pairs of plaques for 96 *livres* each[9] and six plaques for 30 *livres* each in the first half of the year,[10] and one pair of plaques for 96 *livres* each[11] and eight plaques for 30 *livres* each in the second half.[12] These, along with his purchases of less expensive plaques, would have been sufficient for this table.

No other similar table with Sèvres porcelain plaques is known, although a table of this model, also stamped by Carlin but with black and gold japanese lacquer panels in the frieze, is in the Victoria and Albert Museum, London (Jones Collection, 1049-1882). No other known piece of

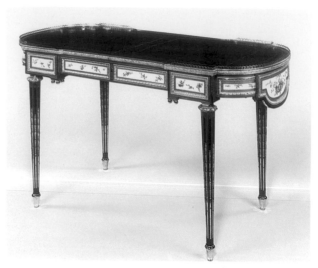

Bureau plat, circa 1778. Stamped by Martin Carlin.

furniture is fitted with curved and shaped plaques like those at each end of the Getty Museum's table. A flat plaque of the same shape is mounted on the frieze drawer of a *secrétaire* in the Metropolitan Museum of Art, New York (Gift of Mr. and Mrs. Charles Wrightsman, 1976.155.110).[13] That *plaque centrée* has no date letter but bears a paper label showing that it cost 60 *livres*. The *secrétaire*, like the Museum's table, was purchased in Paris by Grand Duchess Maria Feodorovna and Tsarevitch Paul Petrovitch of Russia in 1782 (see entry for no. 38 above).

The Museum's table is known to have stood in Maria Feodorovna's boudoir at the palace of Pavlovsk, outside Saint Petersburg, where she described it in 1795.[14] The room also contained two *secrétaires* with Sèvres porcelain plaques decorated with *bleu céleste* borders and painted with flowers; one is now in the Metropolitan Museum of Art (see above),[15] and the other was sold at auction in 1988.[16] Since the table bears Daguerre's label (fig. 39h), it is probable that Maria Feodorovna and her husband purchased all three pieces when they visited his shop on May 25, 1782. The visit was described by the baronne d'Oberkirch, who noted that they bought a great quantity of furnishings,[17] but no list of their purchases has survived. The Sèvres factory's sales records are more informative, showing that they purchased items for themselves as well as receiving many splendid wares from Louis XVI. On June 13, 1782, for example, the king presented them with a quantity of Sèvres porcelain valued at a staggering 112,626 *livres*,[18] including various vases, *déjeuners*, cups and saucers, portrait medallions,

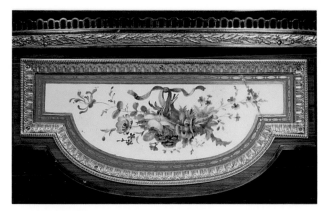

Plaque centrée(?) from the left end of the table

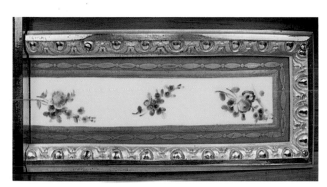

Eighth-circle plaque from the front left side of the table

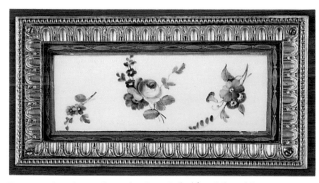

Rectangular plaque from the front left side of the table

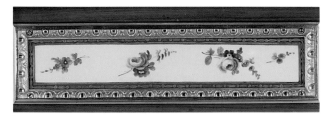

Rectangular plaque from the left side of the drawer on the front of the table

busts, framed paintings on porcelain, and a famous "jeweled" toilet service (see entry for no. 24 above). There was also a pair of specially produced biscuit porcelain busts of the couple, no fewer than thirty copies of their profile medallions, and two cups and saucers painted with their portraits. On June 26, 1782, Prince Bariatinsky, the Russian ambassador to France, purchased another great quantity of Sèvres porcelain from the factory on their behalf,[19] including numerous garnitures of vases as well as many tea services and various cups and saucers, costing the Russian visitors a total of 29,308 *livres*. Many of these pieces survive at the palace of Pavlovsk and in the State Hermitage, Leningrad.[20]

PROVENANCE: Sold by the *marchand-mercier* Dominique Daguerre, Paris, to Grand Duchess Maria Feodorovna of Russia (later tsarina), Pavlovsk, 1782; Russian Imperial Collections, palace of Pavlovsk; sold by the Soviet government, 1931; [Duveen and Co., New York]; Anna Thomson Dodge, Rose Terrace, Grosse Pointe Farms, Michigan, 1931 (sold, Christie's, London, June 24, 1971, lot 135); Habib Sabet, Geneva, 1971 (sold, Christie's, London, December 1, 1983, lot 54); the J. Paul Getty Museum, 1983.

BIBLIOGRAPHY: A. Benois, *Les Trésors d'art en Russie* (Saint Petersburg, 1901–1907), vol. 3, p. 373, vol. 7, p. 186, pl. 20; D. Roche, *Le Mobilier français en Russie: Meubles des XVII^e et XVIII^e siècles et du commencement du XIX^e, conservés dans les palais et les musées impériaux et dans les collections privées,* vol. 2 (Paris, 1913), pl. LV; Duveen and Co., *A Catalogue of Works of Art in the Collection of Anna Thomson Dodge,* vol. 1 (New York, 1939), ill.; A. Coleridge, "Works of Art with a Royal Provenance from the Collection of the Late Mrs. Anna Thomson Dodge," *Connoisseur* (May 1971), pp. 34–36; Sassoon and Bremer-David 1984, pp. 201, 204–207, no. 10; Sassoon and Wilson 1986, p. 34, no. 73; Savill 1988, pp. 887, 901, nn. 83, 87.

1. A.L., Vj3, "Bouillat père," October 24, 1786, fol. 40r (painted with a basket of flowers).

2. K.R., Ve1, September 15, 1778, fol. 25r (sent for burnishing on September 21).

3. Ibid., October 21, 1778, fol. 28v (sent for burnishing on October 29).

4. Ibid., November 16, 1778, fol. 31r (sent for burnishing on November 25).

5. Ibid., September 15, 1778, fol. 23v (sent for burnishing on September 21).

6. A.L., Vj1, "Bouillat [père]," June 1, 1778, fol. 29r.

7. Ibid., July 27, 1778, fol. 29v.

8. A.L., Vj1, "Taillandier," July 24, 1778, fol. 247v.

9. S.R., Vy7, fols. 41r, 41v, 42r.

10. Ibid., fol. 42r.

11. Ibid., fol. 811.

12. Ibid.

13. See F. J. B. Watson, *The Wrightsman Collection,* vol. 1, *Furniture* (New York, 1966), no. 105.

14. Maria Feodorovna, "Description of Pavlovsk" (1795), in Benois (Bibliography).

15. See above (note 13).

16. Sold by the British Rail Pension Fund, Sotheby's, London, November 24, 1988, lot 33. Previously sold from the collection of Mr. and Mrs. Deane Johnson, Sotheby Parke Bernet, New York, December 9, 1972, lot 101; and Sotheby's, Monaco, June 24, 1976, lot 162. This *secrétaire* is stamped by Adam Weisweiler.

17. Henriette Louise, baronne d'Oberkirch, *Mémoires de la Baronne d'Oberkirch sur la cour de Louis XVI et la société française avant 1789, . . .* vol. 2 (Paris, 1853), p. 44.

18. S.R., Vy8, fols. 215v, 216r.

19. Ibid., fols. 181r, 181v.

20. See P. Ennès, "The Visit of the Comte and Comtesse du Nord to the Sèvres Manufactory," *Apollo,* no. 129 (March 1989), pp. 150–156.

Comparison of an eighth-circle plaque from no. 39 with a quarter-circle plaque from no. 33

Paper label of the *marchand-mercier* Dominique Daguerre affixed underneath the back left rail of the table

Paper price labels, one affixed to the back of one of the end drawer plaques, and one affixed to the back of one of the short frieze plaques

40 *Five Plaques for a* Secrétaire
(plaques carrées *and* plaques ovales)

Circa 1783

Sèvres manufactory; soft-paste porcelain; at least three plaques gilded by Henry-François Vincent *le jeune*, mounted on a *secrétaire* attributed to Adam Weisweiler

Oval plaques: HEIGHT 22.9 cm (9 in.); WIDTH 18.7 cm (7⅜ in.). *Central plaque:* HEIGHT 33.6 cm (1 ft. 1¼ in.); WIDTH 26.3 cm (10⅜ in.). *Side plaques:* HEIGHT 33.6 cm (1 ft. 1¼ in.); WIDTH 17.2 cm (6¾ in.)[1]

MARKS: One of the oval plaques and the two smaller rectangular plaques are marked in gold on the reverse with the factory mark of crossed L's, adjacent to the gilder's mark *2000.* The central plaque is inscribed *N°353* in an eighteenth-century hand. No incised marks. (Not illustrated. Plaques cannot be removed for photography.)

PAPER LABELS: The central rectangular plaque and one of the oval plaques have paper labels printed with the factory mark of crossed L's on the reverse. The label on the oval plaque is inscribed *72 [livres]*; the other label is partly torn.

70.DA.83

DESCRIPTION: Three large rectangular plaques, one of slightly greater width, are mounted on the fall front of the *secrétaire.* One oval plaque is mounted on each side panel.

The central rectangular panel has a distinctive border of long double trails of laurel leaves with berries and strings of gilded dots, which cross over each other; this is painted over the white glaze. The borders of the two smaller rectangular plaques and the two oval plaques are painted with a mottled pale green (*pointillé*) ground. On the two rectangular plaques this border does not extend around the inner edges. All three of the rectangular plaques are painted in colors with large bunches of flowers tied by ribbon bows. The flowers include anemones, daisies, pink delphiniums, poppies, a yellow-flowered herb, orange primulas, wallflowers, hollyhocks, jasmine, blue morning glories, nasturtiums, yellow and pink roses, clematis, campanulas, and a dandelionlike puffball. The two oval plaques at the sides are painted with musical trophies.

Tooled and matt gilding frames the outer borders of these plaques. The central plaque also has an outer border of gilding.

CONDITION: All the plaques are unbroken, and their painted surfaces are unworn. The tooling of the gilding is very bright. The right oval plaque has been roughly cut down around much of its edge to fit within the gilt-bronze mount, and the gilding on the left oval plaque is somewhat worn. The upper right corner of the right rectangular plaque became blackened and pitted during firing.

COMMENTARY: The two plaques mounted at each side are *plaques ovales;* the three rectangular ones are *plaques carrées* of the first size, two being narrower than usual. The *plaques ovales* were decorated to be mounted so that their longer axis was horizontal, but they are mounted vertically. This suggests that they were not intended to be mounted on the same piece of furniture as the three rectangular plaques. It is worth noting, however, that the oval plaques and the two smaller rectangular plaques all have very similar borders. One *secrétaire* of the same form is known (see below), with five similarly arranged plaques of the same proportions as those on the present example. They all have *pointillé* borders and are painted with flowers.

The unusual border of the central plaque is known on only three other plaques, of comparable dimensions, which are mounted on the top of a table contemporary with the Museum's *secrétaire,* also attributed to Adam Weisweiler.[2] A variant of this border is found on a set of five Sèvres porcelain plaques mounted on a small table by Martin Carlin in the Wallace Collection, London (C506, F327). They are dated 1783 and are marked by the gilder Henry-François Vincent *le jeune.*

The central plaque may also date from 1783, and its gilding may be attributed to Vincent since the border is so similar to that on the Wallace Collection table. A survey of plaques gilded by Vincent in the kiln registers for the early 1780s shows that in 1783 he worked on many examples that might be linked with the Museum's plaques. On September 29, 1783, there are three "plaques quarrés" of the third size, gilded by Vincent and painted by Edmé-François Bouillat with "bouquets noués" (bouquets of flowers tied by ribbons).[3] In the same firing there were four "plaques longues" gilded by Vincent and painted with flowers (the painter is recorded as Michel-Gabriel Commelin, but see below), as well as two "plaques quarrés" with a "fond Taillandier" gilded by Vincent, with flowers painted by Bouillat. The latter description probably indicates a *pointillé* ground, a specialty of Vincent Taillandier and his wife, Geneviève.

Bouillat was responsible for much of the finest flower painting on plaques made for furniture at Sèvres (see entries for nos. 37–39 above). Since his name appears in the kiln records for 1783, he should be considered a possible painter of the flowers on these plaques. The artists' ledgers of 1783 show that on March 20 Bouillat painted baskets of flowers and "frize sur les Bords" (friezes along the borders) on two round plaques and on another of unspecified shape.[4] On August 14 he was recorded as painting four small square plaques with bouquets of flowers tied by ribbons. Both the artists' ledgers for Commelin and the kiln records show that he too decorated many furniture plaques during 1783. On July 6 he painted flowers and friezes on five *plaques longues* of different sizes.[5] Between April 12 and August 20 he is recorded as "avoir fait les frizes differentes a 25 Plaques differentes grandeurs formes ovales, quarres, et longues peinte par M. Bouillatte" (having painted different borders on twenty-five plaques of various sizes and shapes—oval, square, and rectangular—which had been painted by M. Bouillat).[6] These may have included the large central plaque with its unusual border. Commelin may well have painted only the borders of the plaques credited to him in the kiln records, and not necessarily the flowers in the central reserves. The artists' and kiln records show that in 1783 the painter J.-B. Tandart was also painting flowers on plaques that were gilded by Vincent.[7] The artists' records for 1783 also include some of Mme Taillandier's work on plaques with *pointillé* borders.[8]

During 1783 Daguerre purchased several pairs of plaques that were of higher than average cost, which could include those on the front of the Museum's *secrétaire*. In the first six months he purchased pairs for 144, 240, 292, and 312 *livres* per plaque,[9] and in the second six months he purchased pairs for 120 and 144 (two pairs) *livres* per plaque.[10] He did not buy any pairs of plaques for 72 *livres* each during 1783, although he had purchased three pairs for that price during the previous year, which may have included the oval plaques.

The only comparable known *secrétaire* of this form, with the same arrangement of Sèvres porcelain plaques, was formerly at Harewood House, Yorkshire.[11] Its five plaques all have a pale green *pointillé* ground and are painted with bouquets of flowers (those on the central plaque in a basket suspended from a ribbon). The marks, if any, on these plaques are not known. Some of the plaques listed in the documents for 1783 can be identified on other pieces of furniture. A set of ten plaques with pale blue *pointillé* borders, painted with flowers by Bouillat and gilded by J.-P. Boulanger, are mounted on a cabinet by Carlin in the British Royal Collection.[12] Two more, also dated 1783 and with pale blue *pointillé* borders, gilded by Vincent and with flowers attributed to Bouillat, are mounted on a *secrétaire* in the Wallace Collection (c504, f307).

Secrétaire, circa 1780. Attributed to Adam Weisweiler.

Three plaques mounted on the fall front of the *secrétaire*

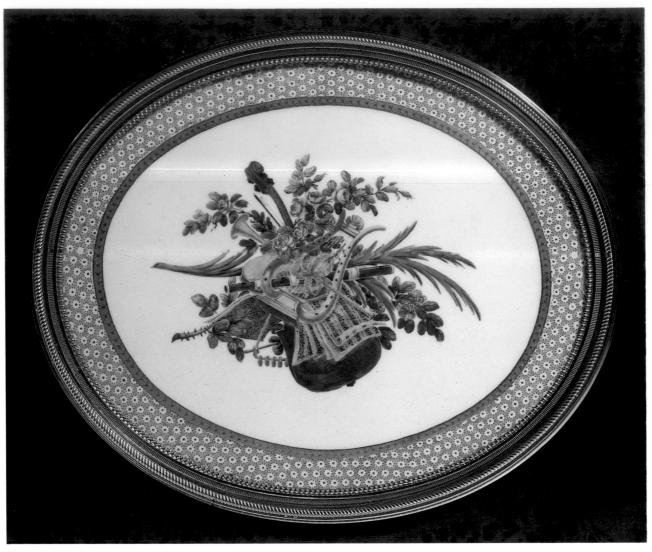

Plaque from the left side of the *secrétaire*

PROVENANCE: Jules Lowengard, Paris; Baron Nathaniel de Rothschild, Vienna, by 1913; Baron Alphonse de Rothschild, Vienna; Baroness Clarice de Rothschild, Vienna and New York, 1942; [Rosenberg and Stiebel, New York, 1950]; J. Paul Getty, 1950.

BIBLIOGRAPHY: S. de Ricci, *Louis XVI Furniture* (London and New York, 1913), p. 127; F. J. B. Watson, *Louis XVI Furniture* (London, 1960), no. 86; J. Meuvret and C. Fregnac, *Les Ebénistes du XVIII*e *siècle français* (Paris, 1963), p. 286 (erroneously described as being in the Metropolitan Museum of Art, New York); G. Reitlinger, *The Economics of Taste*, vol. 2 (London, 1963), p. 426; Sassoon and Wilson 1986, p. 23, no. 49; Savill 1988, pp. 888, 901, n. 92.

1. Dimensions are approximate since the plaques could not be removed from the *secrétaire*.
2. Sold from the stock of E. Joseph, Christie's, London, June 10 et seq., 1890, lot 1047 (ill.), to the dealer Samson Wertheimer for 990 gns.; sold from the stock of Samson Wertheimer, Christie's, London, March 18, 1892, lot 646, to Benjamin for 672 gns. I thank Frances Buckland for this information.
3. K.R., Ve2, fols. 70v, 71r.
4. A.L., Vj2, fol. 31r.
5. Ibid., fol. 106r.
6. Ibid.
7. A.L., Vj2, fol. 253v; K.R., Ve2, fols. 26v, 68r.
8. A.L., Vj2, fols. 250v, 251r.
9. S.R., Vy9, fol. 22v.
10. Ibid., fols. 58r, 58v.
11. Sold, Christie's, London, June 28, 1951, lot 88, to Cameron for 3,000 gns. (present location unknown).
12. De Bellaigue 1979, p. 50, no. 39.

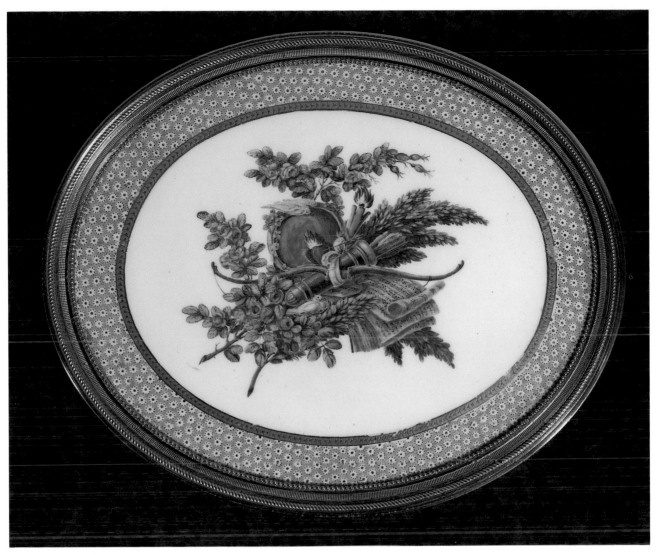

Plaque from the right side of the *secrétaire*

Appendix: Decorators' Biographies

CHARLES-ELOI ASSELIN (active 1765–1804).[1] Painter of flowers and figures. From 1775 he was earning 100 *livres* per month. When he died in 1804, at the age of sixty-one, he was assistant head of the painter's studio.[2]

BARDET (active 1751–1758).[3] Painter of flowers. He came from Vincennes and entered the factory in August 1751 as an apprentice at a salary of 12 *livres* per month.[4] By January 1, 1755, he was twenty-three years old and was earning 60 *livres* per month. On July 1, 1755, it was noted that M. Boileau, the director of the Vincennes factory, had "put Bardet outside the door at the end of May because of his apathy and lack of application." He was made to paint cardboard boxes until January 15, 1756, when he was readmitted to the porcelain studio. On March 1, 1758, he was again shown the door, for "two new acts of disobedience."

FRANÇOIS BAUDOUIN *père* (active 1750–1800).[5] Gilder. He entered the factory in August 1750 and was paid 30 *livres* per month.[6] By January 1, 1755, he was thirty-one years old, and his pay had increased to 60 *livres* per month.

ETIENNE-HENRY BONO (active 1754–1781).[7] *Répareur.* He entered the factory in January 1754 as an *anseur* (handle maker) and was paid 9 *livres* per month.[8] By January 1, 1755, he was thirteen years old and was paid 15 *livres* per month. On January 1, 1757, he was described as "a great perfectionist," and his pay was increased to 21 *livres* per month.

FRANÇOIS BOUCHER (1703–1770; active at Vincennes and Sèvres, 1749–1754).[9] Supplied designs for the studios of sculpture and painting. Engravings of his work were used as a design source for figure painting.

EDMÉ-FRANÇOIS BOUILLAT *père* (active 1758–1810).[10] Painter of flowers and fruit, often on plaques for furniture.[11] He was earning 84 *livres* per month by 1775 and 100 *livres* per month in 1777.

CHARLES BUTEUX *père* (active 1756–1782).[12] Painter of trophies, figures, and flowers. He came from Grandvilliers in Picardy and entered the factory on October 4, 1756, having previously worked in the Chantilly factory.[13] By December 1, 1756, he was thirty-five years old and was described as "painting figures, of which he understands very little, but wisely wants to perfect." By January 1, 1758, his pay was increased to 54 *livres* per month.

ANTOINE CAPELLE (active 1745–1800).[14] Painter of friezes and ground colors, also a gilder from 1780. He entered the factory on September 15, 1745, having previously been a fan painter in Paris.[15] He was initially paid 60 *livres* per month but was earning 112 *livres* per month by January 1, 1755. By then he was thirty-three years old and operated the kiln for painted wares, practicing painting during the intervals between firings. In January his wife was described as a "very mediocre" flower painter who "gives no hope of progress."[16]

ANTOINE CATON (active 1753–1798).[17] Painter of figure scenes. He came from Franche-Comté, entering the factory in April 1753 at a salary of 40 *livres* per month.[18] By January 1, 1755, he was twenty-eight years old and was earning 100 *livres* per month. He was described as good with color. In January 1755 his wife was described as a mediocre painter of flowers, with "little hope of progress."[19] When he died in 1799, he was seventy-three years old.[20]

ETIENNE-JEAN CHABRY *fils* (active 1765–1787).[21] Painter of figure scenes, flowers, and friezes. From 1773 he was paid 51 *livres* per month.

JEAN CHAUVAUX (or Chauveaux) *le jeune* (active 1765–1802).[22] Gilder. From 1774 he was earning 60 *livres* per month.

MICHEL-BARNABÉ CHAUVAUX (or Chauveaux) *l'aîné* (active 1752–1788).[23] Gilder. He entered the factory in October 1752 at a salary of 30 *livres* per month.[24] On January 1, 1755, when he was twenty-four years old, he was described as "talking quickly" and "playing the flute very well." From 1773 he was earning 66 *livres* per month.

ANTOINE-TOUSSAINT CORNAILLE (or Cornailles) (active 1755–1800).[25] Painter of flowers and fruit, gilder. He was born in Ecouans, near Saracelles, and entered the factory in May 1755, having previously worked at Chantilly.[26] At that time he was paid 42 *livres* per month. By January 1, 1755, he was twenty-one years old and was described as having "a crippled left leg that obliges him to carry a crutch." As for his flower painting, he was "not so good at drawing as with his use of color." By January 1, 1756, his drawing was recorded as "stronger," and his pay was increased to 48 *livres* per month. One year later it was increased to 51 *livres* per month and the following year, to 57 *livres*.

MICHEL-DOROTHÉ COUDRAY (active 1753–1774/75).[27] Molder.

CLAUDE COUTURIER (active 1762–1775).[28] Painter of flowers. When he joined the factory, his salary was 36 *livres* per month. It had increased to 72 *livres* per month by the time of his death.

CRESCENT MARK PAINTER (active at least 1753–1760).[29] Painter of birds and landscapes. Possibly Louis-Denis Armand *l'aîné*,[30] though the mark has also been attributed to Jean-Pierre Ledoux (active 1758–1761).[31]

JEAN-FRANÇOIS DEPARIS (active 1746–1797).[32] Head of the *répareurs'* studio from 1774. He began working as an apprentice at the age of eleven, eventually becoming Jean-Claude Duplessis' assistant. He also designed vases and tablewares.

JEAN-JACQUES DIEU (active 1777–1791, 1794–1798, 1801–1811).[33] Painter and gilder of chinoiseries and flowers.

CHARLES-NICOLAS DODIN (active 1754–1802).[34] Painter of landscapes, figure scenes, and chinoiseries. He came from Versailles and entered the factory in April 1754, developing his talent as a figure painter there.[35] At that time he was paid 24 *livres* per month. By January 1, 1755, when he was twenty-one years old, he was earning 42 *livres* per month and was described as having "a good talent and making a lot of progress." In 1759 his monthly salary was increased to 81 *livres*, and in 1762, to 87 *livres*. As Marcelle Brunet has noted, parish records indicate that he was born on January 1, 1734, and died in Sèvres on February 10, 1803. He married Jeanne Chabry, daughter of Jean Chabry, a sculptor at Sèvres, in 1762.[36]

JEAN-CLAUDE CHAMBELLAN, called DUPLESSIS *père* (active 1745/48–1774).[37] Silversmith, *bronzier*, sculptural designer. Born around 1695, he came to Paris from Turin in about 1740 and designed models for the factory as well as supervising the decorators. He also supplied gilt-bronze mounts to the factory.

ETIENNE-MAURICE FALCONET (active 1757–1766).[38] Sculptor, designer of vases and figures, head of the sculpture studio.

FALLOT (active 1764–1790).[39] Painter, gilder. He developed and applied ground colors, in particular a blue ground, and the use of *incrusté* decoration.

JACQUES FONTAINE (active 1752–1775/76, 1778–1807).[40] Painter of flowers, trophies, figures, and grisaille decoration. He entered the factory in May 1752, having been a fan painter in Paris.[41] At that time he was paid 30 *livres* per month. On January 1, 1755, when he was twenty years old, his pay was increased to 60 *livres* per month. He was described at that time as "always walking quickly" and "having one lame finger in his right hand." He was painting flowers and "making a lot of progress." His pay was increased to 66 *livres* per month on January 1, 1756, and to 75 *livres* per month by 1772.

JEAN-BAPTISTE-ETIENNE GENEST (active 1752–1789).[42] Painter of flowers and figure scenes, head of the painters' studio. He entered the factory in May 1752, having been a painter in Paris, and was paid 30 *livres* per month.[43] By January 1, 1755, he was twenty-four years old and was described as having a "superior talent" as a figure painter; by then his monthly salary was 125 *livres,* and this was increased to 150 *livres* as of January 1, 1757.

JACQUES-FRANÇOIS-LOUIS DE LAROCHE (active 1759–1802).[44] Painter of flowers and borders, gilder. He worked principally on tablewares; in 1785 his salary was 90 *livres* per month.

ETIENNE-HENRI LE GUAY *père* (active 1748–1749, 1751–1796).[45] Gilder. He came from Saint-Cloud, entering the factory in December 1748 at a salary of 40 *livres* per month.[46] He left in May 1749 to join the French army, although he had been wounded at the battle of Fontenoy in 1745[47] and as a result had a withered left hand (apparently incorrectly recorded in the documents as his right hand). He returned to the factory in November 1751 at a monthly salary of 50 *livres,* which was increased to 80 *livres* as of January 1, 1755, when he was thirty-four years old. From 1773 he earned 84 *livres* per month, increased to 90 *livres* in 1782.

PIERRE-ANDRÉ LE GUAY *fils aîné* (active 1772–1818).[48] Painter of figure scenes and chinoiserie decoration.

PIERRE-ANTOINE MÉREAUD (or Méreau or Moireau) *l'aîné* (active 1754–1791).[49] Painter of flowers, monograms, emblems, and friezes; gilder. He entered the factory in July 1754, having previously been a painter in Salins, in Franche-Comté.[50] From August 1754 he was earning 30 *livres* per month. By January 1, 1755, when he was twenty years old, he was earning 39 *livres* per month, and by 1764 his salary had increased to 66 *livres*.

JACQUES-FRANÇOIS MICAUD *père* (active 1757–1810).[51] Painter of flowers. He came from near Salins, in Franche-Comté, having worked in the Chantilly factory.[52] He was initially paid 30 *livres* per month. By March 1, 1757, he was twenty-two years old, and it was noted that he had previously been interested in drawing. His salary was increased to 90 *livres* per month in 1773.

JEAN-LOUIS MORIN (active 1754–1787, d. 1787).[53] Painter of figure, military, and marine scenes. He entered the factory on May 13, 1754, having studied surgery in Vincennes.[54] By January 1, 1755, when he was twenty-two years old, his drawing was described as adequate, and he was "making progress with his use of colors." He was paid 33 *livres* per month. On January 1, 1756, he was recorded as having "begun six months ago to paint children in colors," and his pay was increased to 42 *livres* per month, with subsequent increases to 54 *livres* in 1759 and 60 *livres* in 1762.

NANTIER (active 1767–1776).[55] *Répareur.*

PHILIPPE PARPETTE (active 1755–1757, 1773–1806).[56] Painter of flowers, enameler. He entered the factory on May 26, 1755, having previously served as an apprentice in the factory at Chantilly, where he was born.[57] He was initially paid 42 *livres* per month. By June 12, 1755, he was seventeen years old and was recorded as being "good with colors, less good at drawing, but he could perfect it." He had a "sweet and quiet character and applies himself." By January 1, 1756, he was described as showing a lot of promise, and his pay was increased to 48 *livres* per month. From 1780 he was paid 84 *livres* per month.

JEAN-JACQUES PIERRE *le jeune* (active 1763–1800).[58] Painter of flowers. He also worked on ground colors and friezes and did some gilding. From 1774 his salary was 78 *livres* per month.

RAUX *fils aîné* (active 1766–1779).[59] Painter of flowers. From 1775 his salary was 60 *livres* per month.

JEAN-BAPTISTE TANDART *l'aîné* (active 1754–1803).[60] Painter of flowers and fruit. He had previously worked as a fan painter and entered the factory at a salary of 30 *livres* per month.[61] By January 1, 1755, he was twenty-four years old and was described as having a "mediocre but improving talent for painting flowers"; his pay had been increased to 42 *livres* per month. From 1773 he was earning 84 *livres* per month.

PIERRE-PHILIPPE THOMIRE (active 1783–1815).[62] *Fondeur, ciseleur,* maker of gilt-bronze mounts for Sèvres porcelain.

JEAN-BAPTISTE-EMMANUEL VANDÉ *père* (active 1753–1779).[63] Gilder. He entered the factory in April 1753, having previously been a painter in Paris.[64] At that time he was paid 30 *livres* per month. By January 1, 1755, he was twenty-eight years old and was described as a very talented burnisher. His pay had increased to 57 *livres* per month. By January 1, 1757, he was recorded as being in charge of burnishing and was responsible for "directing the women who did this kind of work"; his pay had increased to 60 *livres* per month.

HENRY-FRANÇOIS VINCENT *le jeune* (active 1753–1806).[65] Gilder. He entered the factory in February 1753 at a salary of 36 *livres* per month, having worked in the factory at Saint-Cloud.[66] By January 1, 1755, he was receiving 60 *livres* per month. He was twenty-two years old and was described as "pushing himself to perfect his work." On April 1, 1758, he was recorded as being offered 6 *livres* more per month, "which he has already merited," but he refused because he had "quarrelled with the bookkeepers" at the factory. He had apparently "insulted them, along with others of his colleagues, who were also punished." Between 1774 and 1786 his salary was 78 *livres* per month.

1. Eriksen and de Bellaigue 1987, p. 157; dates given as 1765–1798 and 1800–1804 in Brunet and Préaud 1978, p. 354.
2. R.E., Y7, fol. 137.
3. Eriksen and de Bellaigue 1987, p. 172, with a note that this attribution is unconfirmed; dates given as 1749 and 1751–1758 in Brunet and Préaud 1978, p. 355.
4. R.E., Y8, fol. 50.
5. Eriksen and de Bellaigue 1987, p. 157.
6. R.E., Y8, fol. 5.
7. Brunet and Préaud 1978, p. 356.
8. R.E., Y7, fol. 87.
9. Brunet and Préaud 1978, p. 357.
10. Eriksen and de Bellaigue 1987, p. 167.
11. Also recorded as Etienne-François in Brunet and Préaud 1978, p. 357.
12. Eriksen and de Bellaigue 1987, p. 173.
13. R.E., Y8, fol. 106.
14. Eriksen and de Bellaigue 1987, p. 171; dates given as 1746–1800 in Brunet and Préaud 1978, p. 358.
15. R.E., Y8, fol. 34.
16. R.E., Y8, fol. 35.
17. Eriksen and de Bellaigue 1987, p. 168; dates given as 1749–1798 in Brunet and Préaud 1978, p. 359.
18. R.E., Y8, fol. 40.
19. R.E., Y8, fol. 41.
20. R.E., Y7, fol. 138.
21. Eriksen and de Bellaigue 1987, p. 158.
22. Ibid., p. 161.
23. Ibid., p. 172; dates given as 1753–1788 in Brunet and Préaud 1978, p. 360.
24. R.E., Y8, fol. 6.
25. Eriksen and de Bellaigue 1987, p. 172; dates given as 1755–1792 and 1794–1800 in Brunet and Préaud 1978, p. 361.
26. R.E., Y8, fol. 90.
27. Brunet and Préaud 1978, p. 361.
28. Eriksen and de Bellaigue 1987, p. 158.
29. Ibid., p. 168.
30. I thank Bernard Dragesco for this highly probable attribution.
31. Problems with this attribution have been noted in earlier publications; see Brunet and Préaud 1978, pp. 371, 383, n. 8.
32. Ibid., p. 376.
33. Eriksen and de Bellaigue 1987, p. 171; dates given as 1777–1790, 1794–1798, and 1803–1810 in Brunet and Préaud 1978, p. 363.
34. Eriksen and de Bellaigue 1987, p. 161; dates given as 1754–1803 in Brunet and Préaud 1978, p. 363.
35. R.E., Y8, fol. 80.
36. Ibid.
37. Brunet and Préaud 1978, p. 364.
38. Ibid., p. 365.
39. Eriksen and de Bellaigue 1987, p. 159; dates given as 1773–1790 in Brunet and Préaud 1978, p. 365.
40. Eriksen and de Bellaigue 1987, p. 172.
41. R.E., Y8, fol. 49.
42. Eriksen and de Bellaigue 1987, p. 160; dates given as 1752–1788 in Brunet and Préaud 1978, p. 366.
43. R.E., Y8, fol. 33.
44. Eriksen and de Bellaigue 1987, p. 161; dates given as 1758–1800 in Brunet and Préaud 1978, p. 369.
45. Eriksen and de Bellaigue 1987, p. 162; dates given as 1749–1773, 1777–1778, and 1780–1796 in Brunet and Préaud 1978, p. 371.
46. R.E., Y8, fol. 2.
47. MNS Archives D.1, *Mémoire,* dated October 6, 1751.
48. Eriksen and de Bellaigue 1987, pp. 174–175; dates given as 1773–1817 in Brunet and Préaud 1978, p. 372.
49. Eriksen and de Bellaigue 1987, p. 166.
50. R.E., Y8, fol. 79.
51. Eriksen and de Bellaigue 1987, p. 170.
52. R.E., Y8, fol. 99.
53. Eriksen and de Bellaigue 1987, p. 163.
54. R.E., Y8, fol. 75.
55. Brunet and Préaud 1978, p. 375.
56. Eriksen and de Bellaigue 1987, p. 164; dates given as 1755–1757, 1773–1786, and 1789–1806 in Brunet and Préaud 1978, p. 376.
57. R.E., Y8, fol. 92.
58. Eriksen and de Bellaigue 1987, p. 165.
59. Ibid., p. 170.
60. Ibid., p. 172.
61. R.E., Y8, fol. 71.
62. Brunet and Préaud 1978, p. 381.
63. Eriksen and de Bellaigue 1987, p. 166.
64. R.E., Y8, fol. 62.
65. Eriksen and de Bellaigue 1987, p. 169.
66. R.E., Y8, fol. 8.

Index

Museums are listed under the name of the city in which they are located. Where possible, full names have been given for buyers, collectors, dealers, etc., referred to in the text by surname only.